Religion in Museums

Also available from Bloomsbury

Key Terms in Material Religion, edited by S. Brent Plate
Religious Objects in Museums, Crispin Paine
Sacred Objects in Secular Spaces, edited by Bruce M. Sullivan

Religion in Museums

Global and Multidisciplinary Perspectives

Edited by
Gretchen Buggeln, Crispin Paine, and
S. Brent Plate

Bloomsbury Academic
An imprint of Bloomsbury Publishing Plc

B L O O M S B U R Y
LONDON • OXFORD • NEW YORK • NEW DELHI • SYDNEY

Bloomsbury Academic

An imprint of Bloomsbury Publishing Plc

50 Bedford Square	1385 Broadway
London	New York
WC1B 3DP	NY 10018
UK	USA

www.bloomsbury.com

BLOOMSBURY and the Diana logo are trademarks of Bloomsbury Publishing Plc

First published 2017

British Library Cataloguing-in-Publication Data
A catalogue record for this book is available from the British Library.

ISBN: HB: 978-1-4742-5552-3
PB: 978-1-4742-5551-6
ePDF: 978-1-4742-5554-7
ePub: 978-1-4742-5553-0

Library of Congress Cataloging-in-Publication Data
Names: Buggeln, Gretchen Townsend, editor. | Paine, Crispin, editor. |
Plate,S. Brent, 1966– editor.
Title: Religion in museums : global and multidisciplinary perspectives /
edited by Gretchen Buggeln, Crispin Paine, and S. Brent Plate.
Description: New York : Bloomsbury Academic, 2017. |
Includes bibliographical references and index.
Identifiers: LCCN 2016037706 (print) | LCCN 2016041370 (ebook) |
ISBN 9781474255523 (hb : alk. paper) | ISBN 9781474255530 (epub) |
ISBN 9781474255547 (epdf)
Subjects: LCSH: Religion—Museums. | Religions—Museums. |
Museums—Religious aspects.
Classification: LCC BL45 .R44 2017 (print) | LCC BL45 (ebook) | DDC 200.75—dc23
LC record available at https://lccn.loc.gov/2016037706

Cover design by Dani Leigh.
Cover image © Justin Pumfrey / gettyimages.co.uk; colossal limestone bust
of Amenhotep III, British Museum, London, UK.

Typeset by Newgen Knowledge Works (P) Ltd., Chennai, India.
Printed and bound in Great Britain

Contents

Section V Museum Interpretation of Religion and Religious Objects

Section VI Presenting Religion in a Variety of Museums

Figures

List of Contributors

Steph Berns is a researcher working within the fields of museum studies and the sociology of religion. She previously worked on a postdoctoral ethnographic study, with Lancaster University, about urban rituals and religious events in London. Prior to this, she completed a collaborative doctorate with the University of Kent and the British Museum on visitors performing religious practices in museums. Recent articles have appeared in *Material Religion* and the *Journal of Material Culture*.

Karla Cavarra Britton is lecturer at the Yale School of Architecture. Her academic work focuses on the modern architect's engagement with tradition in twentieth-century architecture and urbanism and has emphasized in a multireligious context the relationship between religion and modern architecture. Her books include the monograph *Auguste Perret: Hawaiian Modern* (edited with Dean Sakamoto); and the interdisciplinary *Constructing the Ineffable*: *Contemporary Sacred Architecture*. Britton's current research addresses modern sacred architecture in the non-Western world.

Gretchen Buggeln holds the Phyllis and Richard Duesenberg Chair in Christianity and the Arts at Valparaiso University. She writes and teaches at the intersection of material culture, architecture, religion, and museum studies. Her most recent book is *The Suburban Church: Modernism and Community in Postwar America*.

Denis Byrne is a research fellow at the Institute of Culture and Society, Western Sydney University, Australia. He is an archaeologist who has worked both in the government and academic spheres of heritage conservation and has been a long-time contributor to critical debates on the practices of archaeology and heritage in Southeast Asia and Australia. He is author of *Surface Collection: Archaeological Travels in Southeast Asia* and *Counter Heritage: Critical Perspectives on Heritage Conservation in Asia*. He is coeditor of *Transcending the Culture-Nature Divide in Cultural Heritage: Views from the Asia-Pacific Region*.

Douglas Cardinal is dedicated to creating beautiful, thriving, and harmoniously built environments. He is a forerunner of philosophies of sustainability, green buildings, and ecologically designed community planning. His architecture springs from

his observation of nature and its understanding that everything works seamlessly together. Cardinal has received many national and international awards including: eighteen honorary doctorates, gold medals of architecture in Canada and Russia, and an award from United Nations Educational Scientific and Cultural Organization (UNESCO) for best sustainable village. He was titled an Officer of the Order of Canada, one of the most prestigious awards given to a Canadian, and he was awarded the declaration of being "World Master of Contemporary Architecture" by the International Association of Architects.

Christian G. Carron is director of collections for The Children's Museum of Indianapolis. In this position he directs the development, conservation, use, and research of a collection of more than 120,000 artifacts and specimens, and was project manager for the exhibition *National Geographic Sacred Journeys.* Carron has more than thirty years of experience managing museum collections and exhibitions for Grand Rapids Public Museum, The Kentucky Library and Museum, Louisiana State Museum, and Missouri Historical Society. He holds an MA in historical administration from Eastern Illinois University and a BA in history, art, and museum studies from Luther College.

Susan Foutz is the director of research and evaluation at The Children's Museum of Indianapolis. In this capacity, she is responsible for the study, design, and implementation of the museum's evaluations of exhibitions and programs, and led the evaluation team for *National Geographic Sacred Journeys*. Ms. Foutz has more than ten years of experience in evaluating informal education setting, including libraries, science centers, natural history museums, and children's museums. She holds an MA in museum studies from the University of Nebraska-Lincoln and a BA in sociology and anthropology from Ohio Wesleyan University.

Matthew Francis is the executive director of the Chilliwack Museum and Archives in Chilliwack, British Columbia, Canada. He studied history and theology at the University of Manchester, concentrating on the theme of sacred space and place. Formerly, he led the Province of Alberta's municipal engagement programs for built heritage conservation.

Tom L. Freudenheim is a freelance writer covering art, architecture, museums, and cultural issues for the *Wall Street Journal, Curator*, and other publications. His lengthy museum career included top-level administrative positions at institutions including the Smithsonian Institution (1986–95), the Gilbert Collection (London), the Jüdisches Museum Berlin, the YIVO Institute for Jewish Research, the Baltimore Museum of Art, and the Worcester Art Museum, as well as a wide range of consulting and public-speaking assignments.

Ed Gyllenhaal holds degrees in religion and Egyptology and has been curator of Glencairn Museum in Bryn Athyn, Pennsylvania, since 1987. His special interest is the interpretation of religion at museums and historic sites.

Samantha Hamilton is an object conservator, currently on leave from Museum Victoria for a PhD at the University of Melbourne on "Best Practice in Conservation Programs for Remote Aboriginal Communities." Her interests focus on programs to build capabilities in remote communities, and developing ethical collections care within museums, based on traditional knowledge systems. Recent publications include: "Wrapped in Country: Conserving and Representing Possum-Cloaks as In/tangible Heritage," in *Refashioning and Redress: Conserving and Displaying Dress*, The Getty Conservation Institute, and "Boorun's Canoe" in *AICCM Bulletin*.

Ena Giurescu Heller is the Bruce A. Beal Director of the Cornell Fine Arts Museum at Rollins College in Winter Park, FL. A graduate of the Institute of Fine Arts, New York University, and previously the founding director of the Museum of Biblical Art, Dr. Heller has published extensively on the interconnectedness of art and religion.

Graham Howes is an emeritus fellow of Trinity Hall, University of Cambridge, a Trustee of ACE (Art and Christianity Enquiry), and author of *The Art of the Sacred: An Introduction to the Aesthetics of Art and Belief*. His most recent publication is "Seeing *and* Believing? Parameters and Possibilities for Sacred Art in City Churches" in *Religion and Art in the Heart of Modern Manhattan*.

Amanda Millay Hughes is an artist and writer living in Durham, NC. She has served as director of external affairs at the Ackland Art Museum at The University of North Carolina at Chapel Hill for more than a decade, where she worked on the pathbreaking Five Faiths project, which aimed to center conversations about faith traditions on works of art originally used in worship. Hughes is currently the director of development and strategy at Duke University Chapel where she provides comprehensive oversight for all aspects of Chapel operations. Learn more about Ms. Hughes at iamnotrothko.blogspot.com.

Tim Johnson retired from the Smithsonian Institution's National Museum of the American Indian in 2015 as associate director for museum programs He currently serves as cochair of the Working Group of the Legacy Sub-Committee of the Niagara-on-the-Lake War of 1812 Bicentennial Committee. In this capacity he has guided the development of the permanent national public art exhibit entitled "Landscape of Nations: The Six Nations and Native Allies Commemorative Memorial," located in Queenston Heights Park.

David Morgan is professor of religious studies and chair of the Department of Religious Studies at Duke University, United States. Author of several books, including *Visual Piety*, *The Sacred Gaze*, and *The Embodied Eye*, his most recent book is *The Forge of Vision: A Visual History of Modern Christianity*, which was the 2012 Cadbury Lectures at University of Birmingham, United Kingdom.

Mark O'Neill has been director of policy and research for Glasgow Life, the charity which delivers arts, museums, libraries, and sports services for the City of Glasgow. Prior to this he worked in various positions in museums in Glasgow, serving as head of Glasgow Museums from 1998 to 2009. He is particularly interested in the social purposes of cultural institutions, in people's motivations to take part in cultural activities, and in the health benefits of cultural participation. He has lectured and published on museum theory and practice and on culture, urban regeneration, and health. His most recent publication is "Museums and Philosophy," in *Philosophy and Museums: Ethics, Aesthetics and Ontology*.

Crispin Paine is a former museum curator and consultant. Recent publications include *Religious Objects in Museums: Private Lives and Public Duties* and *A South Devon Carpenter in Victorian London*. He is working on a fourth edition of the international handbook *Museum Basics*, and on a book on religion in theme parks worldwide. He is an honorary lecturer at the Institute of Archaeology UCL, a cofounder of *Material Religion: The Journal of Objects, Art, and Belief*, a fellow of the Museums Association and of the Society of Antiquaries of London, and a very amateur beekeeper.

Melissa Pederson serves as exhibit developer at The Children's Museum of Indianapolis. In this capacity, she leads exhibit teams in the creation of exhibit content, develops exhibit messaging and storylines, guides artifact interpretation, oversees development of interactives, and writes interpretive scripts and labels. In addition to *National Geographic Sacred Journeys*, she has developed exhibits such as *Terra Cotta Warriors: The Emperor's Painted Army* and *Leonardo: The Mummified Dinosaur*. Pederson holds an MA in museum studies from Indiana University and a BA in history and communications from Dakota Wesleyan University.

S. Brent (Rodriguez) Plate is a writer, editor, public speaker, and visiting associate professor of religious studies at Hamilton College. He is cofounder and managing editor of *Material Religion: The Journal of Objects, Art, and Belief*; president of CrossCurrents/The Association of Religion and Intellectual Life; and serves on several international advisory boards. He has authored/edited twelve books at the intersections of religion and culture including, most recently, *A History of Religion in 5½ Objects* and the edited *Key Terms for Material Religion*. www.sbrentplate.net.

Sally M. Promey is professor of American studies and professor of religious studies in the Faculty of Arts and Sciences, and professor of religion and visual culture and deputy director in the Institute of Sacred Music, at Yale University. She is also founding director of the Center for the Study of Material and Visual Cultures of Religion (mavcor.yale.edu). Current book projects include volumes titled "Religion in Plain View: Public Aesthetics of American Belief" and "Written on the Heart: Christian Sensory Cultures in the United States." Recent edited volumes include *Sensational Religion: Sensory Cultures and Material Practice* (2014) and *American Religious Liberalism* (coedited with Leigh Schmidt, 2012). Among Promey's earlier publications are two award-winning books: *Painting Religion in Public: John Singer Sargent's "Triumph of Religion" at the Boston Public Library*; and *Spiritual Spectacles: Vision and Image in Mid-Nineteenth-Century Shakerism*.

John Reeve recently retired from teaching museum studies at the Institute of Education, University College London, where he is now an honorary lecturer. Previously he was Head of Education at the British Museum, for whom he wrote *A Visitor's Guide to World Religions*. He wrote the chapter on religion and museums, "A question of faith," in Sandell and Nightingale, *Museums, Equality and Social Justice*.

Mary (Polly) Nooter Roberts is professor in UCLA's Department of World Arts and Cultures/Dance and consulting curator for African Art at LACMA. With Allen F. Roberts, she produced the award-winning works *Memory: Luba Art and the Making of History* and *A Saint in the City: Sufi Arts of Urban Senegal*. She is also the author/curator of *Secrecy: African Art that Conceals and Reveals*; and coauthor of *Exhibition-ism: Museums and African Art*; *Inscribing Meaning: Writing and Graphic Systems in African Art*; and *Luba* in the "Visions of Africa" series. In 2007, she was decorated by the Republic of France as a Knight of the Order of Arts and Letters.

Konstanze Runge is the curator of the Religionskundliche Sammlung, Philipps-Universität Marburg, Germany, where she curated exhibitions on *Ethiopian Feasts*, *Religious Diversity in Islam*, and *Soviet Anti-Religious Posters*. She is working on a comparative study of the concept of religion underlying the displays at the Religionskundliche Sammlung and the State Museum of the History of Religion, Saint Petersburg. She edited *Von Derwisch-Mütze bis Mekka-Cola: Vielfalt islamischer Glaubenspraxis* and *"Es gibt keinen Gott!" Kirche und Religion in sowjetischen Plakaten* (with Andrey Trofimov).

Ekaterina Teryukova is deputy director for research affairs at the State Museum of the History of Religion, St. Petersburg, Russia, and associate professor at the Department of Philosophy of Religion and Religious Studies, Institute of Philosophy,

St. Petersburg State University. Recent publications include *Saint-Petersburg English-speaking Protestant Community in the Early 20th Century* and "The State Museum of the History of Religion as a Space for Dialog: Museological Approaches to National, Social and Cultural Issues," in *Bamberger Beiträge zur Europäischen Ethnologie*.

Lauren F. Turek is an assistant professor of history at Trinity University in San Antonio, TX, where she teaches courses on modern US history, US foreign relations, and public history. She earned her PhD in history from the University of Virginia and holds an MA in museum studies from New York University. Prior to earning her PhD, she worked as a content developer and coordinator for Ralph Appelbaum Associates, Inc., a museum exhibition design firm based in New York City.

Gary Vikan was director of the Walters Art Museum in Baltimore from 1994 to 2013; from 1985 to 1994, he was the museum's assistant director for curatorial affairs and curator of Medieval Art. Before coming to Baltimore, Vikan was senior associate at Harvard's Center for Byzantine Studies at Dumbarton Oaks in Washington, DC. A native of Minnesota, he received his BA from Carleton College and his PhD from Princeton University; he is a graduate of the Harvard Program for Art Museum Directors and the National Arts Strategies Chief Executive Program. Vikan's recent books include *Early Byzantine Pilgrimage Art*; *Postcards from the Walters*; *From the Holy Land to Graceland*; and his memoirs, *Sacred and Stolen: Confessions of a Museum Director*.

Menachem Wecker is a freelance reporter based in Washington, DC. He is a former education reporter at *U.S. News & World Report* and is coauthor, with Brandon Withrow, of *Consider No Evil: Two Faith Traditions and the Problem of Academic Freedom in Religious Higher Education*. He won a Catholic Press Association award in 2015 for his arts reporting for *National Catholic Reporter*. He holds a master's in art history from George Washington University.

Chris Wingfield is senior curator at the Museum of Archaeology & Anthropology, University of Cambridge. Previously, he worked at the Pitt Rivers Museum, Birmingham Museum & Art Gallery, and the Open University. His recent work has concentrated on missionary collections, including the coedited *Trophies, Relics and Curios? Missionary Heritage from Africa and the Pacific* and " 'Scarcely more than a Christian trophy case'? The Global Collections of the London Missionary Society Museum (1814–1910)" in the *Journal of the History of Collections*.

Chiara Zuanni holds a PhD in museology from the University of Manchester where she is currently a teaching assistant and also collaborates on research and

digital engagement projects at the Institute for Cultural Practices. She is a research fellow at the Institute of Cultural Capital (University of Liverpool & Liverpool John Moores University), working on the "Liverpool 2018" research project which aims to evaluate the longitudinal impact of the European Capital of Culture award. She has published on the religious history of Kazakhstan, the history of archaeology and museums in Trento (Italy), and on public archaeology and social media engagement in museums.

Acknowledgments

This volume, like any edited collection, took a few years of planning, discussion, contacting, wrangling, writing, editing, and ultimately producing. Many of those involved are the authors of the chapters themselves, but there many others who have provided support, ideas, and inspiration. We would particularly like to thank Bloomsbury Academic for taking on this project and especially Lalle Pursglove for seeing it through.

Gretchen is grateful for the academic support of Valparaiso University and the Duesenberg Chair in Christianity and the Arts. She thanks her coeditors and authors for two years of really interesting conversations about religion in museums. And, as always, she is thankful to John, Hannah, and John Henry, who, with curiosity and patience, listened in and contributed.

Crispin's career in museums and many years of fascination with how religion plays a role in them has given him so many helpful and supportive colleagues and friends that he cannot possibly thank even a tiny few. Perhaps best to thank his grandfather, mother, and school for leading him to such a rewarding interest in both religion and museums.

Brent would like to thank Susanna White, Megan Austin, and Tracy Adler at the Wellin Museum of Art, Hamilton College, for opportunities to do research and teaching within and alongside a fantastic museum. Through the years, I've been inspired to think about museums in new ways by Ivan Karp, Ena Heller, Norman Girardot, and Polly Roberts. Many thanks also for the ongoing input of Tel Mac, Diane Apostolos-Cappadona, Tim Beal, Simon Halliday, and the most amazing display of humanity: Sabina, Camila, and Edna Melisa.

Foreword: Museums, Religion, and Notions of Modernity

SALLY M. PROMEY

This is a book for which many have waited.[1] Time and again, students in museum studies and in material religion ask for resources about the topic of religion in museums. Carol Duncan's *Civilizing Rituals* (1995) and, more recently, Crispin Paine's *Religious Objects in Museums* (2013) have numbered among the few go-to volumes. Now, collected in the rich pages of this anthology, readers can find expert voices, the three editors prominent among them, and interested parties from multiple disciplines and vocations sharing ideas and experience on this key subject.

Why has it taken so long? While this is not the book's primary question (nor should it be), several of the authors gathered here propose compelling answers. If we read closely, and pay careful attention, some even hint at the meta-theoretical narrative, indeed the ideological paradigm, that has most explicitly shaped the ways major Western museums have approached religion and religious objects. Brent Plate is fully on target when he asserts *"religion* is the object that is transformed by the museum" (p. 41 in Chapter 4 of this volume). Many authors in this volume either engage or assume the Enlightenment origins of museums as institutions. One outcome of the Enlightenment was the secularization theory of modernity, now roundly debunked by scholars but still very much in play when it comes to museums and their treatment of religions and religious arts and objects. Secularization theory neatly boxed modern religion as belief, most properly located inside the believer and charged to remain there. When religion shows up outside, which of course it very frequently does, it is presumed to be out of place and thus "other."

But religion is only one term in this equation, and Plate's assertion is thus partial, as I am fairly certain he would agree. He might have added that museums have most specifically aimed to transform *relations* among religions (as belief and as practice) and materialities, including those material artifacts we label art. I'm going to oversimplify more than a bit here for the sake of brevity (this is after all merely a foreword) and useful provocation. I will henceforth write without scare quotes (around modern and premodern and idol and art and superstition, for example) because these qualifying punctuation marks might otherwise proliferate nearly out of control.

Museums as cultural institutions took nascent shape at just the moment when it seemed necessary for mostly Protestant religious reformers and moderns to protect great art from the perceived taint of mostly Catholic and other premodern superstitions. Museums facilitated the process by which Catholic devotional objects, not to mention other sorts of idols from the Christian missions field, might be drained of their natural and supernatural agencies and enchantments and, once purified, resituated for modern contemplation and aesthetic inspiration. James Simpson (2010: 120–1) summarizes this trajectory when he describes museums as asylums that provided objects sanctuary from iconoclasm. Museums as institutions, then, have been part and parcel of the processes of secularization, abstracting objects from lived and embodied contexts and presenting them for disinterested display. It is not terribly surprising that a fairly new and still developing interest in exhibition practices concerning religions roughly coincides with the dismantling of secularization theory. That Sister Corita Kent can be resurrected in 2015–16 as a Pop artist, with art historians paying scant attention, beyond the merely descriptive, to the substance of her religious convictions and practice, however, provides a recent example that demonstrates how tough it is to shake fundamental ingrained cultural hierarchies and biases.[2]

We have not yet adequately explored the lasting implications of secularization theory for the ways we structure the material world and the institutions that present, represent, and display it. Matter, and especially what we might call religious matter, bears substantial weight in precisely this regard. Under this secularization paradigm premodern matter has agency while modern matter's values parse in other ways. It is, in fact, matter and assessments of its powers (and the powers of those forces, natural and supernatural, whose persistence matter may manifest) that occupy the before-and-after, us-and-other, divides. Fundamental categories of Western museum practice constitute pervasive relics of secularization theory and its precedent enlightenment constructions. Hardest hit, perhaps, is the discipline of the history of art where such presumably normative terms as fine art, craft, outsider art, and folk art resist reconception despite widespread acknowledgment of their inadequacies. The ways we think about what sorts of objects merit display in what sorts of collecting repositories (art museum, natural history museum, history museum, etc.), furthermore, continue to be inflected by biases originally perpetuated by secularization theory.

Contributors to this volume stand at varying degrees of proximity to a shared notion of the ideal neutrality of museum spaces. As attractive as this ideal may appear, however, it not only fails to describe contemporary museum practice, but also obscures the historical shape and cultural technologies of these institutions. Museum space is anything but neutral. Any given exhibition, in any given museum, represents multiple constellations of constituents (e.g., curators, educators, patrons, donors, and a range of publics) with diverse and often competing interests, needs, and demands (see Baxandall 1991). Looking beyond this array of individuals and groups, many other aspects of museum practice complicate claims to neutrality. It is

perhaps not surprising that scholars of religion should wonder where and how religion fits in museum display, for the neutrality of museum space is especially suspect when it comes to this subject of inquiry.

The culture of enlightenment that produced museums in their current forms framed these institutions as quintessentially modern entities (see Karp, Kratz, Szwaja, Ybarra-Frausto 2006). An enlightenment crucible projected museums into a progressively secular culture of modernity, and one ultimately predicated on religion's disappearance. In this redaction, as numerous scholars have suggested for well over two decades, religion became a vestigial organ or appendage, a relic of the past, or a token of presumably less advanced civilizations. Emptied of contemporary religious content, museums instead elevated and sacralized art and culture and traced civilizing trajectories that replicated this kind of ascent (about which, see Carol Duncan's persuasive argument in *Civilizing Rituals*). Especially when it comes to religion, then, museums represent an inherently political enterprise, historically having assumed their present shape, in large part, by locating religion securely in other times or other places and replacing it with an elevation of its presumed modern aestheticized counterparts, against which other sorts of display are measured.

Striking gaps open with frequency between this set of strategies in museum origins and the contemporary human material lives they seek to represent to the museumgoing public. Sometimes objects resist the sorts of cultural elevations so-called secular museums seek to enforce; sometimes they implement their own variations. In 1963, for example, Chester Dale gave Salvador Dali's *Sacrament of the Last Supper* (1955) to the National Gallery of Art (NGA). In this case, and in this context, art *should* have trumped the religious subject matter—but art status failed to protect the object from religious practice. Stories (some perhaps apocryphal) have circulated for years about museum visitors praying in front of the image, and even leaving offerings beneath it. For a number of reasons, including its apparently oxymoronic pairing of religion and modern art, this painting does not fit the narrative of modernity that the National Gallery otherwise presents. Devotees, however, raise voices if the painting is not on view and this Dali, in reproductions of various sorts, sells very well in the institution's gift shops. For years the museum's solution has been to display the Dali, but to hang it in out-of-the-way service spaces, also housing the elevator, between the West and East Buildings, or the escalator landing at the eastern end of the West Building. *Sacrament of the Last Supper* thus does not compete for more valuable real estate in the proper galleries where it would also disrupt the narrative flow suggested in the arrangement of modern works of art—and where the occasional pious individual might disrupt other museum fictions as well.

Slippage between museum exhibition and religious practice occurs fairly often. As various authors here note, this is sometimes a deliberate strategy of display. Often, though, the intent is otherwise. This is perhaps most emphatically apparent when display moves outdoors and concerns artifacts beyond the designated fine arts, as happened, for example, in the spaces reserved for showcasing Tibetan Buddhism at the Smithsonian Folklife Festival in 2000. Here Buddhist monks (as practitioners of art

and religion) demonstrated the making of a mandala and an observant local woman left offerings and engaged in devotions at a stupa constructed as an educational artifact for that year's festival on the National Mall in Washington, DC.

The sensory abundance of this woman's practice (lighting candles, inhaling incense and the scent of flowers, seeing the sacred shape of the structure, hearing the sounds of adjacent prayer wheels and musical performances as well as the noise of the festival crowds) called to attention, by contrast, the degree to which the customary culture of museum spaces is heavily informed by a Western enlightenment investment in visuality as the premier sensory experience, most exalted among the senses, the primary mode of the production of knowledge. In relegating religion to an other present (here Tibetan Buddhism) or a premodern past, academics have long granted it greater access to senses deemed more primitive (smell, touch, taste) than the highest sense (sight) or its penultimate (sound). As the academy renegotiates understandings of the relation of secularization to modernity, as it acknowledges the significant presence of religion in contemporary local and global cultures, it has also begun to reevaluate vision's domination of the enlightenment sensory landscape and to attend to the multisensory situation of human experience (see Bennett 1995; Alpers 1991; Baxandall 1991).[3]

The challenge to conventional museum practice here is enormous. We have learned in art and history museums how to *look* at objects, and how to value looking in contexts that assert its neutrality and ubiquity. Despite clichéd claims that seeing is believing, the difficulty is that sight alone often fails to reveal everything we want and need to know. Religious practices are embedded in a multisensory world and simply looking at things, from a Western ocularcentric perspective, is a distinctly partial avenue of engagement, as several authors in this current volume point out. The recent sensory turn, having now moved museum studies as well as other more exclusively academic fields, seeks to address a related set of issues.

If seeing is but one important sense among others, it is also partial in still another way. In the calculus of enlightenment "neutrality," looking registered as a most disinterested sense. As James Elkins (1997) argues in *The Object Stares Back*, however, "there is no looking that is not also directed at something, aimed at some purpose" (21); looking is "tangled with living and acting" (31); "looking is hoping, desiring, never just taking in light, never merely collecting patterns and data" (22). Beyond the valuations assigned in individual acts of looking, sensory experience of every sort is, as David Howes (2005: 3) suggests in *Empire of the Senses*, "permeated with social values." Perception "has a history and a politics that can only be comprehended within its cultural setting" (5; cf. Promey 2014).

While it may appear that museums present objects as evidence from which visitors are invited to draw their own conclusions, knowledge is heavily mediated in museums, mediated by the sorts of institutions they are (and have been), the kinds of spaces they construct and the lighting they provide, the materials of display those spaces accommodate and those they do not accommodate, the selections of objects in their collections, the people who have made these selections, the categories these

selections are presumed to occupy, the conditions of encounter over time and in any given moment, and so on.

In art and history museums visitors have learned not just how to *look* at objects, but how to value them—and how to most highly value some kinds of objects, especially those objects called "art." Museum collections have taken shape around inclinations and imperatives to collect and display certain kinds of things—and not others. This has meant that especially attractive "other" objects often get misplaced into historically more highly valued categories for purposes of display. For example, past habits of collecting and categorization relegated Native American artifacts to natural history museums or to "museums of man." Recognizing the imperialist inadequacies of this practice, curators today have worked to address this situation—and art museums have mounted major displays of Native American objects. Because the category art is most sacred within the Western museological cultural/institutional context, denying art status is frequently understood as something akin to a moral affront. By this valuation, if an object is good, if it deserves our attention, it must be art. Thus, the Art Institute of Chicago exhibition titled "Hero, Hawk, and Open Hand: American Indian Art of the Ancient Midwest and South" (Art Institute of Chicago, 2004–2005) presented ancient Native American works of various sorts as "masterpieces" of "art." Perhaps categorization of the works as art was deemed a necessary first step to exhibition in an art museum—but it was a step that limited the objects in the context of their early production and use, though admittedly it also revealed something consequential about twenty-first-century reception. As part of the educational initiative of this exhibition, curators and museum professionals selected fifteen "masterpiece" objects to be reproduced on flashcards for circulation to public schools.[4]

Practices of selection, moreover, raise questions not just about what to do with objects that survive, but also how to account for and reimagine those that did not. Many objects are rendered invisible in the kinds of museum display to which Western audiences have grown accustomed. Things in motion or performance, for example, present special challenges, as do the kinds of things that have disappeared because collectors did not consider them attractive or important. There are also many instances in which objects remain, but do so below museum radar. While museums make some things visible, they also consign others to invisibility—and these, historically, have often concerned religious belief and practice.

Especially in instances likely to produce disagreement or controversy, curators and publics may be disinclined to fully engage the problematic object. In 1999 and 2000, for example, Chris Ofili's *Holy Virgin Mary*, on display at the Brooklyn Museum, was subject to accusations of blasphemy for its inclusion of feet and a breast made of elephant dung. Here mediation by the press untethered display, disconnected it from its original materiality, and offered it a new disembodied, mostly verbal reality. In the media circus surrounding the Brooklyn Museum's *Sensation* exhibition, virtually no one called attention to the explicitly pornographic cut-outs of female genitalia pasted to the surface of the image. Protestants and Catholics representing the conservative side of the controversy failed to mention the cut-outs because they had not seen

them: They boycotted the exhibition and so knew the painting only in its postage-stamp-size reproductions in which the subject matter of the cut-outs was impossible to identify. Liberal religious groups and the New York art critics largely declined to talk about the little bits of pictures, apparently snipped from magazines such as *Hustler* and *Penthouse*. Instead they devised descriptions that lauded the painting's presumed devotional purity and insisted upon the contextual role of elephant dung in African fertility rites. How ironic that Ofili did not aim to produce art that was neutral or even necessarily benign. He would be among the first to admit that, among other things, his art engages a market fed by notoriety.

Scholars have long recognized the absence of neutrality in museums and collecting institutions, in objects, in collections and collecting practice, in categories and their related genealogies, in looking, and in sensory cultures. This recognition has had insufficient impact on the ways museums display religion. In the now fairly long wake of the critique of secularization theory, as we recalibrate estimations of religion's definition, longevity, and consequence, and as we acknowledge the critical importance of material and sensory practices of religion, the representation of religion in museum exhibitions, and the very notion of exhibition itself, will require serious intellectual, categorical, and institutional attention. This book offers an excellent impetus to reconsideration and begins to suggest important paths forward.

Notes

1. Parts of this foreword are adapted from Sally M. Promey, "Exhibiting Religion," *Religious Studies News* (May 2009): 19, 21.
2. "Sister Corita Kent and the Language of Pop" was installed at Harvard University Art Museums (2015–16) and at the San Antonio Museum of Art (2016). A smaller 2016 exhibition titled "love is here to stay (and that's enough): Prints by Sister Corita Kent" at the University of San Diego, a Catholic institution, provided a more nuanced and effective account of relations between Kent's work and religion. Both exhibitions produced catalogues.
3. I am grateful to Yale history of art doctoral student Shirlynn Sham for calling my attention to Bennett's book.
4. Knowledge of this exhibition I owe to the work of Elizabeth Pope, a panelist in the "Exhibiting Religion" session organized by Colleen McDannell for the American Academy of Religion annual conference, Chicago, November 1, 2008. Gretchen Buggeln was another panelist.

References

Alpers, Svetlana. 1991. "The Museum as a Way of Seeing." In *Exhibiting Culture: The Politics and Poetics of Museum Display*, edited by Ivan Karp and Seven D. Lavine, 25–32. Washington and London: Smithsonian University Press.
Baxandall, Michael. 1991. "Exhibiting Intention: Some Preconditions of the Visual Display of Culturally Purposeful Objects." In *Exhibiting Culture: The Politics and Poetics of*

Museum Display, edited by Ivan Karp and Seven D. Lavine, 33–41. Washington and London: Smithsonian University Press.

Bennett, Tony. 1995. *The Birth of the Museum: History, Theory, Politics*. New York: Routledge.

Classen, Constance. 1998. *Color of Angels: Cosmology, Gender, and the Aesthetic Imagination*. London and New York: Routledge.

Classen, Constance. 2017. *The Museum of the Senses: Experiencing Art and Collections*. London: Bloomsbury.

Duncan, Carol. 1995. *Civilizing Rituals: Inside Public Art Museums*. London: Routledge.

Elkins, James. 1997. *The Object Stares Back: On the Nature of Seeing*. Wilmington, DE: Mariner Books.

Howes, David (ed.). 2005. *Empire of the Senses: The Sensual Culture Reader*. London: Bloomsbury.

Karp, Ivan, Corinne Kratz, Lynn Szwaja, and Tomas Ybarra-Frausto (eds.). 2006. *Museum Frictions: Public Cultures/Global Transformations*. Durham and London: Duke University Press.

Paine, Crispin. 2013. *Religious Objects in Museums: Private Lives and Public Duties*. London: Bloomsbury.

Promey, Sally M. (ed.). 2014. *Sensational Religion: Sensory Cultures in Material Practice*. New Haven, CT: Yale University Press.

Simpson, James. 2010. *Under the Hammer: Iconoclasm in the Anglo-American Tradition*. Oxford, UK: Oxford University Press.

Introduction: Religion in Museums, Museums as Religion

GRETCHEN BUGGELN, CRISPIN PAINE, AND S. BRENT PLATE

Museums are booming throughout the world. For many years in China a new museum would open every day. In the United Kingdom far more people visit museums than attend professional sporting events. In 2014 over sixty-one million people attended museums across North America, while another ten million attended the Louvre alone. And it's not just the numbers that are impressive. Museums play an increasingly vital role in cultural affairs in countries north and south, east and west. They mark and consequently tell history. They display cultural objects and therefore generate culture. They are situated within national agendas and thus create the felt experience of nationalism. And they utilize religious objects and as a result involve themselves in the public understanding of religion.

Meanwhile, religion is playing a newly important global role. Faced with navigating the complexities of international relations, US secretary of state John Kerry recently announced that if he went back to university, he would major in comparative religions rather than political science. Other political leaders around the world are dealing with religious extremism and resurgences in theocracy, while negotiating with their own citizens for whom religious practices and beliefs constitute a core part of their existence. Major foundations are putting up large sums of money to investigate the relations between religion and sociopolitical life. Because religious life and practice continues to play a global role, there is a strong need for mutual understanding across, and even within, religious lines, investigations that are critical to global cooperation and progress.

Museums are responding to new opportunities that have come from globalization, including the globalization of religion. Many museum strategies and programs are discussed in the pages of this volume. Museums devoted specifically to the diversity of religious traditions include St. Mungo's Museum of Religious Art and Life in Glasgow and the Museum of the History of Religion in St. Petersburg. Other major "secular" museums have created blockbuster exhibitions centered on religious art, artifacts, and life, including *Puja: Expressions of Hindu Devotion* at the Smithsonian Institution (1997), *Sacred Spain* at the Indianapolis Museum of Art (2009–10), *Treasures of Heaven: Saints, Relics, and Devotion in Medieval Europe* co-organized by the Cleveland Museum of Art, the Walters Museum, and

the British Museum (2011), and *Hajj: Journey to the Heart of Islam* at the British Museum (2012). Meanwhile, national museums around the world, from India to Ethiopia, Mexico to Indonesia, are filled with ritual objects and sacred artifacts that have been vital to indigenous and global traditions in their regions; by incorporating them into museum collections particular religious identities are integrated into the heart of the nation. Individual, communal, and national identities are shaped in part by the objects that are collected, preserved, displayed, used, and housed within museum environments.

In addition to secular museums, of course, sacred spaces that anchor religious communities have long been repositories of important objects, some finely crafted and others valuable simply because of their use. Places like the Vatican Museums, Hagia Sophia, and the Taj Mahal blur the lines between museum and religious space. There are many cathedrals and temples that are viewed as museums by tourists who are solely intent on capturing a few selfies alongside their artworks, altars, liturgical objects, and in front of their architectural spaces. But pilgrims and the spiritually minded also visit these sacred spaces and their associated museums. Wherever religious objects are displayed, in both sacred and secular museum spaces, people pray, make offerings, and devotionally touch objects—even in "official" museum spaces. There is account after account, many noted in the chapters here, of religious behavior in museums, behavior that can rattle museum professionals and raise difficult questions about the display of such objects.

The chapters that follow indicate the protests and struggles that escort the relations of religion and museums, but also the many positive opportunities for individual learning and intercultural and interreligious exchange and understanding. Museums wishing to interpret religion and religious artifacts have realized that attention to the predisposition and needs of the visitors is absolutely vital. Visitors come to the museum for a variety of reasons, from a wide range of backgrounds, and with diverse expectations for their museum experience. The globalization of both collections and visitors especially complicates the interaction of museum and visitor around religious artifacts and spaces. Museums provide spaces where people of different religious backgrounds encounter the practices and beliefs of others, their sacred artifacts, religious cultures, and traditions. In the secularizing developed world, an increasing number of people have limited exposure to religious traditions and practices, and museums may be one of the few places where these visitors meet religion. In the developing world, museums can be places of safe encounter and profitable learning, as well as storehouses for traditions themselves.

This volume emerges out of such material and cultural crossings, finding the religious dimensions of secular museums, and the secular uses of religious objects on display. Situated within new globalized flows of commerce, politics, and culture, the relations between religion and museums becomes a productive starting point from which to pursue multiple trajectories in political, social, and cultural life. The implications of the relations move far beyond religious traditions and museum collections

and connect with international legal issues, cultural appropriation, secularization, corporate sponsorships, economic reform, histories of art, and theological orthodoxy.

The chapters that follow show just *how* museums address religion and treat religious objects. This collection offers wide-ranging studies that take stock of developments in fields of museum studies, anthropology, history, art history, and religious studies and chart a course for future research and interpretation. Leading and emerging scholars explore the cultural work of museums from cultural studies perspectives and demonstrate the role of museums within the rapidly developing interest in visual and material culture among religious studies scholars. Meanwhile, leading practitioners with a museum studies perspective explore the work of museums as they care for and present religious artifacts, and interpret religion as a crucial component of human cultures.

Outline of the volume

The volume is divided into six sections, each with a different focus: (1) museum buildings, (2) objects, (3) responses to objects and displays, (4) collecting and research, (5) museums' interpretations of religion and religious objects, and (6) the variety of types of museums in which religion appears. Each topic is approached from multiple standpoints, with careful attention to theoretical movements as well as practical examples taken from case studies. With this volume we intend to offer an overview of religion-museum connections, summarize current research in the field, and ultimately lead out with new ideas and pointers for future work in the area. The six sections are meant to be heuristic, and we believe they are helpful ways to parse the variety of ways of connecting religion and museums. Overlaps and interconnections necessarily occur across the sections.

The first section investigates how museum buildings structure the visitor's experiences of the sacred. In our time museums have become *the* desired commission for many architects, who pull out the stops to create signature buildings. At the other end of the spectrum are small, local institutions that house their collections in less remarkable, but often still evocative buildings. There is no single way the material setting for museum collections invokes the sacred and no single visitor response. But there are notable patterns of engagement. In Gretchen Buggeln's introduction to this section, she proposes four ways that museum buildings can materially move visitors toward an awareness of the transcendent and offers examples of those modes of engagement. Karla Britton uses the writing of mid-twentieth-century Christian theologian Paul Tillich to argue that art museums can play a role in a community's religious life by opening the spiritual dimensions of reality. Tillich (and Britton) argue that this may be particularly the case when museum visitors confront works of art that reveal the depth, uncertainty, and even the darker side of humanity. Finally, Gretchen Buggeln's interviews with Douglas Cardinal, the Canadian architect of the Smithsonian's National Museum of the American Indian in Washington, DC, and Tim

Johnson, a long-term administrator at the museum, offer personal perspectives on the design and use of the celebrated and highly influential museum building. The contributions to this section demonstrate that there are many, often subjective, ways that people, from designers to visitors, respond to museum space.

Once visitors have entered the physical space of the museum they begin to focus on the objects that are displayed in galleries, and the second section is devoted to the ways some of these objects begin to make meaning within their spaces, harboring cultural and religious significance. Each of the essays here takes a different scholarly approach, looking at objects as sources of religious, ethnographic, historic, and archaeological knowledge. Brent Plate's chapter offers a consideration of religious objects within the museum space. By comparing two natural history museums, Plate asks about how "religion" itself becomes an object that is parsed within the long scope of human evolutionary history. Mary Nooter Roberts continues the questions of classification, as she draws on her extensive experience in curating exhibitions of African art. She finds that ethnographically informed displays of objects change the museum experience, allowing the objects to become active as they take on lives of their own and prompt visitors to respond to them in devotional ways. Turning to "history" objects, Lauren Turek helps us see how curators can use the display of particular items to make the past tangible to those in the present. Key here is the sensory appeal of objects that invoke memories, re-presenting the past for body and mind alike. Likewise, but from an archaeological perspective, Chiara Zuanni highlights how religious pasts get reconstructed in the present through particular objects, things that belong to another time and are not always accessible to current understandings. Many of these differences come to a head when dealing with human remains, and Zuanni takes note of some of the ways museums and public policy become intertwined in a search for proper ethical considerations. Denis Byrne writes the final chapter of this section, exploring popular religious practices of Asia and considering the ways sacred objects change meanings in and out of the museum. Questions of superstition and magic arise, and the efficacy of deities is distinguished as they move between temple and museum environments.

Yet, even if the buildings are created in particular ways, and even if each object has a physical and cultural history, the viewers who arrive at the museum to see— and sometimes feel and hear—objects bring their own histories, experiences, and religious understandings. The third section examines some of these engagements. Many human responses to a collection of objects in museums are possible, ranging from personal devotional engagement to ethical claims about the proper ownership of objects to journalistic and media responses to religion in museums. For her chapter, Steph Berns pulls on her extensive research in one of the largest museums in the world, the British Museum, and uses the metaphor of "devotional baggage" to ask about what people bring with them to this place. What they bring are attitudes and perceptions, shaped by various factors in their lives, but they also bring their own objects to be blessed and taken home and sometimes to leave behind in the

galleries. Graham Howes has also spent time investigating visitors' experiences in museums, and in his chapter he relates responses from the blockbuster exhibition *Seeing Salvation* at the National Gallery, London. From a sociological perspective, Howes distinguishes a variety of responses, from objective "cognitive" takes to more personal "creedal" responses; at the same time many visitors had significant, though varied, experiences that were more than just intellectual musings as the objects triggered feelings both secular and spiritual. Picking up on questions of legal and ethical responses to museum objects (a discussion started in Zuanni's chapter in the previous section), Mark O'Neill gives a survey of repatriation efforts and debates since the end of World War II. The question of who "owns" specific objects must take into account cultural considerations, legal battles, and international relations, as the specificities of culture contrast with so-called universal values. The fourth chapter of this section is by arts journalist Menachem Wecker, who makes a plea for more media attention to the relations of art and religion, especially having noted so many excellent museum exhibitions with religious themes in recent years. That said, there is hard work to be done in writing about these themes in ways that remain true to the art and the religious lives that are affected.

One of the challenges every museum faces is how to balance public-facing activities and research, and how to make sure that each supports and feeds the other. Section IV looks at museum collecting and research in the field of religion. It is often said that a museum that doesn't collect is dead; David Morgan sets this scene by explaining how and why individuals and museums have collected and do collect in the field of religion, and how this collecting relates to the museum's mission, to its research agenda, and to its public services. Collecting and research in museums are at their best when they are deeply involved in the community, and Matthew Francis illustrates this graphically by describing two museums set up by minority faith groups in Western Canada. Samantha Hamilton, from the other side of the world, analyzes the impact on the conservation profession of the postcolonial recognition of the material spirituality of subaltern people—and the huge contribution that Indigenous people and conservators, working together, can make to religion in museums. It is a vital lesson for all museum workers. Finally, Ekaterina Teryukova and Konstanze Runge, two representatives of "Museums of Religion," offer example and inspiration by describing the collecting and research their museums—in Russia and Germany— carry out, building on long and rich traditions, and involving a wide constituency of partners and supporters.

All objects in museums bear the mark of curatorial intention, all are "interpreted" in one way or another by museum staff, even if simply by choosing to put a particular object in a display case or tell a particular story about it. In Section V, museum professionals express the challenges and opportunities of presenting religion to the public, and reflect on their experiences as educators and curators who have explored a range of topics and interpretive techniques. Museums can be important sites of interfaith communication and bridge

building, and Amanda Hughes argues in her introduction that "radical hospitality," a welcoming of diverse perspectives, should mark the work of museum curators and educators who tackle religious topics. John Reeve, former head of education at the British Museum, offers a broad survey of the treatment of Islam and Islamic artifacts in a wide range of museums, noting what has worked well and what is challenging for museums and communities. *Hajj: Journey to the Heart of Islam*, the highly successful exhibition at the British Museum, presents an invaluable case study. Tom Freudenheim reflects that, over his long career working for art museums and arts organizations, he has noticed that museums are "embarrassed" to present the relevant religious content and context of object in their collection, particularly if that content is Christian. This is a mistake, he argues, if museums are going to do justice to the art they interpret. Gretchen Buggeln presents a case study of first-person interpreters at Colonial Williamsburg, who become artifacts themselves when they embody characters from the past and engage visitors in conversation. This is a resource-heavy mode of interpretation, but a very useful technique for prompting visitors to face directly and honestly the complex realities of the spiritual dynamics of past communities. Christian Carron, Susan Foutz, and Melissa Pederson of the Children's Museum of Indianapolis relate the experience of interpreting religion to families with children in the carefully planned and successfully executed *National Geographic Sacred Journeys* exhibition. Finally, Gary Vikan, former director of the Walters Art Museum in Baltimore, shares his experiences introducing American audiences to Byzantine icons in a series of carefully planned exhibitions, in which he meticulously designed the display settings to evoke the numinous for visitors.

Finally, it's surely permitted simply to enjoy the topic of religion in museums, and to celebrate the huge richness and variety of the field. The final section provides an overview of this diversity. Crispin Paine does so by examining the many different types of museums in which religion can be found, from "Religion Museums" to everyday secular local history museums—which he wants to see do much more local research. Ena Heller tells the at-first-joyful but eventually sad story of New York's Museum of Biblical Art and the contribution it made to the art world's appreciation of the religious meaning of so much art. Among denominational museums, those set up by missionary organizations are among the most varied and intriguing. Chris Wingfield examines the history of three different types: those set up "at home" as fund-raising schemes; those established as tools of mission in "the field"; and the sites of former mission stations that have now become heritage sites. However, it's not always essential to choose between art/antiquity and religion when founding a museum. Ed Gyllenhaal rounds up the whole book by describing a museum that triumphantly fused a superb collection of historic art with a didactic collection of antiquities assembled and displayed to teach the faith. It continues to use the beautiful and the historic to present and explain religion.

Each of the sections of this volume provides global perspectives on "religion in museums" past and present and begins to point toward future connections and considerations. We will return to some of the future directions in a brief Afterword. Crossing from the natural sciences to the human sciences to the humanities, the multidisciplinary nature of this collection provides new insights into the ever-expanding arena where religious life and museums meet.

Section I Museum Buildings

1 Museum Architecture and the Sacred: Modes of Engagement

GRETCHEN BUGGELN

Human beings experience museum collections in highly structured architectural settings. From the overall form and ornament of museum buildings, to individual installations in gallery spaces, to museum gift shops and restaurants, museum architecture shapes the visitor experience. The visitor's encounter with the museum begins outside the building as she absorbs the museum's relationship to its surroundings and moves toward the entrance. How and when elements of the transcendent inflect her visit will be guided of course by the objects and their interpretation, but also by the spatial frame. In our conversations about religion and museums, space and place call for attention (see Giebelhausen 2008; Lampugnani 2008; Smart 2010). These spaces may actively encourage, enhance, or deny the potentially religious or sacred components of the museum and its collections, both intentionally and unintentionally. Can museum space evoke the sacred? Can a museum *be* a sacred space? Who and what will determine where and when this is the case? This section of *Religion in Museums* considers the contribution of museum architecture to the visitor's potential experience of the transcendent.

Architecture critic Paul Goldberger (2010, 6) has observed, "We have in our culture conflated the aesthetic and the sacred, which is why, I suppose, that the art museum seems to have replaced the cathedral." This crowning of museums, particularly art museums, as the temples of our times is a widely stated sentiment, and perhaps the most common way of thinking about the connection between museum architecture and the sacred. The analogies are evident: museums are often monumental, costly, commanding buildings full of precious relics. For Western societies that have elevated the aesthetic and the power of high culture in an increasingly secular milieu, it may mean that the museum has replaced the house of worship as the place where citizens seek the transcendent. The likening of museums to temples or churches is so common that it calls for further analysis (Farago 2015). Here, however, we are concerned primarily with the reference to building type. This is one way the architecture of the museum can contribute to a sense of the sacred.

But there are other ways as well. Museum spaces become places of transcendence when the disposition of architecture and visitor coincide in both scripted and unpredictable ways. I suggest four modes in which museum architecture can operate

to engage the transcendent or sacred: *associative, magisterial, therapeutic,* and *redemptive.* An associative connection to the sacred happens when the setting is deliberately like (or actually is) the architecture of a particular religious tradition. In the magisterial mode, the aesthetic dimensions of museum space command authority and draw the visitor away from quotidian concerns and into the liminal space of the transcendent. The therapeutic mode invites individualized visitors on a quest for a healing spirituality, established through a connection to art, culture, and the natural world. Finally, in the redemptive mode, museums function as cultural monuments, and the architecture of museums itself confronts and conquers past challenges while promising and renewing hope for the future. These categories are not meant to appear comprehensive or mutually exclusive, but are ways of understanding the types of work that museum architecture, specifically, does in the context of the questions of this volume.

The Associative Mode

Museum architecture or exhibition design can evoke the sacred through direct material references to the worship environments of a religious tradition. In this volume, Gary Vikan's account of his exhibitions of Orthodox icons demonstrates how a curator can intentionally, through carefully designed material settings that mimic sacred space, evoke a sense of the numinous for museum visitors (see Chapter 23 in this volume). Exhibition setting, music and evocative sounds, lighting, and placement all play a role. In his chapter about the interpretation of religion in art museum settings, Tom Freudenheim describes the resonance of religious art in a related architectural setting; experiencing medieval art in the "authentic" architectural setting of the Cloisters of the Metropolitan Museum, for instance, is quite different from seeing it on the white walls of a square gallery (see Chapter 20 in this volume). Similarly, an encounter with the magnificent sixteenth-century Isenheim altarpiece, set in the middle of the nave of the chapel of a thirteenth-century Dominican convent, now the Unterlinden Museum, is stunning and evocative. Matthew Francis similarly describes the Sikh Heritage Museum in Abbotsford, British Columbia, where a museum is placed in an annex to a historic, still used worship space, and the effects of that worship space carry over to the museum (Chapter 14 in this volume). Such associative spaces may also be temporary installations, such as the Tibetan Shrine room at the Rubin Museum in New York City. In all these cases, a religious architectural setting, or close proximity to one, sets the tone for interpretation.

Visitors to museums that house the collections of particular religious groups are often believers and practitioners, primed to see objects and interpret stories as part of their own sacred history. The space then, almost regardless of its material character, bears the imprimatur of the faith that contributes religious authenticity. All associative resonances depend to a degree on visitor familiarity, on knowing what the worship space and material practices of a given tradition look like. Even forming associations between Gothic architectural details and medieval cathedrals, for instance, requires

prior knowledge. It is also possible, however, that certain sensory responses to the setting, such as a feeling of watchfulness and awe in vast spaces with high ceilings, dim light, and hushed sounds may trigger religious sentiments in visitors who associate those particular sensory experiences with their experiences of religious ritual. Because the encounter with architecture can be similar in museums and ecclesiastical spaces, a visitor familiar with both will find the sensory and spiritual aspects of one experience graft to the other, the aesthetic conflating with the divine.[1]

Carol Duncan, in *Civilizing Rituals: Inside Public Art Museums* (1995), notes that early museums were deliberately designed to resemble temples and palaces, although the institutions were secular. While museums making literal architectural references to sacred forms have been rare since the mid-twentieth century, the occasional use of sacred motifs persists. Moshe Safdie's granite and glass National Gallery of Canada (Ottawa, 1988), is a striking example of the continuation of this tradition. Placed at the heart of Canada's capital, Safdie's museum answers directly to the nearby Gothic parliament buildings and the 1858 Cathedral of Notre Dame d'Ottawa across Sussex Drive (Figure 1.1). As Douglas Ord (2003, 5) has noted, the National Gallery "suggests a glittering and immense cathedral" with a vast nave leading to a three-tiered western cupola enclosing the Great Hall. From the outside, the building appears as a combination of long nave ending in a towering chancel, the long line of clustered columns on the exterior suggesting buttresses. Inside, visitors ascend a long, sloping ramp toward the light of the Great Hall before entering the galleries. Ord notes the "premodern sacral mix-and-match" of interior architectural references that confront the visitor and encourage "a mood of awe and reverence" (22, 21). Safdie here deployed the "vocabulary of religious experience" deliberately and effectively (26). Perhaps tellingly, at the very center of the main gallery building is the meticulously restored interior

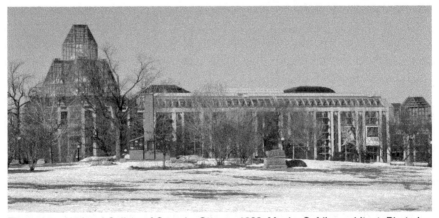

Figure 1.1 National Gallery of Canada, Ottawa, 1988. Moshe Safdie, architect. Photo by D. Gordon E. Robertson. Copyrighted work available under Creative Commons Attribution only licence CC BY 4.0 http://creativecommons.org/ licenses/by/4.0/.

of Rideau Chapel, an 1867 neo-Gothic space with an intricate, fan vaulted ceiling, taken from Ottawa's Convent of Our Lady of the Sacred Heart.

It is important to note that "sacred architecture" itself has taken many, nontraditional forms since the mid-twentieth century. Generations of believers who have worshiped in modern spaces bring a different kind of architectural reference to their encounter with the museum. Modernism, for them, does not necessarily connote the secular. For some, a restrained modernism might in fact be the most familiar architectural expression of the sacred. A quieter, contemplative, contemporary museum space is the diminutive Pulitzer Foundation for the Arts in St. Louis (2001), designed by Japanese architect Tadao Ando, who is known for his pared down concrete buildings, among them both museums and churches. The Pulitzer building and Ando's celebrated subterranean Chichu Art Museum in Japan (2004), in their use of smooth concrete walls, starkly sparse and intimate spaces, and dramatic use of natural light, have much in common with his best-known ecclesiastical building, the Church of the Light in Osaka, Japan, a small church with a simple cross cut into the altar wall. Ando wanted the Pulitzer Foundation to be a "sanctuary" as well as a "laboratory," a connection that is literal in its likeness to his sacred spaces.[2]

The Magisterial Mode

Museum architecture in the magisterial mode depends on the elevation of the aesthetic experience and the magnificence of affective design for its transcendent effect. Art museums, in particular, tend to exhibit these features, and when we speak of museums as "temples of culture," it is typically this mode that is invoked. In the eighteenth century, art gained autonomy outside of the framework of the church, and new philosophical ideas about the value and meaning of art and beauty polished art's aura. Eighteenth-century philosophers of aesthetics believed that vision and taste, particularly the ability to recognize and appreciate true beauty, were intimately connected with moral sensibility, and this language found its way into public discourse. Duncan (1995, 14) writes, "[T]he invention of aesthetics can be understood as a transference of spiritual values from the sacred realm into secular time and space." What was previously the domain of religion—revelation, transcendence, transformation—found a home in the secular museum.

For nearly two centuries, most notable art museums looked like classical temples, with grand elevated entrances, pillars, and porticos. Yet their literal references to the sacred were far less notable than their resonances with democracy and classical culture. Many nineteenth-century museums tended to be populist and democratic spaces for the cultivation of civility and moral improvement, at least in principle. But in the twentieth century, Duncan argues, another kind of art museum experience came to dominate. She charts the rise of what she calls the "aesthetic museum," museums that promoted "art for art's sake" rather than art for technical or historical knowledge or political and social transformation. These museums, Duncan (1995, 10) notes, contained numerous spaces that called for ritual behavior, "corridors scaled for

processions, halls implying large, communal gatherings, and interior sanctuaries designed for awesome and potent effigies." The ritual atmosphere thus created by the architecture promoted an attitude and receptivity in line with Western expectations of what it meant to encounter great works of art or significant artifacts of culture.

One might think that the turn toward Modernism in museum architecture in the twentieth century reversed the sacred sense provided by the magnificence of the neoclassical temple form. As Paul (2010) Goldberger writes, "Modern architecture, as everyone knows, often made claims to being utterly and totally rational, a claim that, if true, would make modernism altogether incompatible with the qualities of sacred, or religious, space." But, he continued, "of course, as everyone knows, thankfully modernism was not always true to its claims, and not nearly as rational as it pretended to be." Modernism for a time had minimized the presence of the museum building in order to place the emphasis on the art. But postwar architects turned back from this approach, notably with Frank Lloyd Wright's Guggenheim Museum that again showcased the museum building itself. Modernism in fact reveled in co-opting the language of the sacred. Louis Kahn's Kimbell Art Museum (1972) in Fort Worth, Texas, is a perfect example of this, a numinous museum space lauded by critics and frequently described in ethereal terms. Kahn was a keenly austere modernist, working in simple and bold geometric forms, often in raw, unfinished concrete, yet he spoke fluently about the spiritual nature of architecture. (Tadao Ando's Modern Art Museum, with its aesthetics reminiscent of Japanese Buddhist temples, now sits next door to the Kimbell and pays tribute to the modernist master with its own smooth concrete walls.)

In our current era of showcase buildings, designed by star architects for eager municipalities hoping to increase their cultural capital and tourist revenue, the magisterial mode of architecture, at least for the well-heeled museum, dominates. Religious or sacred resonances can arise out of the spectacular and sublime effects of extraordinary museum settings. Frank Gehry's museum designs operate in this mode. The success of his Guggenheim Museum in Bilbao, Spain, increased the cultural appetite for museum buildings that have become the chief art objects of many a collection. Some critique this "spectacularization" of museum architecture as the enemy of contemplation of individual art objects. But it is certainly not the enemy of contemplation per se. Many lament the commercialization of the museum, and showy architecture certainly can be a massive, seductive advertisement. But a confrontation with magisterial beauty still has the power to transport the visitor to the realm of the transcendent.

Duncan contends that the ritual behaviors of the art museum demonstrate and reify the social and political power and privilege of the nations and classes of people who shape them. Andrew McClellan (2008) has more recently argued that "ritual space" may overstate the reality of unified public behavior in art museums. He suggests "utopian space" might be a better metaphor, indicating "a seductive vision of harmonious existence and communal values in a parallel realm of order and beauty" (8). Museums, he believes, are places where visitors can feel good about humanity,

"refuges of authenticity and affect" (9). He thus gives visitors more agency as they make meaning in museums. Another critique comes from Karla Britton, who, in Chapter 2 in this volume, challenges the idea that the transcendent moments and ritual behaviors in the art museum must be by nature secular. Her reading of Paul Tillich raises the possibility of genuine sacred encounters with "secular" art and architecture. What unites all these approaches is that the visitor response they question is primarily an aesthetic one—drawn out by the arresting visual and material qualities of art and architecture.

The Therapeutic Mode

How is museum architecture responding to a changing religious landscape? As the relationship between individuals and religious institutions loosens and shifts, particularly among the educated classes in Western, developed countries, new museum architecture indicates an accommodation of a "spiritual but not religious" (SBNR) mindset. This is not the same as the notion of a "secular spirituality" questioned by Karla Britton in her chapter in this section. By the therapeutic mode I do not mean a vague utopianism, or an "art for art's sake" valorization of the aesthetic, but a religious experience that is highly individualized, and valued for a sense of connection to God (or other spiritual source) through art and, especially, nature. SBNR believers are yet *believers*, but in individualized, eclectic ways. This type of belief system is tied only loosely to traditional doctrinal ideas and shies away from authoritarian institutions. It retains, nonetheless, a belief in a benevolent God who wants the best for people and will reward their moral behavior. This is the type of religious spiritual vision, I believe, most evident in typical visitor responses to the architecture of the National Museum of the American Indian, as well as Ando's Chichu and many other museums that have opened up their walls to look out to natural environments. This resonates, powerfully, with individuals seeking to locate and express their personal spiritualities on the way to centering and healing in a complex, media-driven world. Art and nature are not simply utopian antidotes, but pathways to God.

Douglas Cardinal's museum buildings, including the National Museum of the American Indian (NMAI; see later) and the Canadian Museum of History (1989), perform this task for seekers. With their organic forms, warmth, soft edges, and spaces that manage to be both magnificent and hospitable, they present an inviting spirituality. (In using the term "therapeutic" to describe these buildings, I am thinking mostly of their effect on non-Natives; Native peoples would possibly read these forms as a more literal interpretation of their spiritual traditions.) The particular utopian vision they present is not monolithic, national, or political, but individual and spiritual. Notably, unlike museum buildings of the past that stood as well-ordered fortresses against the chaotic world outside, architecture in this mode is open to the natural world, and its formal features often mimic nature (the waterfall and stone cliffs of the Cardinal's NMAI, the meandering, transparent segments of the River). This is not museum architecture

that wants to slide back into nature, however, but architecture that draws on nature's primal strength for its own power and vision.

Architecture with these characteristics is a natural fit for cultural and scientific institutions where nature is the chief attraction. For instance, Architect Lee H. Skolnick describes the visitor's approach to his Marine Park Environmental Center in a wetlands area of Brooklyn, New York, as a journey: "[T]he processional pathway led to a series of sequential revelations and an ultimate goal," a glassed-in exhibit space, with views out to the wetlands and bay (MacLeod 2005, 127). Another example is the full-sized Smart Home on display for several seasons (2008–13) in a courtyard of the Museum of Science and Industry, Chicago. Visitors browsed through a crisp, modern, Green home, explored new environment-friendly technologies, and walked through a yard with the latest in composting techniques and native plants. Here the healing aspects of nature were combined with the beauty of an architect-designed modern house full of new gadgets: nature therapy and retail therapy all at once. At least on my two visits, the guide explained it all with religious fervor.

The Redemptive Mode

In her book *Holocaust Memorial Museums: Sacred Secular Space* (2015), Avril Alba considers several Holocaust museums as "built theodicy," that is, sites that claim the providence of God in the face of evil. "Holocaust history and memory displayed in these institutions," she writes, "has a profoundly metahistorical or 'sacred' aspect" and "the memorial practices of these institutions more often than not find their starting points in the sacred symbols, rituals, archetypes and narratives of the Jewish tradition" (7). Alba's specific argument is intricate and carefully nuanced, but in the broader sense this idea opens up another way of thinking about the sacred as embodied in museum architecture, one that is particularly applicable to museums (and exhibitions) built around a narrative that drives toward meaning. In this way history museums, in particular, can be experienced as transcendent spaces.

All memorials or historical museums certainly do not offer a redemptive vision. On the one hand, the September 11 Memorial and Museum in New York City, for instance—the "memorial" part is a vast, gaping hole into which water rolls endlessly—is a sacred site for many, but it may speak more of despair than hope. On the other hand, the Flight 93 National Memorial in Shanksville, Pennsylvania, with its hilltop museum, alleys of living trees, natural landscape, and powerful narrative, tells a story of redemption, made possible by the heroism of the victims. Museum architecture in the redemptive mode conveys universal, resonant stories that have cosmic dimensions.

Museums tell stories primarily with artifacts and exhibitions, but the building itself can participate. One of Alba's (2015) case studies is the United States Holocaust Memorial Museum (USHMM). Behind a brick and limestone neoclassical façade, James Ingo Freed's Washington, DC building "references the perverse machinations of government gone wrong, evoking the security of democracy while simultaneously

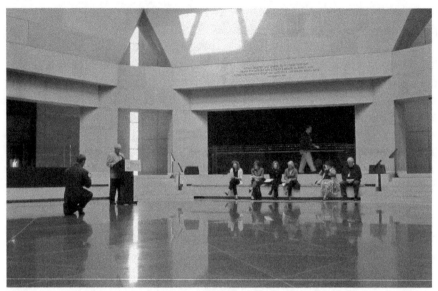

Figure 1.2 In the Hall of Remembrance, USHMM, Washington, DC. A volunteer reads the names of Holocaust victims during the Days of Remembrance of the Victims of the Holocaust. The verse from Deuteronomy etched into the wall of the room reads, "I CALL HEAVEN AND EARTH TO WITNESS THIS DAY. I HAVE PUT BEFORE YOU LIFE AND DEATH, BLESSING AND CURSE. CHOOSE LIFE—THAT YOU AND YOUR OFFSPRING SHALL LIVE." Photo by AgnosticPreachersKid. Copyrighted work available under Creative Commons Attribution only licence CC BY 4.0 http://creativecommons.org/ licenses/by/4.0/.

exposing its weaknesses and inherent fragility." Inside the dark and moody building, however, there is a straight path to the light and peaceful Hall of Remembrance that "contains the necessary space for consolation and reflection" (64; Figure 1.2). Moshe Safdie's new Historical Museum of Yad Vashem (NHM, 2005) is a long, triangular structure that cuts through the crest of the Mount of Remembrance in Jerusalem, connecting the Holocaust to the epic history of Israel (111). The visitor's journey through the anguish of the exhibition ends in the "vibrant present, embodied in the pine forests of Jerusalem" (113).

Alba (2015, 87) is critical of the way that the USHMM transforms the Jewish story into an expression of universal suffering and redemption, providing "an arresting metahistorical framework upon which to build a message for all humanity." But the universality of such messages, especially in the wake of tragedy so often a component of memorial sites, renders them a source of transcendence for potentially all visitors. Museum architecture in the redemptive mode materially invokes the positive aspects of culture and history to tell a story of resiliency and triumph. This is not merely a "feel good" response, but a metahistorical, metaphysical resolution of good versus evil. Douglas Cardinal claimed the NMAI building embodies humanity and forgiveness, despite the tragic stories visitors find within. David Adjaye, the architect of the newest museum at the center of the United States Capitol, the National Museum

of African American History and Culture (2016), says that the primary spirit of his building is the posture of praise. "Everything lifts you up into the light," he said. "This is not a story of past trauma. For me, the story is one that's extremely uplifting" (Q&A 2012). The building, wrapped in a porous metal screen meant to represent the work of free black ironworkers in the South, hovers above the ground, the outward angle to its tiered sides suggesting upward movement. This kind of spiritual, redemptive vision is rarely embodied in the architecture of history museums, particularly those that do not include a memorial to a deeply moving or troubling event. But the potential for architecture to materially participate in the evocation of sacred themes is proven by these highly visible museum projects.

Conclusions

The dynamic of the sacred in museum spaces involves a dialogue between the architecture of the place (both the exterior, which shapes visitor expectations, and interior, which directs the experience of viewing the objects), the inherent qualities of the objects, the nature of the interpretation, and of course the dispositions and knowledge that individual visitors bring to the spaces (see Chapter 9 in this volume). One of the ideas of this brief survey is that there is no single, unchanging mode of engagement. These four proposed modes that museums spaces have of invoking the sacred—associative, magisterial, therapeutic, and redemptive—are simply possibilities. Eilean Hooper-Greenhill (1990, n.p.) asks, "How far does the form of the museum building and the arrangement of internal spaces in fact construct a way of seeing a particular subject matter?" and "Does the knowing subject (curator, visitor) abstract the building from the perception of a thing or does the form and material specificity of the building intimately shape the way things can be known?" These questions about the relationship between museum spaces and the museum experience are largely unanswered, and quite possibly unanswerable. But the potential for a museum's architectural space to elicit or enhance the visitor's experience of transcendence or the sacred is clearly evidenced in these spaces and the way designers and visitors speak about them.

Notes

1. Because these responses are to a degree culturally determined, each individual's reaction to a space will be shaped by the aesthetics of worship in his own culture or tradition—which might look quite different from the numinous qualities described here. I am not making an argument for universal human response to these particular aesthetic markers.
2. This was included in the statement by the Pulitzer museum guide, March 5, 2011.

References

Alba, Avril. 2015. *Holocaust Memorial Museums: Sacred Secular Space*. London: Palgrave Macmillan.

Duncan, Carol. 1995. *Civilizing Rituals: Inside Public Art Museums*. London: Routledge.

Farago, Jason. 2015. "Why Museums Are the New Churches." BBC.com, July 16. http://www.bbc.com/culture/story/20150716-why-museums-are-the-new-churches.

Gielbelhausen, Michaela. 2008. "Museum Architecture: A Brief History." In *Companion to Museum Studies*, edited by Sharon MacDonald, 223–244. London: Wiley-Blackwell.

Goldberger, Paul. 2010. "Architecture, Sacred Space, and the Challenge of the Modern." Paper presented at the Chautauqua Institution, New York, August 12, p. 6. www.paulgoldberger.com/lectures/46.

Hooper-Greenhill, Eilean. 1990. "The Space of the Museum." *Continuum: The Australian Journal of Media and Culture* 3 (1). http://wwwmcc.murdoch.edu.au/readingroom/3.1/Hooper.html.

Lampugnani, Vittorio Magnano. 2008. "Insight versus Entertainment: Untimely Meditations on the Architecture of Twentieth-Century Museums." In *Companion to Museum Studies*, edited by Sharon MacDonald, 245–262. London: Wiley-Blackwell.

MacLeod, Suzanne (ed.). 2005. *Reshaping Museum Space: Architecture, Design, Exhibitions*, London: Routledge.

McClellan, Andrew. 2008. *The Art Museum from Boulee to Bilbao*. Berkeley: University of California Press.

Ord, Douglas. 2003. *The National Gallery of Canada: Ideas, Art, Architecture*. Montreal: McGill-Queens University Press.

"Q&A: Architect David Adjaye on His Vision for the New Museum." 2012. Smithsonian.com, February. http://www.smithsonianmag.com/ist/?next=/arts-culture/q-and-a-with-architect-david-adjaye-18968512/.

Smart, Pamela G. 2010. *Sacred Modern: Faith, Activism, and Aesthetics in the Menil Collection*. Austin: University of Texas Press.

2 Toward a Theology of the Art Museum

KARLA CAVARRA BRITTON

In 1917, the city of Santa Fe undertook the construction of an art museum suitable to its new status as a state rather than territorial capital, New Mexico having been admitted to the Union only in 1912. The city fathers chose Issac Hamilton Rapp, known for his evocation of the regional pueblo-style architecture of the American Southwest. The building he designed not only made reference to that style, but included elements deliberately borrowed from the traditional mission church: the museum's auditorium is unmistakably in the form of a chapel much like that at the Acoma pueblo, with frescos depicting the early Franciscan missions of colonial times. Anticipating by a century the current emphasis on the surrogate religious nature of the art museum, Rapp's overtly ecclesially inspired design seems simultaneously to assert the religious dimension of the aesthetic experience, but also the secularization of religious life. The hall remains one of the most used public halls of Santa Fe for music, dance, and theater—ironically all within a space that is clearly evocative of the sanctuary space of an adobe church.

The question before us is how to read such an interweaving of the sacred and the profane in the architectural form of the art museum, and to ask whether such a syncretism is in the end able to sustain the tension between the two? Or, more strongly put, could it be that the art museum holds a distinct place within the *religious* life of a community, which actually resists the assumption that its more secular identity is necessarily distinct from overtly sacred spaces? As a source for such reflection, we turn to the thought of the twentieth-century Christian existentialist theologian Paul Tillich, who maintained a sustained philosophical engagement with the visual arts throughout his career, especially through a personal connection with the Museum of Modern Art (MoMA) in New York City. Of particular importance for our purposes here is his contention that the arts (and especially visual arts) are uniquely able both to open an otherwise hidden dimension of existence to human awareness, and at the same time to open us as human beings to its reception.

Tillich on Art and Architecture

Following World War II, the Museum of Modern Art provided the impetus for Paul Tillich to engage in a series of reflections that served to deepen his theology of culture as it had begun to evolve before his emigration from his native Germany to

the United States. In three texts written for events at MoMA, Tillich addressed in particular the relationship between religion and art. One essay, "Art and Ultimate Reality," was originally delivered as a talk he gave in January 1959 at a MoMA event entitled "Dimensions 1959" (Tillich 1987b). In the same year, Tillich (1987e) also wrote an introduction to the exhibition catalogue *New Images of Man* which presented the human figure in the aftermath of Expressionism and in the light of abstraction. And then in 1964, Tillich (1987a) wrote an address on the occasion of the opening of the new galleries and sculpture garden of the museum (see Figure 2.1). These texts, along with his establishment in 1961 of the Society for the Arts, Religion and Contemporary Culture (founded with the theologian Marvin Halverson and Alfred Barr, the art critic and founder of the MoMA), firmly established Tillich's ties to the museum and afforded him the opportunity to engage contemporary art in light of his central theological commitment to the idea of humanity's "ultimate concern."

Tillich's interest in the power of visual sensation was informed through his lifelong appreciation for architecture and his interest in the relationship between art, spatial experience, and human awareness. His writings for the museum thus address both his vision of an art museum's higher purpose as a collective cultural symbol, as well as his belief in the museum as a *place* in which an individual may encounter an opening up of the religious dimensions of reality. In "Art and Ultimate Reality,"

Figure 2.1 Museum of Modern Art Sculpture Garden, 1953. Photo courtesy of the Museum of Modern Art, licensed by Art Resource. By kind permission of PJAR Architects.

Tillich (1987b, 139) referred to MoMA as "a favored oasis within this beloved city of New York," a place which symbolized for him the values out of which the world may be truly made. Tillich (1987a, 246) opened his 1964 MoMA address with a heartfelt description of his own personal encounter with the museum:

When in the year 1933 we came as refugees from Hitler's Germany to New York, it was a great moment for us when we discovered the Museum of Modern Art. It was the first place in this bewildering city where we could say: "This is home!" It was home, not because it awakened German and European memories but because it was good! It represented to us all that for which we stood and fought and which made us strangers in the old country when that country let itself be conquered by the forces of evil. This museum then appeared to us as an embodiment of honesty in creative expression, both in architecture and in the arts for which architecture gives the space and the frame.

Fundamentally, Tillich believed art and architecture, as they interact in the art museum, can provide an essential experience that is not a surrogate for religious experience, but actually a deepening of it. He argued that the visual arts give to us means of understanding that they alone can provide, and that are fundamental to our fully formed humanity. In this manner the art museum extends to the individual an experience that cannot be encountered anywhere else. As Tillich explained:

For the arts do both: they open up a dimension of reality which is otherwise hidden, and they open up our own being for receiving this reality. Only the arts can do this; science, philosophy, moral action and religious devotion cannot. The artist brings to our senses and through them to our whole being something of the depth of our world and of ourselves, something of the mystery of being. (247)

The arts express the full range of human emotion and experience, which he regarded as essential elements of any serious theological reflection.

Tillich frequently referred to his discovery of art as a response to the horrors of the trenches of World War I, where he served for five years as a chaplain in the German army (including Verdun). For instance, in "One Moment of Beauty," written in 1955, Tillich described his early transformative encounter with the painting of Botticelli's *Madonna and Child with Singing Angels*, which he visited at the Kaiser Friedrich Museum in Berlin while on leave at the end of the war. While acknowledging that he later came to know that the picture "is not the greatest," the moment of ecstasy for Tillich (1987d, 235) was unforgettable:

That moment has affected my whole life, given me the keys for the interpretation of human existence, brought vital joy and spiritual truth. I compare it with what is usually called revelation in the language of religion. I know that no artistic experience can match the moments in which prophets were grasped in the power of the Divine Presence, but I believe there is an analogy between revelation and what I felt. In both cases, the experience goes way beyond the way we encounter reality in our daily lives. It opens up depths experienced in no other way.

Out of the philosophical and theological reflection that followed such experiences, Tillich established the meaning and power of art in immediate terms and demonstrated how from his perspective religion and culture are intertwined and cannot be separated.

Unlike the forms of "secular spirituality" that have become associated with contemporary art museums, therefore, Tillich insisted more firmly on the spiritual work that the visual arts must fulfill by recognizing the uncertain, demonic, and even tragic aspects of humanity that lead toward religious concern itself. For him, the power of modern artists was in their disclosure of just such a depth in human experience and the ultimate issues surrounding them. Uncertainty is the point where religion and art intersect, and where art in its pointing to the truth about the human condition expresses that ultimacy which is religious (see Tillich 1987f).

"Secular Spirituality" and the Contemporary Art Museum

With Tillich's understanding of the spiritual significance of art and architecture in mind, then, we may turn to a closer reading of the idea of "secular spirituality" as it has been expressed in a variety of recent museum and cultural projects. The phrase has come to be associated with the art museum as the supposed surrogate to religious institutions in the late capitalist age (Frampton 2010; Housden 2014, http://www.huffingtonpost.com/roger-housden/the-spirit-of-now). It simultaneously evokes the institutional nature of the museum (expressed through its architectural language) and points to a place that opens up the transcendent dimensions of human experience by making reference to a creative realm larger than itself. Secular spirituality refers as well to the commercialization of religious experience, through which one is encouraged to "consume" certain experiences offered by the museum, which also provides the means to do so. In a society whose younger members especially are suspicious of traditional forms of religious community, a more detached and abstract spirituality also speaks to the members of the individualized "spiritual but not religious" sector of the population, for whom religion is no longer about collective identity but the individuation of spiritual experience (Housden 2014, http://www.huffingtonpost.com/roger-housden/the-spirit-of-now.)

Understood in this context, the contemporary art museum is often thought of as a place where one may connect to an intuited world beyond the limits of one's own ego—a place that suggests a world of meaning and value, but one which is not necessarily identified with any particular tradition or institutional form. Importantly, the secular nature of this spirituality affords the observer tremendous flexibility in appropriating a highly individualized interpretation of its content. Without a clear point of reference to a particular tradition, one can project a variety of psychological or spiritual states in order to develop a sense of connection. Such spirituality does not need a church, a synagogue, or a mosque for it is a means into a nonrational intuition of ideas of truth, goodness, and beauty. It is a quality of knowing that recognizes the presence of realities we may not have words for, a fourth dimension that can move us beyond the present into something else.

Contemporary examples of such a secular spirituality are of course numerous— to mention representative examples one might think of James Turrell's 2013 light installation at the Guggenheim Museum in New York; or the architecture of Tadao Ando and his design of the Chichu Museum built in 2004 for the art works of Walter De Maria, James Turrell, and Claude Monet, situated on the island of Naoshima off the coast of western Japan; or Janet Cardiff's 2013 sound installation of "The Forty Part Motet" at the Cloisters' Fuentidueña Chapel in Manhattan. An especially layered example is the recently constructed complex known as "The River" at Grace Farms in New Canaan, Connecticut, designed by the Tokyo-based architectural firm SANAA (Kazuyo Sejima and Ryue Nishizawa and Associates). This project may be seen as a deliberate evocation of an intertwining of an animistic appreciation of the natural environment, with an appeal to ideals of community and social justice as the inter- secting elements of a secularized spiritual appreciation of the sacred and the profane. SANAA has designed contemporary art museums including the Glass Pavilion at the Toledo Museum of Art in Ohio (2006); the New Museum of Contemporary Art in New York City (2007); and the Serpentine Gallery Pavilion in London (2009). Although the River at Grace Farms is not strictly speaking a museum, but rather a multipurpose community center and landscape design, the architect and clients' intention is none- theless to foster an encounter with the arts, alongside providing a venue for pursuing social justice issues and building community while exploring dimensions of faith.

Such evocations of a secular spirituality as these perhaps differ significantly from architects who appeal more directly to sacred spaces for the design of their muse- ums, and yet who evoke a similar secularity nonetheless. Steven Holl, for example, writes of his design for an addition to the Nelson Atkins Museum in Kansas City (2007) that it was the application, in a nontheistic museum, of the theistic vocabulary he used in his Chapel of St. Ignatius completed in 1997 in Seattle, Washington. He openly evokes the idea of "sacred spaces infused by light," informing an architecture that is designed to be experienced from the inside-out. As Holl (2010, 190–191) explains, "We play with the Buddhist ideas of being and non-being—a sort of non- theistic beginning and continuum based on the notion of the self—and set out to create continuous spaces in which compassion grows through light infusion."

Beyond the Secular

In the face of such blissful indeterminacy, however, Tillich reminds us that when art fails at the central purpose of surfacing the tragic, the unrecognized demons will break forth elsewhere—as they did in the fury of the Nazis. Looking at his contem- porary cultural situation, Tillich (1987c, 95) was convinced that a religious concept such as crucifixion (and not resurrection) had to be the dominant spiritual motif, for destructiveness rather than harmony characterized contemporary existence. It was in this context that Tillich understood Picasso's *Guernica*, calling it the example par excellence of a "Protestant" understanding in which nothing is covered up and reality is squarely faced. The museum becomes a place where one encounters the reality

of the world as it is, and rather than being a place of comfort or retreat actually challenges our understanding of human experience.

The art museum, then, is a "space frame" integral to the artistic experience of the theologically significant tragic dimension of aesthetic experience. For Tillich, architecture is an exercise in creating space that has two necessary characteristics: first, to create a place which is a distinctly human space, whether public or private; and second, to make that finite space open to the infinite. Architecture should, in other words, express both our human finitude and our innate openness to the infinite (Dillenberger 1987, xxv). So while architecture in relation to religion is usually expressed in buildings such as churches, in the museum building it may also serve the purpose of creating a space that is symbolically evocative of the transcendent (and tragic) dimension of human experience to which the art itself is intended to allude. Tillich (1987a, 247) wrote in his 1964 address at MoMA a passage that expresses this vision of the idea of a museum and its architecture as a space-frame:

> If the works of art open up and reveal what was closed and hidden, a breakthrough must occur in every artistic encounter with reality, a break through the familiar surface of our world and our own self. Only if the things as they are ordinarily seen and heard and touched and felt are left behind, can art reveal something out of another dimension of the universe. Without breaking our natural adherence to the familiar, the power of art cannot grasp us.

Revisiting Tillich restores to the symbolism of the art museum a cultural significance that has waned during the last decades of its commercialization and proliferation, rendering its symbolic potential to appear hollow and dishonest—a symbol without reference to those deeper and more tragic elements of the human experience. Such thinness may more often than not evoke a kind of "aesthetic fatigue" (to use George Kubler's term in *The Shape of Time* [1962, 80]), replacing depth with a sense of jaded familiarity. A potential consequence of this phenomenon is a rupture between art and space and between art and the communal context in which it functions: Tillich wants to maintain instead a close connection between the disruptive potential of art and the spaces in which it is viewed and experienced within a community. Separation between the two diminishes both, as art moves toward the cliché of "art for art's sake" and architecture toward the scenographic. This may even have become true for Tillich's beloved Museum of Modern Art, which in recent decades has been at the center of the explosive economic and cultural development of Manhattan in what is frequently referred to as the return of a gilded age (McGuigan 2015, 18). Tillich's concept of the expressive potential of visual art, in particular, speaks to a way of resituating the art museum in the world at large, for he understands the museum as uniquely able to achieve such an interpretive power, even compared with religious devotion. In this way, Tillich helps to refocus the vicissitudes of the museum as the surrogate religious institution of our age—and its "secular spirituality." Perhaps therefore, in retrospect, the ecclesial form of Rapp's Santa Fe Museum (and other museums like it)

is more fitting than one might at first suppose. The museum, rather than standing in the place of the religious building, more authentically stands alongside it as they together conjure the full spiritual dimensions of the human condition, both the aesthetically beautiful and the existentially tragic.

References

Dillenberger, John, with Jane Dillenberger. 1987. "Introduction." In *Paul Tillich: On Art and Architecture*, edited by John Dillenberger, in collaboration with Jane Dillenberger, ix–xxviii. New York: Crossroad.

Frampton, Kenneth. 2010. "The Secular Spirituality of Tadao Ando." In *Constructing the Ineffable: Contemporary Sacred Architecture*, edited by Karla Britton, 96–112. New Haven: Yale School of Architecture.

Holl, Steven, with David van der Leer. 2010. "Theistic—Polythistic—Non-theistic." In *Constructing the Ineffable: Contemporary Sacred Architecture*, edited by Karla Britton, 182–191. New Haven: Yale School of Architecture.

Housden, Roger. 2012. "Secular Spirituality: An Oxymoron?" *Huffington Post*. http://www.huffingtonpost.com/roger-housden/secular-spirituality-an-oxymoron_b_1211837.html (accessed June 4, 2016).

Housden, Roger. 2014. "The Spirit of Now." *Huffington Post*. http://www.huffingtonpost.com/roger-housden/the-spirit-of-now_b_4590875.html (accessed June 6, 2016).

Kubler, George. 1962. *The Shape of Time: Remarks on the History of Things*. New Haven: Yale University Press.

McGuigan, Cathleen. 2015. "Money Changes Everything." *Architectural Record* 203/5 (May): 18.

Tillich, Paul. 1987a. "Address on the Occasion of the Opening of the New Galleries and Sculpture Garden of the Museum of Modern Art." In *On Art and Architecture*, edited by John Dillenberger, in collaboration with Jane Dillenberger, 246–249. New York: Crossroad.

Tillich, Paul. 1987b. "Art and Ultimate Reality." In *On Art and Architecture*, edited by John Dillenberger, in collaboration with Jane Dillenberger, 139–157. New York: Crossroad.

Tillich, Paul. 1987c. "Existentialist Aspects of Modern Art." In *On Art and Architecture*, edited by John Dillenberger, in collaboration with Jane Dillenberger, 89–101. New York: Crossroad.

Tillich, Paul. 1987d. "One Moment of Beauty." In *On Art and Architecture*, edited by John Dillenberger, in collaboration with Jane Dillenberger, 234–235. New York: Crossroad.

Tillich, Paul. 1987e. "A Prefatory Note to *New Images of Man*." In *On Art and Architecture*, edited by John Dillenberger, in collaboration with Jane Dillenberger, 241–243. New York: Crossroad.

Tillich, Paul. 1987f. "Religious Dimensions of Contemporary Art." In *On Art and Architecture*, edited by John Dillenberger, in collaboration with Jane Dillenberger, 171–187. New York: Crossroad.

3 Native Americans on the National Mall: The Architecture of the Museum of the American Indian, Smithsonian Institution—Interviews with Douglas Cardinal and Tim Johnson

GRETCHEN BUGGELN

Introduction

On September 23, 2015, I visited the Smithsonian's National Museum of the American Indian (NMAI, opened 2004) in Washington, DC, the same day Pope Francis was in town. When checking out at the gift shop, the salesperson asked me, "Did you come in to Washington to see the Pope?" "No," I replied, "I've been here the whole day." Immediately the middle-aged woman behind me in line gushed, "Oh, but this is spiritual on its own!" and asked me if I had been upstairs to see the "Our Universes" exhibition. The sense of the NMAI as a "spiritual" place is widespread among Native and non-Native visitors alike. This stems in part from the exhibition content, but also from the impression that Indians, or First Nations people, are powerfully connected to the land and the cosmos. Spirituality in this place is an expectation.

The NMAI building, designed by Canadian Blackfoot architect Douglas Cardinal, contributes to this sense of spirituality, but in a way somewhat different from the more typical monumental, formal classicism described by Carol Duncan in *Civilizing Rituals* (1995). The warm, orange-colored Kasota limestone-clad building sits on a 4.25 acre, wedge-shaped lot at the southeast corner of the Mall, directly across from the United States Capitol (Figure 3.1). It is surrounded by a carefully constructed Eastern lowland landscape restoration that now effectively buffers the museum from the hustle and bustle of the city.[1] A waterfall rushes from the side of the building as if springing from a cliff, and meadow, wetland, and woodland areas now attract wildlife. One enters the building on the southeast side under an enormous cantilevered overhang, and walks directly into a large open space known as the "Potomac." The museum's four floors contain a theater, a variety of exhibition spaces, a celebrated American restaurant, and several gift shops. The space feels warm, human, and natural (Figure 3.2).

The design and construction of the museum was a complicated and difficult process, a product of Washington and New York politics and high-level misunderstandings and machinations (see Lonetree and Cobb 2008). The museum is

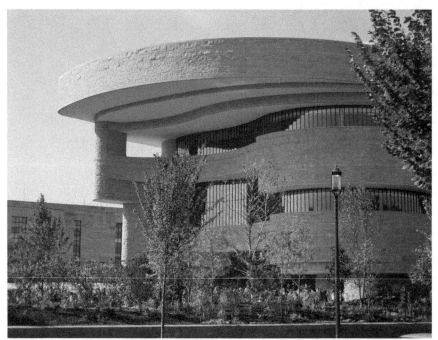

Figure 3.1 National Museum of the American Indian, 2004. Photo by Biggins at en.wikipedia. Copyrighted work available under Creative Commons Attribution only licence CC BY 4.0 http://creativecommons.org/ licenses/by/4.0/.

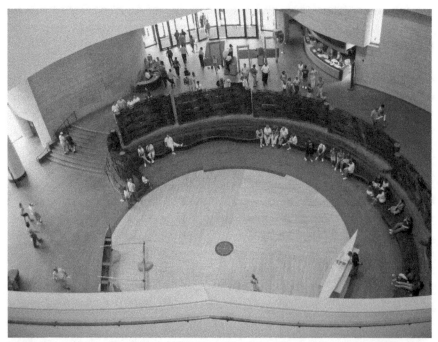

Figure 3.2 Interior of the National Museum of the American Indian, from the second floor looking down into the first floor Potomac. Photo by Quadell. Copyrighted work available under Creative Commons Attribution only licence CC BY 4.0 http://creativecommons.org/ licenses/by/4.0/.

undeniably the work of Douglas Cardinal (2015; see Boddy 1989), although he did not complete the building and certain points of the design were as a result, according to him, "absolutely compromised."[2] His lament that "the soul was taken out of the building" sums up his feeling about the finished product. It is interesting to note that Cardinal thus defines his work in spiritual terms, a soaring organic form whose wings, according to his perspective, were clipped. Nonetheless, the building is universally admired by visitors and employees as a space that they find uplifting and inspirational.

In order to understand what this architecture means and how it works, I interviewed both Douglas Cardinal and Tim Johnson, former associate director for Museum Programs (retired October 2015). Excerpts from these conversations give insight into the intention behind the NMAI's design and the way that the sacred is invoked in architecture and practice in the space.

Interview with Douglas Cardinal, 14 Lodge Rd., Ottawa, ON, October 23, 2015

Gretchen Buggeln: Maybe you could you explain your understanding of the "spiritual," and how that relates to your vocation as an architect.

Douglas Cardinal: I suppose a lot of it comes from my own background, because my father is from a First Nations background. My mother is more German background. I learned from my father's culture, the Anishinaabe culture in many ways the Blackfoot tradition . . . And I have always preferred to sync within the worldview of the indigenous people because I feel that they're closer to themselves and closer to nature and to the environment . . . we evolved a society, human society, of loving and caring. And that's how we survived . . . finding our connection with the earth, the land, and everything around us.

GB: When you design, is your sense of the sacred or spiritual at play?

DC: Yes, because that's part of my life. I'm thinking totally Anishinaabe. I'm not thinking like the dominant culture at all. I don't even think the way the dominant culture works. I mean, I have to go to the sweat [lodge] every week just to try to clean my head out of that weird thinking, that colonial thinking, because it starts affecting me in an ill way.

GB: Loving and caring . . . so how do you make love and caring in architecture?

DC: Well, for one thing, you put people at the center, whatever you do . . . I'm not building pyramids for the system. Because I feel that in this land here, in the Americas, the people are the center.

GB: Your buildings emphasize the circle?

DC: Yeah, the buildings emphasize the circle . . . I look at a building like it's a living being. And I look at each space like a cell within a living organism . . . I have a series of questions that I want to ask about that cell, say a living room, or a kitchen. First of all, what is the function, how many people, what is the purpose of the space, how many people are in the space, how do they want

to relate together . . .? Like, what kind of stage set are you going to have to better people's lives in the space?

GB: When you held the vision sessions,[3] was there much conversation about the spiritual meaning that that building should have?

DC: When I came to Washington, the Smithsonian, I was supposed to design a national museum for the American Indian. [I ask] Where are the Indians? Well, you know, everybody looks dumbfounded. So, how can I design the National Museum of the American Indian without Indians? I want to talk to the elders. "Oh. Okay." So anyway, there were good people there that really have some history and they hunted down some amazing elders.

A lot of the elders knew me. But it wasn't me asking them or telling them what to do. I mean, you don't tell Indians what to do (laughs).

We all sat in a circle [in the vision sessions]. And I said, we've come here because they want us to build a home on the mall, here, that represents who we are: the National Museum of the American Indian. "Really! In Washington?" Yes. "Phew. I don't know about that, you know, look what their cavalry did to our people, I mean, I don't know whether I'm feeling comfortable even coming here." Well, they want us to be here, and to create a monument for our people . . . it's going to be right in front of the Capitol. "Really! Well, we could look at it as an opportunity . . . they'll see that we're still here, every time they look out their window . . . they've done everything to destroy us, but we're still here. We can look at it that way."

"Well, before we do anything we should bless the site," one of the elder's said. "We have to do things in our way, and that is a spiritual way. Everything we do, we have this great gift of life, and we thank the Creator for this beautiful gift, life, and this beautiful day, all things. That's what we should do . . . we owe something to our next generation. Yes, we suffered. We've suffered terribly. But we have to be present. The only way to be free and open is to forgive. You can't open your heart to people . . . you can't be loving and caring if you carry around all this anger and this resentment. So first thing we have to do is, let's talk about forgiveness.

So, one of the elders says, "Oh, we can't bless this site anyway . . . it's still, it's February! And we bless a site in the spring. So, I don't think we can go bless this site." [Another elder said], "Well, I'm from Florida, and it's spring in Florida. *I* can bless the site!" And he came, this elder came, with his own camera crew . . . So he went out there, and blessed the site.

GB: I would guess that even before you got to that circle with the elders, you already had something in your mind.

DC: (Nods.) What happened is, at night I would write down all the things that I would hear. Write it down. And during the last night, they all went around the circle. And it was very powerful, because there was total consensus . . . So I said, do you want me to say what I heard? "Yes. Ok." So, I read all, top to bottom, the whole vision of the museum. And then there was absolute silence. And they said, "Will you read it again?" And I read it again. Silence. And the patriarch said, "That is *our* prayer, and that comes from *us*, and that's our vision." And the matriarch, she said, "You go on the site, you drive a stake in

the ground, you tie your foot to that stake, you stand there with your spear, and you bring our vision into reality. That's your job."

So I asked [them to] choose four elders to guide me through the whole process, always be with me, to always keep me on track.

See, I look at the building as I design the building — yes, it has to have a spirit, has to have a vision, okay . . . you see, it starts growing from the inside out, and then I start wrapping a shell around that, whatever that form is, but then it's also relating from the outside in, the built environment determines it, the sun angles, the wind, all these things start shaping it from the outside in. Like a tree. It's shaped from the inside out but because of the wind and the sun and everything, it's shaped also . . . from the outside in. It's reflecting its environment.

GB: The vision that you expressed . . . what kind of principles were on that list that would have reflected spirituality?

DC: Well, in that building, for example, is the Potomac, which is a circle, and it's open in the six directions. In the four directions of the compass. Heaven and earth, you step down into the earth. You look up, and there's opening to the heavens. So you are relating the building to the — to all of creation. The six directions. The creator. And in our culture we turn our pipe to the four directions, heaven and earth, and we connect ourselves to all of creation. 'Cause we're interconnected. We have to be humble, in a sense, in the universe. We have to connect ourselves to the source of all light which is that *energy.*

GB: Did that come out of that first, four-day conversation [the vision sessions]?

DC: Oh, yeah. Throughout the whole thing.

GB: The sense of connecting to nature and recovering wholeness?

DC: Yeah. But there is also an inner responsibility, where you turn the pipe not to the six directions, but the seventh direction, which is the power and creativity within yourself. You are the seventh direction on this planet. With all the forces of nature that are around you, the creator has given you the gift of creativity . . . And, you have to use those powers in all humility, because if you don't, you'll destroy all of life around you.

GB: You aren't describing the stereotypical architect.

DC: I know! And it's a challenge because what you feel, though . . . it's an opportunity of bringing that message to people that enter the building. You notice the people in the building, it's a different — they connect with each other. Because you put that vibration in everything you do. You see, if you do that in how you plan, and how you work with people in the building, and how you work with designing it, and how you even work with the workmen who put it together, that vibration, that energy is there . . . To me there's nothing more powerful than the language of architecture . . . Why not create an environment that shapes people in a good way?

I said to Carter Brown [J. Carter Brown, former director of the National Gallery of Art, at the time chairman of the US Commission of Fine Arts, a review panel that oversees art and architecture in the Capitol], What is your vision? What do you want to see? "Well, my idea," he says, "is that I.M. Pei building [National Gallery of Art] is a lantern . . . and I want these two lanterns in front of the Capitol with the

Washington monument at the end." Therefore I'm to sculpt this building in such a way that most of the openings, the larger openings would be facing the Capitol, and the other openings would be facing the Mall? In about the same proportion as the I.M. Pei building? I'm supposed to have the same sized architrave, everything? And I can sculpt it more in a female shape? "Yes, that would be appropriate." Ok! I mean, I will do that.

Interview with Tim Johnson, Associate Director for Museum Programs at the National Museum of the American Indian, Smithsonian Institution, NMAI, September 23, 2015

Gretchen Buggeln: Tell me about how you have experienced this building.

Tim Johnson: I live here much of the time, and spend a lot of time in here, and it's a very cohesive piece of work . . . we know, from feedback we get from visitors to the museum, that the building itself is one of the significant draws for people to come to the National Museum of the American Indian.

I've been asked before, what is your favorite art object or part of the museum? And I think it is the building itself. I think it is absolutely stunning. It exudes an emotional vibration or . . . sort of an energy. The organics of the building are just remarkable, and it is virtually impossible to take a bad picture of this building, from any angle, it is just absolutely remarkable that way. And I think, ultimately, a profoundly important achievement, for the architect, and for the organization to position a building of this design right here in the heart of Washington DC, next to the US Capitol. It is a stark contrast really, although it melds in well, it is nevertheless a contrast to the straight lines and hard angles and generally white stone of all the other buildings that surround it. I think it is an expression of Native culture . . . and the origins of those cultures and arts, I think it resonates really quite well.

GB: Could you tell me about your own involvement?

TJ: I was at the Native American Center for the Living Arts in the early '80s through the mid '80s. The National Museum of the American Indian Act was '89. Then the consultation processes took place in the early '90s. But because of the Tribal museum background I had, we were following the developments, certainly since '89, as to what was going on. There were a number of consultations that were held, internationally, gathering up ideas for what the institution needed to do . . . also gaining insights on perhaps what the look of the building would be. [These conversations, the fruit of over a decade of planning, were summarized in three volumes of architectural programming documents, *The Way of the People*, published in 1991.]

GB: The document from the discussions, *The Way of the People*, is that something that you yourself refer to?

TJ: If you look at the building, the interior spaces clearly come out of the programmatic intent. We have the Potomac area, the grand atrium, it's a multipurpose space, it is in effect a place for people to gather, where we have

all sorts of performances, expressive cultural programs in that area . . . that plaza idea, you know, really has worked out well, and that central feature that Douglas and the designers oriented in the cardinal directions and all of that is in itself a very community based sort of idea and it's worked out really well for us.

GB: Do you consider this building to be a sacred space, however you want to define sacred?

TJ: Yeah, I don't define sacred in religious terms. But there is an impact that space has, architectural spaces, on people. Not just the spaces, but the look, and the aesthetics of buildings themselves. Just like art, you know, it can affect you. Emotionally it can trigger your inherent sense of the feelings you get from something that's beautiful.

There are different types of visitors that come to the museum. There are those who are really object oriented, they want to see the objects, it's very important for them to see real things that exist and have been created. There is another type that is really coming for all kinds of information. These are the folks that read every word on the labels and on the panels and everything. They really want to accumulate knowledge. More of a didactic presentation works for those folks. And then there are folks who come for the experience that in some ways only public spaces can provide. And that is grand, large spaces that are awe inspiring and pleasing to be a part of, pleasing to experience. On that level I think our museum, certainly, because of the architecture, satisfies that particular group almost always . . . Why is that? Because you're not just walking into a square room, with square walls. When you approach this space, it's quite dramatic, right? I even like the west wall here, to me it is just like a big cliff that goes straight up. And it evokes a feeling of power of nature for me, actually quite impressive by scale.

GB: There's a kind of sheltering quiet when you walk in.

TJ: A mature landscape, now . . . It's all come together quite well (see Blue Spruce and Thrasher, 2008). I was just inspired the other day, in fact, by the entrance, you know, that cantilever over the building. I was walking behind these [visitors] . . . they come around the corner and once they saw this massive natural form and the cliff overhanging they were just like "oh, wow!" You know what I mean? It's an amazing building. It feels like nature, so I think Douglas Cardinal was really successful at making this feel like much more of a natural object. And we all know how nature inspires us when we experience its beauty. And in that sense the museum provides inspiration for people.

GB: Museum buildings . . . like sacred spaces . . . provoke a kind of ritual response or ritual behavior in people. Do you think there is a way that this building does that?

TJ: I think this building does do that. I recounted that experience of watching those folks literally go "wow!" and look up right away, and first experience the three dimensional nature of everything. But also, in the center of Potomac, one of the things we see a lot is people go there—you know there is a flooring design there, hardwood right in the center, there's a four directional, circular symbol there, and you wouldn't believe how many people go right to the

center of the Potomac and stand there, and put their arms out, and look up, and just gather it all in, you know?

GB: Non-Natives?

TJ: Oh yeah, absolutely, everybody, all different walks. Kids gravitate toward it a lot, too. You'd be surprised at how many folks want to just experience the feeling of that space, right in that center location. And of course they look right up at the oculus and just take it all in. That very much is like, I think, the experience that people would get from a cathedral, and the intended impact of looking skyward, and being a little bit in awe of the space that's been created there.

GB: Is there an effort to interpret the building for the visitors?

TJ: We've made an effort to make sure we interpret most of what people would encounter based on the design of the building. The gardens, the landscape around the building, really add to the overall experience.

GB: If you had a visitor who was particularly interested in Native American spirituality, where would you point that visitor?

TJ: I think the Potomac is the place for that. The prism scatters the light, you can follow the light all the way as the sun moves around the building, kind of follow that pattern around. Like many Native architectural structures, the main door faces east toward the sun.

GB: What is your sense of how the building teaches?

TJ: Well I don't think it reinforces stereotypes, although some would say that it's got a bit of a southwest feel with the cliffs and things of that nature, although, quite frankly, you can find these forms in the northeast as well, the area is carved out by wind and water. So I think overall it does a good job in capturing a sense of living within a geography, within a place, no matter where you are from. You get the feel this is a special place, because of the natural forms it has a geographic sensibility to it. I think that carries with it a great power for Native Peoples. And if you are talking about spirituality, then you have to fold into that identity, and for most Native peoples, who have had longstanding inhabitation of certain parts of the world, those parts of the world become very much engrained into the culture. The motifs and symbols that you see on the artwork are from the experience that they have with other life forms in that part of the world. The colors that they use are drawn from the kinds of colors they encounter in those environments. So environment plays a huge role—environment, geography—in the aesthetics and forms of Native art. In that respect I think the building really resonates quite well with Native people.

GB: How do you see this building in dialog with other buildings here in the center of Washington?

TJ: The building is in contrast to most of the buildings around it within Washington. It signals a particular identity and a distinction, and that is very important. Its organic forms suggest the state of the world prior to Western encounter, right? So that is another important aspect to it, architecturally. And because it is a part of the fabric of, and really essential to understanding the history of, America, the building, in its geographic location, is in dialog with the US Capitol. I think there is a more intimate relationship with this building. The US Capitol is pretty impressive. But there is a different kind of

relationship that people have when they are looking at and approaching this building. It feels much more natural.

GB: This is a building I think that, symbolically at least, connotes a kind of flow of time.

TJ: Exactly, because that is what shapes nature, right? Over long periods of time, whether through wind, water, or erosion, working its way to create these beautiful flows, yeah it has that feeling. I recall looking at the earlier conceptual drawings, sketches of Douglas Cardinal about this building and everything had to do with circles, and how he created circles and how he intersected them and joined them and moved, flowed from one to the other, you know? But what is fascinating is that there was a very technical, conscious understanding by Douglas of geometry to actually arrive at this thing that looks like a completely natural object that was carved out of the elements.

Notes

1. Designed by Jones & Jones Architects and Landscape Architects Ltd. of Seattle and EDAW Inc., landscape architects in Alexandria, VA.
2. Cardinal worked with GBQC Architects of Philadelphia and architect Johnpaul Jones (Cherokee/Choctaw); Polshek Partnership Architects of New York City completed the project; Ramona Sakiestewa (Hopi) and Donna House (Navajo/Oneida) also served as design consultants.
3. Cardinal hosted four days of "vision sessions" in Washington in 1995, with the goal of crafting a "vision statement." Participants were representatives of Native peoples throughout North and South America. Smithsonian staff witnessed these conversations.

References

Blue Spruce, Diane, and Tanya Thrasher (eds.). 2008. *The Land Has Memory: Indigenous Knowledge, Native Landscapes, and the National Museum of the American Indian*. Chapel Hill: University of North Carolina Press for the Smithsonian Institution.

Boddy, Trevor. 1989. *The Architecture of Douglas Cardinal*. Edmonton: NeWest Press.

Duncan, Carol. 1995. *Civilizing Rituals: Inside Public Art Museums*. London: Routledge.

Lonetree, Amy, and Amanda J. Cobb (eds.). 2008. *The National Museum of the American Indian: Critical Conversations*. Lincoln: University of Nebraska Press.

Personal Interview with Douglas Cardinal, Ottawa, October 23, 2015.

Personal Interview with Tim Johnson, Washington, DC, September 23, 2015.

Section II Objects, Museums, Religions

4 The Museumification of Religion: Human Evolution and the Display of Ritual

S. BRENT PLATE

Within a few months' time, for unrelated reasons, I walked through two museums that are similar in mission and presentation: The Musée de L'Homme (Museum of Man; hereafter, MH) in Paris, France, and the Museo de la Evolución Humana (Museum of Human Evolution; MEH) in Burgos, Spain. Both were built from the ground up or majorly renovated in the past decade. Both are anchored in central locations in old European cities. Both tackle large questions of human existence and provide sweeping histories stretching millions of years. Both display archaeological finds, giving up-to-date interpretations of the material, and pointing to the place of the past within the present. Both contrast the scientific with the artistic, and include artistic objects alongside archaeological objects in the galleries. Both supply multidisciplinary perspectives, combining the human and natural sciences, on questions of who we are, why we are here, and where we are going. And both dance around issues of religion, but in slightly different ways.

In this brief chapter I compare the two museums to ask questions about how (to put it vaguely for now) religion can be "found" in public institutions such as museums, and how the display of objects in museum settings has an impact on the public understanding of religion. While there are specific objects in these two museums that many people would quickly categorize as "religious," I am more interested in the ways museums might help us rethink what religion means and how it has evolved within a history of *Homo sapiens*. Just as objects undergo a process of "museumification," a change in their status due to their recontextualization within a museum (a process akin to "sacralization"; cf. Paine 2013), so does the category of religion undergo a transformational process. What I'm ultimately arguing is that *religion* is the object that is transformed by the museum.

Immersive Riverside Museums

The MH reopened in 2015 after six years of radical renovations. It is housed within the same walls of the Palais de Chaillot at the Trocadéro as it was when it was originally founded in 1938 through the work of Paul Rivet. From the museum windows the Seine is prominent in the foreground while the Eiffel Tower rises in the background, but apart from the setting very little remains of the old museum. The newly renovated

space reflects many of the changes in museums over the past century, and the new site is oriented around the existential questions: "Who are we? Where do we come from? Where are we headed?" Answers to these are placed within the long narrative of human evolution. With such an orientation it would not seem to be difficult to find religion within that history.

Walking through the galleries of the MH, the visitor is offered a chronology of sorts, but one that is intercut with thematic groupings. Large glass displays are set up along the main gallery: massive cases filled with an array of materials that give the gallery the distinct appearance of a *wunderkammer*. Taxidermied birds perch next to wooden fetishes and beaded jewelry. Old, misshapen skulls are set in front of large modern photographs of contemporary urban dwellers and their piercings, and all that next to an ornate hijab. Objects gather and evoke themes we could label "devotional images" or "bodily decoration," while other objects present a (sometimes idiosyncratic) history of prosthetic legs or phrenology. Several small figurines represent dogs from around the world, indicating their symbolic and actual functions as guardians and mediators: a wooden mask of a dog from the Ivory Coast, a simple terracotta carving from Vietnam, an elaborate ceramic dog from China. The press kit released at the reopening suggests how the objects are displayed so as to "elicit contemplation and stir emotion" (Musée de L'Homme 2015, 28).

One of the more creative displays is a rounded table with a map of the world printed on an acrylic surface. On the map are arrows showing rice foodways, stemming from Southeast Asia and moving across the world. Most interesting here was the attention to sameness and difference, how rice has been developed for differing uses in differing places, a fact reinforced by the smell of rice: visitors can put their nose up to the display in various spots on the display and smell what rice made in India, China, or South America smells like. It's a clever way to show sameness and diversity, to "demonstrate the many ways we have found to feed ourselves" (Musée, 30). The comparative impulse is strong throughout the MH, but taken with a light—at times almost whimsical—hand.

The MEH in Burgos is an impressive structure that dominates a central area along the Arlanzón river (formerly the site of a parking lot). The imposing Cathedral of Burgos is visible across the water.[1] MEH is situated within a larger "Human Evolution Compound" that includes a convention center and research center designed by architect Juan Navarro Baldeweg, and the museum has become a significant tourist site for northern Spain. The entire compound was built chiefly to provide a space to house, display, and study the archaeological discoveries from the nearby mountains of Atapuerca. The objects discovered through the latter half of the twentieth century have proven to be some of the most important finds in recent years and comprise the largest and earliest collection of human remains in all of Europe. The archaeological site of Atapuerca became a UNESCO world heritage site in 2000.

Entering the MEH on street level, the visit begins downstairs, underground, thus evoking archaeological excavation. Displays of found skeletal remains are spread across numerous darkened rooms. *Homo antecessor* and *Homo heidelbergensis* are

well represented through reconstructed displays, and with diagrams and images they show the enormous scale of the Atapuerca dig with its multiple caves and chasms. From these remains the visitor heads upstairs where the local humanoid discoveries are set within a larger history of evolution, and questions are framed around origins and how *Homo sapiens* got to where we are now. Going up one more floor the museum turns to matters of cultural evolution, displaying the archaeology that indicates early symbolic functions, tool and fire use, and artistic creation. Ultimately, we get to contemporary neuroscience which is extolled as an important scientific development that allows us to know "where we come from" and "who we are" in new ways. I don't know how much was intentional, but I came away with a feeling that neuroscience is the new archaeology; plumbing the depths of the brain will reveal discoveries about humans that heretofore we had to dig out of the ground. (Here, unfortunately, as in much popular presentation of neuroscience the disembodied brain tends to be emphasized at the expense of the rest of the body.)

Both the MH and the MEH are typical of twenty-first-century museum design. Both emphasize "immersive experiences," especially through the use of electronic technology and multi-sensual displays. They each stress education and accessibility and are situated within a larger scientific research complex that includes libraries, laboratories, and meeting spaces. Architecturally, they both have large uncluttered spaces with lots of light, and in the publicity materials announce their "openness" to the surrounding environment. The MH says it wants visitors to engage in "contemplating, touching, listening, reading, smelling, playing, participating" (Musée, 20). The MEH aims "to be a center in which to imagine, sense, and reflect on what it is to be human" (Martín Nájera 2010, 12).

Religious Objects

Where is "religion" in all this? There are many ways to answer such a question, some of it explicit within the displays themselves. The MH in particular displays a great variety of objects that symbolically operate in religious registers, or that were once used for religious purposes. One cluster of objects is made up of a wooden West African power figure, a bronze Shiva Nataraja, an earth-touching Buddha, and a Christian crucifix. Another cluster is particularly creative in its display of the "transformation" of Senegalese amulets, showing how people have used old glass Perrier and plastic water bottles and through some decorative flourishes repurposed them as conduits of spiritual power. Throughout the clustered displays each object "tells its own story while remaining an integral part of an overall theme" (Musée, 21), though it is clear the "story" must be concocted by the visitor as there is little information about most objects.

I won't rehearse here the transition of objects from ritual space to museum space, nor recount the museum as its own sacred space (many other chapters in this volume chart such transitions well; cf. Sullivan 2015). Instead I want to briefly think about museums like the MH and MEH that offer long takes on human life on earth and

open up ways to think about the place of religion itself within human evolution, and how the museum is a medium of that history. Religion becomes much more implicit in this view.

The religious dimensions are less explicit in the MEH than in the MH, and because of that the interpretive challenge is more difficult, but I think richer. If we dig deeper, and approach the topic creatively, we can begin to see religious life and practice growing alongside evolution. First and foremost it is seen in the ceremonial burial of the dead, to which the MEH devotes several displays. Evidence of the oldest known funerary practices, dated 500,000 years ago, was found in Atapuerca. One display in the museum recreates a 60,000-year-old Neanderthal burial ceremony with the corpse in fetal position placed on a bed of plant material, as the living gather around and offer flowers (Figure 4.1). Archaeologists have identified pollen from various plant species at the sites of such burials and surmise these came from flowers that were made as offerings. So the diorama speculatively recreates the scene of the rite, with just enough suggestion (clusters of handpicked yellow flowers) to make it intriguing, while simple enough not to speculate far beyond the material evidence.

Bound up with death and burial is the rise of symbolic artwork. Spaces like the Galería del Sílex at Atapuerca show an intricate ritualistic space filled with wall paintings, decorated pottery, and the remains of domesticated animals, alongside human remains. Though the nature of the rituals is unknown, and the "meaning" of the

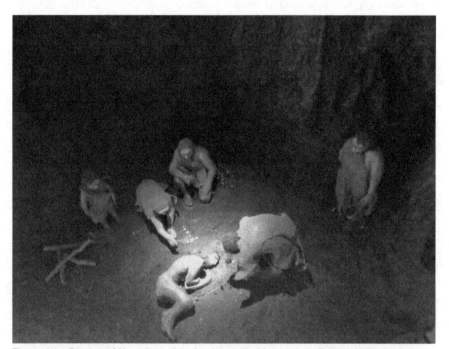

Figure 4.1 Display of Neanderthal burial rite at the Museo de la Evolución Humana, Burgos. Photo by S. Brent Plate

specific symbols probably lost to history, the mix of slaughtered animals, symbolic artwork, and burial points pretty clearly to what we have come to call "ritual." The emphasis on symbolic creation and use, with accompanying cognitive abilities to communicate in an economy of symbols, points to the ability to dwell within and through "fictions," a practice necessary for the rise of *Homo sapiens* as the prominent humanoid species. As Yuval Noah Harari (2015, 38) has recently explained it, "The real difference between us and chimpanzees is the mythical glue that binds together large numbers of individuals, families and groups. This glue has made us the masters of creation."

The massive brain development of species such as *Homo sapiens* was reliant on the domestication of such things as fire, dogs, rice, and wheat. Simultaneously, the mythic, symbolic, and ritualistic activities of humans pushed brain developments in new directions. Humans were able to think as easily about things that don't exist (but might) as about things that do. Deities may be the logical endpoint of such thinking, but this is not the only way that abstract, symbolic, and fictional thinking operates. Indeed, it is the collective ability to imagine, tell, and even sometimes believe in other worlds, other possible structures of reality, which finally gave *Homo sapiens* the advantage, becoming the "masters of creation." In an oversimplified nutshell, "We imagine, therefore we are."

Museums like the MH and MEH tend to shy from the word "religion." Ritual, symbol, and myth are used, but not religion. There are multiple reasons for this. Some are rooted in respect for the scientific method and others in deference to visitor concerns, but that is all too much to cover here. The other reason, I suspect, is that museums are working with outmoded conceptions of religion. To rethink religion in the museum, I want to come back to one display that begins to allow us to think about religion differently and get beyond the "burial and symbols" approach: the rice display in the MEH.

Like most sacred things, there's nothing inherently sacred about rice; it all depends on how the things are used. And certainly rice is used in rituals and takes on sacred symbolism. Anything that is as basic a human necessity as rice will inevitably end up with a religious function. But I'm actually not interested in arguing that rice can become sacred, for example, when it is offered to the goddesses Shridevi or Uppalamma. It's not simply that objects are, or are not, sacred or religious. It's that objects like rice are part of a larger matrix of historical and cultural—diachronic and synchronic—flows that connect with aspects of human life that we designate as religious. Humans and things are "entangled" in evolutionary history, as Ian Hodder (2012) puts it.

The word "religion," like the words "culture," "art," and "history," is a heuristic term, a generic category that scholarly, political, and social forces establish to help understand the world. "Religion" is the word scholars and others use to describe a network of myths, rituals, and symbols that foster social cohesion, provide meaning, purpose, order, and orientation, often but not always with reference to supernatural forces. Within such critical definitions rice can be understood within religious pathways (like

the MH display showing the foodways), merging into and out of rituals and symbols in parts of the world, and intersecting with multiple cultural traditions. Following the display in the MH, the scholar of religion might be provoked to follow not some transmission of doctrine or holy text across geographic space, but the transmission of basic objects like rice, incense, or paper, and enquire about their religious intersections, how they've created part of the substrate upon which the more abstract elements of myths and rituals operate.[2]

In short, religion is a category of human life alongside economy, politics, family, and so on. Within human evolution we need to move beyond simple identification of objects as religious or not, and toward points where the flows of life intersect, overlap, and transform each other.[3] That may be through the colorful flowers as people gather together to collectively mourn, or through the symbolic sacrifices of animals, or collective sharing of fictions. From such a perspective, museums of natural history are filled with religion.

Conclusion

My suggestions here lead in two directions. Toward museum studies I argue that a broader view of "religion" is needed, and for that it is necessary to listen to the critical takes of religious studies scholars who are not so narrowly focused on "beliefs" and "gods" as is popularly assumed. In the other direction, religious studies scholars might find new grounds for thinking about the category of religion in a history of human evolution, finding bases for symbolism, myths, rituals, and communal life.

Related, there is a third direction, though less developed. My discussion has been mainly descriptive of museum display, the presence and absence of religious elements in those displays. But there's also an implicit plea here for the museum as a space to subtend the relations of religion and science. Too much bad popular wisdom, and a handful of narrow-thinkers on either side, have pretended that there are great divides between science and religion. The critiques tend to be rooted in shabby conceptions of both religion and science, as if all religious people are "creationists," and as if all science is reductive. Museums like the MH and the MEH bring science and religion (and culture and economics, etc.) together to tell a story that is indebted to both, and thus might provide important tools for the public understanding of religion.

Religion gets museumified. Not as a stable object with definable edges, but as part of larger flows of science and history. Religion intersects, as each of the following chapters in this section indicate, with historical, archaeological, ethnographic, and artistic dimensions of human life. The museumification of religion entails a refreshed understanding of religion in the history of human evolution. Not the intellectualist God-searching mind, but the sensual, embodied rice-eater.

Notes

1. While there is a science versus religion element to be interpreted in the city landscape, the two institutions have in fact recently set up a discount ticket for visitors who want to see both sites in the same day.
2. This is part of what I was attempting in *A History of Religion in 5½ Objects* (Plate 2014).
3. A number of scholars in recent years have turned to the evolution of religion through the cognitive sciences. Many of these isolate "religion" as a way of thinking, and usually an overly simplified thinking about "gods." Others, like Bellah (2011) and Whitehouse (2012) have much to offer to the conversation.

References

Bellah, Robert. 2011. *Religion in Human Evolution*. Cambridge, MA: Harvard University Press.

Harari, Yuval Noah. 2015. *Sapiens: A Brief History of Humankind*. New York: HarperCollins. Kindle Edition.

Hodder, Ian. 2012. *Entangled: An Archaeology of the Relationships between Humans and Things*. Oxford: Wiley Blackwell.

Martín Nájera, Aurora. 2010. "El Museo de la Evolución Humana de Burgos, una caja de luz para reflexionar sobre la evolución," *revista ph* 76: 10–12.

Musée de L'Homme. 2015. "The New Musée de L'Homme." Press kit.

Paine, Crispin. 2013. *Religious Objects in Museums: Private Lives and Public Duties*. London: Bloomsbury.

Plate, S. Brent. 2014. *A History of Religion in 5½ Objects*. Boston: Beacon Press.

Sullivan, Bruce M. (ed.). 2015. *Sacred Objects in Secular Spaces: Exhibiting Asian Religions in Museums*. London: Bloomsbury Academic.

Whitehouse, Harvey. 2012. "Ritual, Cognition, and Evolution." In *Grounding Social Sciences in Cognitive Sciences*, edited by Ron Sun, 265–284. Cambridge, MA: MIT Press.

5 Altar as Museum, Museum as Altar: Ethnography, Devotion, and Display

MARY NOOTER ROBERTS

Ever since objects from Africa have been exhibited in both fine arts and anthropology museums in the West, problems of categorization have been paramount. How should things that were used for daily and ritual life as objects of governance, education, spiritual mediation, and healing be characterized in museum settings when they have been excised from earlier careers and transplanted to contexts for which they were never intended? Do they still possess powers and capabilities that enabled earlier uses? Are sacred objects still imbued with spiritual attributes, or do they become defunct once placed in museum vitrines on pedestals, or worse, within natural-history display cases or dioramas supposedly documenting "traditional" ways of life? These questions have been the subject of numerous projects, including the acclaimed exhibition *ART/artifact* (Vogel 1988), which sought to demonstrate that the "fine arts" and "material culture" categories to which objects are often relegated are artificial attributions replete with remnants of colonial classifications that denied coeval equality to diverse cultures of the world.

Exhibiting works of spiritual devotion in culturally affirming and paradigm-shifting ways has been a particular focus of several museums involved with the arts of Africa and African diasporas during the past quarter century. Examples offer insights into powers that may inhere in religious objects and that may be imparted to museum visitors depending upon display approaches. Since 1993, a series of exhibitions on Africa and its diasporas has featured recreations of shrines and altars, prayer rooms, commemorative spaces, and *botanicas* (Afro-Latino pharmacies hosting spiritual healing). In each case, displays became *active* during their exhibitions as certain visitors engaged with them. From the offering of flowers, coins, photographs, and cigarettes to the performance of *capoeira* (an Afro-Brazilian martial art) before an altar; from assuming a prayer position before a beaded shrine to the touching of portraits of a saint to obtain sacred blessings; environments proved to be far more than passive representations of religious practices. Rather, they served as places of spiritual interaction. Indeed, displays took on "lives" of their own at their originating institutions and as they traveled. These exhibitions, staged by the Museum for African Art in New York and the Fowler Museum at UCLA, were *Face of the Gods: Art and Altars of Africa and the African Americas* (Thompson 1993); *Sacred Arts of Haitian Vodou* (Cosentino 1995); *A Saint in the City: Sufi Arts of Urban Senegal* (Roberts and Roberts 2003);

Botanica Los Angeles: Latino Popular Religious Art in the City of Angels (Polk 2005); and *Mami Wata: Arts for Water Spirits in Africa and Its Diasporas* (Drewal 2008).

The history of this exhibitionary lineage is important for visual culture studies and literatures of display, as well as for understanding the dynamics of religions in museums. These exhibitions were ethnographically grounded, in that they presented broader contexts of objects based on long-term field research; and not just within their sociopolitical and spiritual frameworks, but in relation to other objects and performances that create meaning-filled loci of sacred energy. Not only are processes of "recreation" and translation in such museological projects complex and nuanced, but visitor responses—whether intended or unintended—have been compelling. Questions of representation are raised: How are such displays similar to or different from old-fashioned natural-history "dioramas"? Can they be considered "authentic," and if so, by whose criteria? What ethics are engaged in activating or consecrating a shrine on view in a museum? What forms may religious devotion take within museum contexts? What do such displays reveal about social histories of objects, efficacies of "things," and, more broadly, the "lives" of exhibitions? And finally, what do shrines and altars have in common with museums and the dynamics of exhibition display?

Recreating Shrines in Museums

To understand how a shrine, altar, or prayer space may be considered an "exhibition" requires critical analysis of how exhibitions are defined in museum contexts. In her classic article "Objects of Ethnography," Barbara Kirshenblatt-Gimblett (1991) examines the arbitrary process of selecting ethnographic fragments detached from their earlier contexts when attempting to reconstitute cultural phenomena in museums. Artist Fred Wilson has shown how deliberate juxtapositions can influence the production of meaning, for when recast in new display combinations, objects—as traces of larger social and political histories—offer powerful, unexpected meanings (Corrin 1994). Stephen Greenblatt (1991), in Karp and Lavine's landmark edited volume on *Exhibiting Cultures*, contrasts resonance and wonder achieved through display tactics, suggesting how and why some exhibitions evoke strong emotional responses. Shrines and altars accommodate all of these elements: selection, juxtaposition, association, resonance, and wonder.

When devotees and/or practitioners build shrines, they select items to stand for greater wholes, and recombine them in ways that augment and transform their meanings, just as exhibitions do. By creating a microcosm of ideas and associations, an altar becomes an approachable universe, or as Robert Farris Thompson (1993) documents among Yoruba of Nigeria, a "point where the world comes together" as a "face of the gods." How such microcosms assume new lives in museum settings is the focus of this brief chapter.

Recreation of indigenous displays in museums reflects processes of cultural translation. In most of the cases noted here, knowledge of the shrine or altar, how it looked, and its semantic polyvalence is based upon long-term scholarly research. The

displays usually resulted from extensive consultation with religious practitioners, and some were created by such specialists. A few altars were moved from their original locations to museum settings. When this was not feasible, shrines were recreated to look as much like originals as possible, following photographic documentation and collection of authentic objects. In *Face of the Gods* (1993), a historical altar known only through early archival photographs was composed by locating and reconstituting the works of art that had originally belonged to it. Yet, the process of translating an indigenous devotional environment to a Western museum context is most successful when it is not a literal translation into one's own language of display, but rather, as Walter Benjamin (1968) has expressed, when translators (curators, designers, educators) themselves become *changed* by the language from which they are translating.

Each of these exhibitions addressed the politics of presenting religious phenomena in museum settings, and the complexity of displaying devotional objects from diverse spiritual traditions. Far more importantly, all were extraordinary examples of what can happen when devotional engagement occurs spontaneously in exhibition contexts. Altars in some exhibitions were part of a single cultural matrix, as in *Sacred Arts of Haitian Vodou* (1996) curated by Donald J. Cosentino and Marilyn Houlberg for the Fowler Museum of Cultural History (Figure 5.1). By contrast, in *Face of the Gods*, for the Museum for African Art in New York as curated by Robert F. Thompson

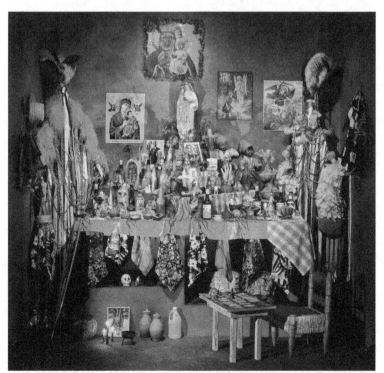

Figure 5.1 The *Petwo/Kongo* altar from the exhibition *Sacred Arts of Haitian Vodou* organized by the Fowler Museum at UCLA. Photo by Denis J. Nervig, 1995.

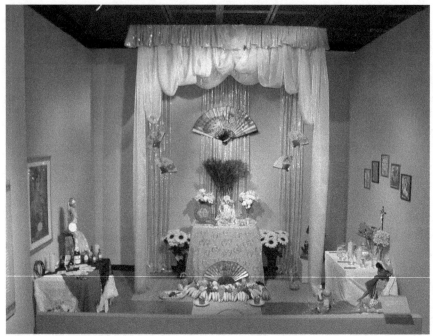

Figure 5.2 Throne (*trono*) for Ochún erected by Sonia Gastelum for the exhibition *Botanica Los Angeles: Latino Popular Art in the City of Angels* at the Fowler Museum at UCLA. Photo by Don Cole, 2004.

and assisted by C. Daniel Dawson, over a dozen altars from diverse African and African diasporic traditions were recreated, including Yoruba (Nigeria), Santería (Cuba), Candomblé and Umbanda (Brazil), and Sa'amaka (Suriname). In the UCLA Fowler Museum's *Botanica* exhibition, curated by Patrick Polk in close consultation with several renowned practitioners in Los Angeles, a healing shop was constructed after the sort of storefront one might encounter in any major US city. At the back, a doorway led to five shrines, each assembled by a local healer of a particular faith (Figure 5.2).

These exhibitions resulted in spontaneous interactions of visitors with shrines and altars on display (see Roberts 2008). Devotees left offerings and miscellaneous items of meaning and memory. Despite the fact that most of the altars were "recreations" as opposed to original altars, performances, consecrations, and blessing ceremonies occurred before them on a regular basis. For instance, on opening night of *Face of the Gods* in New York City, a number of guests prostrated themselves before the shrines. In both *Face of the Gods* and *Sacred Arts of Haitian Vodou*, so many gestures of devotion were enacted that the museum staff had to determine what would become of offerings. In the case of the former, money left on shrines was used to refurbish materials as the exhibition traveled. And in both cases, the exhibitions evoked very particular reactions and responses as they traveled to different cities in

the United States and the Caribbean where diasporic Africans reside, as do others who have converted to religions on display.

A final example, *A Saint in the City: Sufi Arts of Urban Senegal* (2003), which I curated with Allen F. Roberts for the Fowler Museum at UCLA and which then traveled to five US venues, offers a compelling case of the ambiguity between ethnographic research, religious devotion, and museum experience. The exhibition focused on the pervasive visual imagery associated with one of Senegal's most influential Sufi movements called the Mouride Way, which was founded by the poet, mystic, and saint Cheikh Amadou Bamba (1853–1927). For Mourides, all images are based on a single photograph of the saint taken by French colonials as a surveillance photograph in 1913, which, paradoxically, has become the catalyst for an explosion of visual imagery despite the fact that the negative can no longer be found (Roberts and Roberts 2003). Images document the saint's miracles while imparting *baraka* blessing energy. Given our awareness of the intense and personal emotional manner in which Mourides interact with images, we warned security staff that there might be devotees who would touch or otherwise engage with images in a sanctified manner, and asked them *not* to prevent visitors from doing so since this was an ordinary practice in Senegal. Furthermore, such evident devotions would be—for us—the most powerful measure of the exhibition's success.

Opening night brought many guests from the Mouride community that has existed in Los Angeles for many years. In fact, it is the life history and teachings of the saint that inform and inspire such people's ability to travel the globe for business and to endure long periods away from their families. One room in the *Saint in the City* exhibition recreated after the prayer room of a *marabout* holy man in Dakar named Serigne Faye, was a mesmerizing place covered with devotional images. Most striking were larger-than-life photo-realist paintings by ardent Mouride artist Assane Dione. In interstices between these beautiful paintings of the saint and his descendants were other images, some hand-made, others mass-produced, but all addressing aspects of the saint's life and miracles. Also in abundance were clocks and rugs, Koranic tablets, sacred books, tea-making implements, prayer beads, fans, calligraphic works, and glass-covered wall-pieces depicting the Kabbah and other iconic Muslim symbols. Two disco lights of myriad colored facets hung from the ceiling, each inscribed by Assane Dione with one of the ninety-nine names of God. When the disco lights were illuminated and rotated, the names were beamed upon everyone in the room (Roberts 2010, 92–95).

An important element of touch was involved in the experience of Serigne Faye's recreated sanctum. As soon as Mourides entered, many circumambulated the room and as they did, they gently swished their hands across the foreheads of the sainted portraits. In another location of the exhibition that suggested a typical street scene in Dakar with vendor stands and myriad images of Bamba, a Mouride visitor to the exhibition opening removed one of the booklets of Bamba's poetry from a book stand meant to reflect how such works are sold. He sat down in front of the display

and sang the poems in the booklet. Many others gathered around him until a chorus of singers could be heard throughout the gallery. On another occasion, when a very important Mouride cheikh was visiting with several of his devotees from the San Francisco area, the cheikh entered the prayer room, picked up one of the blank Koranic tablets, and inscribed a sacred poem on it in ballpoint pen. As he did so, each of the devotees approached the *marabout* on his stomach, sliding across the rugs to the holy man's feet to pay respects and demonstrate his devotion as the *marabout* then sang the verses aloud.

These are not circumstances one expects in museum galleries, yet when they happen they demonstrate an authenticity that transcends objects or exhibitions on their own, and blur boundaries between anthropological research, devotional practices, and museological approaches. Such intense moments demonstrate the enduring power of worship that may be prompted by a visual act and then culminate as corporeal engagement (Roberts 2010, 92–95). Furthermore, many of the individuals engaging with the displays in these last examples were members of diasporas and far from their homelands. By defying any sense that the spiritual is out of reach because of geographical distances, devotees bring the divine into human proximity and materialize the untouchable, reify the unknowable, and give shape and form to the inchoate, even at the remove of a museum.

Such powerful declarations of worship are testimony to ambiguous yet potentially transformative relationships and dichotomies between museums and sacred places. Visitors' responses underscore remarkable resonances between exhibitions and shrines and altars that exact presence, performance, and participation despite artifices of exhibitionary format. Visitors respond because they feel that even at the remove of a museum, objects and environments retain their power to bless, protect, and promote.

Much can be learned about sacred phenomena in museums by approaching the topic from the opposite direction as well, by studying temple structures and sacred visual culture in terms of their relationships with and similarities to museum practice. This two-way approach brings the insights of ethnographic research into the conversation. Currently, Allen Roberts and I (2016) are investigating spiritual practices associated with a South Asian saint named Shirdi Sai Baba (d. 1918), whose devotional diasporas extend to many African countries and around the world. In documenting the display strategies involved in his astounding temple complexes in India and Mauritius, and the innovative visual technologies incorporated into devotional practices dedicated to this saint, it becomes clear that understanding sacred display in museums is contingent upon understanding the dynamics of display by indigenous peoples themselves in their own exhibitionary contexts. In many respects, temple complexes in Mauritius and the pilgrimage site in India for Shirdi Sai Baba are museums unto themselves, and at the same time they house "official" museums and reliquaries where the "original" and most "authentic" sacred objects are placed on view for visitors' visual, tactile, and other kinds of performative interaction. Exploring the dynamics of such temple complexes may offer new paradigms for

museum representations of sacred arts, including a growing interest in virtual web-based displays whereby visitors may "curate" their own altars, make offerings, and receive blessings online.

First voices and testimony from devotees can provide insider views of multivalent curatorial processes and extremely complex conceptualization, negotiation, implementation, and interpretation that go into the curation of temples and altars. Such a dialogical approach enables one to consider different ways that temples and museums define what is "authentic" and what is a "recreation" where shrines are concerned, and how devotees and museum visitors may subvert such categories to create their own definitions for displays on view. Through visual and multisensorial engagements such as performances, offerings, and other reciprocal acts of participation, visitors bring displays to life and ensure ongoing efficacies of museum presentations.

References

Benjamin, Walter. 1968. "The Task of the Translator." In *Illuminations*, by Walter Benjamin, 69–82. New York: Schocken Books.

Corrin, Lisa G. 1994. "Mining the Museum: Artists Look at Museums, Museums Look at Themselves." In *Mining the Museum: An Installation by Fred Wilson*, 1–22. New York: The New Press.

Cosentino, Donald (ed.). 1995. *Sacred Arts of Haitian Vodou*. Los Angeles: UCLA Fowler Museum of Cultural History.

Drewal, Henry John (ed.). 2008. *Mami Wata: Arts for Water Spirits in Africa and Its Diasporas*. Los Angeles: Fowler Museum at UCLA and Seattle: University of Washington Press.

Greenblatt, Stephen. 1991. "Resonance and Wonder." In *Exhibiting Cultures: The Poetics and Politics of Museum Display*, edited by Ivan Karp and Steven Lavine, 42–56. Washington, DC: Smithsonian Institution Press.

Kirshenblatt-Gimblett, Barbara. 1991. "Objects of Ethnography." In *Exhibiting Cultures: The Poetics and Politics of Museum Display*, edited by Ivan Karp and Steven Lavine, 386–443. Washington, DC: Smithsonian Institution Press.

Polk, Patrick A. 2005. *Botanica Los Angeles: Latino Popular Religious Art in the City of Angels*. Los Angeles: Fowler Museum at UCLA and Seattle: University of Washington Press.

Roberts, Allen F., and Mary Nooter Roberts. 2003. *A Saint in the City: Sufi Arts of Urban Senegal*. Los Angeles and Seattle: UCLA Fowler Museum of Cultural History and the University of Washington Press.

Roberts, Mary Nooter. 2008. "Exhibiting Episteme: African Art Exhibitions as Objects of Knowledge." In *Preserving the Cultural Heritage of Africa: Crisis or Renaissance?* edited by Kenji Yoshida and John Mack, 170–186. Oxford: James Currey and Unisa Press.

Roberts, Mary Nooter. 2010. "Tactility and Transcendence: Epistemologies of Touch in African Arts and Spiritualities." In *Religion and Material Culture: The Matter of Belief*, edited by David Morgan, 77–96. London and New York: Routledge.

Roberts, Mary Nooter, and Allen F. Roberts. 2016. "Spiritscapes of the Indian Ocean World: Reorienting Africa/Asia through Transcultural Devotional Practices." In *Afrique-Asie. Arts, espaces, pratiques*, edited by Nicole Khouri and Dominique Malaquais, 55–83. Paris: Presses Universitaires de Rouen et du Havre.

Thompson, Robert Farris. 1993. *Face of the Gods: Art and Altars of Africa and the African Americas*. New York and Munich: The Museum for African Art and Prestel.

Vogel, Susan. ed. 1988. *ART/artifact: African Art in Anthropology Collections*. New York: The Center for African Art, New York and Prestel Verlag.

6 Religious History Objects in Museums

LAUREN F. TUREK

Religious objects abound in museum collections, yet by virtue of their religious origins and sacred status, they present curators and exhibition designers with a number of interpretive challenges. Chief among these is deciding which story or stories a particular object should tell to visitors and how that object should tell it. While it is conventional to describe objects as mute and devoid of agency unless and until a curator, interpreter, or museum educator steps in to "reveal the stories that objects represent," religious history objects offer a potentially dizzying array of meanings and stories from which to choose (Dudley 2012, 11; cf. Knell 2012, 327; Kahn 1995, 325). Religions, as well as religious practices and beliefs, have never been monolithic or static. Even within a specific historical moment and religious community, faith leaders and individual believers have ascribed vastly different emotional, spiritual, and cultural meanings to the same object. Perhaps this helps to explain why, as scholars such as Mark O'Neill and Crispin Paine have lamented, museums so rarely explore "the world of feeling embodied in religious buildings, artefacts and rituals" (O'Neill 1996, 192), or use the religious objects in their collections to tell the histories of popular, rather than "official," religious expressions (Paine 2013, 22, 118).

Although there is a burgeoning literature on material religion and religious objects in museums, the scholarship on how museums can use religious objects to create a sense of history in their exhibits—or how they can use secular objects to tell religious histories—remains thin. Yet for curators eager to make the past legible to contemporary museumgoers, religious objects offer insights into the worldviews and interior lives of people who lived long ago that few other types of historical artifacts can parallel. This chapter will discuss a few case studies, including a conceptual design project that I worked on for a Jewish museum, in tandem with an overview of the extant literature on religious objects in history exhibitions. In so doing, it will highlight the challenges and opportunities that museums face when they interpret religious history objects and reflect on the intrinsic, extrinsic, and ascribed properties that make these objects so potentially powerful as a means of imbuing exhibitions and museum spaces with a sense of history (see Paine 2013, 15).

Challenges and Opportunities

In 2007, while working for a private exhibition design firm, I joined a project team tasked with developing a conceptual design for a California-based museum of Jewish culture. Although the museum space and exhibitions that we envisioned never left the concept phase, the discussions we had among ourselves and with the curators about how to use the museum's collections to tell the story of Jewish settlement in the western United States provide a useful framework for considering how to bring religious history and religious history objects into exhibitions effectively.

The museum boasted a rich collection of Judaica and ceremonial objects — including Torah scrolls and Kiddush cups, as well as everyday items such as spice boxes and a silver tea service — all of which provided the raw materials to illuminate Jewish religious traditions, the history of migration and the global Jewish diaspora, and, more specifically, the personal experiences of Jews who migrated to the American West. Yet these objects could not necessarily speak for themselves. As Gaynor Kavanagh (1996, 6) notes, "[O]bjects not only have to be identified and set within categories of meaning, they have also to be positioned and understood within their social, political and temporal contexts." Rather than display these objects as art pieces, our team discussed a strategy for embedding them within a historical narrative that embraced the personal stories of Jewish families living in California at the turn of the twentieth century. With storytelling as the primary interpretive strategy, we aimed to contextualize sacred as well as secular objects using historic images, oral histories, and interactive programming that would reveal how individuals experienced ceremonial practices, understood Jewish religious concepts, and incorporated their faith into their daily lives. We then planned to situate those individual stories along a larger narrative arc that highlighted local communal events, such as the establishment of the first synagogues in California, and stretched back through the centuries to explore the global history of Jewish migration. In this schema, religious objects would provide authentic material touchstones to ground the narrative and create an immersive historical experience for visitors.

Pursuing this approach might have allowed our team to accomplish one of the major interpretive responsibilities that Paine (2013, 11) asserts religious objects in museums have, which is "to help visitors understand how the object was understood in its religious context — to help the museum visitor see the object through the eyes of the devotee." Focusing on individual interactions with religious objects, set in historical context, creates opportunities to explore the "sensual, emotional, and experiential" aspects of religious belief, which, as Paine argues, "is how the overwhelming majority of believers actually consume religion and its objects" (109).

This objective does present challenges, however. In her review of the *Treasured Possessions* exhibition that ran in 2015 at the Fitzwilliam Museum in Cambridge, England, Madeline McMahon (2015) delights in the exhibition's effort "to show devotional objects used in private versus those used in public — that is, in a church," but argues that, as revealing as private objects of devotional culture are, their meaning can

remain unintelligible, even with historical context and interpretation. After describing a sixteenth-century lead-glazed stove tile from Germany that features a scene of the crucifixion, she states: "The tile is telling—Christ made his way into the early modern kitchen—but also obscure: we can't be sure whether that stove fed and heated a Protestant or a Catholic family," and, furthermore, "we cannot recreate precisely what [such items] meant to early modern owners" (McMahon 2015). Yet some time periods and collections (especially those with oral history components) might offer more opportunities to uncover the spiritual and emotional motivations that shaped how the people of the past interacted with religious objects. Certain historic objects might even evoke an emotional response from modern viewers, allowing them to forge a visceral connection to the past. That said, McMahon is correct in noting that curators and historians cannot capture and convey the interior thoughts of historical figures "precisely."

Still, religious history objects can help to lay bare the spiritual beliefs, cultures, sensual engagements, and worldviews of those who lived long ago, creating a sense of history by making strange those aspects of historical faith traditions that visitors may assume they will find familiar. In his analysis of Anglican material religion in early America, Louis P. Nelson (2007, 220, 204) reminds readers that "early Anglican life was animated by the power of supernatural forces—both good and ill," and as such, Anglican religious buildings and objects acted as "agents of supernatural theologies that animated the ordinary." He suggests that with careful interpretation, we can rediscover the largely forgotten meanings of "sacred geometries" in headstones and church windows, designs that held deep significance to their creators and exemplified the palpability of the supernatural in everyday life (207). Likewise, Nelson argues that seventeenth- and early-eighteenth-century American Anglican iconography reveals a conception of God as "sovereign and interventionist," a view that "was something very different from the image of a gentle and benevolent deity often projected by later Anglicans" (217). By uncovering these meanings ascribed in religious history objects, a thoughtful exhibit can draw attention to the fact that religious beliefs, practices, and communities change over time, even as it situates visitors in a specific historical moment.

Sacred Spaces: Senses and Sensibilities in the Museum

But how can museum interpreters provide the necessary context to fully understand the intrinsic, extrinsic, and ascribed meanings of a religious history object within the confines of the exhibition format? As any curator knows, exhibit labels are not and should not be books on the wall. In her work on religious displays at the Horniman Museum in South London, Neysela Da Silva (2010, 185) acknowledges the need for interpretation, lest an object lose its ascribed meaning upon becoming a "museum object," but asserts that "lengthy documentation accompanying each artifact is not the best way forward in helping people understand religious pieces," as few visitors will suffer through dense or excessive exhibit texts. She calls instead for museums

to devise educational or interactive programs to provide dynamic context to visitors (186). Others have suggested that "recreating the original context of religious objects" through immersive environments, interpretive videos, or first-person interpretation methods (as practiced at living history museums; see Buggeln, this volume) might prove more engaging than an overreliance on written narratives (see Paine 2013, 108–109; Magelssen 2007, 37–38). Crispin Paine (2000, 157–158) praised the Lifetimes Gallery at Croydon's Clocktower Library in London for incorporating videos, oral history recordings, and computer interactives in a display it mounted in the late 1990s, noting that "because it focuses on the experience of individuals in Croydon, particularly over the last hundred years, it is the first social history museum in London to give proper attention to the place of religion in people's lives." Using a diverse array of immersive strategies (technological or otherwise) along with individual stories and memory seems to offer one potentially effective way to create a sense of history in an exhibit through the interpretation of religious objects.

These strategies have the added benefit of allowing curators to consider the nontextual and nonvisual aspects of religion and religious objects, evoking an experiential sense of history in an exhibit through sound, touch, smell, and even taste. Louis Nelson's (2007, 236) discussion of how all five senses "were equally powerful ways of knowing and shaping cultural experience" for early American Anglicans reminds us of the importance of engaging all of the human senses when interpreting religious history:

> The scent of cedar drew upon a variety of associations—both natural and biblical—to sense the sacred in the space of the church. The sound of the church bell inaugurated the sacred in time. The taste of wine and the touch of the chalice commingled God and communicant and invited the Church Militant and the Church Triumphant to partake together. As a result, sound, smell, taste, and touch were powerful agents of breaching the thin veil between the natural and supernatural worlds in the seventeenth and early eighteenth centuries.

While taste may prove challenging in a gallery (though perhaps not in the museum café), sound, touch, and smell all offer interesting sensory possibilities for curators seeking to reveal such lost meanings to visitors through an immersive, sensual experience. Rather than simply recreating the visual context in which the people of the past used a devotional object by reconstructing an altar or domestic space, curators might infuse the gallery with appropriate scents, play music or ambient sounds that evoke a particular time and place, and include reproduction objects or materials for visitors to touch.[1] In exhibits that present the history of more than one faith tradition, these sensorial elements can also provide an additional interpretive layer for exploring religious differences and commonalities—such as the use and meaning of sacred aromatics—which might otherwise go unnoticed.[2]

Blending sensual and narrative approaches thus offers an opportunity to create moments of productive surprise for visitors, particularly in comparative or thematic

exhibits. As Karen Chin (2010, 201) asserts in her article on educational programs at the Asian Civilizations Museum in Singapore, even the simple act of positioning a religious history object contextually with secular artifacts and devotional items from other faiths can give visitors a sense of just how interconnected yet diverse the people of the past were in their religious practices as well as their daily lives. Narrative interpretation and museum education programs that draw attention to these juxtapositions have the potential to reveal unexpected cultural confluences, to expose the roots of religious conflicts, or to look anew at the breathtaking variety of human spiritual life.

Similarly, comparative religious history exhibits that incorporate memory, especially through oral history recordings or written recollections, can help visitors immerse themselves in the individual, emotional experiences of both popular and official religion. In 2006, the Asian Civilizations Museum mounted a special exhibit on religious pilgrimages, which drew on the personal stories and collected objects of contemporary pilgrims from four different religions. Chin argues that not only were the artifacts in the exhibit "transformed by the personal narratives into important symbols of the pilgrimage," but the comparative and thematic nature of the exhibition itself "allowed our visitors to experience the common threads revealed by similar objects on display" (212). According to Chin, incorporating personal narratives also enabled visitors "to understand not just the intellectual, social, or cultural expression of religion but also the personal and emotional aspects" (213). This strategy lends itself just as well to historical exhibits. Indeed, the conceptual design that my team devised for the Jewish cultural museum proposed an interactive media table that would link three-dimensional images of museum objects, mainly artifacts that were too fragile to display in the gallery, with oral histories and family recollections about religious ceremonies as well as life at the turn of the twentieth century. In this way, we hoped to inspire visitors to discover new connections between the religious objects in the museum's collection and the world that the Jewish community created in the American West.

Conclusion

Featuring memory, sensory context, and individual stories in an exhibit reminds visitors and curators alike that the sensual, emotional, and spiritual world that shaped how historical actors interacted with and understood sacred objects in the past no longer exists. Whether official or private, religious customs, beliefs, and communities were never homogeneous, and they changed with time. While curators cannot recover these vanished worlds and worldviews completely, there are tools they can deploy to create a sense of history for museum visitors. Careful interpretation, sensitive displays, and personal stories can all help to reveal the deep meanings that inhere to—or have been ascribed to—religious history objects.

Notes

1. Mark O'Neill (1996, 192) has suggested the need for aural as well as additional visual context (in the form of flickering candlelight, for example) in recreated displays as well.
2. For example, where Nelson uncovers the sacred meaning of the scent of cedar for early American Anglicans, S. Brent Plate (2014, 93) reveals how the incense burned in Turkish mosques rendered the word of Allah "visible and fragrant" to worshippers (see also Paine 2013, 110).

References

Chin, Karen. 2010. "Seeing Religion with New Eyes at the Asian Civilisations Museum." *Material Religion* 6 (2): 192–216.

Da Silva, Neysela. 2010. "Religious Displays: An Observational Study with a Focus on the Horniman Museum." *Material Religion* 6 (2): 166–191.

Dudley, Sandra H. 2012. "Encountering a Chinese Horse: Engaging with the Thingness of Things." In *Museum Objects: Experiencing the Properties of Things*, edited by Sandra H. Dudley, 1–15. New York: Routledge.

Kahn, Miriam. 1995. "Heterotopic Dissonance in the Museum Representation of Pacific Island Cultures." *American Anthropologist* 97 (2): 324–338.

Kavanagh, Gaynor. 1996. "Making Histories, Making Memories." In *Making Histories in Museums*, edited by Gaynor Kavanagh, 1–14. London: Leicester University Press.

Knell, Simon J. 2012. "The Intangibility of Things," In *Museum Objects: Experiencing the Properties of Things*, edited by Sandra H. Dudley, 324–335. New York: Routledge.

Magelssen, Scott. 2007. *Living History Museums: Undoing History through Performance.* Lanham, MD: Scarecrow Press.

McMahon, Madeline. 2015. "Reflections on 'Treasured Possessions' and Material Culture." *JHIBlog*, August 10. http: //jhiblog.org/2015/08/10/reflections-on-treasured-possessions-and-material-culture/ (accessed September 30, 2015).

Nelson, Louis P. 2007. "Sensing the Sacred: Anglican Material Religion in Early South Carolina." *Winterthur Portfolio* 41 (4): 203–238.

O'Neill, Mark. 1996. "Making Histories of Religion." In *Making Histories in Museums*, edited by Gaynor Kavanagh, 188–199. London: Leicester University Press.

Paine, Crispin. 2000. "Religion in London's Museums." In *Godly Things: Museums, Objects and Religion*, edited by Crispin Paine, 151–170. London: Leicester University Press.

Paine, Crispin. 2013. *Religious Objects in Museums: Private Lives and Public Duties.* London: Bloomsbury.

Plate, S. Brent. 2014. *A History of Religion in 5½ Objects: Bringing the Spiritual to Its Senses.* Boston: Beacon Press.

7 Archaeological Displays: Ancient Objects, Current Beliefs

CHIARA ZUANNI

The topic of religious archaeological objects in museums is little explored and raises many challenges, not least the difficulty in defining such objects. It is beyond the scope of this chapter to enter into a discussion about the complexities of both terms—"archaeology" and "religion"—but the chapter adopts a broad perspective of both. As such, it will consider a wide range of objects: those belonging to religious traditions, which are displayed in archaeological galleries, and those recovered and studied by archaeologists, which are displayed in museums of religion. The aim of this chapter will be to assess the impact and embedding of religious motives in dealing with archaeological material, both from the professionals' and visitors' viewpoints.

As Timothy Insoll (2004, 22) noted, "[T]he archaeology of religion is complex, and, put simply, the material implications of the archaeology of religion are profound and can encompass all dimensions of material culture." Many archaeological objects in museums do effectively belong to religious contexts (e.g., temples, sacred precincts, and funerary contexts), which often proffered well-preserved objects, and the complexities of studying such artefacts are many and varied. For one, these contexts are often themselves touristic destinations (e.g., Egyptian, Greek, or Meso-American temples), and their monumentality influences public perceptions of their cults and ancient inhabitants. Second, objects which would today be considered part of everyday life and abstract from religion might have possessed religious connotations in the past. For example, Christina Riggs (2014, 15), in her examination of the religious implications of seemingly mundane ancient Egyptian artefacts, such as the linen used for wrapping mummies, highlighted the difficulty of "apprehend[ing] materiality as experienced *in* the ancient past, which is quite a different undertaking than understanding our experience *of* ancient materiality" (emphases in the original).

The removal of objects from their original contexts and their subsequent public display add a further layer of meaning and complexity. Lawrence E. Sullivan and Alison Edwards (2004, xiii) cite Charles H. Long's suggestion that a "resemblance between museums and religions is their ambivalence towards time." In museums, objects are simultaneously removed from the flow of time *and* recontextualized within a time period in order to be presented to visitors.

Until fairly recently, religious objects were included in historical narratives without much thought given to their original roles (Paine 2013, 3–4). Fortunately the rise

of post-processual[1] archaeologies and indigenous archaeology has highlighted the importance of respecting the beliefs of source communities and current believers. For example, the Native American Graves Protection and Repatriation Act (NAGPRA 1990) in the United States regulates the inventory, conservation, interpretation, and restitution of artefacts (and human remains) belonging to Native American populations. More recently, in 2006, the World Archaeological Congress adopted the Makau-Rau Accord that handles both human remains and sacred objects.

This brief chapter will consider archaeological objects belonging to past religions and to current religions, and will finally turn to funerary contexts since the debate (e.g., regarding current legislation and codes of ethics) on human remains is so closely linked to religious beliefs and practices. I will focus on changing definitions and attitudes toward religious objects, and their appropriations in the contexts of archaeological exhibitions, both by museum professionals and visitors.

Past Religions

In some cases, objects belong to a past civilization, whose religion is no longer practiced. Classical archaeology is one example of this, whereby religious artifacts from Classical contexts are often either presented thematically (e.g., in a "Greek religion" section) or chronologically (e.g., used to demonstrate the "evolution" of Greek civilization). Written sources can be used to interpret this material, such as in traditional displays of the Greek pantheon, but such artifacts and monuments are often valued more for their aesthetic qualities than for their original religious functions. Indeed, this might have been the case in the past (e.g., statues), while political motives may have equally influenced past perceptions of religious representations, such as the Athenian Parthenon frieze. Classical archaeology also provides examples of how an object's link with an ancient religion is not necessarily central to its contemporary display and interpretation. The "Elgin marbles" are a case in point; the ongoing dispute between Greece and the British Museum is based largely on issues of national identity rather than religion.

Another case is ancient Egypt, which still holds great fascination for the public (Brier 2013; MacDonald and Rice 2009). Its religion, particularly its funerary practices, plays a prominent role in this fascination, permeating public perceptions and popular cultural representations of Ancient Egypt. Manchester Museum offers an interesting example of this in the case of the "spinning statuette." This is a statuette of an Egyptian dignitary (Figure 7.1), originally located in a temple to remember the deceased and now housed in Manchester's Egypt Gallery, which "went viral" in an online video in 2013 when it was recorded spinning, seemingly of its own accord. Disseminated through social media and news websites, the video engendered numerous theories about how and why this statuette was moving—with many of the explanations revealing popular conceptions of ancient Egypt (Zuanni 2016). Many people, contributing their ideas via social media, reflected on the "power of the Egyptian gods," revealing a fascination—and, in some cases, belief—in this religion.

Figure 7.1 The "spinning" statuette, in the Manchester Museum, University of Manchester. Photo by Chiara Zuanni.

Indeed, a few commenters revealed that they belonged to ancient religions, or modern ones inspired by ancient Egyptian beliefs, such as the Thelemites. The idea of a curse was proposed by many, and attention was drawn to the inscription on the back of the statuette, which asks for a libation to the gods; suggestions were made, some in earnest and others in ridicule, to appease the statuette by following this rite.

These brief examples give evidence to what many have argued: that, despite the centuries—millennia even—separating their original users from contemporary viewers, these objects still have the power to prompt strong reactions. Some reactions may be based on knowledge (or pseudo-knowledge) of that ancient religion (Fowler 1977); others may shift from a religious interpretation to a focus on the object's aesthetic qualities or its role in a national identity; while still others may employ the object as a springboard to challenge the very idea of religion itself.

Current Religions

The display of archaeological objects belonging to religions that are still practiced—whether one of the big monotheisms or the religion of a minority group—raises a different set of issues. For example, in archaeology galleries, early Christian remains might be displayed in chronological order, adding to the picture of the period they belong to (Early Christian, Byzantine, Middle Ages, etc.), but not necessarily prioritizing their religious character; objects that were once venerated, protected in a church, may now be displayed in a way that does not clearly present religious functions or associations.

Similarly, religious objects can be drawn upon to highlight wider historic narratives. For example, one of the aims of the Egyptian Worlds gallery of the Manchester Museum was to emphasize the development of Egyptian history after the Roman period; the display therefore included some Coptic and Islamic material. However, during ethnographic interviews that I conducted (Zuanni 2016), only a few visitors to the gallery acknowledged the presence of these objects and recognized them as belonging to different religions and different periods of Egyptian history. In fact, one visitor remarked that it was "nice to see how Egypt was multicultural also back then," thus not distinguishing between the different periods of these faiths. Most other visitors did not comment on the Christian and Islamic artefacts, since they appeared to consider them as completely separate to the more ancient remains from the same area. Therefore, while Coptic textiles and a copy of the Qur'an might have been easier to recognize, they did not successfully communicate the passing of time in Egyptian history to a contemporary audience. Indeed, this example recalls the idea of ambivalence of time as pertinent to both religions and archaeological displays.

In other cases, where everyday objects bear religious iconographies, curators have to choose between emphasizing their symbolic meanings or their ancient functions. An example of this might be a mass display of Roman lamps bearing Christograms, displayed alongside other lamps with different decorations. Similarly, aesthetic values—eventually associated with an art historical perspective on some of these objects—might contribute to a de-prioritization of religious meanings: sculptured parts of an early Christian altar or ambo, for example, may be praised for their artistic features and displayed in sequence with other objects from the same period.

A different case is that of religious museums, where relics and ancient ritual objects are displayed on the edge between a sacred and an arts-historical perspective. St Mungo's Museum of Religious Life and Art is a well-known and oft-cited example of this. Richard Sandell (2007, 48), who described St. Mungo's as a museum that aims to foster a reciprocal understanding of different faiths, investigated visitors' understanding of the displays and experiences in the galleries. He noted that the museum encourages reflections on religious prejudices by producing exhibits that aim to challenge them. Another example of the religious museum is the Church museum, which may house objects found through archaeological excavations

(e.g., below the current flooring of the associated church); these could be displayed to demonstrate the long history of that religious community.

Objects belonging to non-Western cultures pose their own set of issues. For example, Tapati Guha-Thakurta has examined the presence of Indian religious objects in Western museums, discussing reconstructions of the context of sacred objects. Guha-Thakurta (2008, 180) highlights "the constant blurring of boundaries between the 'secular' and 'sacred' denominations of such ancient objects," which have to negotiate "the multiple demands of art, authenticity, and popular devotion, as they stand to embody both international goodwill and a contentious religious and cultural politics of nationhood." A similar multiplicity of boundaries is highlighted by Chantal Knowles, who discusses the multiple negotiations involved in the study and restoration of a Maori *waka* (canoe), which was not only an object but also a *taonga*, that is, an object associated with an ancestral identity (Knowles 2013).

Indeed, indigenous archaeologies have played a major role in recognizing the need for respecting, acknowledging, and curating sacred objects. Museums Australia has issued precise guidelines for working with such objects: *Continuous Cultures, Ongoing Responsibilities: Principles and Guidelines for Australian Museums Working with Aboriginal and Torres Strait Islander Cultural Heritage* (Museums Australia 2005; also see Chapter 15 in this volume). NAGPRA has set a standard in working with Native American human remains and cultural items and prompted wider literature discussing the interpretation of indigenous archaeological record. The World Archaeological Congress has also intervened on the question with a series of documents (*The Vermillion Accord on Human Remains* (1989); and *The Tamaki Makau-rau Accord on the Display of Human Remains and Sacred Objects* (2005); see also Fforde 2014). These developments have been substantially informed by postcolonialism and postmodernism, which in archaeology have influenced mostly post-processualist archaeologies, with their recognition of the need to respect other cultures' interpretations and the multiplicity of meanings. In the museum sector, these developments have also contributed to a series of repatriation policies both at a national level (by the government itself or national museum associations) and by individual museums.

The Question of Human Remains

Human remains have been a central part of many repatriation policies (e.g., Fforde, Hubert, and Turnbull 2002), but they have also been affected by the ethical debate concerning their treatment. In the United Kingdom, in 2004, the Human Tissue Act implied a revision of the treatment of human remains within the heritage sector as well as in hospitals: in 2005, the Department for Culture, Media, and Sport published its *Guidance for the Care of Human Remains in Museums*, which deals with de-accessioning, loans, claims for return, storage, conservation, collection management, display, access and educational use, and research on human remains. Consequently, museums have acknowledged these changes within their own

policies and have reflected on how to respectfully display these remains, with "sufficient explanatory material" (DCMS 2005) alerting visitors to the presence of these remains in the galleries (see also Chapter 11 in this volume).

The Manchester Museum has been at the forefront of these debates and, in 2008, two main episodes contributed to provoke a wide reaction in the press and among its visitors. First, as part of the consultations for the redisplay of the Egyptology gallery, three mummies were covered with the aim to highlight how these bodies needed to be exhibited sensitively and respectfully, and thus stimulate a discussion on the most appropriate way to display them in the Egypt Gallery (Exell 2013). Second, the temporary exhibition on the Lindow Man presented different perspectives on this bog body, including those of a neo-Pagan group (Honouring the Ancient Dead). The covering of the mummies and the recognition of a neo-Pagan group in an institutional space were harshly criticized by some members of the public, and Tiffany Jenkins (2011) accused the museum of an excess of political correctness.

However, while until the late 1980s druidic and neo-Pagan groups might have been labeled as "cult archaeologies" (e.g., Cole 1980), since the 1990s their interpretations of past sites and practices have been the object of academic research; Barbara Bender's (1998) work on Stonehenge is a case in point. Alongside issues surrounding the value of alternative interpretations and narratives of the past, neo-Pagan groups have also contributed to the debate on human remains, emphasizing the respect due to the dead, whom in some cases they consider as their ancestors, and thus arguing that their bodies should be removed from display and reburied (for more on the debate, see, e.g., Pearson, Schadla-Hall, Moshenska et al. 2011).

Briefly, human remains in museums raise many ethical questions concerning their treatment, their display, and the opportunity of their restitution to source communities. At the same time, the fascination they provoke also offers a gateway to ancient people, their funerary practices, and their beliefs, consequently shedding much light on ancient lives.

Conclusion

I have argued that archaeological religious objects in museums pose many challenges, stemming both from the history of the objects and their collections, and from past and current beliefs about these objects and their contexts. Postcolonial and postmodern movements have led to the recognition of past appropriations of indigenous objects by Western museums, and thus codes of ethics have regulated the restitution to descendant communities of sacred objects—acknowledging the different meaning of "sacred" in different cultures—and human remains.

However, in archaeological displays, religious objects are still often presented as part of chronological and/or thematic exhibits and their religious implications are often ignored or deprioritized, reflecting a less conspicuous presence of "religion," a

lacuna also evident in archaeological theory more generally (Insoll 2004). Additionally, as Coleman (2013, 156) suggests, our judgment and selection of interpretation is also influenced by

> a distinction between those religions that are perceived as traditional and as having a requisite historical connection with an archaeological site, and those religious beliefs that are considered to be invented, or reinvented, traditions. The concept of authenticity informs decisions in such cases but creates numerous inequities in our treatment of religious groups.

Consequently, certain interpretations are more accepted than others, both by curators—in approaching the displays—and visitors—in reacting to the same displays. In conclusion, archaeological religious objects in museums need to be carefully contextualized and presented, acknowledging the communities that might be affected by such displays, and maintaining an awareness of the displays' potential for appropriation by other groups.

Acknowledgment

I am grateful to Dr. Ceri Houlbrook and Dr. Konstantinos Arvanitis for her suggestions and comments on this chapter and to the Manchester Museum for having welcomed me in the galleries during the fieldwork.

Note

1. Post-processual archaeologies include a diverse (and debated) body of work. Here, I am referring to the impact of postcolonial ethics and politics on the interpretation of the archaeology of non-Western cultures (Shanks 2008) and to the acknowledgment of the multiplicity of meanings of the past and its artefacts. Thus, these developments led to the recognition of the agency of local communities and the respect for their traditional beliefs.

References

Bender, Barbara. 1998. *Stonehenge: Making Space*. Oxford: Berg.
Brier, Bob. 2013. *Egyptomania: Our Three Thousand Year Obsession with the Land of the Pharaohs*. New York: Palgrave Macmillan.
Cole, John R. 1980. "Cult Archaeology and Unscientific Method and Theory." *Advances in Archaeological Method and Theory* 3: 1–33.
Coleman, Elizabeth Burns. 2013. "Contesting Religious Claims over Archaeological Sites." In *Appropriating the Past: Philosophical Perspectives on the Practice of Archaeology*, edited by Geoffrey Scarre and Robin Coningham, 156–175. New York: Cambridge University Press.
Department for Culture, Media and Sport. 2005. *Guidance for the Care of Human Remains in Museums*. London: DCMS.

Exell, Karen. 2013. "Engaging with Egypt: Community Consultation and the Redevelopment of the Ancient Egypt Galleries at The Manchester Museum." In *Museums and Communities*, edited by Viv Golding and Wayne Modest, 130–142. London and New York: Bloomsbury.

Fforde, Cressida. 2014. "The Tamaki Makau-rau Accord on the Display of Human Remains and Sacred Objects." In *Encyclopaedia of Global Archaeology*, edited by Claire Smith, 7209–7213. New York: Springer.

Fforde, Cressida, Jane Hubert, and Paul Turnbull (eds.). 2002. *The Dead and Their Possessions: Repatriation in Principle, Policy and Practice*. New York: Routledge.

Fowler, Peter J. 1977. *Approaches to Archaeology*. London: A. and C. Black.

Guha-Thakurta, Tapati. 2008. "'Our Gods, Their Museums': The Contrary Careers of India's Art Objects." In *Spectacle and Display*, edited by Cherry Deborah and Cullen Fintan, 154–183. Malden, MA, and Oxford: Blackwell.

Insoll, Timothy. 2004. *Archaeology, Ritual, Religion*. London and New York: Routledge.

Jenkins, Tiffany. 2011. *Contesting Human Remains in Museum Collections*. New York: Routledge.

Knowles, Chantal. 2013. "Artifacts in Waiting: Altered Agency of Museum Objects." In *Reassembling the Collection: Ethnographic Museums and Indigenous Agency*, edited by Rodney Harrison, Sarah Byrne, Anne and Clarke, 229–257. Santa Fe, NM: School for Advanced Research Press.

MacDonald, Sally, and Michael Rice (eds.). 2009. *Consuming Ancient Egypt*. Walnut Creek, CA: Left Coast Press.

Museums Australia. 2005. *Continuous Cultures, Ongoing Responsibilities. Principles and Guidelines for Australian Museums Working with Aboriginal and Torres Strait Islander Cultural Heritage*. Available online at: http://www.nma.gov.au/__data/assets/pdf_file/0020/3296/ccor_final_feb_05.pdf (accessed on March 8, 2016).

Native American Graves Protection and Repatriation Act (NAGPRA). 1990. Public Law 101–601, 25 U.S.C. 3001–3013, November 16.

Paine, Crispin. 2013. *Religious Objects in Museums: Private Lives and Public Duties*. London: Bloomsbury.

Parker Pearson, M., T. Schadla-Hall, G. Moshenska, D. Sayer, M. Lapinoja, M. Pitts, King Arthur Pendragon, J. Elders, and A. Sutphin. 2011. "Forum: Resolving the Human Remains Crisis in British Archaeology." *Papers from the Institute of Archaeology*, 21: 6–34.

Riggs, Christina. 2014. *Unwrapping Ancient Egypt*. London: Bloomsbury.

Sandell, Richard. 2007. *Museums, Prejudice and the Reframing of Difference*. London: Routledge.

Shanks, Michael. 2008. "Post-Processual Archaeology and After." In *Handbook of Archaeological Theories*, edited by R. Alexander Bentley, Herbert D. G. Maschner, and Christopher Chippindale, 133–144. Lanham, MD: AltaMira Press.

Sullivan, Lawrence, and Alison Edwards (eds.). 2004. *Stewards of the Sacred*. Washington, DC: American Association of Museums in cooperation with the Center for the Study of World Religions, Harvard University.

World Archaeological Congress. 1989. *The Vermillion Accord on Human Remains*. Available online at: http://worldarch.org/code-of-ethics/ (accessed March 8, 2016).

Zuanni, Chiara. 2016. "Mediating the Past: Museums and Public Perceptions of Archaeology." The University of Manchester, unpublished PhD thesis.

8 Museums, Religious Objects, and the Flourishing Realm of the Supernatural in Modern Asia

DENIS BYRNE

This chapter extends outside the museum to consider how people in East and Southeast Asia relate to sacred objects in the context of contemporary popular religion. Except for those acquired archaeologically, the religious objects from Asia now residing in museums have been diverted from their usual circuits within living networks of devotion. Many were captured by Western explorers, antiquarians, and scholars in the course of their own circuits of travel in Asia (Byrne 2016). With few exceptions, once inside museums these objects are quarantined from the devotional practices of believers, and while this does not spell the demise of their efficacious supernatural power it has tended to mean they have become subject to active processes of discursive secularization. Their reputations for miraculous power and their lineal histories of empowerment tend either to be ignored in museum discourse or consigned in the past tense. Religious objects exist very uncomfortably in the secular rational theatre of modernity where objects are not supposed to "behave themselves as subjects," a realm where people are supposed to be in charge not just of themselves but also of the materiality in their lives (Pels 2010, 613).

The followers of popular religion in Thailand, China, and the space of the Chinese diaspora, the areas from which I draw my examples, have in common a conviction that the buildings and objects associated with the spirits and deities they worship are animated by miraculously efficacious supernatural power. "Associated" is perhaps too weak a word: they apprehend the materiality of these places and things to be continuous with the divinities they worship or placate. For these people, who number in the hundreds of millions, the places and objects in question are animated in a manner not incompatible with Jane Bennett's (2010) understanding of material vibrancy. The scholarly term "popular religion" will be used to describe the beliefs and practices of these devotees, thus distinguishing their worship from the tenets of institutional, text-based, orthodox religion. Popular religion entails a relationship to the material world that departs radically from that endorsed by modern ontologies of secular rationalism. An argument can be made that museums in Asia which exhibit religious objects should draw closer to their "public" by closing the gap between the space of the museum and the space of popular religious practice.

Magic in the Museum

Much of the materiality of popular religion is magical, a term encompassing the idea that objects such as statues, amulets, shrines, and sacred springs are numinous and efficacious, but also the idea that this efficacy can be transferred via contagion between human bodies and sacred objects and that it can be mobilized for human ends by the practice of magic. The term "numinous," meaning the embodied presence of spiritual power (Levy, Mageo, and Howard 1996, 13), is a key one here, as is "immanence," referring to the "within-ness" of divine force. The term "magic" covers those practices employed to access and manipulate this force.

The magical aspect of popular religion is flourishing in modern contemporary Asia, Africa, Latin America, and in parts of Europe and North America. It exists not merely alongside modernity but in concert with it. In East and Southeast Asia, rather than withering in the face of the various "miracles economies," popular religion and economic advancement appear to be mutually reinforcing (e.g., Goossaert and Palmer 2011; Jackson 1999). In the early twenty-first century, there is every indication that belief in the numinous quality of sacred objects and places—many of them included on the heritage inventories of Asia or housed in museums there—will continue to be perfectly compatible with late modernity (Meyer and Pels 2003). An understanding of the magical and the numinous is of key importance in appreciating the way followers of popular religion regard and interact with religious objects in museums.

The conventional secular-rational approach that underwrites the work of heritage management and museum curation is hopelessly inadequate to encompass old objects and places that in the eyes of religious devotees are alive with supernatural potency (Byrne 2014). What is called for are heritage and museum practices that are able to equitably accommodate both the secular-rationalist ontology of the museum visitor for whom a religious object is of antiquarian, aesthetic, and historical meaning and value and the magical-supernatural ontology of the visitor for whom the same object is a material embodiment of a divinity and thus an object of miraculous, efficacious potential. Acknowledgment should also be given to the likelihood that many visitors will be able to encompass both points of view simultaneously.

The Temple as a Museum

It would be mistaken to draw too strong a distinction between the museum and the temple in terms of the attention given to historical context and provenance. While temples primarily facilitate the worship of deities, via their statues and other material representations, worship is generally also informed by historical consciousness. There is consciousness of where the image has been and what it has done over its career. This can be seen in the case of Thai Buddhism. After Ayutthaya fell to the Burmese in 1767 a new capital was founded further down the Chao Praya River at Thonburi, later to become Bangkok. New temples were built for the capital and King Rama I, founder of the present dynasty, populated them with Buddha images

collected from temples dispersed across the kingdom, including hundreds from the ruins of temples in Ayutthaya (Wells 1975, 39). They functioned as symbolic capital, lending legitimacy to the new dynasty, but this was inseparable from their intrinsic divinity and efficacious power. Carried to the new capital in a spirit of piety, many of the images were already renowned for their miraculous efficacy. Their reputations would have preceded them and would certainly have been key in attracting worshippers. The new capital, in a sense, functioned as a museum for Buddha images in a way that is not dissimilar from the way village temples in Thailand function as repositories for Buddha images found intact or fragmentary in the fields and jungle (Figure 8.1)

The peripatetic history of the Emerald Buddha Jewel (*Pra Kaeo Morakot*), the palladium of the Thai state, now residing in a temple in the Royal Chapel in Bangkok, is central to its reputation for efficacy, a repute which acts as a magnet that draws hundreds of thousands of worshipers a year. For centuries the Emerald Buddha was coveted and fought over by princes and kings in mainland Southeast Asia, most recently being captured in Vientiane in 1778 by a Thai general and taken to Thonburi (Reynolds 1978). This history, intimately known to its worshippers, redounds to the object's fame and power. A secular museum visitor's interest in a Buddha image might also be piqued by its history, as conveyed, for example, on a label, but for a pious Buddhist this history exists not just in textual sources but as a sedimentation of magical power embodied in the material form of the object. This power speaks to the object's history as a divine agent as well as to the potentiality of its agency in the

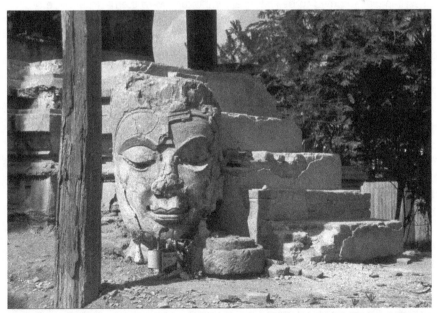

Figure 8.1 Head of a Buddha image at the ruins of a shrine at Lopburi, Thailand. Photo by Denis Byrne, 1989.

present. It is this power that tends to be effaced in the museum context, as Richard Davis (2015, 24) notes of the Sivapuram Somaskanda statue in the Norton Simon Museum in Pasadena, however much care may be given to displaying the object in a contemplative ambience evocative of a religious setting.

It would be mistaken to think that it is only in Western museums that religious objects from Asia undergo this kind of secularization. The modern nation-state in Asia has been waging a campaign against popular religion for well over a century. This "antisuperstition" movement (Goossaert 2006), founded on the notion that belief in the supernatural is an impediment to science and the development of modern economies, has profoundly shaped the field of heritage management in Asia (Byrne 2014). The modern museum in Asia has acted both as a collection of symbols of the national polity and as a secular space into which objects which have been worshipped by the "superstitious" can be quarantined from such attention.

During the Republican era in China (1912–49), thousands of temples were ransacked or destroyed by modernist reformers or were converted into offices and schools. In 1930, a teacher at a temple in Guangzhou, which was being used as a school, complained to the authorities that worshippers were causing disturbance there, whereupon the religious objects remaining in the temple were removed to a museum (Poon 2011, 74). Elsewhere in the city during the 1920s and 1930s numerous deity statues were removed from temples, re-designated as antiquities, and placed in museums (83–85). What was at play here was not simply the physical transfer of the objects into a secular space but a discursive makeover whereby they were transposed into a different meaning system, that of antiquarianism. In some cases, temples deemed to be historically important were themselves made over in this way. In the 1920s, China's Ministry of Interior forbade local governments to worship the deities Yue Fei and Guandi while also ordering certain of their shrines to be preserved. Rebecca Nedostup (2009, 264) observes of these latter temples that "their new preservation without ritual held out the prospect that they would survive only in a static museum-like state."

Performativity and Genealogy

In general, people will not waste their resources making offerings to images which fail to perform. News of the miraculous deeds of particular sacred images and sites were broadcast in premodern times by word of mouth, as is still the case today, except that the tabloid press, television, text messaging, Twitter, Facebook, and the Internet have vastly extended the reach of this form of news and the speed with which it travels. The propensity of the miraculous to spontaneously erupt means believers become acutely careful observers of religious sites and objects, whose supernatural efficacy tends to wax and wane and is difficult to predict (Chau 2006; Smith 2006). The situation in Asia seems broadly similar to that in medieval Christendom, where, as Mary Douglas (2002, 74–75) observes, "the possibility of a miracle was always

present; it did not necessarily depend on rite, it could be expected to erupt anywhere at any time in response to virtuous need or the demands of justice."

One commonly sees devotees making offerings to whole or fragmentary statues of the Buddha housed in temple museums in Thailand, which often simply take the form of covered outdoor spaces where old images (such as those referred to earlier) discovered by farmers in their fields or in the jungle are curated within the consecrated space of the temple compound. Any one of these objects has the eruptive potential to perform miraculous deeds for a devotee and thus to acquire new renown as divinely efficacious. The opportunities for such worship are absent or far more limited in state-run museums, but the principle stands that any sacralized image, however long it has been seemingly dormant or however sequestered its situation in a museum may be, is potentially efficacious.

The potential of sacred images to perform miracles is acquired via rites of sacralization or via a direct connection with a divine being (as in the case of a saint's relic) or an object of known supernatural potency. It is by the latter route that most of the sacred objects of Chinese popular religion are empowered. Newly painted or sculpted images of Chinese gods are based on a relatively stable template of the deity's physical appearance, but this is secondary in importance to their lineal "descent" from existing images of established repute. When newly made statues of a god are placed on the same altar as an old, famously empowered statue of the same god, divine potency is transmitted to the "offspring" image by means of the latter being in physical touch with the parent image. Similarly, in Thai Buddhism, statues of the Buddha are sacralized by linking them via sacred threads to older, famous images (Swearer 2004).

Offspring statues taken from the altar of a Chinese deity may become the agents by means of which a root temple establishes branch temples (see Lipten 1999). Branch temples are also "activated" by the transfer of ash from the root temple's incense urn to the urn of a new temple, the latter assuming a "divided incense" (*fenxiang*) relationship with the mother temple (208). A new deity image would be no more than an empty vessel without these lineal mechanisms of power transfer. While a follower of Chinese popular religion who encounters a deity image in a museum would be unlikely to know the details of its lineal descent, he or she would be likely to assume it possessed such a history as well as the magical potency which that history confers.

Sacred Images in Motion: The Goddess Mazu

Sacred images tend to have mobile careers, in a sense the transfer of such an image into a museum exemplifies this, except that the act of transfer normally terminates its career. The mobility of the images of Chinese gods consists not just in radiation, as described earlier, but in circulatory travel. The cult of the goddess Mazu provides a case in point. Born Lin Moniang in coastal Fujian around 960 ce, the goddess

Mazu, whose official title is Tian Hou, was locally renowned as a woman of spiritual power. Upon her death in 987 she ascended to heaven from Meizhou Island, Fujian, a few kilometers offshore from her home village. Soon legends spread about her miraculous deeds in protecting seamen caught in storms in the waters of the Taiwan Strait (Rubinstein 2003, 183). In the twelfth century she began to be worshipped as a god, attracting a great following initially in south coastal China and then further afield, including in Taiwan and Southeast Asia. A small number of Mazu temples in Taiwan claim to have direct lineal connections to the Meizhou mother temple in China, and they work to build their own networks of smaller Mazu temples radiating out around them in a mother-daughter relationship (185). Statues of the goddess, animated with her *ling* (efficacious power), travel out along these networks and pilgrims flow backward along them (Figure 8.2)

Among the more than 500 Mazu temples in Taiwan (in 1979), the most eminent are those able to show, through their temple chronicles and in other ways, that they received incense ash and a *shen-hsian* (a statue of the goddess in which she has an obvious manifest presence) from one of her origin temples in Fujian (193). With improved relations between Taiwan and the PRC over the past few decades it has been possible for Taiwanese temples to advertise their relationship with the Fujian temples by taking their *shen-hsiang* on pilgrimages back to them. The statues return to their own temples with their *ling* recharged. In turn, deities from mainland temples have toured Taiwan.

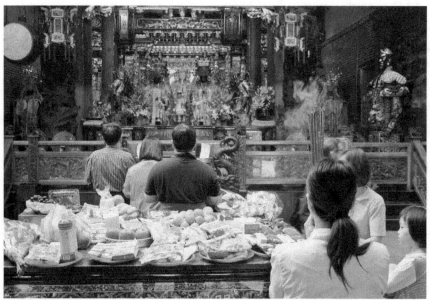

Figure 8.2 Worshipers at the Kuandu Mazu temple, near Taipei. Photo by Denis Byrne, 2010.

As Julius Bautista (2010) observes, sacred religious objects move because they are efficacious, and they are efficacious partly because they move. What he points to here is the importance of the equation of power and mobility in popular religion. The immobility of sacred images in museums reflects, perhaps, not so much a cessation of movement in space—after all, they may circulate between museums—as movement into a discursive space in which the image's agency in its own mobility will be denied. In popular practice is always understood that a statue of Mazu desires to revisit its mother temple. No such volition is credited to sacred images in museums.

Conclusions

With few exceptions, museum collections represent a dead-end street for religious objects. While devotees may visit them in custody, so to speak, and while very occasionally they are repatriated back into the religious realm, for the most part their active careers as sacra are over. Many of Asia's museums, particularly those located in former colonies, were founded or heavily influenced by Westerners steeped in the secular-rational principles of the Enlightenment. But in postcolonial Asia, as well as in modern China, Japan, and Thailand, the museum has been assigned a key role in modern state formation (Anderson 2006), a role closely articulated with state-sponsored anti-superstition campaigns designed to produce modern subjects (Byrne 2009). And yet everywhere in contemporary Asia there is evidence that these campaigns have failed. Popular belief in the magical-supernatural continues to thrive or is resurgent in the context of popular religion. Given this, now may be an appropriate time for museums to reexamine their role as agents of secularization and to admit a new relationship with religious devotees and deities.

At the least it should be made possible for devotees of a deity to make offerings to that deity's image where it is displayed in a museum. The gods and spirits of popular religion in Asia are not remote in their holiness. Devotees hope to benefit from a deity image's power but the deity and its image—the two being indivisible—are seen as needing the prayers, offerings, or other support of devotees in order to maximize their efficacy. In Overmyer's (2008, 177) words, gods, humans, and ghosts "are all connected by bonds of mutual influence and response."

But, of course, allowing devotee visitors to make offerings also effects a larger change. It breaks what I would call the circle of secularity that conventional secular rational museum practice inscribes around a sacred object. It signals to those who are not devotees that there is more to this object than meets the eye.

References

Anderson, Benedict. 2006. *Imagined Communities*, revised edition. London: Verso.
Bautista, Julius J. 2010. "Tracing the Centrality of Materials to Religious Belief in Southeast Asia." In *Asia Research Institute Working Paper Series No. 145*, National University of Singapore.

Bennett, Jane. 2010. *Vibrant Matter: A Political Ecology of Things*. Durham, NC: Duke University Press.

Byrne, Denis. 2009. "Archaeology and the Fortress of Rationality." In *Cosmopolitan Archaeologies*, edited by L. Meskell, 68–88. Durham, NC, and London: Duke University Press.

Byrne, Denis. 2014. *Counterheritage: Critical Perspectives on Heritage Conservation in Asia*. New York: Routledge.

Byrne, Denis. 2016. "The Problem with Looting: An Alternative View of Antiquities Trafficking in Southeast Asia." *Journal of Field Archaeology* 41(3): 344–354.

Chau, Adam Yuet. 2006. *Miraculous Response: Doing Popular Religion in Contemporary China*. Stanford: Stanford University Press.

Davis, Richard H. 2015. "What Do Indian Images Really Want? A Biographical Approach." In *Sacred Objects in Secular Spaces: Exhibiting Asian Religions in Museums*, edited by Bruce M. Sullivan, 9–25. London: Bloomsbury.

Douglas, Mary. 2002. *Purity and Danger: An Analysis of Concepts of Pollution and Taboo*. London and New York: Routledge.

Goossaert, Vincent. 2006. "1898: The Beginning of the End for Chinese Religion?" *Journal of Asian Studies* 65 (2): 307–337.

Goossaert, Vincent, and David A. Palmer. 2011. *The Religious Question in Modern China*. Chicago: University of Chicago Press.

Jackson, Peter. 1999. "The Enchanted Spirit of Thai Capitalism: The Cult of Luang Phor Khoon and the Post-Modernization of Thai Buddhism." *South East Asian Research* 7 (1): 5–60.

Levy, Robert I., Jeannette Marie Mageo, and Alan Howard. 1996. "Gods, Spirits, and History: A Theoretical Perspective." In *Spirits in the Culture, History and Mind*, edited by J. Mageo and A. Howard, 11–27. New York and London: Routledge.

Lipten, Joseph H. 1999. "Merit, Morality, and Money at the Taipei Palace of the Saintly Emperor," PhD thesis, Department of Anthropology, University of Virginia.

Meyer, Birgit, and Peter Pels (eds.). 2003. *Magic and Modernity: Interfaces of Revelation and Concealment*. Stanford: Stanford University Press.

Nedostup, Rebecca. 2009. *Superstitious Regimes: Religion and the Politics of Chinese Modernity*. Cambridge, MA: Harvard University Asia Center.

Overmyer, Daniel L. 2008. "Chinese Religious Traditions from 1900–2005: An Overview." In *Cambridge Companion to Modern Chinese Culture*, edited by Kam Louie, 171–197. Cambridge: Cambridge University Press.

Pels, Peter. 2010. "Magical Things: On Fetishes, Commodities, and Computers." In *The Oxford Handbook of Material Culture Studies*, edited by Dan Hicks and Mary C. Beaudry, 613–633. Oxford: Oxford University Press.

Poon, Shuk-Wah. 2011. *Negotiating Religion in Modern China: State and Common People in Guangzhou, 1900–1937*. Hong Kong: The Chinese University Press.

Reynolds, Frank E. 1978. "The Holy Emerald Jewel: Some Aspects of Buddhist Symbolism and Political Legitimation in Thailand and Laos." In *Religion and Legitimation of Power in Thailand, Laos, and Burma*, edited by Bardwell Smith, 175–193. Chambersburg, PA: Anima.

Rubinstein, Murray A. 2003. "'Medium/Massage' in Taiwan's Mazu-Cult Centers: Using Time, Space, and Word to Foster Island-Wide Spiritual Consciousness and

Local, Regional, and National Forms of Institutional Identity." In *Religion and the Formation of Taiwanese Identities*, edited by P. Hatz and M. Rubinstein, 180–218. New York: Palgrave Macmillan.

Smith, Steve A. 2006. "Talking Toads and Chinless Ghosts: The Politics of 'Superstitious' Rumours in the People's Republic of China, 1961–1965." *American Historical Review* 111 (2): 405–427.

Swearer, Donald. 2004. *Becoming the Buddha: The Ritual of Image Consecration in Thailand*. Princeton, NJ: Princeton University Press.

Wells, K. E. 1975. *Thai Buddhism, Its Rites and Activities*. First published 1939. Bangkok: Suriyabun.

Section III Responses to Objects, Museums, and Religion

9 Devotional Baggage

STEPH BERNS

Visitors bring many things to their museum experiences. They enter with their own agendas, needs, and preferences (Falk and Dierking 2012), which define their "entrance narratives" (Doering and Pekarik 1996) and shape their meaning-making strategies (Hooper-Greenhill 1999). They also carry *cultural baggage* loaded with intellectual, social, and religious tools (Scott 2007) that influence what they engage with and how they behave and think about the things they encounter (Esner 2001).

Baggage provides a useful metaphor. It not only refers to intangibles such as memories and perceptions, as implied earlier, but in its literal sense, it means tangible belongings that travel with us. However, visitor studies and evaluations tend to privilege cognitive tasks such as retention and meaning-making. Hence, any*thing* that comes with the visitor—be it an item of jewelry or a prayer book—is usually dismissed as the visitors' orbital debris.[1] Moreover, there is a "forgetness to things," particularly when those things are "unthinkingly ready-to-hand" (Hodder 2012, 48). Thus, staff, researchers, and even visitors may not intend to dismiss material baggage, but often they do.

A similar picture exists within tourism studies, where things such as souvenirs are frequently considered as "little more than the traveler's extended baggage" (Lury 1997, 77). However, as Celia Lury argues, tourists and things are mutually implicated in tourist practices and destination decisions. Actor-network theory (see Latour 2005) also recognizes the agency of things. Its principle of "generalized symmetry" holds that nonhuman elements possess forms of agency that enable them to act upon humans and other things. As such, agency is not an exclusively human process. Instead agency is enabled by heterogeneous networks made up of both human and nonhuman entities. And so, like the tourism networks described by Lury, both people and things have a role in every action. These ideas are gradually finding their way into museum and religious studies, with research on embodied and tactile visitor-object engagements (see Dudley 2013; and Paine 2013), which challenge misconceptions that museums are hands-off and devotion-free.

In this brief chapter I draw on this materially minded research and introduce the concept of *devotional baggage.* Devotional baggage describes things visitors bring to museums that hold religious value and, in keeping with the heterogeneity of the actor-network approach, this baggage includes material objects along with their associated rituals, beliefs, protocols, and (mediated) sacred beings. Some of these

things are brought specifically, while others come along as part of the visitors' usual attire. Once in the museum, these things have the potential to transform the visitor experience in ways that are physical, religious, social, and emotional. In addition, devotional baggage makes visitors' religious practices visible, leading other visitors and staff to notice and, occasionally, respond to their presence.

In fact it was the visibility of things that brought visitors' object-orientated devotional practices to my attention during my doctoral research at the British Museum, London (2010–13). There I questioned visitors about the objects they brought and observed what they touched, who witnessed them, and how they were described, managed, and challenged.[2] Through my examination of these things, I identified three overlapping themes that I will cover in this chapter. First, I attend to the things that visitors brought to bless and take away. Second, I look to the things that visitors left as offerings; and third, I address the nature of bringing devotional baggage to public museums from the perspective of those who practice and witness these material rituals.

Objects to Bless

Certain things possess the power to spread their sacred aura to other objects and places through a process of contamination (Belk, Wallendorf, and Sherry 1989). Relics possess this ability, which explains why visitors to the British Museum's 2011 exhibition *Treasures of Heaven: Saints, Relics and Devotion in Medieval Europe* were seen venerating the exhibits and blessing items they owned (see Berns 2016). One such visitor was Charlotte (Catholic, twenties) who brought along a small plastic sleeve containing a red thread. This thread, according to its label, had touched a bone belonging to Saint Thérèse. This was Charlotte's relic. She explained:

> There's something quite special about taking a relic that you already own and touching it because I think the belief is that by touching that object to those relics . . . it absorbs something of the sacred nature of that item . . . [and] becomes part of your personal devotion.

Similarly, Matthew (Catholic, fourteen years old) described his wooden cross as a "spiritual camera" as it allowed him to capture and retain the relics' sacred aura. "It's like you come away with something from that exhibition that is real," his mother added. Thus, as "contact relics" to be used in future devotional interactions, these blessed belongings provided the visitors with the material and spiritual means to reconnect with the saints and the various places of contamination, be they churches, pilgrimage sites, or other museums. Holding their possessions also provided these visitors with a form of physical contact with the saints as both the exhibited objects and the visitors' belongings mediated the same sacred beings. Henceforth, devotional baggage tends to gravitate to things that share properties. These thing-thing relationships then draw in humans (Hodder 2012). In other words, the relationships

between things drive what to visit, what to avoid, how to act, and who and what to involve. Thus, every action performed by the visitor is partly enabled and partly constrained by the things displayed and the things in hand.

This process of sacred contamination was made possible by the open-ended nature of the relics' ritual networks. However, the museum setting is different to most established places of worship and so modification is usually required. For instance, in order to make her silent intercession, Charlotte moved slowly through the galleries to find the space to place her hand on the display cases. "I would feel daft just rushing round," she said. I also saw Matthew kneel before cases with his cross pressed upon the glass. These brought-in objects were, therefore, key determinants in defining their owners' route, pace, and interactions. Though the museum lacked many of the things that these devotees would find in places of worship, such as kneeling cushions, bringing along devotional baggage helped to address these gaps by (partially) reassembling familiar ritual environments. This was also evident in the galleries displaying Buddhist statues, where I observed visitors listening to their personal music devices while meditating.

At the same exhibition, Andros (Greek Orthodox, thirties) held a plastic carrier bag against various cases containing the relics of saints. The bag, I later discovered, contained books bought in the museum that day, including a postcard for his father in Greece. Usually visitors purchase souvenirs after their exhibition visit, as the shop is located at or after the exit (Figure 9.1). Yet, in order for commodities to become imbued with blessings, they must leave the shop (Starrett 1995). Hence, Andros

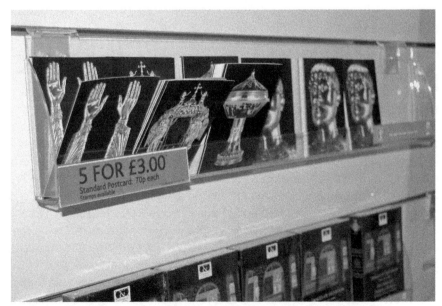

Figure 9.1 Postcards from the *Treasures of Heaven* exhibition shop. Photo by Steph Berns.

reentered the exhibition (through its one-way exit) to imbue his purchases with blessings as he would on pilgrimage.

Catholic and Orthodox Christians were not the only visitors to bring things to transform. Students from a local school of shamanic homeopathy brought with them glass vials of alcohol to create remedies through energy-channeling techniques. The course draws on Eastern medicine, herbalism, homeopathy, and shamanic healing, among other practices. I first saw the students meditating at the *Treasures of Heaven* exhibition and in the permanent Egyptian galleries. However, only after speaking to Carrie, a student, did I learn about the vials. Taking a small corked bottle from her pocket, Carrie explained:

> I channel the energy from a particular object into a remedy bottle. In this case I use liquid . . . It's like you're opening a portal. We're creating a link so the remedy becomes linked to that object. When someone takes it, [they are] able to access that link.

The energy-imbued alcohol, therefore, operated in a similar way to Andros's postcard. As mediators, they allowed third parties to access the spiritual power of the exhibited objects beyond the museum.[3]

The visitors' baggage was determined, to a large extent, by their owners past experiences. Hence, those who were accustomed to veneration, pilgrimage, or channeling were more likely to bring objects to perform these practices. The visitors' belongings were bonded in shared religious networks, which included the museum exhibits and sacred/spiritual beings, that ultimately, drew them together.

Objects to Leave

Devotional baggage may also be left in the museum as offerings to honor and appease sacred beings or in exchange for blessings and favors. For example, at the Smithsonian's National Museum of African Art, in Washington DC, staff observed and encouraged visitors to leave offerings at a reconstructed Beninese shrine. According to curator Christine Kreamer, the objects left (which included a hairbrush and bracelet charms) showed that visitors were interacting with the reconstruction "*as if* it were a functioning, dedicated altar" (Luthern 2009; emphasis added). Mary Nooter Roberts (1994) reported similar offerings at a 1993 exhibition at the Museum for African Art, New York, where visitors left coins on Afro-Atlantic altars made by "artists of faith" and by the museum staff (see Chapter 5 in this volume). However, unlike Kreamer, Roberts did not negate the authenticity and sacrality of the museum-made altars. On the contrary, she proposed that the different altars were brought "alive" by visitors' material contributions irrespective of their maker. In other words, both types of altar invited devotional responses and both were duly transformed by the visitor-brought objects.

However, offerings can pose conservation and health issues for exhibits, particularly if, like fruit, they rot and attract insects. Because of this, at Brighton Museum and

Art Gallery, staff incorporated a donations box into its Hindu shrine exhibit to enable local Hindus to "use and view [the shrine] as sacred" (Parker 2004, 68). Similarly, at the Manchester Museum, a donation box was added to a display of the "Lindow Man a Bog Body Mystery" exhibition (Lindow Manchester 2014), which attracted coins, gold rings, and the odd sweet wrapper. Thus, instead of prohibiting the making of offerings because of their potential risks, these museums provided conservation-friendly ways to facilitate and redirect the rituals. Consequently, the museums became caretakers and gatekeepers to the donated objects, which legitimized the offerings and their associated devotional practices.

Examining how museums manage offerings helps to reveal the ways in which institutions contend with religious practices. Museums that remove offerings or prevent visitors from leaving objects erase all material evidence of such acts. This erasure may be on conservation grounds, but also because some staff (and visitors) view the museum as secular and the objects as historical and divorced from religious practices. In such museums, left offerings are—to take Mary Douglas's (2003, 50) definition of dirt—out of place and destructive to the museum's "existing patterns of order" (117). This appeared the case at the Victoria and Albert Museum (V&A), when, in 2000, several staff members disapproved of a temporary altar installed in front of a Bodhisattva statue, which invited visitors to gift (provided) paper flowers (Open University 2014). The reason for the staff's response is suggested in a later report in which one of the V&A's Asia curators asserted that the V&A was primarily an art museum and not a place to worship (Nightingale and Greene 2010). These material practices thereby expose where the protocols associated with the visitors' objects conflict with the museum's codes of conduct. In places where offerings are deemed inappropriate, staff assert their power with "do not touch" signs and barriers. Visitors may also abstain from leaving offerings as they adhere to the view that museums are devotion-free. Whatever the reasoning for erasing or refraining, when no traces of devotional acts remain, their absence perpetuates the view that the exhibits are no longer part of ongoing religious practices.

Being Seen

Brought-objects give devotional acts material form, meaning that those who witness them *in action* are more likely to construe what they see as religious. For example, at the British Museum's 2012 exhibition *Hajj: Journey to the Heart of Islam*, a number of my interviewees assumed that the exhibition held religious importance to Muslims on account of the increased presence of niqab- and thobe-wearing visitors. Similarly, in Christiane Gruber's (2015) research at the Martyr's Museum in Tehran, she describes the affecting scene of male visitors holding rosaries as they silently sobbed. Hence, the prayer beads made the men's intangible prayers perceptible to others.

At *Treasures of Heaven*, Margarit (Russian Orthodox, thirties) was very conscious of her visible presence in the public galleries as she stood at the side of a case containing a relic of Christ. Margarit came to the exhibition on a number of occasions

to venerate the relic, sometimes for over half an hour. Each time she brought her small prayer book, which she held closed, usually with her eyes downcast. Though accustomed to venerating, Margarit felt uncomfortable in the Museum. "It's definitely difficult," she told me.

> People come by, they wonder "What is she reading?," "I wonder why she's standing there so long," so you feel distracted . . . We try to stand somewhere on the side, but still, obviously, you want to see the image of the Lord.

Aware that her behavior may invite unwarranted attention, she toned down her embodied ritual and refrained from genuflecting. Margarit regarded her physical and devotional interactions not only as potentially obstructing, but as out of keeping with the perceived social norms of the museum.

Margarit was not the only one to perceive the performance of religious rituals as subversive. This was also the view of Philip Fisher (1997, 11), author of *Making and Effacing Art*: "It would be an act of madness to enter a museum, and kneel down before a painting of the Virgin to pray for a soldier missing in battle, lighting a candle and leaving an offering on the floor near the picture." Anise, a Russian Orthodox visitor (twenties), was very aware of this viewpoint, saying, "You can't do things which you would normally be allowed to do in a church . . . Here people will think that you are mad." Such perceptions, again, perpetuate a normative visitor experience that is cognitive and disembodied. These assumptions not only affect those who witness such acts but, as seen with Anise and Margarit, prevent and alter the ways devotees conduct religious performances.

Margarit and her prayer book also attracted the attention of visitor Sally (Christian, fifties). "She has a book with her," Sally observed, "but she's not reading. She's not even looking at the [exhibited] object." Clearly alarmed by what she felt was "disconcerting" behavior, Sally exclaimed that they were in "a museum, not a church!" Negative responses to devotional acts performed by visitors are often attributed to the common perception that museum objects are decontextualized artefacts and are therefore inert. Yet, this view affords museums too much power. Museum objects are not silenced like "tools no longer in use" (Fisher 1997, 19). Nor can institutions (or visitors) prevent devotional baggage from entering their buildings. Rather, exhibited objects continue to communicate and invite responses from those who are accustomed and attuned to their calls.

These calls to action include the rare occasions when religious (or religion-related) exhibits propel visitors to bring objects to attack. Such was the case in 2015 when Islamic State militants took sledgehammers to what they perceived as idolatrous statues in Syria's Mosul museum. Being seen (and videoed) with their sledgehammers was central to their act of propagandist iconoclasm. Despite the rarity of such incidences, the threat of deliberate or accidental damage has led some museums to restrict what visitors can take in, thus affecting all forms of baggage-carrying behavior.

Observers may also perceive religious acts as the work of novice visitors who fail to differentiate objects in museums from those in places of worship. Mark

Elliot (2006, 71) found this at The Indian Museum, Kolkata, where staff concluded that visitors who smeared vermillion paste on Hindu statues were not sufficiently "museum-minded." Such views underestimate how the pivotal role habituated religious practices outside of the museum shape encounters inside the museum.

Finally, some visitors encourage the bringing of devotional baggage in order to communicate their religious agenda. For example, on most Saturdays, tour groups of Jehovah's Witnesses come to the British Museum to visit archaeological artefacts that relate to places, people, and events mentioned in the Old and New Testaments. In addition to wearing badges with a space to name their congregation, some tours encourage attendees to bring along their Bibles for collective readings. Holding Bibles both unites the groups and differentiates the tours from other visitors (Figure 9.2). Central to this is the Bible's portability, as one guide explained: "The Bible can be read in any place. It can be read in any circumstance." Thus, bringing their Bibles not only demonstrates the groups' faith in the scripture over all other (secular) interpretations, it also provides a sense of continuity with their doctrinal studies and missionary work.

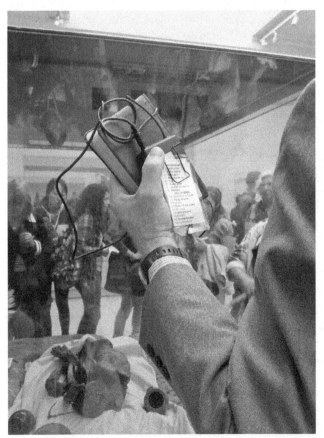

Figure 9.2 A Witness' guide holding his Bible. Photo by Steph Berns.

In other words, their belongings provide a sense of belonging that frames their shared museum experience.

Conclusion

Examining the role of religion in museum visitor-object encounters necessitates an approach that challenges the centrality of the human participants and acknowledges the agency of nonhuman things. In this chapter I have illustrated how brought-in things reduce the agency of museum visitors. Yet, more than this, devotional baggage decreases the agency of museum staff. Unlike the exhibited objects, brought-in things are not selected by curators. Rather, it is the visitors' prior ritual experiences with objects that prevail. And so, these visitor-object relationships make it possible to resist the attempts of museum staff to frame religious objects in ways that devotees consider alien to their more established religious habits.

Thus, on the one hand, visitor-object engagements involve elements of uncertainty, given the distinctiveness of the museum setting. On the other hand, there is continuity as the visitors, their belongings, and the exhibits are already enmeshed within networks of devotional practice over which museums have little power. That said, as curators choose what artefacts and topics are displayed, they too influence who and *what* comes to the museum. However, as Bruno Latour (2005, 237) asserts, it is counterintuitive to distinguish "what comes from the object" and what comes from the human participant. Focus should, instead, remain on what they do.

Notes

1. Visitors' smartphones and tablets feature in a growing number of studies thanks to their capacity to host museum content (see museumsandtheweb.com).
2. This research was conducted as part of an AHRC collaborative doctorate. To maintain the anonymity of my interviewees, pseudonyms are used throughout.
3. Visitors also photographed sacred exhibits on their smartphones to share with their online social networks.

References

Belk, Russell, Melanie Wallendorf, and John F. Sherry. 1989. "The Sacred and the Profane in Consumer Behavior: Theodicy on the Odyssey." *Journal of Consumer Research* 16 (1): 1–38.

Berns, Steph. 2016. "Considering the Glass Case: Material Encounters between Museums, Visitors and Religious Objects." *Journal of Material Culture* 21 (2): 153–168.

Doering, Zahava, and Andrew Pekarik. 1996. "Questioning the Entrance Narrative." *The Journal of Museum Education* 21 (3): 20–23.

Douglas, Mary. 2003. *Purity and Danger: An Analysis of Concepts of Pollution and Taboo*. New York: Routledge.

Dudley, Sandra. 2013. *Museum Materialities: Objects, Engagements, Interpretations*. New York: Routledge.

Elliott, Mark. 2006. "Side Effects: Looking, Touching, and Interacting in the Indian Museum, Kolkata." *Journal of Museum Ethnography* 18: 63–75.

Esner, Rachel. 2001. "In the Eye of the Beholder: On Cultural Contexts and Art Interpretation." *Journal of Museum Education* 26 (2): 14–16.

Falk, John, and Lynn Dierking. 2012. *Museum Experience Revisited*. Walnut Creek, CA: Left Coast Press.

Fisher, Philip. 1997. *Making and Effacing Art: Modern American Art in a Culture of Museums*. Cambridge, MA: Harvard University Press.

Gruber, Christiane. 2015. "The Martyrs' Museum in Tehran: Visualizing Memory in Post-Revolutionary Iran." *Visual Anthropology* 25 (1–2): 68–97.

Hodder, Ian. 2012. *Entangled: An Archaeology of the Relationships between Humans and Things*. Malden, MA: Wiley-Blackwell.

Hooper-Greenhill, Eilean (ed.). 1999. *The Educational Role of the Museum*, second edition. London: Routledge.

Latour, Bruno. 2005. *Reassembling the Social: An Introduction to Actor-Network-Theory*. Oxford: Oxford University Press.

Lindow Manchester. 2014. "Offerings in the Lindow Man Exhibition." *Lindow Manchester*. August 7. https: //lindowmanchester.wordpress.com/2014/08/07/offerings-in-the-lindow-man-exhibition/.

Lury, Celia. 1997. "The Objects of Travel." In *Touring Cultures: Transformations of Travel and Theory*, edited by Chris Rojek and John Urry, 75–95. London: Routledge.

Luthern, Ashley. 2009. "Make an Offering to Mami Wata before Time Runs Out." *Smithsonian*. July 21. http: //www.smithsonianmag.com/smithsonian-institution/make-an-offering-to-mami-wata-before-time-runs-out-12443424/.

Nightingale, Eithne, and Marilyn Greene. 2010. "Religion and Material Culture at the Victoria Albert Museum of Art and Design: The Perspectives of Diverse Faith Communities." *Material Religion: The Journal of Objects, Art and Belief* 6 (2): 218–235.

The Open University. 2014. Religion Today: Themes and Issues. OU.

Paine, Crispin. 2013. *Religious Objects in Museums: Private Lives and Public Duties*. London: Bloomsbury.

Parker, Toni. 2004. "A Hindu Shrine at Brighton Museum." *Journal of Museum Ethnography* 16: 64–68.

Roberts, Mary Nooter. 1994. "Does an Object Have a Life?" In *Exhibition-ism: Museums and African Art*, edited by Susan Mullin Vogel, Chris Müller, and Mary Nooter Roberts, 37–56. New York: Museum for African Art.

Scott, Monique. 2007. *Rethinking Evolution in the Museum: Envisioning African Origins*. London: Routledge.

Starrett, Gregory. 1995. "The Political Economy of Religious Commodities in Cairo." *American Anthropologist* 97 (1): 51–68.

10 Transactional and Experiential Responses to Religious Objects

GRAHAM HOWES

Religious art objects have long been perceived as an integral component of most of Europe's major national collections. Although their precise provenance was often complex and immensely varied—deriving from diplomatic trade-offs, the spoils of war, revolution, and colonial expansion, defunct or pillaged religious institutions, and the Grand Tour trophies of wealthy individuals—the motivation for their acquisition and public display was relatively unequivocal. This was to embody and reinforce a presumed, symbiotic relationship between religion and nationhood and Church and State, and to provide visual testimony and legitimation for both the supposedly Christian roots of national identity and for Christianity's continuing cultural presence.

Indeed even in an overtly "secularizing" post-Enlightenment and post-Revolutionary France, *l'art sacré* remained a continuing and specific category of exhibit both in the Louvre and in many major provincial art galleries. In England's National Gallery—partly founded in 1824 so that its art "might serve as a perpetual teacher of Good" (Hamlyn 1993, 9)—the official rationale for exhibiting "Scriptural Subjects" was even more explicit. For such art was firmly located at the top end of a formal hierarchy—running from "popular" to "High" art—acknowledged by artists, critics, and public alike. There was strong consensus as to what the functions of such High art should be: it should serve essentially "religious" ends, reinforcing and echoing belief, and appealing, in the Victorian painter Etty's words, "to those deep, mysterious and inward feelings of our nature which all must own, but no-one can define" (Select Committee 1845, 204). It was also perceived as having a more overtly "political" role. Many Victorian artists, clergy, and politicians were not alone in presuming that public exposure to "Scriptural Subjects," whether in galleries or through cheap prints, might effectively defuse serious working-class radicalism. This notion of religious art's potential role as an effective instrument of social control was, one suspects, at least as widely endorsed by many Victorians as Ruskin's more celebrated dictum that "Beauty is God's handwriting."

Fast-forward to the end of the twentieth century and such paternalistic presumptions concerning the public and private role of religious art in museums are barely intelligible, even nonexistent. The reasons are relatively clear. One is the exponential impact of secularization—definable here as the process whereby religious beliefs, practices, and institutions lose social significance—on public responses to

religious art objects, in whatever medium, whether inside or outside the museum. Secularization (however defined) generates three powerful and identifiable consequences for the contemporary apprehension of religious art objects. One is the declining power and efficacy of traditional religious symbolism. At its most mundane the process has involved the willful appropriation of sacred symbols by secular institutions, not least the advertising and fashion industries, and their apparent desacralization to serve material rather than spiritual ends. The second consequence, at a rather deeper level, is a reduction in the spiritual voltage of traditional religious symbolism to the extent that such symbols can no longer function—à la Durkheim— to bind people together within a collective belief system. Put differently, are such symbols still able, in whatever setting, to stir what David Brown (1999, iv) has called "the religious imagination"? Or even residual folk memory? Or must they be abandoned in favor of other, newer, sets of symbols? Or is it already too late, in that Christian iconography, for example, is *already* experienced by a significant majority of Europeans as a dead language, like Sanskrit or ancient Egyptian hieroglyphics, rather than as part of a living religious tradition? A third consequence of secularization for religious art objects is even more profound, and its roots go even further back. It springs from a—perhaps *the*?—theological problem that has perpetually challenged religious art. It is the expression of the invisible reality by the visible. How, in stone and on walls and on wood, can we now discern an identifiably religious subtext?

A more recent and equally powerful constraint on religious art objects generating identifiably religious sentiments in the viewer is a so-called post-modern culture where religious consciousness—indeed *all* consciousness—is often so highly fractured and diffuse. One outcome is the contemporary paradox of a highly visual culture in which religious imagery has itself become increasingly invisible. Such a paradox may, of course, be a symptom of postmodernity itself, one of whose features is a so-called crisis in representation whereby we no longer view artistic forms as a repository of perceptual customs shared by the artist and ourselves. This is not only because of the current critical tendency—which has also had its impact on theology—to view the form and content of a work of art as essentially structured by its readers and perceivers. It is also because, as James Martin (1990, 192) has put it, "all the frameworks of narrative description employed in the history and interpretation of both art and religion as well as all previous identifications of beauty and holiness as categories of interpretation . . . are dissolved in the acids of modernity."

We may indeed be witnessing what Arthur Danto (1986, 25), following Hegel, has called "the philosophical disenfranchisement of art" and in which therefore "religious art has no presence and no function."). Yet surely Danto's judgment on such art (presumably past *and* present?) is both too self-consciously aphoristic to be persuasive, and also woefully short on firm supporting evidence? This is unsurprising, for within contemporary Western culture, comparatively little is known—not least empirically— about the responses of believers and unbelievers alike to religious artwork, whether in church, temple, mosque, or gallery. What kind of "transaction" takes place, and can

we ever pinpoint the interstices of "religious" and "aesthetic" experience, or discover how deep-laid, personal, and complex such a process can be for any visitor?

Seeing Salvation at the National Gallery, London: A Case Study

Back in 2000 a major research opportunity presented itself. In that year, the National Gallery staged a major exhibition called *Seeing Salvation: The Image of Christ*. It aimed to show how the figure of Christ had been represented in the Western tradition, and to explore the power of the religious image within that tradition. It also sought, as the catalogue put it, "to demonstrate that modern secular audiences can engage with the masterpieces of Christian art at an emotional as well as a purely aesthetic or historical level" (Finaldi 2000, 7). The exhibition was phenomenally successful, averaging over five thousand visitors per day over four and a half months, and breaking box office records for any British art exhibition of the previous two decades. Unsurprising therefore that as a sociologist with an interest in religious aesthetics I should want to explore the apparent paradox of the success of such an exhibition in a society then recently described by the French academic René Rémond (1999, 74) as "one of the most secular in Europe."

To do so, I drew upon four sources of information: (1) interviews with individuals immediately after they had seen the exhibition; (2) the findings of a market research enquiry commissioned by the gallery into visitor responses to the exhibition itself; (3) interviews conducted by a graduate student colleague with most of the major art critics who covered the show; (4) 327 personal letters of appreciation and denigration sent to the gallery's director by individuals following their visit. From these four sources I was able to identify two distinct, yet often interconnected modes of response to the exhibition (cf. Howes 2007; Davie 2003; Paine 2013). These I categorized as the *transactional* and the *experiential*. The former identified some of the more generalized educational and social outcomes recorded in the data, while the latter pressed closer to the personal experience of individuals. Both "voices" are clearly audible in quotations that follow.

Transactional Responses

Four differing kinds of transactional responses were readily identifiable. The first can be described as *cognitive*. For example, "I knew that I was somewhere special," or "It was a most enlightening and moving experience," or again, "I had seen *Seeing Salvation* as heritage, albeit a shared religious heritage, rather than a locus of vital religious experience."

The second kind of perceived transaction was more overtly *didactic*, where visitors often saw the exhibition as essentially a learning experience, and one where they could readily link form to function in religious art. For example, "I realized that this was part of my religious heritage. Indeed it took me back to my schooldays," or "Here were well-loved paintings presented in a new light as aids to devotion besides being

great works of art. Hidden meanings, often lost to the modern viewer are revealed to increase understanding."

The third type of personal transaction is best described as *iconographic*, in that it attests to the power of images per se. "These are images that teach the Faith," one viewer firmly asserted, while another reflected, far less unequivocally, that "although I am not a practicing Christian, I was moved to tears by many of the images." For others it was an opportunity to articulate a more overtly agnostic stance on the historical veracity of the Christ image ("How do we know he had a beard?") or to comment, very acutely, that "although Christian iconography is a vocabulary or language with which we are now unfamiliar, the central question is how we have formed this image, and how this image has formed us over two thousand years?" This, as Burch Brown (1989, 87) reminds us still remains a crucial, even central, question at the heart of theological aesthetics.

The final type of transaction suggested by the collected data is less complex psychologically than the preceding three. It can best be described as *credal* in the sense of seeing the exhibition as affirming and legitimating Christian belief and identity in general as well as a kind of personalized Christology in particular. Here is one typical example: "I'm one of those large numbers of people who perhaps feel that Christianity is unfashionable, neglected by the media and unacceptable as part of national cultural life. We were grateful for this exception to the rule." Or another who wrote to the director: "It made for some of the most effective religious broadcasting that I have seen." And a third, who surmised, "Art drew people to God once—perhaps it could do so again?" Not everybody took this position. One of those interviewed remarked that although the exhibition clearly articulated such doctrines as the Incarnation and Immaculate Conception, as far as he was concerned, "I find what seems to be a requirement to believe in these and other points of dogma an irksome imposition." Another was even more robust: "Frankly, I found the show yawn-inducing . . . *Seeing Salvation* makes you feel like Christianity itself needs a bit of saving."

Experiential Responses

The same research data yielded not only (as we have seen) an identifiable set of transactions between viewers, exhibition subjects, settings, and the religious objects themselves. It also pointed to a wide spectrum of richly variegated visitor experiences, and in language which was often overtly personal and emotive. For example, "The exhibition blew one's mind with such thought and feeling, quite inexpressible in words. And strangely, I felt other people were expressing something quite unique . . . There was a quietness, a silence, a hush, as if the pictures and the artefacts exerted a powerful hold on the visitors." Or again, "The space was jammed with people, but all with a sense of the contemplative, allowing the works gathered to speak in many diverse ways to those before them. This was particularly special and very rare . . . to have a truly meaningful spiritual experience in a very crowded art gallery, I mean." And finally, "It was like going into a cathedral, and the atmosphere among the other

people was quite astonishing—we were full of awe, sorrow and reverence. It was quite astonishing." Equally arresting were the reports from the ever-observant gallery attendants that "we saw some people praying in front of images in the exhibition as they moved around"—a telling reaffirmation of the originally devotional character of many of the chosen exhibits.

A further, identifiable cluster of experiential responses can be described as the "loosely numinous," as when visitors reported, "I felt we hadn't entirely left the spiritual in art behind," or that "it gave me new insights and different emotional and spiritual responses." Finally there were those—a not insignificant quarter of all respondents—firmly situated at the opposite end of our "experiential" spectrum, whose reactions to their visit must be classified as "essentially negative." Some feared proselytization, or had serious doubts about the historical veracity of the image of Christ ("How," asked one "could we come to decide what Christ looked like?"), while others felt that Christianity, even God, was now dead, or at least dying. A more statistically significant caveat was essentially a skeptical, and profound, awareness of "inhabiting a society, a secular society, where religion has become irrelevant and has nothing valuable to offer, both in terms of its art and in terms of its moral principles." At this extreme end of the spectrum, the *Seeing Salvation* exhibition proved for one visitor at least, no more than "an occasion where I saw everything but felt nothing."

Conclusions

This case study has been, of necessity, retrospective, monocultural, and credally site-specific. It has also been heavily dependent on unverifiable responses provided by visitors to an exceptionally successful, and widely publicized, British exhibition of religious art. At a deeper level perhaps, the "transactions" and "experiences" reported in the research also point toward some other levels of explanation. One is that while many—visitors and art critics alike—saw *Seeing Salvation* as cultural heritage, albeit a shared *religious* one, rather than as a vehicle for primary religious experience, their reactions also suggest that modern "secular" audiences can also engage with, in this case, Christian art at an emotional as well as a purely aesthetic or historical level. Second, on this evidence it is clear that, in certain circumstances, religious art in a secular setting such as the National Gallery can also serve as an effective vehicle for religious meaning. Indeed in this sense *Seeing Salvation* may have offered a powerful corrective to the conventional contention that modern museum culture effectively de-sacralizes religious art. As the British sociologist Roger Homan so eloquently put it in his own letter to the director, "There is a sense in which galleries have plundered the pictured prayers of devout men, and students of art have lost interest in their subject matter. Hence I greatly welcome your recovery of the devotional intentions of artist and the focus upon their religious themes instead of their technical virtuosity" (National Gallery Archive undated).

One consequence may be that subsequent exhibitions on religious themes may also still have served to articulate and sustain religious identity in today's secular world (cf. *Treasures of Heaven*, 2011; *The Sacred Made Real*, 2005). More prosaically, in a predominantly post-Christian culture like much of the West, it seems that any future relationship between religion and the visual arts, and especially religious objects and religious experience, is not necessarily as tenuous or problematic as it is so often presupposed to be.

References

Brown, David. 1999. *Tradition and Imagination: Revelation and Change*. Oxford: Oxford University Press.

Burch Brown, Frank. 1989. *Religious Aesthetics*. Princeton, NJ: Princeton University Press.

Danto, Arthur C. 1986. *The Philosophical Disenfranchisement of Art*. New York: Columbia University Press.

Davie, Grace. 2003. "Seeing Salvation: The Use of Text as Data in the Sociology of Religion." In *Public Faith? The State of Belief and Practice in Britain*, edited by Paul Avis, 92–105. London: S.P.C.K.

Finaldi, Gabriele (ed.). 2000. *The Image of Christ*. London: National Gallery Publications.

Hamlyn, Robin. 1993. *Robert Vernon's Gift: British Art for the Nation*. London: Tate Gallery Publishing.

Howes, Graham. 2007. *The Art of the Sacred*. London: I.B. Tauris.

Martin, James. 1990. *Beauty and Holiness*. Princeton, NJ: Princeton University Press.

Paine, Crispin. 2013. *Religious Objects in Museums: Private Lives and Public Duties*. London: Bloomsbury Academic.

Rémond, René. 1999. *Religion and Society in Modern Europe*. Oxford: Oxford University Press.

Report, Proceedings and Minutes of Evidence of the Select Committee on Art Unions. 1845. London.

11 Museums and the Repatriation of Objects, 1945–2015

MARK O'NEILL

Repatriation claims for valuable and symbolically powerful objects which were acquired in disputed circumstances have a long history, from Cicero's prosecution of Gaius Verres in 70 bce on charges including the plunder of temples when he was governor of Sicily, to the return of art looted by Napoleon's armies to Italy—but not to Egypt—after his defeat in 1815 (Miles 2008). The conflict between divine and human rules about the disposition of human remains has been an ethical issue in Western culture since at least the time of Sophocles, whose Antigone claimed the right to bury her brother despite the king's injunction that, as a rebel, his body be exposed. This chapter will however focus on the period since 1945 and in particular on claims to museums in Anglophone countries for the return of these special categories of objects.

During this period a complex new field of "international heritage law" has emerged (Vadi and Schneider 2014) and issues of repatriation have been the focus of often heated national and international legal and diplomatic disputes and of public and academic debates. These have not only involved private individuals, groups, and states, along with some of the world's most prestigious museums, but also proponents of competing regimes of value. Champions of scientific, cosmopolitan ideals uphold what they see as the legacies of the Enlightenment and cultural internationalism, while others demand that legacies of Empire be overturned and the rights of cultural groups to their heritage be recognized and historical wrongs corrected (Greenfield 1989).

Museums are at the intersection of many of these debates because they play a peculiar role in modern secular societies, preserving objects which are considered so special that they exist outside the market and the realm of private property (reflecting their cultural value) and must be passed on to future generations to be preserved for all time (which constitutes them as heritage).[1] While the case for museums is often made in terms of research, preservation, education, and science, there is also a ritual dimension to their role in society, conferring a secular sacredness on the objects in their care which transcends their material nature, due to their age, beauty, status as "art," symbolic or cultural meaning, or historical associations. The difficulty museums have in acknowledging the quasi-sacred nature of the objects in their care even extends to the large percentage of their holdings which have an explicit religious

meaning and is reflected in the rarity of museum displays about religion, and museo-
logical studies of religious objects.

Within the context of international and national laws relating to these special
objects, this chapter will highlight three of the most prominent areas where signifi-
cant repatriations—and debates—have taken place: objects spoliated by the Nazis
from Jews between 1933 and 1945; human remains and sacred objects taken by
European colonizers from indigenous peoples; and unprovenanced antiquities looted
or assumed to be looted and illegally exported from their country of origin. These will
be put in the context of the academic, museum, and public debates they generate
and the wider issues they raise about ethics, history, and cultural preservation in the
twenty-first century.

Background

Though there was some provision for repatriation of cultural property after World
War I, it only became extensive and systematic after World War II. The Declaration of
London in 1943 set out the Allies' intention to "do their utmost to defeat the methods
of dispossession" of the Nazis and led to various instruments to implement it (Prott
2009, 4). For the first time in history, "restitution may be expected to continue for
as long as works of art known to have been plundered during a war continue to be
rediscovered" (Hall 1951, quoted in Prott 2009, 8). The first international instrument
to deal explicitly with the issue came in 1954, with the *Hague Convention for the
Protection of Cultural Property in the Event of Armed Conflict*, agreed under the aus-
pices of UNESCO (United Nations Educational, Scientific and Cultural Organisation).
Four further major conventions followed, powerfully influenced by the voices and
interests of newly liberated former colonies. The two that most directly relate to repa-
triation were the 1970 *Convention on the Means of Prohibiting and Preventing the
Illicit Import and Export and Transfer of Ownership of Cultural Property*, and the 1995
UNIDROIT Convention on Stolen or Illegally Exported Cultural Objects (Forrest 2010,
166–217). The *World Heritage Convention* of 1972 marked a conceptual shift from
"cultural property" to "cultural heritage," with the latter being a much broader term
that "expresses a public interest to be protected irrespective of ownership" (Vadi and
Schneider 2014, 6, 7).

Nazi Spoliation

While the Allies did put in place mechanisms for restitution of art spoliated by the Nazis
(Norman 1965; Nicholas 1994, 407–444), these dealt only with immediate issues at
a time of great confusion, displacement of peoples, and lack of knowledge about the
whereabouts or survival of stolen works of art. Significant new developments did not
begin until the 1990s, arising from research into the scale of the looting (e.g., Nicholas
1995; Simpson 1996), improved documentation which meant that museum archives
were now accessible to survivors and their families, and growing awareness that

museums had acquired objects spoliated by the Nazis. This led to the Washington Conference on Holocaust Era Assets in 1998. The forty-four governments and thirteen nongovernmental organizations that took part agreed on what has become known as the Washington Consensus. This involves "non-binding principles" on the need to identify art that had been "confiscated by the Nazis and not subsequently restituted, to publicize this information, and to encourage the use of alternative dispute resolution mechanisms for resolving ownership claims" (DCMS 2006, 6). A huge program of provenance research has followed and resolution procedures established (Wechsler and Ledbetter 2004; Karrels 2014). In the United States resolutions have been sometimes by negotiation and sometimes through courts, while in Europe the state is more involved, with the United Kingdom, for example setting up a Spoliation Advisory Panel in 2000 to consider claims (DCMS 2006). Though the Washington Consensus established an important principle based on the unique status of the Holocaust, the number of individual objects returned (or for which compensation was paid) is relatively small, and in the past five years some American museums have, according to one report, used legal technicalities to resist claims.[2]

Repatriation to Indigenous People in the United States, Canada, OAustralia, and New Zealand

European colonizers and their settler descendants collected hundreds of thousands of objects and human remains from the indigenous peoples they encountered, whether through trade, gift, theft, or force.[3] Decolonization and the growth of indigenous rights movements have led to demands for the return of human remains, funerary objects, and objects of particular religious or cultural significance.

In the United States restitution is mandated by the *Native American Graves Protection and Repatriation Act* (NAGPRA) act of 1990. This compels federal agencies and institutions that receive federal funding to return Native American human remains and "cultural items" to lineal descendants and culturally affiliated Indian tribes and Native Hawaiian organizations. These include human remains, funerary objects, sacred objects, and objects of cultural patrimony, and the returns are supported by federal grants (Graham and Murphy 2010). Legislation akin to NAGPRA has been passed in both Australia (at national and state levels) and New Zealand, enabling repatriation within their countries. Both have, mainly through units within their national museums, also secured the voluntary return of significant numbers of human remains and cultural objects from overseas. In Canada, under provisions of the Museums Act of 1990, and the reports of the 1992 Task Force on First Peoples and Museums, jointly sponsored by the Assembly of First Nations and the Canadian Museums Association (1994), museums deal with claims on a case-by-case basis (Simpson 2001, 296). In all these countries significant returns have been made (Simpson 1996, 2009).

Indigenous peoples from these countries have had limited success in claims to museums in Britain and Europe for the return of human remains and sacred or funerary objects (Paterson 2010). New Zealand is particularly concerned with the

return of *Mokomokai*—preserved Maori heads—and over forty overseas museums have been involved in returns (Loc. Gov. 2016). The special status of human remains led the UK government to create an exception to the legal prohibition on national museums deaccessioning objects. After an initial period of opposition the director of Britain's Natural History Museum (NHM), which holds the national collection of human remains, argued: "We are a science-based organisation but we do not believe that the scientific value should trump all other claims; nor do we believe that the ethical, religious, and spiritual claims should necessarily trump the scientific value." The NHM's "commonsense" approach led, in 2011, to the return of 138 ancestral remains to the Torres Strait Islands as part of an agreement in which scientific study could continue. A spokesperson for the Museums Association said, "This shows that long-standing disputes, however intractable they appear, can be resolved through respectful conversations to produce a satisfactory compromise" (Atkinson 2011). The British Museum has returned some bone fragments but not seven *Mokomokai* because "it was not clear whether or not a process of mortuary disposal had been interrupted or disturbed; and that it was not clear that the importance of the remains to an original community outweighed the significance and importance of the remains as sources of information about human history" (British Museum 2016). In addition to human remains, cultural objects have been returned by museums in Exeter, Glasgow, and Aberdeen to indigenous peoples in Australia, the United States, and Canada, respectively (Legget 2000; O'Neill 2004; Curtis 2006).

Unprovenanced Antiquities

Despite the 1970 UNESCO Convention on looted antiquities many museums in the United States, most notably the immensely wealthy Getty, but also the Metropolitan, Dallas, and Toledo art museums, spent vast sums on "dodgy" antiquities during the museum boom of the 1970s–1990s—called "the Age of Piracy" in one dramatic account of the world of organized art looting and its links with major museums (Felch and Frammalino 2011). This meant that when the governments of "art rich" countries such as Italy, Greece, and Turkey threatened to take legal action and to withhold loans, the museums were in a weak position despite the legal grounds of the claims being questionable and even when—in fact precisely because—the origin of the works could not be determined. According to the *New York Times*, early opportunities to make a "symbolic repatriation" to Italy had been missed by museum obstinacy, leading to an escalation of demands. Works worth over half a billion dollars have been returned to these countries, most famously the Euphronios krater by the Metropolitan Museum and a statue of the Greek goddess Aphrodite by the Getty. Where the issues have not been resolved relations have broken down completely—the Turkish state has withdrawn cooperation, especially loans, with any museums (including the British Museum) that refuse to meet its demands (Eakin 2013).

The Debates

Many archaeologists and curators saw the repatriation of indigenous human remains and artifacts as an attack on their intellectual freedom and a significant loss to research. Indigenous peoples asserted their right to treat the remains of their kin (often the first returns were of the remains of named individuals) and members of the cultural groups in ways which accord with their beliefs—and maintain that the museums have had long enough to research the remains, many of which are not even inventoried. Opinion has shifted over time and now perhaps a majority of curators and archaeologists also support the process, on ethical grounds, and as a way of discovering new knowledge and building partnerships (see Chapter 15 in this volume). All this has generated a rich literature exploring the processes, meanings, and outcomes for the peoples and institutions involved (see, e.g., Graham and Murphy 2010; Turnbull and Pickering 2010; Fforde, Hubert, and Turnbull 2002).

Archaeologists in general saw the collecting of unprovenanced antiquities by art museum curators as an "ethical crisis." Renfrew (2000), for example, argued that they were not only colluding in looting which destroys contextual knowledge, but with the international drugs and money laundering networks with which the looters were also involved. James Cuno (2008) argued that museums should be able to acquire unprovenanced antiquities because the trade had not been stopped by the prohibition and that, at minimum, museums could rescue objects and preserve them for posterity. The *New York Times* concluded that "[b]y failing to deal with the looting problem a decade ago, museums brought a crisis upon themselves. But in zealously responding to trophy hunting from abroad, museums are doing little to protect ancient heritage while making great art ever less available to their own patrons" (Eakin 2013).

Universal Museums

All of the aforementioned examples, where returns have taken place, are exceptions to a general resistance to repatriation claims, including those for some of the most celebrated disputed objects in the world: the Benin Bronzes, the bust of Nefertiti, the Rosetta Stone, and, most famous, the Elgin/Parthenon Marbles. Each object has a unique history, but in the past thirty years the complex issues involved have coalesced around the ideal of the "universal museum." In 1984 the Trustees of the British Museum made explicit their reasons for rejecting the claims of the Greek government for the Parthenon Marbles and sought "to correct the lack of understanding of its function as a universal museum which plays a unique role in international culture" and whose collection recognizes "no arbitrary boundaries of time or place" (Wilson 2002, 323). This defense was elaborated significantly by Neil MacGregor (who originally trained as a lawyer) (2004a, 2004b) when he became director in 2002. He argued that the purpose of the universal museum was to "show the world as one."

In 2003, to support the British Museum, nineteen leading institutions signed a "Declaration on the "Importance and Value of Universal Museums." The case for the universal museum has been further developed by Cuno (2008), now director of the Getty Museum, who has defended it on the grounds that repatriation claims are made for narrow nationalist and sectarian reasons, in many cases by current populations who have no real links with the creators of the objects. Like MacGregor he argues that objects are of universal significance to humanity, not to any specific cultural group or nation and in the universal museum visitors learn about difference as they make comparisons between cultures when they walk from gallery to gallery. Cuno (2011, 44, 54) has expanded his argument to include rejection of the critical theory based analysis of museums as "ideological instruments of political and social power" and instead maintains that they are instruments of liberalism, objectivity, cultural internationalism, and individual agency.

Tiffany Jenkins, staking out a claim on some of the "attention space" (Collins 2002) provided by the debate, has merged the claims of nation-states, indigenous people, neo-pagans, pro-repatriation curators, archaeologists, and anthropologists sympathetic to some repatriation, critical theorists, and postmodern thinkers into one great assault on the "tenets of the Enlightenment" and represents it as a "crisis of authority": "the most important point is that cultural institutions no longer consistently hold up the values and sense of purpose integral to their formation in the eighteenth and nineteenth centuries" and fail to "impose" their cultural authority (Jenkins 2011, 146, 75). Like others who oppose repatriation she draws on the philosopher Anthony Appiah's (2006) work on cosmopolitanism, and his warnings against essentializing cultures and identities in ways which can form the basis for intolerance (see also Cuno 2008, 118–122).

The intellectual coherence and historical accuracy of the concept of the universal museum have been criticized. These institutions have long claimed to represent universal values, but in the nineteenth century these values were not to "show the world as one" but to show that there was a clear hierarchy of civilizations, races, and genders. The framework of their displays has changed little since then, and there is no evidence from thirty years of museum studies that visitors to universal museums make the claimed cross-cultural comparisons or draw conclusions which increase their tolerance (Abungo 2009; Curtis 2006; O'Neill 2004). The debates reflect not only the difficulty of finding a shared analysis of the past, but suggest that the kind of history espoused by universal museums is artificially purified, implicitly rejecting Walter Benjamin's (1992, 248) view that "every object of civilisation is also an object of barbarism." If there is a historical basis for pointing to the intolerant and violent aspects of national and cultural "imagined communities" (Anderson 1991), there is also a basis for seeing the legacies of the Enlightenment as including not just scientific rationality but also scientific racism, not just the Rights of Man but also revolutionary terror (O'Neill 2006).

Perhaps the most noteworthy feature that emerges from this cursory history of repatriation over the past thirty years is the lack of consistency in the application of

ethical principles (Rowland 2013). Some exceptions have been made to the non-disposal rules of major Western museums for Nazi-spoliated objects and for some human remains. The United Kingdom's Spoliation Advisory Panel recommended a change in the law prohibiting the disposal of cultural property to make an exception for Nazi spoliation material—but not for other claims, on the grounds that "[t]he misappropriation of cultural property carried out in the Nazi era was unique in its extent, and in its purpose" (DCMS 2006, 5). Unlike Holocaust claims, those of indigenous people to museums in the United Kingdom are not supported by a formal process, though national guidelines were put in place in 2000 (Legget 2000). Thompson (2014) has pointed out the discrepancy between how American art museums manage Nazi claims (where their self-regulation is supported by external scrutiny) and those relating to antiquity (which does not have external scrutiny).

While the Holocaust and atrocities committed during the colonial period may be incommensurate in some dimensions, it is not clear why the basic principles of redress should be applicable to one but not the other. The UK legislation (the Human Tissue Act of 2004) which enabled national museums to return human remains was triggered not by museum debates but by a scandal involving hospital doctors removing thousands of babies' organs without their parents' permission. The fact that a principle about the ethical treatment of bereaved people and the bodies of their relatives was extended to people outside the United Kingdom is suggestive.

Appiah (2015), in a point not quoted by proponents of the universal museum, clarifies the distinction between issues of group identity and the legacies of historical wrongs: "Though I can think of lots of good reasons for repatriating art—that it was stolen, that it's site-specific, that there isn't a lot of art of its kind in the place it's going back to—the idea that art belongs in a national home is not among them." An interesting intervention in the repatriation debate by an establishment insider, which seems to have gone unremarked (a Google Scholar search produces no references), was by Mark Jones (2013), former director of the National Museum of Scotland and of the V&A. In a wide-ranging review of the issues, he argues that "the same standard must be applied universally. We cannot have one rule for Scotland or Spain and another for Turkey or Nigeria. We cannot proclaim objects belong in the British Museum 'where they can be seen in a world context by a general audience' without recognising that Istanbul (like Beijing, Shanghai, Delhi, or Mumbai) can also claim to be a 'world city' with a 'global audience.' " Pointing out that the artefacts about which there would be serious dispute are very limited in number, he concludes that "the risks of action are overestimated and the risks of inaction are underestimated. But most important for me is that we owe it to our proud tradition of museums serving the public interest to see where something is wrong and take steps to set it right" (70). Implicit in Jones's—and Appiah's—view is that museums depend for their authority not just on their intellectual but also on their ethical rigor.

Despite the global recession, and despite predictions of their being superseded by digital substitutes, the number of museums in the world—currently at approximately 55,000, about one for every 130,000 people—continues to grow, as does the

literature of museology. The latter offers many explanations of this phenomenon—economic, cultural, political, educational, aesthetic, Foucauldian, Harveyite—but none seems quite to capture why these institutions seem to have become essential to modern societies. Perhaps there is a clue to what is missing in the areas in which exceptions have been made to the presumption against return. The atrocities of the Nazis pose deep questions as to whether "Western Civilization" is at heart truly enlightened or whether evil is also part of its heritage. The possession of Greek and Roman antiquities has long been a symbol that modern Westerners are the legitimate heirs of these archetypal civilizations (Hoock 2010). The treatment of human remains raises profound issues of mortality even in the most secular societies, which have found it difficult to maintain a purely materialistic perspective. Until "universal" museums acknowledge their role in constructing an identity for their own "imagined community" of enlightened liberal Westerners and until museums in general acknowledge their role in meeting the ritual, if not the spiritual, needs of a secular society, they will find the ethical clarity and rigor recommended by Jones difficult to attain (O'Neill 2012).

Notes

1. The UK government's Department for Culture, Media and Sport (DCMS) adopted the following definitions: "Restitution" refers to the return of an object from a museum collection to a party found to have a prior and continuing relationship with the object, which is seen to override the claims of the holding museum. "Repatriation" refers to the return of an object of cultural patrimony from a museum collection to a party found to be the true owner or traditional guardian, or their heirs and descendants. "Spoliation" refers to the plunder of assets, in this context works of art, during the Holocaust and World War II (DCMS 2000).
2. The American Association of Art Museum Directors (AAMD 2016) website lists 23 and the UK Spoliation Advisory Panel (DCMS 2016) lists 12. World Jewish Repatriation Organisation Report, reported in the Ilnytzky (2015).
3. For a sense of the scale of these operations see, for example, Coombes (1994) on Africa and Cole (1985) on North West Coast America.

References

AAMD. 2016. https://www.aamd.org/object-registry/resolution-of-claims-for-nazi-era-cultural-assets/browse (accessed February 4, 2016).
Abungo, George. 2009. " 'Universal Museums': New Contestations, New Controversies." In *UTIMIT 2008: Past Heritage-Future Partnerships*, edited by Mille Gabriel and Jens P. Dahl, 32–43. Copenhagen: International Working Group for Indigenous Affairs.
Anderson, Benedict R. 1991. *Imagined Communities*. London: Verso.
Appiah, Anthony. 2006. *Cosmopolitanism*. New York: W.W. Norton & Co.

Appiah, Anthony. 2015. "There Is No National Home for Art." *New York Times*, 21 January. http://www.nytimes.com/roomfordebate/2015/01/21/when-should-antiquities-be-repatriated-to-their-country-of-origin/there-is-no-national-home-for-art (accessed February 2, 2016).

Assembly of First Nations and Canadian Museums Association. 1994. *Turning the Page: Forging New Partnerships between Museums and First Peoples*. Ottawa.

Atkinson, Rebecca. 2011. "Natural History Museum to Return 138 Human Remains." *Museum Journal News*. October 3. http://www.museumsassociation.org/museums-journal/news/10032011-nhm-repatriation (accessed January 29, 2016).

Benjamin, Walter. 1992. *Illuminations*. London: Fontana Press.

British Museum. 2016. "Repatriation to New Zealand." http://www.britishmuseum.org/about_us/management/human_remains/repatriation_to_new_zealand.aspx (accessed February 1, 2016).

Cole, Douglas. 1985. *Captured Heritage*. Seattle: University of Washington Press.

Collins, R. 2002. "On the Acrimoniousness of Intellectual Disputes." *Common Knowledge* 8 (1): 47–70.

Coombes, Annie E. 1994. *Reinventing Africa*. New Haven: Yale University Press.

Cuno, James B. 2008. *Who Owns Antiquity?* Princeton, NJ: Princeton University Press.

Cuno, James B. 2011. *Museums Matter*. Chicago: University of Chicago Press.

Curtis, N. 2006. "Universal Museums, Museum Objects and Repatriation: The Tangled Stories of Things." *Museum Management and Curatorship* 21 (2): 117–127.

Department for Culture, Media and Sport. 2000. http://www.parliament.the-stationery-office.co.uk/pa/cm199900/cmselect/cmcumeds/371/0060805.htm (accessed February 7, 2016).

Department for Culture, Media and Sport. 2006. "Restitution of Objects Spoliated in the Nazi-Era: A Consultation Document." London: Department for Culture Media and Sport.

Department for Culture, Media and Sport. 2016. "Spoliation Advisory Panel." http://old.culture.gov.uk/what_we_do/cultural_property/3296.aspx (accessed February 1, 2016).

Eakin, Hugh. 2013. "The Great Give Back." *New York Times*, January 26. http://nyti.ms/18OXTbu (accessed February 7).

Felch, Jason, and Ralph Frammolino. 2011. *Chasing Aphrodite*. Boston, MA: Houghton Mifflin Harcourt.

Fforde, Cressida, Jane Hubert, and Paul Turnbull. 2002. *The Dead and Their Possessions*. London: Routledge.

Forrest, Craig. 2010. *International Law and the Protection of Cultural Heritage*. London: Routledge.

Graham, Martha, and Nell Murphy. 2010. "NAGPRA at 20: Museum Collections and Reconnections." *Museum Anthropology* 33 (2): 105–124.

Greenfield, Jeanette. 1989. *The Return of Cultural Treasures*. Cambridge, UK: Cambridge University Press.

Hoock, Holger. 2010. *Empires of the Imagination*. London: Profile Books.

Ilnytzky, Ula. 2015. "US Museums 'Increasingly Avoid' Returning Nazi-Looted Art." *The Times of Israel*, June 26. http://www.timesofisrael.com/us-museums-increasingly-avoid-returning-nazi-looted-art-report/ (accessed May 15, 2015).

Jenkins, Tiffany. 2011. *Contesting Human Remains in Museum Collections*. New York: Routledge.

Jones, Mark. 2013. "Restitution Begins at Home." *Art Newspaper* 250: 67–70.

Karrels, Nancy. 2014. "Renewing Nazi-Era Provenance Research Efforts: Case Studies and Recommendations." *Museum Management and Curatorship* 29 (4): 297–310. doi:10.1080/09647775.2014.934050.

Legget, Jane A. 2000. *Restitution and Repatriation*. London: Museums & Galleries Commission.

Loc. Gov. 2016. "Repatriation of Historic Human Remains: New Zealand Law Library of Congress." http://www.loc.gov/law/help/repatriation-human-remains/new-zealand.php (accessed February 1, 2016).

MacGregor, N. (2004a). The British Museum. *ICOM News* (1)7.

MacGregor, N. (2004b). The British Museum. *The British Museum Magazine* 48.

Miles, Margaret M. 2008. *Art as Plunder*. New York: Cambridge University Press.

Nicholas, Lynn H. 1994. *The Rape of Europa: The Fate of Europe's Treasures in the Third Reich and the Second World War*. London: Macmillan.

Norman, B. 1965. "Nazi Spoliation and German Restitution: The Work of the United Restitution Office." *The Leo Baeck Institute Yearbook* 10 (1): 204–224.

O'Neill, Mark. 2004. "Enlightenment Museums: Universal or Merely Global?" *Museum and Society* 2 (3): 190–202.

O'Neill, Mark. 2006. "Enlightenment Traditions, Sacred Objects and Sacred Cows in Museums: Response to Tiffany Jenkins." *Material Religion* 2 (3): 359–368.

O'Neill, Mark. 2012. "Museums and Mortality." *Material Religion* 8 (1): 52–75.

Paterson, Robert K. 2010. "Heading Home: French Law Enables Return of Maori Heads to New Zealand." *International Journal of Cultural Property* 17 (04): 643–652.

Prott, Lyndel V. 2009. *Witnesses to History*. Paris: United Nations Educational, Scientific and Cultural Organization.

Renfrew, Colin. 2000. *Loot, Legitimacy, and Ownership*. London: Duckworth.

Rowland, D. J. 2013. "Nazi Looted Art Commissions after the 1998 Washington Conference: Comparing the European and American Experiences." *KUR—Kunst Und Recht* 15 (3–4): 83.

Simpson, Elizabeth. 2001. *The Spoils of War*. New York: H.N. Abrams in association with the Bard Graduate Center for Studies in the Decorative Arts.

Simpson, Moira. 1996. *Making Representations*. London: Routledge.

Simpson, Moira. 2009. "Museums and Restorative Justice: Heritage, Repatriation and Cultural Education." *Museum International* 61 (1–2): 121–129.

Thompson, Erin. 2014. "Successes and Failures of Self-Regulatory Regimes Governing Museum Holdings of Nazi-Looted Art and Looted Antiques." *Columbia Journal of Law and the Arts* 37 (3): 379–404.

Turnbull, Paul, and Michael Pickering. 2010. *The Long Way Home*. New York: Berghahn Books.

Vadi, Valentina, and Hildegard Schneider. 2014. *Art, Cultural Heritage and the Market*. Heidelberg: Springer.

Wechsler, Helen, and Erik Ledbetter. 2004. "The Nazi-Era Provenance Internet Portal: Collaboration Creates a New Tool for Museums and Researchers." *Museum International* 56 (4): 53–62. doi:10.1111/j.1468-0033.2004.00050.x.

Wilson, David. 2002. *The British Museum*. London: British Museum Press.

12 The Case for the News Media's Critical Engagement with Museum Religious Exhibits

MENACHEM WECKER

It wasn't discovering penicillin, to be sure, but a happy accident set the stage for what would become one of the favorite articles that I have ever reported. It was winter 2005, and I had graduated college recently. I had already sold a review of the Philadelphia Museum of Art's exhibition *Jacob Van Ruisdael: Master of Landscape* to my editor at the *Jewish Daily Forward*, with promises that Ruisdael, the Jewish painter, all but invented landscape painting. (I was, remember, a kid.) I listened to the phone ring, and soon the late Seymour Slive, then professor emeritus at Harvard University and seventeenth-century Holland specialist, picked up from his summer home in Kennebunkport, Maine. At the time, he was eighty-five years old; amusingly, he called me "sir" throughout the duration of the thirty-minute conversation.

I explained to Slive, who had curated the Philadelphia show and authored the catalog, that I wanted to discuss Ruisdael's Jewish faith. After all, the guy was named Jacob; his dad was Isaack; and his uncle was named Salomon van Ruysdael. You cannot get more biblical than that, and to further solidify the case, Ruisdael had twice painted the Jewish cemetery at Ouderkerk aan de Amstel, about half an hour outside of Amsterdam. (Per Jewish custom, the burial ground was referred to via euphemism: *Beit Chaim*, or "house of life.") Ruisdael must have been a painter of the tribe, so to speak, I believed naively.

I still remember Slive's response like it was yesterday. "Sir, I think you are chasing a will-o'-the-wisp in trying to find a firm connection," he began. And so I was. It turns out that Ruisdael was Mennonite—thus the biblical names running through the family—and not Jewish. And then Slive was adding deadpan, "Sir, there is a gentleman called Abraham Lincoln, and one named Samuel Adams." What was an embarrassed reporter to do? In turning journalistic lemons into something drinkable, it turned out, all was not lost. I filed a story about how and why I, and others before me, mistakenly confused Ruisdael to be a Jew.

But it was something that came up elsewhere in the conversation that was a "lightbulb" moment for me in my realization of how much work remains to be done when it comes to carefully studying the intersection of religion and the arts and taking both domains equally seriously. Slive explained to me his theory that Ruisdael was surely not commissioned by Jewish patrons to paint those scenes of Ouderkerk's cemetery, because the tombstones in his paintings have pseudo-Hebraic, gibberish

inscriptions rather than true Hebrew letters. Jewish patrons shelling out a pretty guilder (or surely quite a few thousand guilders) for the work, Slive insisted, would have demanded true Hebrew letters rather than the comparatively lazy solution of faking it.

Thinking quickly, I raised the question of Rembrandt's depiction of Moses atop Mount Sinai bearing the Tablets of the Law, and I wondered aloud what it meant that the inscriptions were mostly correct but that Rembrandt made so many errors in the Hebrew. "There are mistakes in the Hebrew?" Slive said, sounding surprised. Sure, I told him; and not only that, but the Dutch painter combined the versions of the Ten Commandments from the book of Exodus and from the book of Deuteronomy. "There are two versions of the Ten Commandments?" Slive asked. Indeed there are. And to whatever degree Rembrandt relied on his friend, or close acquaintance, Menasseh ben Israel to provide the necessary texts, it is clear that Rembrandt had a working knowledge of the biblical stories he so inventively represented (see Zell 2002).

As I sit penning this chapter on a flight to Amsterdam to cover what promises to be an unprecedented exhibit of Hieronymus Bosch's works (including religious works, of course) in his hometown of 's Hertogenbosch (colloquially Den Bosch), it's easy to get excited about many of the places where faith and art are seeming to jibe so well. A major exhibit on Martin Luther is being planned at the Minneapolis Institute of Arts, and a curator has assured me that the local Lutheran community has taken a strong interest in the exhibition.

But it's also bittersweet to think that New York couldn't sustain its Museum of Biblical Art (MOBIA), however much it went out with a bang with its fascinating show of Donatello sculptures from Florence's Cathedral Foundation Museum (see Chapter 25 in this volume). (The reopening of the Museo dell'Opera del Duomo, with its ingenious placement of the Ghiberti Gates of Paradise and the Donatello sculptures, is itself a major success story.) Writing in the *Atlantic*, David Van Biema (2015) noted that MOBIA "corrected for a massive flaw in museum culture by being a gallery dedicated to the religious nature of religious art," and it did so as "a *secular* museum dedicated to the religious nature of religious art."

Religion is a frequent (albeit sometimes uninvited) guest at countless exhibits at secular museums throughout the world, and I've been fortunate to spend time at Dallas's Museum of Biblical Art and St. Louis University's Museum of Contemporary Religious Art (MOCRA) in recent years. To varying degrees, both adopt a secular, museological approach, rather than an apologetic posture. But still MOBIA's inability to thrive—or even tread water—in New York City haunts.

Appetites in newsrooms for the unique sort of recipe, in which both art and religion are given equal footing, seem to be becoming somewhat of an endangered species. There are notable exceptions, but they are just that—exceptions rather than the rule. Religion sections are being dismantled and rolled, increasingly, into metro sections, and serious coverage of art exhibits continues to play second fiddle to more popular-culture oriented content, increasingly displayed as lists.

The case for more journalistic engagement (as well as critical engagement from the scholarly community) of religious art exhibitions at museums and galleries shouldn't

be a complicated pitch to make at all. Nor should it require much space. It's virtually impossible to talk about art and art history of any time period or any geographical location without devoting a good deal of serious attention to religion. And when one considers any number of the measures that typically make the case for important news stories—the number of people affected, the amount of money at stake, etc.—religious art ought to be taken very seriously indeed.

Countless people worldwide have religious art in their homes, or printed materials that include religious art; regularly or semi-regularly attend worship or religious community-oriented events at sacred spaces that feature sacred art; or encounter design, architectural, advertising, and a variety of other elements which rely on a visual language and vocabulary forged in religious context, even if they are unaware of those religious origins. For me as a reporter, I have found it thrilling to write about a body of religious artwork in which each piece is essentially a work of self-portraiture, because religious artists insert highly personal aspects of their deepest-felt beliefs and faith. A red brushstroke or a blue square might have formalist significance, as it simultaneously references heavier stuff: heaven and hell, life and death, and the like.

I used to write a weekly column on Jewish arts for the New York–based *Jewish Press*, and it could sometimes be a struggle to find serious artwork that merited critical review on such a regular basis. One can only unpack Chagall so many times, and one tires soon of debunking the myth that Jews are aniconistic, or eschew representational art (Bland 2000). Since I've started writing for *National Catholic Reporter* on the visual arts, I have encountered exactly the opposite challenge. It's hard to find important works of art that *aren't* Catholic; instead, one needs to make difficult decisions of what to cover, and what to pass over reluctantly and with trepidation.

Not only has the role religion has played in patronizing important art and providing rich content and themes to inform paintings proven so large that it defies any informative estimation, but discussing religion without using a vocabulary of art history is equally foolish and accident-prone. The materials and surfaces used to create and preserve sacred texts; the ways that houses of worship have been decorated; all of the accessories in the service of sacred ritual—including the installation of clergy at weddings, births, initiations into the community, deaths, etc.—and the ways that a visual language can help inform and expand the understanding of religious texts and rites can all be teased out in a simultaneous study of both the arts and religious studies.

The case ought to make itself. However central art and aesthetics are to religious life and practices, there's no denying that there are important pitfalls to be wary of in the religious art enterprise. Most troublingly among the challenges is the kind of propagandist analysis that either casts religion or art in a parasitic role, in which the one is wielded to discredit the other, or, conversely, an apologetics, where mere lip service is paid to one discipline as it is leveraged to promote the other in idealistic, overly promotional, and highly immature and unsophisticated manners. Even as many exhibits in secular museums show representational Jewish and Islamic art, they post throwaway lines in catalogs or wall texts denying that Jewish or Islamic artists

created such work. Sometimes the cart is made to drag along the horse, or the curator who is trying to pin the tail on the donkey (itself a problematic approach) misses the donkey's rear altogether. Additionally, religious kitsch abounds, in which the visual is merely a device employed to illustrate the religious concept (Jesus among the Jewish scholars, the sacrifice of Isaac, etc.) rather than engaging in a dialogue with the texts or traditions (cf. Elkins 2004).

When Rembrandt adds Joseph's wife to his painting of Jacob blessing Joseph's children Ephraim and Menasseh, that addition of the female figure, who is not set in that scene in the Genesis account, is adding an interpretive wrinkle to the text (cf. Bal 1991). This, Rembrandt suggests, was not just an event that gathered three generations of men. Inherent in the conversation about which of the children should get the greater blessing was not only a conflict between father (Jacob) and son (Joseph) about how to raise the latter's children, but the boys' mother was present too. Or at least she should have been, Rembrandt figured.[1]

The degree to which artistic license in visual storytelling ought to inform study of the texts, whether for scholars or for people of faith, is up for grabs. To return to Bosch, particularly the "Temptation of St. Anthony" in the collection of Kansas City's Nelson-Atkins Museum of Art, which was recently elevated from Bosch's studio to the master's hand—the inclusion of particular demons surely reveals more about Bosch's own imagination and about sixteenth-century Holland than it does about what evil beings might have actually sought to tempt the saint (depending on one's beliefs and approaches to demonology). To Bosch, a figure with a tail and a funnel that doubles as both a hat and as a shirt, a fish with legs (a reversal of Disney's take on a mermaid), and another hooded figure with a long beak are the culprits.

Even if modern audiences might hope to see different tempters—drones or robots, for example, creatures that can build upon some of the animals which have come to light in the 500 years since Bosch's death, or, in this US election cycle, any number of one's political antagonists—Bosch's attempt can plant the seed of the possibility of biblical aesthetic exploration in his viewers, as well as providing a blueprint for that framing.

Art can give permission to casual and religious readers of scripture to imagine those texts in their own images, or in other familiar modes. That's why it's vital for museums to show—and more importantly, to contextualize properly!—the intersection of religion and the arts, and why the scholarly community ought to take note and stake out a horse in the game. As much as academia may strive to navigate and to elevate interdisciplinary inquiry, the enterprise can resemble ancient and medieval alchemy—a fascinating proposition, but one that hovers only symbolically within reach on the periphery of the impossible. And of course, the news media would need to take note as well. Journalists are supposed to pay special attention to man-bites-dog, rather than dog-bites-man, stories, not to mention the fact that a sophisticated, in-depth marriage of religion and the arts could, with the right planetary alignment, help reporters covering both beats find clearer and more accessible ways to explain complex ideas in plain language.

The aspect that I have found most compelling and thrilling about reporting on religious art exhibitions—that is to say exhibitions that wrestle honestly and deeply with religious content and themes, without missionizing or apologizing (as the Minneapolis curator told me of the show, it will be a Luther show, rather than a Lutheran show)—is the very factor that often spells its demise, or violent restriction, in the secular and mainstream media. To me, it can be very difficult to discuss religion without either getting very divisive and defensive quickly, or descending rapidly into the domain of either cliché or atmospheric, 10,000-foot expressions and discourse that have more to do with public relations-speak or political statements than with elucidating or explicating. That's even the case given that being a reporter often grants me a platform and mechanism to discuss intense and highly personal aspects of people's faith with them in settings where it would otherwise be thought impolite. (At the dinner table, for example.) It can make for awkward pauses and defensive postures to ask a stranger off-the-bat what she or he thinks will occur after death, or what motivates him or her to go to services regularly, or how she or he avoids the seemingly inevitable challenge of faith becoming more and less exciting and easy to connect with at different points. When one considers that faith is often wrapped up irrevocably, and often unhappily, in broader issues that relate to family, to personal struggles, and the like, this can be an even more perilous terrain to navigate with sources.

But when I am interviewing experts and artists about the intersection of faith and the arts, especially as found in the "secular" cultural repository of the museum, somehow the conversation is magically about simple, universal currency—squares and circles, reds and blues, tones and tints—rather than complicated, individualized terminology. There are still very powerful tropes at play, whether heaven and hell, life and death, the meaning of life, or one's place in an intelligently designed world. Or, of course, the rejection of those paradigms and templates, when I am reporting on the agnostic communities and perspectives. But art provides an entry point to quickly become very specific and probing without getting so controversial that the conversation folds before it has even begun.

Note

1. For this line of thinking, I am indebted to my friend and colleague Richard McBee, with whom I have discussed the painting, and many other works, at great length.

References

Bal, Mieke. 1991. *Reading "Rembrandt": Beyond the Word-Image Opposition*. Chicago: University of Chicago Press.
Bland, Kalman. 2000. *The Artless Jew: Medieval and Modern Affirmations and Denials of the Visual*. Princeton, NJ: Princeton University Press.

Elkins, James. 2004. *On the Strange Place of Religion in Contemporary Art*.
 New York: Routledge.
Van Biema, David. 2015. "The Death of an Underdog in American Art." *TheAtlantic.com*,
 May 4. http://www.theatlantic.com/entertainment/archive/2015/05/the-death-of-an-
 underdog-in-american-art/392198/ (accessed April 15, 2016).
Zell, Michael. 2002. *Reframing Rembrandt: Jews and the Christian Image in Seventeenth-
 Century Amsterdam*. Berkeley, CA: University of California Press.

Section IV Museum Collecting and Research

13 Museum Collection and the History of Interpretation

DAVID MORGAN

It is common nowadays to organize the recent history of the humanities in terms of a series of "turns," a figure of speech intended to register fundamental shifts in the way scholars of literature, religion, cultural studies, anthropology, or art define evidence, interpretation, and the discourses that inform their research and writing (Mitchell 1994; Clark 2004; Hicks 2010; Hazard 2013). The *linguistic turn* substituted the view that discourse shapes reality for the positivist view that language bore a stable, enduring relation to its referent, that truth was out there waiting to be captured by the act of representation.[1] Deconstruction emptied texts of inhering essences and stressed the play and temporality of signifiers over their anchorage or permanence. In the 1960s this post-structuralist approach was applied to images by Roland Barthes (1972). Yet students of visual culture quickly noted that images were not reducible to language, nor were they representations of text or objective conditions. And Barthes himself wrote differently about images in his later career (Mitchell 1980; Bryson 1984; Barthes 1981). Thus, the *pictorial turn* began in the work of scholars who wanted to understand how image and text collaborated.

While scholars contemplated the career of images and texts, particularly in the world of mass-mediation, they realized that production was only part of a much larger story, that artifacts were shaped by readers and viewers. Reception became a major interest during the 1980s and 1990s, leading to what has been called the *ethnographic turn*.[2] But ethnography still foregrounds language. It has been the claim of the *material turn* to take the recalcitrant substance of things as incommensurate with discourse. If the pictorial turn rejected the view that everything was language, and fixed attention on the image as something different, a form of evidence that bears its own features and needs to be studied, the material turn applies a similar logic to everything, regarding objects of all kinds, not just images, as presenting an autonomy, life, and set of expectations that pull the analyst from the comfort of familiar interpretive modes.

One may wonder if claims for such "turns" are more a matter of self-advertisement or hermeneutical branding in the marketplace of academic style and fashion. It is noteworthy that turns are often generational, or the product of one cohort that seeks to distinguish itself from a rival disposition. So it is not surprising that some have conveyed skepticism about the substance of one turn or another (see, for instance,

Culyba, Heimer, and Petty 2004). Nevertheless, such turns may well present new opportunities for redefining method and evidence, for marshaling the combined efforts of scholars, and for facilitating interdisciplinary connections that preceding discourses may have missed or discouraged.

I have framed this so far as a matter of academic inquiry. But the study of material culture is not only a scholarly affair since the history of objects is also very directly the history of their collection, interpretation, and exhibition. The history of material culture, in other words, is inextricable from the history of museums. For this reason, the material turn in recent decades holds critical implications for museum practice. In order to show how, and to provide some indication of where research related to both would do well to proceed, it will be necessary to begin with an account of the relationship between museums, material culture studies, and the study of religion. It will also be helpful to consider the related "pictorial turn" since this has shaped the practice of art history and visual culture studies, changing how scholars study and interpret images. From there it will be possible to say something about the future of object research as it relates to the collection and display of images and artifacts.

Art, Colonialism, Mission History, and the museum

The scrutiny of material evidence among historians, religion scholars, and anthropologists is not new. We cannot tell the history of the study of religions without telling the history of the study of architecture and the collection and study of artifacts. The history of Greco-Roman religion and the religions of the ancient Near East were the first in the modern era to occupy broad interest among scholars and the educated public. During the middle of the eighteenth century, Winckelmann (1987) inaugurated the study of ancient Greek and Roman sculpture, much of it religious in nature, going far to inspire the long-living cult of Neoclassicism. German writers of the Romantic period published accounts of collections of paintings and portrayed the arts as infused with religious significance for the present. For many of them, that meant baptizing the arts into the Christian religion, a prospect that would have shocked Winckelmann's erotic celebration of pagan nudity. In a poem of 1800, "The Union of the Church and the Arts," August Schlegel portrayed the Church as an allegorical figure returning to earth to summon the arts into her service. The Church goes first to Parnassus to find the arts, gathered there, humiliated after the destruction of Apollonian religion. There the Church speaks:

Well then, you arts, you shall be reborn
When you well adorn my doings here below,
When you lead the holies from heaven
To earth, expounding in figure.
Already inspiration stirs in you its plumage,
See to it, then, as it ought to be,
Bewildered by exuberance you do not lose your way
On unaccustomed flights.[3]

It is a relationship that only the Church would describe as a "union" (Bund). Forsaken by the death of the pagan cult of beauty to which the arts were devoted, they are now offered renaissance by a militant Christianity that warns them not to lose themselves to the sensuous indulgence to which their inspiration might be tempted. Whereas Schiller, in his famous poem "The Gods of Greece" (1788), had mourned the disenchantment of nature, "die entgötterte Natur" ("un-deified nature") that Christianity had achieved by defeating the old gods, Schlegel swings in the opposite direction.

Friedrich Schlegel, the poet's like-minded brother, celebrated visits to galleries in Paris, writing a series of letters published in 1803 that helped rediscover the art of Germany and Italy before the Renaissance. Late medieval devotional art was praised by Romantics in Germany and later in England for the unity and purity of purpose that August Schlegel envisioned in his poem and by the artist group that called themselves the *Lukasbund*, also known as the Nazarenes. In France the achievements of Gothic art were hymned by the Goncourt brothers. The consequence of this Romantic cult of the national past paralleled the formation of the Louvre as a museum devoted to the patrimony of the people. At work in both the French Revolution's end to absolute monarchy and Romanticism's Christian rebirth was an incipient nationalism that assembled the artifacts of the national past in order to offer it up as a template for public guidance, for inspiration of the modern nation. The museum became a principal institution for sorting out a usable past. This mission applied to art museums as well as to museums dedicated to national history and folk culture. These remain popular destinations for schoolchildren to this day, where the task is to study and appreciate the lives of national forebears.

Among antiquarians, the museum helped collect the relics of ancient civilizations that were assembled by entrepreneurs, collectors, and archaeologists. Focus on ancient Greece and Rome was paralleled by the study of the Holy Land. Chief among the tools of such study were the artifacts that were excavated or purchased. The other major source of artifacts was the colonial project of European states scrambling to secure foreign lands and markets in competition with their national rivals. England, France, Germany, Belgium, and Holland took commerce and statecraft around the world and amassed large collections of artifacts in the process. These items entered some of the same collections as Greco-Roman sculpture and Medieval Christian altarpieces. The fact that they seemed incommensurate with one another may help account for the emergence of the term "material culture," which works on a different level than "art." If art, and especially the religious art of the Christian tradition, was what the European national projects were happy to call the resources from which they derived their own national narratives, material culture may have seemed the better nomenclature for describing what non-European peoples produced.

In his survey of the history of the concept of material culture in Anglo-American anthropology, Victor Buchli has dated the terminology to the middle of the nineteenth century. Buchli (2002, 2) asserts that "the study of material culture itself became one of the cornerstones of the nascent independent discipline of anthropology"

(cf. Pearce 1994). "Euro-American museums," he adds, "were the institutions in which material culture studies as we know it originally found their home and thrived." These museums were quite often collections gathered during European colonization, and were therefore, as Buchli (2002, 3) puts it, "intimately related to larger cultural projects" (Stocking 1985). For example, in 1897, a British force executed a "punitive expedition" against the kingdom of Benin for the slaughter of 248 men engaged in an ill-conceived commercial expedition to the city of Benin during the year before. Among the spoils collected by the British force, which annexed the territory to the British crown, were a large cache of jewelry, vessels, masks, ornamental weaponry, figures, bronze plaques, and ivory carvings depicting warriors and royal scenes. A large number of these made their way to the British Museum. In 1900, Augustus Henry Lane-Fox Pitt-Rivers, founder of one of the most important ethnographic collections of all, which was eventually established at Oxford, where it remains today, published a catalog of the Benin objects, picturing 393 artifacts (Pitt-Rivers 1900). Another collection of objects began with the work of British Protestant missionaries in India, Oceania, Malaysia, and China. The London Missionary Society formed a museum as early as 1814 to receive and display the objects and deities gathered by missionaries in the field in order to demonstrate the advancing work of the Society (see Chapter 26 in this volume). The objects were referred to as "trophies of Christianity," taken in the field of battle, as it were, the captured ensigns or flags of Christ's defeated enemies. Near the end of the nineteenth century, the London Missionary Society deaccessioned its collection, large numbers of which went to the British Museum and the Pitt-Rivers Museum at Oxford (Morgan 2015).

Once the objects were installed within history or ethnography museums, they were deployed within a significantly different taxonomy, serving therefore very different narratives of cultural development. But their cultural biographies did not begin with the missionaries who collected them. The objects occupied the social worlds of their original producers and owners, but were sometimes acquired through conquest by rival groups long before Western missionaries arrived. And when the missionaries did get them, their departure from indigenous culture was inaugurated in some cases by display within churches in order to demonstrate their subordination to Christianity as a way of encouraging native populations to recognize the superiority of Christianity over indigenous belief and practice. On some occasions objects were destroyed, as in the case of a Protestant missionary working on a Malaysian island in 1817. When the inhabitants of a village presented their idols to him as a testament of their conversion to Christianity, he advised them "to pack them all up in a large box (into which they formerly used to be put for their night's rest), and to place a heavy load of stones upon them, and to drown them in the depth of the sea, in my presence" (Anon 1820). It was a decisive act of iconoclasm that converted the sleeping chamber of the gods into their coffin. But many other objects were collected by missionaries and sent to London, Boston, and other metropoles for display. Missionaries of the London Missionary Society sent hundreds of objects to be exhibited in a museum begun in 1814.[4] The collection was said to rival the holdings gathered by Captain Cook and

deposited at the British Museum. Each year at their annual meeting, the members and board of the LMS would go to the museum, "where friends of mission are want to repair, to revive their sympathies by an actual inspection of those idol gods which it is the first aim of the society 'utterly to abolish'" (Anon 1843).

Even after the objects entered the different context of new collections and institutions, the story they were applied to telling could be a related one—the narrative of Western civilization's role in the world based on its determination to assist societies less fortunate in industrial sophistication, science, medicine, reason, and morality. The display of technological artifacts was designed to educate, edify, and celebrate. World Fairs had done so since the middle of the nineteenth century, displaying the latest technology and industrial products, and singing national hymns of industrial and commercial progress. Such objects, it was understood, were material demonstrations of a nation's advance, measured against the accomplishments of rivals. They were the very means of progress and the durable proof of cultural superiority. "Comparison," wrote the president of the commission overseeing the 1876 Centennial Exhibition in Philadelphia, "is vital to the success of any exposition . . . You can never discover your success or your failure without comparison. You cannot gauge your status without comparison with other nations" (quoted in Rydell 1984, 32). Religion was intimately interwoven in this ideology of material progress since Christianity was fashioned as the engine of moral progress best suited to democracy. And it was Christianity's promotion of the ameliorating effects of civilization that Britain invoked as the highest rationale for its colonial mission.

Art History, Visual Culture, and the Pictorial Turn

So the history of material culture comes to the twentieth century with considerable baggage. As icons of culture, objects are testimony in ideological courts of opinion, material evidence supporting claims of various kinds. The history of interpreting objects continued in the development of another nineteenth-century practice, the discipline of art history as it was shaped in European and to a lesser degree American universities. Art historians developed a number of useful techniques for interpreting images that remain in use today—formal analysis, connoisseurship, and iconography. The first trains attention on describing the physical properties of medium, artistic treatment of materials, and the resulting impression created by the work of art, singling out those characteristics of the object or surface that endow the work with its aesthetic gravity or presence. Connoisseurship is the practice of examining the signature features of a painting, drawing, or sculpture in order to recognize the hands involved in its production, which serves as the basis for making attributions of authorship. This skill, practiced in order to identify the makers of anonymous or contested pieces, is greatly valued by museums and collectors and is directly proportional to the financial value fixed to works of art. Finally, iconography is the procedure of tracing the use of motifs or visual formulae, employed by artists when designing their work.

Each of these approaches to the artistic object takes its physical appearance as primary evidence. But art historians have not been content with these methods. Erwin Panofsky, for example, a master at iconographical study, also wanted art historical work to access the intellectual history in which art participated. So he developed what he termed "iconology" as a method of study, by which he meant the comparison of works of art to other cultural artifacts such as philosophy, literature, music, and religious ritual. In the 1960s and 1970s, the impact of Marxist thought on art history became evident in British and American practice. Art was studied in the context of class. Avant-garde art could be seen as radical and more traditional forms as the tools of the interested classes of capital and aristocracy that put art to work for their sense of privilege. Feminism and psychoanalysis were responsible for pushing art historical interpretation into historically ignored domains such as gender and sexuality. This destabilization of interpretive practice, described at the time as "the crisis of the discipline," upset the canon of fine art and invited further unconventional approaches such as focusing on homosexuality in the history of art. The rise of interest in popular culture during the 1960s in fine art such as Pop Art, Fluxus, and Happenings, encouraged art historians to move beyond the traditional territory of fine art to examine the history of popular culture, mass-produced artifacts, and nonart objects. With this came the recognition that reception studies could be as important as the study of production. The esteemed status of genius, magisterial skill, the canon, and the authority of the fine art museum all came into question as art historians began to develop the idea of visual culture as a paradigm for their discipline rather than fine art.

Not everyone was prepared to follow this path, fearing that it would undermine the very identity and academic and professional status of the art historian as one vested with particular skills and subject matter. Thomas Crow, for instance, famously warned that visual culture would lead to the forfeiture of important tools for analyzing the materiality of objects: "To surrender a history of art to a history of images will indeed mean a de-skilling of interpretation, an inevitable misrecognition and misrepresentation of one realm of profound human endeavor." Crow worried that "a panicky, hastily considered substitution of image history for art history can only have the effect of ironing out differences and pulling all the objects of the world into a muddle of Western devising" (in "Visual Culture Questionnaire" 1996, 36).[5] The alarm aroused by the prospect of a fundamental shift to a visual culture paradigm has largely subsided, largely because no consistent paradigm emerged to take over. The panic of its critics was overwrought since what they opposed has not become a viable alternative. The idea that visual culture meant a single-minded privileging of the optical and the disembodiment of imagery has been rejected in practice by scholars of visual culture.

Recent years have witnessed a productive exchange of views on the idea of visual culture, but one that revealed that many art historians were committed to fine art. Visual culture became widely used as a term signifying everything that was not included in the canon—snapshots, advertising, posters, tattoos, comic strips, and graffiti. This descriptive approach kept the focus on fine art and on the image as the

focus of study. As a result, "visual culture" became the designation for a broader category of images, and often lacked an analytical approach to the question of what "culture" meant in the term "visual culture." But there were more discerning uses of the term at work. Drawing on Michael Baxandall's (1972) pioneering study of visual practices, Svetlana Alpers (1983, xxv) embraced as the object of her study the history of Dutch visual culture rather than a narrower focus on Dutch art. She elaborated on what she had in mind in 1996: visual culture meant a way of concentrating "on notions about vision (the mechanism of the eye, on image-making devices (the microscope, the camera obscura), and on visual skills (map-making, but also experimenting) as cultural resources related to the practice of painting" (Alpers in "Visual Culture Questionnaire" 1996, 26; cf. Walker and Chaplin 1997). Like Baxandall (1972, 109), Alpers understood visual practices as social practices that tell us more about a society than information encoded abstractly as the "meaning" of fine art. Others have demonstrated no hostility to the fine arts within the purview of visual culture studies, evincing a broadly interdisciplinary approach that refuses to abandon attention to the formal characteristics of images, though they are strongly inclined to situate fine art within the larger domain of political theory, cultural criticism, media theory, and the study of gender and sexuality (Howells 2003; Mirzoeff 2002; Sturken and Cartwright 2001). Still others stressed studying the reception of images, their circulation, and the aesthetic categories, visual practices, and epistemologies that were deployed in the reception of images (Morgan 1998; Pinney 2004; Howes 2007; King 2010). But if interdisciplinary emphasis threatened to diminish the significance of the fine arts, accent on use and reception easily led interpretation away from the domain of art history and into the life-worlds of those who put the images to work. Such a move suited anthropologists and religion scholars, but less so art historians.

There were, of course, writers who importantly challenged the practice of art history from within the discipline. For instance, David Freedberg's widely read book, *The Power of Images* (1989) asked why art historians ignored images that involved horror, obscenity, sexual arousal, magic, witchcraft, and idolatry, contending that such practices were out of sympathy with the rationalist, humanistic, taste-bound preferences of the discipline of art history. His book showed in dazzling breadth and detail what scholars were missing as a result. The life of images and the range of human response to them commanded a power that needs to be understood. For scholars of religion, the argument is especially compelling since images and objects enjoy a significant role in many, indeed, according to Freedberg, virtually all, religions. They described what he calls the "myth of aniconism," which is the claim that some religions accord no role to imagery of any kind. In fact, this is virtually unfounded. Images and powerful objects are to be found in nearly all religions. The challenge is to know where to look to find them. The Protestant critique of Catholicism, so important to the definition of Protestantism itself, fixes attention on the altar and the pulpit as spaces to be reserved for the performance of the spoken word. But Protestants have always found other places for pictures, symbols, and objects such as instructional spaces, their own bodies and clothing, and most importantly, the home.

W. J. T. Mitchell, a very influential theorist, has suggested that the pictorial turn itself is eventuated by the anxiety that modern philosophy has had with images. Martin Jay's magisterial study *Downcast Eyes* (1993) revealed the widespread suspicions of visuality embedded in the history of French critical thought. Mitchell (1994) noted the different forms of iconophobia at work in Wittgenstein, Rorty, and the Frankfurt School, suggesting in an essay first published in 1992 that this is "a sure sign that a pictorial turn is taking place." The fear or concern about the power of images, he claimed, arose from the fact that "pictures form a point of peculiar friction and discomfort across a broad range of intellectual inquiry" (13). The consciousness that everything was language was now being applied to the suspicion that everything was imagery. The same apprehension has periodically gripped cultural critics about commodities and capital. When a form of representation achieves a particular status marked by ubiquity and received wisdom, it becomes the target of critique. The material turn should be scrutinized accordingly.

Research Agendas and the Mission of Museums

This brings us to the important question about what museums can do in light of the scholarly shifts in attention and priority. Happily, a good deal of everything I've narrated has been taken up in a variety of very useful studies of museum practice (Dudley 2010, 2012, and 2011; Paine 2013 and 2000; Pearce 1998). According to the visual culture approach that stresses visuality as an embodied aspect of human culture, images do not belong to a disembodied genealogy of images, but to the lifeworlds of those who crafted and used them. They are part of something much larger and need to be studied and exhibited in ways that can disclose the worlds to which they belong. Objects are not examples of ideas waiting to be tagged by wall texts, but participants in extended networks of things, spaces, institutions, and people. The challenge for the curator is how to convey this in a way that does not require an attendant lecture or essay. The concept of visual culture also stresses that images are technologies that teach and operationalize a variety of embodied engagements with the world around us. They show us how to see, what to value, what to ignore, how to think, what to want, what to hate, who is important and who is not.

The material turn also urges us to think about audiences, about users, about the reception of objects. One might say that images and other kinds of objects are forms of interface, ways of connecting to places, people, times, forces, and institutions that cannot otherwise be touched, seen, or approached. This is what I have in mind by the idea of a world revealed by how we examine an object, and it has been very provocatively explored in an essay by Tim Ingold (2012), "Making Culture and Weaving the World." What we learn from the history of objects acquired by the London Missionary Society is something that others have explored in the history of Hindu and Buddhist objects, namely, that the lives of objects are not over when they leave the artist's studio or the tenure in their originally intended setting comes

to a close (Davis 1997; Wingfield 2010; and this volume). Objects have an ongoing life, not simply of abstract meanings attached to them, but a physical presence that evolves with the settings in which they are placed. Capturing this is a major challenge for curatorial practice, but if we are to grasp something of the rich biography of things, of wresting them from the rigid and rarefied spaces of Platonic *museality*, we need to imagine ways of showing how an object moves in temporality rather than transcends it. Installation and programming are obviously key, but the education of curators and staff is indispensable. These must be fed by collecting and research. Museums must seek out objects that expand collections in different directions, and they must sponsor or undertake research programs that put the holdings to work, making them available for curators and scholars as well as audiences. Objects may be regarded as novels with many chapters. If they can open up artifacts to museum visitors in this way, they will allow multiple connections or points of entry to them. Objects are parts of networks of humans and nonhuman artifacts, and they are afloat in temporal flows. These may be understood as two vital axes on which every artifact can be mapped. The creative challenge is therefore how to show these aspects in the presentation of objects.

Notes

1. Derrida (1997). The written signifier, Derrida argued, "is always technical and representative. It has no constitutive meaning" (11). For a helpful situating of Derrida, see Vásquez (2011, 225–229).
2. Important texts in reception studies include Fish (1980) and Radway (1984). In religious studies, see Orsi (1996).
3. August Wilhelm Schlegel, "Der Bund der Kirche und die Künste" (1800), in Busch and Beyrodt (1982, 54; my translation).
4. Seton (2012). The American Board of Commissioners for Foreign Missions also established a missionary museum in Boston—see Knight (1847). On the objects collected in the South Pacific by the LMS, see King (2011; 2015).
5. Crow targeted his remarks at one book in particular, which had articulated a concept of visual culture that he considered objectionable: Bryson, Holly, and Moxey (1994).

References

Alpers, Svetlana. 1983. *The Art of Describing: Dutch Art in the Seventeenth Century*. Chicago: University of Chicago Press.
Anon. 1820. "Destruction of Idols." *Missionary Register* March: 127.
Anon. 1843. "London Missionary Society." *Illustrated London News* 55 (May 20): 342.
Barthes, Roland. 1972. *Mythologies*. Translated by Annette Lavers. New York: Hill and Wang.
Barthes, Roland. 1981. *Camera Lucida*. Translated by Richard Howard. Berkeley: University of California Press.

Baxandall, Michael. 1972. *Painting and Experience in Fifteenth Century Italy: A Primer on the Social History of Pictorial Style*. Oxford: Oxford University Press.

Bryson, Norman. 1984. *Word and Image: French Painting of the Ancien Régime*. Cambridge: Cambridge University Press.

Bryson, Norman, Michael Ann Holly, and Keith Moxey (eds.). 1994. *Visual Culture: Images and Interpretations*. Hanover: University Press of New England.

Buchli, Victor. 2002. "Introduction." In *The Material Culture Reader*, edited by Victor Buchli, 1–22. Oxford: Berg.

Busch, Werner, and Wolfgang Beyrodt (eds.). 1982. *Kunsttheorie und Malerei Kunstwissenschaft*, vol. 1 in Kunsttheorie und Kunstgeschichte des 19. Jahrhunderts in Deutschland: Texte und Dokumente, 3 vols. Stuttgart: Philipp Reclam Jun.

Clark, Elisabeth A. 2004. *History, Theory, Text: Historians and the Linguistic Turn*. Cambridge: Harvard University Press.

Culyba, Rebecca J., Carol A. Heimer, and JuLeigh Coleman Petty. 2004. "The Ethnographic Turn: Fact, Fashion, or Fiction?" *Qualitative Sociology* 27 (4) (Winter): 365–389.

Davis, Richard. 1997. *Lives of Indian Images*. Princeton: Princeton University Press.

Derrida, Jacques. 1997. *Of Grammatology*. Corrected edition. Translated by Gayatri Chakravorty Spivak. Baltimore: The Johns Hopkins University Press.

Dudley, Sandra H. (ed.). 2010. *Museum Materialities: Objects, Engagements, Interpretations*. London: Routledge.

Dudley, Sandra H. (ed.). 2011. *The Thing about Museums: Objects and Experience, Representation and Contestation: Essays in Honour of Professor Susan M. Pearce*. Abingdon and New York: Routledge.

Dudley, Sandra H. (ed.). 2012. *Museum Objects: Experiencing the Properties of Things*. London: Routledge.

Fish, Stanley. 1980. *Is There a Text in the Class? The Authority of Interpretive Communities*. Cambridge: Harvard University Press.

Freedberg, David. 1989. *The Power of Images: Studies in the History and Theory of Response*. Chicago: University of Chicago Press.

Hazard, Sonia. 2013. "The Material Turn in the Study of Religion." *Religion and Society: Advances in Research* 4: 58.

Hicks, Dan. 2010. "The Material-Cultural Turn: Event and Effect." In *The Oxford Handbook of Material Culture Studies*, edited by Dan Hicks and Mary C. Beaudry, 25–98. Oxford: Oxford University Press.

Howells, Richard. 2003. *Visual Culture*. Cambridge: Polity.

Howes, Graham. 2007. *The Art of the Sacred: An Introduction to the Aesthetics of Art and Belief*. London: I.B. Tauris.

Ingold, Tim. 2012. "Making Culture and Weaving the World." In *Museum Objects: Experiencing the Properties of Things*, edited by Sandra Dudley, 368–384. London: Routledge.

Jay, Martin. 1993. *Downcast Eyes: The Denigration of Vision in Twentieth-Century French Thought*. Oakland: University of California.

King, David Shaw. 2011. *Food for the Flames: Idols and Missionaries in Central Polynesia*. San Francisco: Beak Press.

King, David Shaw. 2015. *Missionaries and Idols in Polynesia*, exhibition catalog, Brunei Gallery, SOAS, University of London. San Francisco: Beak Press.

King, E. Frances. 2010. *Material Religion and Popular Culture*. London: Routledge.

Knight, Helen C. 1847. *Missionary Cabinet*. Boston: Massachusetts Sabbath School Society.

Mirzoeff, Nicholas (ed.). 2002. *The Visual Culture Reader*, revised edition. London: Routledge.

Mitchell, W. J. T. (ed.). 1980. *The Language of Images*. Chicago: University of Chicago Press.

Mitchell, W. J. T. 1994. "The Pictorial Turn." In *Picture Theory*, edited by W. J. T. Mitchell, 11–34. Chicago: University of Chicago Press,

Morgan, David. 1998. *Visual Piety: A History and Theory of Popular Religious Images*. Berkeley: University of California Press.

Morgan, David. 2015. "Thing." In *Key Terms in Material Religion*, edited by S. Brent Plate, 253–259. London: Bloomsbury.

Orsi, Robert A. 1996. *Thank You, St. Jude: Women's Devotion to the Patron Saint of Hopeless Causes*. New Haven: Yale University Press.

Paine, Crispin (ed.). 2000. *Godly Things: Museums, Objects, and Religion*. London: Leicester University Press.

Paine, Crispin. 2013. *Religious Objects in Museums: Private Lives and Public Duties*. London: Bloomsbury.

Pearce, Susan M. (ed.). 1994. *Interpreting Objects and Collections*. London: Routledge.

Pearce, Susan M. 1998. *Collecting in Contemporary Practice*. London: SAGE.

Pinney, Christopher. 2004. *"Photos of the Gods": The Printed Image and Political Struggle in India*. London: Reaktion.

Pitt-Rivers, Augustus Henry Lane-Fox. 1900. *Antique Works of Art from Benin*. London: Printed privately.

Radway, Janice A. 1984. *Reading the Romance: Women, Patriarchy, and Popular Literature*. Chapel Hill: University of North Carolina Press.

Rydell, Robert W. 1984. *All the World's a Fair: Visions of Empire at American International Expositions, 1876–1916*. Chicago: University of Chicago Press.

Seton, Rosemary. 2012. "Reconstructing the Museum of the London Missionary Society." *Material Religion* 8 (1): 98–102.

Stocking, George W., Jr. (ed.). 1985. *Objects and Others: Essays on Museums and Material Culture*. Madison: University of Wisconsin Press.

Sturken, Marita, and Lisa Cartwright. 2001. *Practices of Looking: An Introduction to Visual Culture*. Oxford: Oxford University Press.

Vásquez, Manuel A. 2011. *More Than Belief: A Materialist Theory of Religion*. Oxford: Oxford University Press.

"Visual Culture Questionnaire." 1996. *October* 77 (Summer): 25–70.

Walker John A., and Sarah Chaplin. 1997. *Visual Culture: An Introduction*. Manchester: Manchester University Press.

Winckelmann, Johann Joachim. 1987. *Reflections on the Imitation of Greek Works in Painting and Sculpture, translated by* Elfriede Heyer and Roger C. Norton. La Salle, IL: Open Court.

Wingfield, Chris. 2010. "Touching the Buddha: Encounters with a Charismatic Object." In *Museum Materialities: Objects, Engagements, Interpretations*, edited by Sandra Dudley, 53–70. London: Routledge.

14 Community-Led Museums Exploring Religious Life in Canada: Abbotsford's Sikh Heritage Museum and Mennonite Heritage Museum

MATTHEW FRANCIS

In March 2016, Toronto's Aga Khan Museum took out a full-page ad in *The Globe and Mail*—one of Canada's hallmark newspapers—to promote its upcoming speakers' series "Islam and Muslims in the Twenty-First Century." Six lectures, with titles such as "Of Hockey and Hijab: New Reflections on Being Female, Canadian, and Muslim," were designed to "explore questions of identity and belonging, youth and integration, and immigration and settlement" (Anon 2016). The ad went on to highlight this as an opportunity to "take part in Q&A sessions following each lecture—and share your thoughts about Canada and the world in the 21st twenty-first century!"

Such endeavors on the part of Canadian museums may be seen to follow trends of participation espoused compellingly by Nina Simon (2010) and other advocates of community-led principles of curation. They also comply with a history wherein public museums in Canada—particularly in the twentieth century—have treated religion and lived the religious life with a fair degree of reluctance. It is one thing for a museum with a specifically religious mandate or supporting constituency—such as the Aga Khan Museum—to present symposia like the one prominently and expensively advertised in *The Globe and Mail*, but it would appear to be rather a different matter for such a series to be offered by the likes of our Provincial museums, which are publicly funded, or by the many small history museums—local or regional—dotting the Canadian landscape. Canadian public policy and discourse since the 1960s—not least in Quebec, but also through official efforts of the government of Canada to promote multiculturalism—have contributed to an enlarged secular consciousness, whereby public institutions are understandably wary of granting priority or privilege to any one group or religious tradition, and all the more so to a group that has played an historically dominant or normative role in Canadian society.

This kind of uniquely Canadian multicultural secularity, which may have several advantages, has been often expressed in our museums community. On the whole, it has led to the exclusion of lived religion or spirituality from the work of many public museums, and the increased proliferation of stakeholder-based museums, presenting their own stories and material cultures in their own ways. It begs the question of the mandate of our public museums as contexts for meaningful interaction, addressing important issues of past, present, and future. I would like to suggest (drawing

upon Nina Simon's work, and that of David Goa and others) that community-based, and even community-led, fieldwork in lived religion may be a tonic for Canadian public museums' allergies to specifically religious content. This approach may provide a way forward in enriching the conversations museums can cultivate, while not compromising our public mandates.

Two institutions representing distinct cultural communities—the Sikh Heritage Museum and the Mennonite Heritage Museum, both located in Abbotsford, British Columbia—are examples of a curatorial phenomenon which isn't new, but appears to be on the rise. Recently established within the same mid-size Canadian city (pop. 138,000), each organization has emerged from within its own group and cultural milieu, but seeks to present these "interior" stories both internally and also externally to broader audiences. Interwoven with and inseparable from the life of these two cultural communities is their own specifically religious context, with compelling comparisons, including similarities and differences, between the Sikh and Mennonite experience in Canada. A third strand present in the conversation is the work of the Reach Gallery Museum, a city-funded public Gallery-Museum also located in Abbotsford, which has made intentional efforts to include Sikh and Mennonite content, though in a way that is consistent with the typical presentation of religious groups in Canadian public museums. The community of Abbotsford, then, has functioned as a sort of petri dish for what Shelly Nixon (2012) has called "Faith in a Glass Case," the curation of religious life in Canadian museums.

Ethnographic and museological fieldwork in religious communities is nothing new, and indeed scholars like David Goa, in his work developing the Folklife program at the Provincial Museum of Alberta (now the Royal Alberta Museum), have honed this work in the Canadian context. His fieldwork culminated in the exhibition *Anno Domini: Jesus through the Centuries* (2000–2001), one of the few examples of a major Provincial museum in Canada exploring the place of religion, and especially Christianity. Goa (2013, 89–90) describes the essential posture of his curatorial approach as one of a kind of "spiritual friendship":

> The gift of spiritual friendship is the care of the soul (*custos animi*). Curatorial leadership is caring for the struggle for meaning in the lives of those with whom we work and caring for tradition, memory, experience, and place as landscapes of meaning for a whole community . . . The twentieth century has been a crucible for this theme, and, given the pluralism of Canada, it has been vividly so here. In a sense our country is a living laboratory of continuity and change in tradition and community.

At first glance, Sikhs and Mennonites may not appear to have much in common. Their origins are separated by continents, languages, and a basic religious ethos. However, from a comparative religions perspective, intriguing points may be noticed. Such comparisons are not intended to minimize real historic and religious differences, but rather to consider how each group might see itself, and how they may be understood by others. In order to understand why both Mennonites and Sikhs in a

Canadian city like Abbotsford would be motivated to develop their own independent museums, tracing the basic facets of their identity is valid. As Goa (2013, 81) suggests, "[P]rimary field research requires a working knowledge of the cultural map of the community we wish to know."

Both Sikhism and the Mennonite tradition began in the fifteenth and sixteenth centuries, catalyzed by the teaching of two significant individuals: Guru Nanak (1469–1539) and Menno Simons (1496–1561). The Mennonite expression of the Christian faith, along with other Anabaptist movements, was a self-defined "radical" aspect of the larger Protestant Reformation taking place at the time within Western European Christianity. The Sikh faith was a new religious movement emerging from within, but distinct from, the dominant Hindu and minority Muslim religions of the Indian subcontinent. Both religious trajectories—Sikh and Mennonite—saw themselves as redefining the typical religious understandings of their places and times. In this sense, both founders can be seen as "reformers" in circumstances characterized by sweeping changes. Both traditions soon gained traction amid minority populations that experienced varying degrees of persecution for their religious beliefs and practices, at first in their homelands and then abroad.

Mennonite retention of the *Platdietsch* language and Sikh use of written *Gurmukhi* in their sacred texts is one other area of commonality between the two traditions, in addition to kinship-based ways of life and work. While both Sikhs and Mennonites flourished in agrarian settings and are renowned for their agricultural successes, Mennonites are historically pacifists, while many Sikhs have gained prestige through military service. Some members of both the Mennonite and Sikh traditions have at times embraced distinctive modes of dress and appearance, for reasons associated with their creeds and modes of life. Other characterizations of difference may be equally illustrative.

Sikh and Mennonite diasporas, particularly in the twentieth century, have led to dynamic immigration into Canada, with significant settlement in the Fraser Valley region of British Columbia. Typically, the agricultural experience of both groups opened up opportunities for work in that sector. In the words of Satwinder Bains (2013, 171), speaking of the Sikh pioneers to Abbotsford but equally truly of many Mennonites, initially they "were attracted by offers of work in a raw and newly colonized land." Each group has its own unique story which has grown out of shared experiences of displacement, marginalization, liminality, and collective and personal struggles to build good lives in a new place, which may or may not be perceived as a new "home."

Museum Space and Place—Adaptively Reused and Purpose-Built

The Sikh and Mennonite Heritage Museums are very different buildings, and the scope and scale of each represent that organization's development to date. One is an annex to an historic place of worship, and the other is purpose-built for exhibition

and interpretation. Their scope and scale also differ, primarily due to each community's patronage relationships. The Mennonite Heritage Museum has just built a new facility that is impressive in many respects. The Sikh Heritage Museum has sensitively reused a heritage environment to animate its program. Both organizations are continuing to reach out through their collections and educational work to their own cultural communities and beyond, to engage and fulfill their goals.

The Mennonite Heritage Museum, while related to an existing Mennonite Historical Society in the region, was primarily the dream of a small network, with an ambitious purpose-built facility and grounds funded by one major benefactor. With a grand opening of their ambitious new building in early 2016, the institution has a small cadre of full-time staff with professional credentials, and a strong mandate to present Mennonite and Anabaptist history to a public audience. The facility is bright, large, and the exhibit design is executed with a high level of professionalism, representing best practice for the inclusion of technology (Figure 14.1).

The Sikh Heritage Museum—articulated specifically as an ethnographic museum—has been developed entirely by knowledgeable volunteers, within the space of the historic *langar* of the Gur Sikh Temple, a designated National Historic Site of Canada. The historic temple, located upstairs, still functions as a Sikh place of worship, with regular prayers and the reading of the sacred scriptures, the Sri Guru Granth Sahib. Downstairs, in the modest community hall, the museum has been sensitively developed within the century-old premises. It is a richly storied setting, replete with layers of Sikh experience that the new Mennonite Heritage Museum will take decades to accrue.

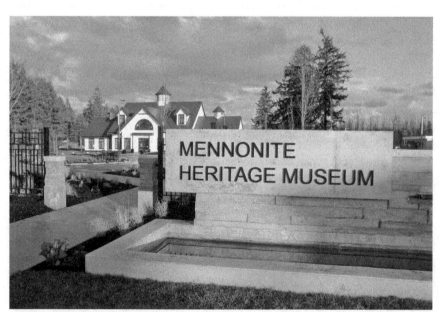

Figure 14.1 Mennonite Heritage Museum, Abbotsford, British Columbia, 2016. Copyright Modfos 2016. Used by permission.

The Sikh Heritage Museum is a project of "recovered" history that has been recuperated from an earlier rejection and omission by the collective porous Canadian memory of fact and reality. Macdonald and Fyfe (1998) suggest that some collections in the past have not been held as "museum worthy" and that diverse communities are starting to develop responses to their own histories with modes of representation that are both politically and socially significant (Bains 2013, 173).

Conducive to this historiographical approach, the space etched out for the museum is a recovered space, consciously and carefully re-presented for curatorial purposes, creatively staging a broad range of exhibits exploring numerous topics and themes, including feminist takes on Sikh culture and lived religious experience. The physical environment, while typical of many museums with its exhibit panels and artefact cases, also maintains some of the historical "feel" of its historical role as the *langar*. While participants describe this more as a matter of course, or necessity, perhaps it is not accidental that the place employed for this new museum was the communal kitchen and hall characteristic of all Sikh gurdwaras. While not a historical place of ritual, the *langar* still plays a critical role in the life of the Sikh community.

Both the Sikh Heritage Museum and its Mennonite counterpart may be thought of as "denominational" museums, best falling into that category, according to Nixon's (2012, 23) taxonomy of Canadian museums presenting religious subject matter. While both use integrated ethnographic approaches, they are equally free to treat their own specifically religious subjects, exploring ritual life and theological distinctives through their own lenses, in ways often deemed outside the scope or mandates of public institutions in Canada.

Across town, but also in Abbotsford, the Reach Gallery Museum (www.thereach.ca), established by the City of Abbotsford as a cultural center in 2008 has also explored the Mennonite and Sikh experience as cultural communities. The year 2009 saw the launch of *A Common Thread: Textiles from Stó:lō, South Asian & Mennonite Communities*. This exhibition drew together not only the Mennonite and Indo-Pakistani communities, but also the "People of the River," the local Indigenous people, exploring traditional narratives and mythologies through quilts and textile practices. Their exhibitions since that time have raised themes arising in these and many other cultural communities. It remains to be seen whether themes approaching the religious life more specifically will be explored, but smaller regional museums in Canada may be positioned to take on that work, and community-led fieldwork may prove to be one way forward. In the meantime, we will continue to see independent institutions such as the Sikh Heritage Museum and the Mennonite Heritage Museum filling that gap in both public and private realms.

References

Anon. 2016. Advertisement in *Focus* section, following p. F10, *The Globe and Mail*, Saturday, March 26.

Bains, Satwinder. 2013. "When Old Becomes New and the Telling Is Re-told: Sikh Stories within Museum Walls." In *Diverse Spaces: Identity, Heritage, and Community in Canadian Public Culture*, edited by Susan L.T. Ashley. Newcastle: Cambridge Scholars Publishing.

Goa, David. 2013. *Working in the Fields of Meaning: Cultural Communities, Museums, and the New Pluralism*. Edmonton: University of Alberta/Chester Ronning Centre for the Study of Religion and Public Life.

Macdonald, Sharon, and Gordon Fyfe (eds.). 1998. *Theorizing Museums: Representing Identity and Diversity in a Changing World.* Sociological Review Monographs. Oxford: Blackwell.

Nixon, Shelly. 2012. "Faith in a Glass Case." PhD dissertation, University of Ottawa.

Simon, Nina. 2010. *The Participatory Museum*. Santa Cruz: Museum 2.0.

15 Sacred Objects and Conservation: The Changing Impact of Sacred Objects on Conservators

SAMANTHA HAMILTON

You can't beat that, can you, when first-hand knowledge is coming from someone with experience.

—John "Sandy" Atkinson

The Emergence of Conservation

Italian Renaissance artists happily retouched and repainted religious icons "to revive the colors to the desired freshness . . . or to update the paintings' iconography" (Conti 2004, 106–107). This focus on the aesthetic revival of religious artworks was also achieved through cleaning and the removal of darkened varnishes. However, controversy over the extent of such intervention eventually led to the call, in many European countries, for "conservation instead of restoration" (Koller 2000, 6). John Ruskin (1849, 161–162), notably, believed that "the true meaning of the word restoration . . . [is] total destruction . . . a destruction accompanied with false description of the thing destroyed." But in contrast Eugène Viollet-le-Duc (1996) ascertained that restoration was an opportunity to incorporate present values based on comprehensive knowledge of the past.

Meanwhile restoration was no longer performed by artists, but by an emerging conservation profession which in the nineteenth century began approaching the preservation of cultural materials through a scientific lens (Stoner 2005). This scientific focus also became foundational in the training of conservation-restoration specialists, particularly after the destruction caused across Europe by Word War II (Marconi 1961). The now-orthodox attitude was expressed in a whole series of manifestos and professional codes, beginning with *The Manifesto of the Society for the Protection of Ancient Buildings* (1877) which recommended "protection in place of restoration" through "staving off decay by daily care" (Morris 1877, 2).

Attitudes, however, did not remain static. Whereas in 1984 the International Council of Museums-Conservation Committee (ICOM-CC) described the main aim of the profession as the comprehension of the "material aspect of objects of historic and artistic significance in order to prevent their decay and to enhance our understanding of them" (Isar, von Imhoff, and von Imhoff 1984, 2), by 2008 it had agreed that

in conservation "all measures and actions should respect the significance and the physical properties of the cultural heritage item" (ICOM-CC 2008, 1).

This addition of "significance" to the physical properties of a heritage item that a conservator should respect was a major development. There is now an understanding

> that the significance of an art work does not reside in the physical fabric of the object alone but in the meanings that people attribute to it and the feelings of connection and ownership that they have for it. Intangible aspects of the past that are connected with, or experienced through, the object are considered heritage as much as the physical fabric of the object itself. (Wain 2011, 1)

Much of the change in conservators' thinking can also be attributed to working with Indigenous sacred materials in a museum context. The formation of "ethnographic conservation" as a specialization in the twenty-first century has seen the exploration of the conservator's role in understanding the intangible aspects of sacred objects. It has, too, seen the involvement at all stages of source communities, and the development of appropriate training, guidelines, and approaches to preservation and treatment (ICOM-CC n.d.; Walston 1978; Heikell 1995; Clavir 1996; Sadongei 2006; Pearlstein 2007; Sloggett 2009; Pandozy 2015).

In the United States and Canada the approach to preserving sacred objects has also been influenced by the Native American Graves Protection and Repatriation Act (NAGPRA) (1990) and the Task Force Report on Museums and First Peoples (1992), while around the world the United Nations' Convention for the Safeguarding of Intangible Cultural Heritage (2003), the Protection and Promotion of the Diversity of Cultural Expressions (2005), and the Declaration on the Rights of Indigenous Peoples (2007) have provided further support in devising ethical standards (Clavir 2015; Welsh 1991; Odegaard 1995).

The Treatment of Indigenous Sacred Objects

There are various examples of how conservators have ethically approached the treatment of Indigenous sacred museum objects, including the identification of harmful pesticide residues on materials which have been repatriated or loaned back to Native American communities. This collaborative work has also seen the creation of suitable care and handling procedures for both museum workers and community members (Hill and Reuben 2007; Jemison 2001; Osorio 2001; Cross, Odegaard, and Riley 2010). Aside from this Wolfe and Mibach (1983) considered how modern, scientific conservation treatment could interfere with the integrity of the object and destroy its functional and spiritual value. The authors explored issues such as the legal ownership of collections and the conflict of value systems between Native American community members and museum professionals. As a step toward developing appropriate conservation methods, Wolfe and Mibach produced guidelines which encourage conservators to work with religious rather than political representatives from source communities; to be prepared for varying opinions and information

from different community groups; to do the absolute minimum needed to preserve the object; and to form a working group to deal with the broader aspects of conserving Native American sacred objects.

In another example Mellor (1992) presents the issues and complexities related to the appropriate exhibition and conservation of sacred African objects. The author poses questions around the treatment and display of a Yoruba beaded crown and an Igala shrine figure. The crown is a premier piece of divine regalia, which needs the internal lining mended, however, in Yoruba culture only the king may look inside. While the shrine figure, proposed for museum display, is a restricted object which should only be seen by people of a specific age, sex, or initiation status. Through personal research, consultation with anthropologists and curators, yet without direct contact with the source communities, Mellor interprets the cultural sacredness, spiritual context, purpose, and relevance of various objects. He determines that conservation materials and techniques should not have any negative implications and resolves that collections care need not involve cultural actions such as feeding, washing, dancing, spitting, beating, or sacrificial offerings, as the objects have been removed from their original context. Instead Mellor proposes that a well-informed conservator should be able to identify appropriate treatment when they have considered all aspects of an object—including its intangible qualities.

Australian Aboriginal Sacred Art

Australian Aboriginal art represents one of the longest continuous traditions in the world, dating back 50,000 years. Art is a reflection of the diverse social structures, language groups, religious beliefs, and ceremonies from across the vast continent. This creative expression connects the present to the past and human beings with the supernatural world and activates the powers of the ancestral beings. It is an expression of identity and connection to the land. It is central to Aboriginal life and is inherently connected to the spiritual domain often referred to as the *Dreaming*. The *Dreaming* is a European term which Aboriginal people use to "describe the spiritual, natural and moral order of the cosmos" (Caruana 2012, 10). Morton (2000, 9) quotes Paddy Japalijarri Stewart: "My Dreaming is the kangaroo Dreaming, the eagle Dreaming and budgerigar Dreaming so I have three kinds of Dreaming . . . [This] is what I have to teach my son, and my son has to teach his son the same way my father taught me, and that's the way it will go on . . . and no-one knows when . . . [it] will ever end."

In precolonial times, Aboriginal art was made to fulfill cultural needs and for ceremonial purposes; it was to be viewed only by the initiated with an appropriate level of awareness. These objects are referred to as secret/sacred and are part of a system of restricted knowledge which could be related to gender, age, or the protection of the rights and interests of a certain social group or clan. However post colonialism a significant amount of this secret/sacred material has emerged in museums for public viewing (Caruana 2012).

The Museum Setting

Museums across the world house significant collections of sacred Australian Aboriginal and Torres Strait Islander objects, mostly collected from the end of the nineteenth to the early twentieth century. Such objects were not initially seen as representing the spiritual domain, but as curiosities and examples of materials from exotic locations (Pickering 2015; Morphy 1998). But sacred objects have a living meaning; too often they are taken with inadequate documentation out of their context into a museum, where they are wrongly interpreted (Batty 2014).

Langton (2000, 16) believes that "for some art historians and anthropologists, it is self-evident that many works of 'Aboriginal art' are rather artefacts of the colonial encounter. But there remains the difficulty of mapping out the detailed world of Aboriginal religious life and culture proper—the world which lies behind the encounter—and of acknowledging the density of signs, of knowledge, and of images that Aboriginal people bring to this encounter."

Although museum curators can be experts in Indigenous cultures they may be unaware "of the specific cultural context of these objects, in particular the distress that their open-display, or retention, can cause to Australian Indigenous people" (Pickering 2015, 428). There is an ethical dilemma for museum professionals and traditional owners: who has authority to speak on the presentation and preservation of sacred materials? Consultation with community members is standard practice and follows protocols involving Indigenous Cultural and Intellectual Property (ICIP) and the rights of Aboriginal people to make decisions about the interpretation and treatment of secret/sacred materials (Mundine 2010; Arts Law Centre of Australia 2011; Australia Arts Council 2007; Aboriginal and Torres Strait Islander Library 2012; Museums Australia 2005). In Australia at least, consultation with community representatives about the preservation of sacred materials has generally been carried out by curators rather than by conservators, but conservators are increasingly working with curators to use existing relationships and established consultation processes to create a shared space for interdisciplinary knowledge transfer (Hamilton 2013; Hamilton and Allen 2013; Hamilton and Paton 2015; Davidson et al. 2014; Carrington et al. 2014), and professional conservation bodies in Australia, New Zealand, and Canada have all updated their codes of ethics to include respect for the sacred integrity or cultural significance of cultural materials (Smith and Scott 2010; CAC/CAPC 2000).

The *Gupapuyngu Bark Painting Project*

The *Gupapuyngu Bark Painting Project* at Museum Victoria (MV) is an example of a dialogue between senior curator Lindy Allen, conservator Samantha Hamilton, and traditional owners and Gupapuyngu elders, Indigenous scholar Dr. Gumbula, and his brother and artist Milay Gaykamanggu. The project explored the challenges of conventional conservation practice, and the efficacy of a cross-cultural and collaborative research methodology, to ensure cultural integrity and the preservation of Indigenous

cultural patrimony in a museum setting. The aim of the project was to establish culturally appropriate treatment and preservation regimes for two bark paintings in the Donald Thomson Collection (Figure 15.1) (Hamilton and Allen 2015). This collection is relatively unknown but is "one of the most comprehensive and significant collections of Aboriginal cultural heritage material in the world," collected in the mid-1930s and early 1940s (Museum Victoria n.d.).

Figure 15.1 Painting, bark Birrkuda (Native Bee) Dhaawu, 1937, by Ngarritj Ngarritj (Attributed), Gupapuyngu Daygurrgurr clan, eastern Arnhem Land, Northern Territory, Australia: Donald Thomson Collection. Copyright Museums Victoria.

The bark paintings in question were excluded from Museum Victoria's 2009 *Ancestral Power and the Aesthetic* exhibition (the first exhibition to showcase the extraordinary sacred clan designs from eastern and central Arnhem Land in northern Australia) because of their poor condition. Donald Thomson's field writings reveal the complexities associated with the painting traditions of the Yolngu (the people of Arnhem Land) and the fundamental importance of *minytji* (painted designs). He described the significance of achieving a fine aesthetic quality or "brilliance" in Yolngu art and its link to *marr* (strength, spiritual power) and the power of the *wangarr* (totemic ancestors). These sacred clan designs were painted by men of high ceremonial status on the bodies of boys and men during specific ceremonies, and have cultural sensitivities and gender restrictions (Allen 2010; Gumbula 2011). As a result questions arose for the conservator around the cultural implications associated with the treatment or handling of these works, the value of their aesthetic integrity for future generations, the integration of traditional materials and techniques for preservation purposes, and what is an acceptable level of intervention in the opinion of the traditional owners.

The consultation and collaboration was spread over a twelve-month period, and from the initial discussion at the Melbourne Museum it was clear that the Western concept of preservation and conservation treatment in a museum setting was foreign to the Gupapuyngu. Dr. Gumbula expressed that he was part of a living culture that actively engaged with and painted these sacred designs. He went on to say that if these paintings were in his community they would be buried and new ones painted (Gumbula 2011). Through subsequent meetings and conversations involving *Yolgnu matha* (the language spoken across Arnhem Land), the treatment proposal explored various avenues. These included the traditional owners considering repainting areas of lost paint—especially the white, which is a common issue associated with bark paintings—to restore the aesthetic brilliance and shine associated with these images and their associated power. They also contemplated the idea of Milay being trained to perform the desired conservation treatment.

However as the relationship developed and knowledge was exchanged and created through demonstrations and the exploration of Aboriginal perspectives and conservation ethics (Figure 15.2), the traditional owners decided that in fact the conservator should perform the treatment according to current conservation standards, with the addition of prescribed instructions. These included that the paint should be consolidated with the least interventive method which would not directly interfere with the original "hand" of their grandfather, who as a result of this project and associated archival research was identified as the artist. Furthermore, the Elders expressed their desire for a cellulose-based adhesive to be used in this process as it now aligned with their understanding of the chemical composition of the wooden support. This was referred to as "bush medicine" (Gumbula and Gaykamanggu 2012).

As a result of this project, the artist of the sacred art works was identified, stronger relationships were developed between museum departments, new knowledge was created between the museum and community, community knowledge and wishes

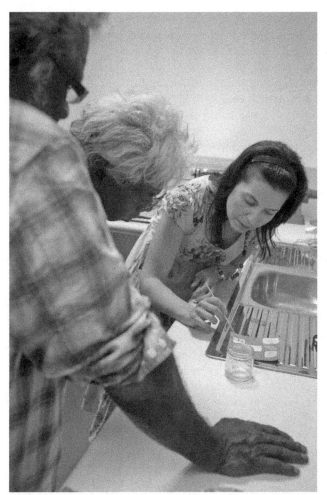

Figure 15.2 The author demonstrating a conservation technique on samples of bark.
Copyright Museums Victoria. Photo by Benjamin Healley.

were integrated into the conservation decision-making process, and new museum documentation was created which included the Yolgnu language.

References

Aboriginal and Torres Strait Islander Library. 2012. *Protocols for Libraries, Archives and Information Services*, Information and Resource Network Inc. http://www.aiatsis.gov.au/atsilirn/protocols.php (accessed January 23, 2011).

Allen, Lindy. 2010. *Ancestral Power and the Aesthetic, Arnhem Land Paintings and Objects from the Donald Thomson Collection.* Exhibition catalogue. Melbourne: Museum Victoria.

Arts Law Centre of Australia. 2011. "Indigenous Cultural and Intellectual Property." AITB information sheet. Australian Government National Arts and Crafts Industry Support.

http://www.artslaw.com.au/images/uploads/aitb/AITB_information_sheet_-_Indigenous_
cultural_and_intellectual_property_ICIP_2.pdf (accessed November 23, 2015).

Australia Council for the Arts. 2007. *Protocols for Producing Indigenous Australian Visual
Arts*, second edition. http://www.australiacouncil.gov.au/__data/assets/pdf_file/0004/
32368/Visual_arts_protocol_guide.pdf (accessed January 23, 2011).

Batty, P. 2014. "The Tywerrenge as an Artefact of Rule: The (Post) Colonial Life of a Secret/
Sacred Aboriginal Object." *History and Anthropology* 25 (2): 296–311.

Canadian Association for Conservation of Cultural Property and Canadian Association of
Professional Conservators. 2000. *Code of Ethics and Guidance for Practice*. https://cdn.
metricmarketing.ca/www.cac-accr.ca/files/pdf/ecode.pdf (accessed September 20, 2014).

Carrington, Sade, Jonathan Kimberley, Vanessa Kowalski, Sophie Lewincamp, Patrick
Mung Mung, Gabriel Nodea, Roseleen Park, Marcelle Scott, and Robyn Sloggett. 2014.
"Conservation and the Production of Shared Knowledge." *ICOM-CC 17th Triennial
Conference Preprints, Melbourne, 15–19 September*, edited by Janet Bridgland.

Caruana, Wally. 2012. *Aboriginal Art*, third edition. London: Thames & Hudson.

Clavir, Miriam. 1996. "Reflections on Changes in Museums and the Conservation
of Collections from Indigenous Peoples." *Journal of the American Institute for
Conservation* 35 (2): 99–107.

Clavir, Miriam. 2015. "Preserving the Physical Object in Changing Cultural Contexts." In *The
International Handbooks of Museum Studies: Museum Transformations*, edited by Annie
E. Coombes and Ruth B. Phillips, 387–412. New York: John Wiley & Sons.

Conti, Alessandro. 2004. "History of Restoration." In *Issues in the Conservation of
Paintings*, edited by David Bomford and Mark Leonard. Reading in Conservation series,
102–122. Los Angeles: Getty Conservation Institute.

Cross , Peggi S., Nancy Odegaard, and Mark R. Riley. 2010 "Lipoic Acid Formulations
for the Removal of Arsenic and Mercury from Museum Artifact Materials." *Journal of
Archaeological Science* 37: 1922–1928.

Davidson, Christina, Vanessa Kowalski, Vanessa Kredler, Djambawa Marawili, Robyn
Sloggett, and Will Stubbs. 2014. "Harvesting Traditional Knowledge: The Conservation
of Indigenous Australian Bark Paintings." *ICOM-CC 17th Triennial Conference Preprints,
Melbourne, 15–19 September*, edited by Janet Bridgland.

Gumbula, Dr. 2011. Personal communication between Dr. Gumbula and Samantha
Hamilton, Melbourne, November 29.

Gumbula, Dr., and M. Gaykamanggu, 2012. Personal communication between
Dr. Gumbula, Milay Gaykamanggu, and Samantha Hamilton, Melbourne, October 12.

Hamilton, Samantha. 2013. "Conservation Community Consultation during the Bunjilaka
Redevelopment Project at Melbourne Museum." Paper presented at the *Australian
Institute for the Conservation of Cultural Materials (AICCM) Contexts for Conservation*,
The Science Exchange, Adelaide, SA, 23–25. http://www.aiccm.org.au/conservation-
community-consultation-during-bunjilaka-redevelopment-project-melbourne-museum
(accessed October 25, 2014).

Hamilton, Samantha, and Lindy Allen. 2013. *Gupapuyngu Bark Painting Project*. http://
aiccm.org.au/projects/indigenous-projects/gupapuyngu-bark-painting (accessed
October 25, 2014).

Hamilton, Samantha, and Lindy Allen. 2015. "To Shine Again or Just Survive? Gupapuyngu
Bark Paintings in the Donald Thomson Collection." Paper presented at the *Museums*

Australia National Conference 2015, A Cultural Cacophony, Town Hall, Sydney, 21–24 May 2015.

Hamilton, Samantha, and Steaphan Paton. 2015. "Boorun's Canoe." *AICCM Bulletin* 36 (2): 105–115.

Heikell, Vicki-Anne. 1995. "The Conservator's Approach to Sacred Art." *WAAC Newsletter*, 17 (3). Western Association for Art Conservation (WAAC). http://cool.conservation-us.org/waac/wn/wn17/wn17-3/wn17-310.html (accessed August 27, 2015).

Hill, Richard W., and Peter Reuben. 2007. "Decontaminating Sacred Objects of the Haudenosaunee." Proceedings of a Conference Symposium *Preserving Aboriginal Heritage: Technical and Traditional Approaches, Ottawa, Canada, September 24–28, 2007*, edited by Carole Dignard, Kate Helwig, Janet Mason, Kathy Nanowin, and Thomas Stone, 195–199. Ottawa: Canadian Conservation Institute.

International Council of Museums—Committee for Conservation (ICOM-CC). 2008. *Terminology to Characterize the Conservation of Tangible Cultural Heritage*. International Council of Museums—Committee for Conservation (ICOM-CC). http://www.icom-cc.org/242/about-icom-cc/what-is-conversation/terminology/#.Vq6_1LJ95D8 (accessed September 20, 2014).

International Council of Museums—Committee for Conservation (ICOM-CC). n.d. *Objects from Indigenous and World Cultures Working Group*. International Council of Museums—Committee for Conservation (ICOM-CC). http://www.icom-cc.org/26/working-groups/objects-from-indigenous-and-world-cultures/ (accessed September 20, 2014).

Isar, Raj Bridgland, Janet and Christoph von Imhoff. 1984. *The Conservator-Restorer: A Definition of the Profession*. International Committee of Museums Conservation Committee (ICOM-CC). http://www.icom-cc.org/47/history-of-icom-cc/definition-of-profession-1984/#.Vp8ds_I97IU (accessed September 12, 2014).

Jemison, Peter G. 2001. "Poisoning the Sacred." *Contaminated Collections: Preservation, Access and Use*. Proceedings of a symposium held at the National Conservation Training Center (NCTC), Shepherdstown, West Virginia, April 6–9, 2001, Collection Forum 17: 38–40.

Koller, Manfred. 2000. "'Surface Cleaning and Conservation." *Conservation Perspectives*, The GCI Newsletter. 15 (3). The Getty Conservation Institute. http://www.getty.edu/conservation/publications_resources/newsletters/15_3/feature.html (accessed October 29, 2015).

Langton, Marcia. 2000. "Religion and Art from Colonial Conquest to Post-Colonial Resistance." In *The Oxford Companion to Aboriginal Art and Culture*, edited by Sylvia Kleinert and Margo Neale, 16–24. Melbourne: Oxford University Press.

Marconi, Bohdan. 1961. "Programme of the Faculty of Conservation at the Academy of Fine Arts in Warsaw." *Studies in Conservation*. 6 (4), Abstracts of the Rome Conference Contributions 1961: 148–149.

Mellor, Stephen P. 1992. "The Exhibition and Conservation of African Objects: Considering the Nontangible." *Journal of the American Institute for Conservation* 31 (1), Conservation of Sacred Objects and Other Papers from the General Session of the 19th Annual Meeting of the American Institute for Conservation of Historic and Artistic Works. Albuquerque, New Mexico, June 3–8, 1991: 3–16.

Morphy, Howard. 1998. *Aboriginal Art*. New York: Phaidon Press Inc.

Morris, William. 1877. *The Manifesto of the Society for the Protection of Ancient Buildings*. Society for the Protection of Ancient Buildings. https://www.spab.org.uk/downloads/The%20SPAB%20Manifesto.pdf (accessed January 22, 2016).

Morton, John. 2000. "Aboriginal Religion Today." In *The Oxford Companion to Aboriginal Art and Culture*, edited by Sylvia Kleinert and Margo Neale, 9–16. Melbourne: Oxford University Press.

Mundine, Djon. 2010. "Is it Sacred?" *Artlink* 30 (4) (December): 56–58.

Museum Victoria. n.d. "Donald Thomson Collection." *Collections & Research*. Museum Victoria. https://museumvictoria.com.au/collections-research/our-collections/indigenous-cultures/donald-thomson/ (accessed May 1, 2015).

Museums Australia. 2005. *Continuous Cultures, Ongoing Responsibilities: Principles and Guidelines for Australian Museums Working with Aboriginal and Torres Strait Islander Cultural Heritage*. Canberra: Museums Australia. http://museumsaustralia.org.au/userfiles/file/Policies/ccor_final_feb_05.pdf (accessed January 13, 2011).

Odegaard, Nancy. 1995. "The Conservator's Approach to Sacred Art." *WAAC Newsletter* 17 (3) (September). Western Association for Art Conservation (WAAC). http://cool.conservation-us.org/waac/wn/wn17-3/wn17-310.html (accessed August 27, 2015).

Osorio, Ana Maria. 2001. "Tribal Repatriation of Sacred Objects: Public Health Issues." *Contaminated Collections: Preservation, Access and Use*. Proceedings of a symposium held at the National Conservation Training Center (NCTC), Shepherdstown, West Virginia, April 6–9. Collection Forum 17: 82–92.

Pandozy, Stefania. 2015. "The Ethnological Materials Laboratory." *Bollettino Dei Monumenti Musei e Gallerie Pontificie XXXI–2013:* 417–435. Edizioni Musei Vaticani.

Pearlstein, Ellen. 2007. "Collaborative Conservation Education: The UCLA/Getty Program and the Agua Caliente Cultural Museum." *Proceedings of a Conference Symposium 2007, Preserving Aboriginal Heritage: Technical and Traditional Approaches, Ottawa, Canada, September 24–28, 2007*, edited by Carole Dignard, Kate Helwig, Janet Mason, Kathy Nanowin, and Thomas Stone, 305–310. Ottawa: Canadian Conservation Institute.

Pickering, Michael. 2015. "'The Big Picture': the Repatriation of Australian Indigenous Sacred Objects." *Museum Management and Curatorship* 30 (5): 427–443.

Ruskin, John. 1849. *The Seven Lamps of Architecture*. New York: J. Wiley & Son.

Sadongei, Alyce. 2006. "What about Sacred Objects?" *Western Association for Art Conservation* (WAAC) *Newsletter* 28 (2) (May): 14–15.

Sloggett, Robyn. 2009. "Respect: Engendering Participatory Relationships in Conservation Education." *Journal of the Canadian Association for Conservation* 34: 10–20.

Smith, Catherine, and Marcelle Scott. 2010. "Ethics and Practice: Australian and New Zealand Conservation Contexts." In *Conservation: Principles, Dilemmas and Uncomfortable Truths*, edited by Alison Richmond and Alison Bracker, 184–196. London: Butterworth-Heinemann in association with the V&A Museum.

Stoner, Joyce H. 2005. "Changing Approaches in Art Conservation: 1925 to the Present." *Scientific Examination of Art: Modern Techniques in Conservation and Analysis*. Proceedings of the National Academy of Sciences (Sackler NAS Colloquium). http://www.nap.edu/read/11413/chapter/5 (accessed October 21, 2015).

Viollet-le-Duc, Eugene A. 1996. "Restoration". In *Historical and Philosophical Issues in the Conservation of Cultural Heritage*, edited by Nicholas Stanley Price, Mansfield Kirby Talley, and Alessandra Melucco Vaccaro, 1: 314–318.

Wain, Alison. 2011. "Values and Significance in Conservation Practice." Paper presented at the *Conservation in Australia: Past, Present and Future* AICCM National Conference, October 19–21, Canberra, Australia. https://aiccm.org.au/sites/default/files/WAIN_ NatConf2011.pdf (accessed June 21, 2015).

Walston, Sue. 1978. "The Preservation and Conservation of Aboriginal and Pacific Cultural Material in Australian Museums." *AICCM Bulletin* 4 (4): 10–21.

Welsh, Elizabeth, C. 1991. "A New Era in Museums—Native American Relations." *The Western Association for Art Conservation (WAAC) Newsletter* 13 (1) (January): 9.

Wolfe, Sara J., and Lisa Mibach. 1983. "Ethical Considerations in the Conservation of Native American Sacred Objects." *Journal of the American Institute for Conservation* 23 (1) (Autumn): 1–6.

16 Collecting and Research in the Museum of the History of Religion

EKATERINA TERYUKOVA

The State Museum of the History of Religion was established in 1932 in Leningrad. This period of Soviet history was full of hardships: implementation of an expanded antireligious campaign, increasing activism by the League of Militant Atheists, large-scale closure of churches, seizure of church valuables, and the proclaiming of religion as a vestige of the past which should be replaced by a new society based on the principles of freethinking and "scientific atheism." It was in these difficult sociopolitical and ideological conditions that this unique museum—the Museum of the History of Religion—was opened. Today it remains the only Russian and one of the few world museums whose permanent and temporary exhibitions show religion as a universal cultural phenomenon with a long and intricate past, actively developing.

The museum grew from the idea of an independent department for evolution and typology of culture, as part of the Leningrad Museum of Anthropology and Ethnology (the *Kunstkamera*). This idea was initiated by the famous Russian ethnologist, and one of the founders of Russian religious studies, Leo Shterenberg. It was initially brought into being through a series of exhibitions that illustrated the most important and universal elements of human culture in its historical development. As religion is one of the key elements of culture, an exhibition on religion was also planned. The exhibition's concept was built up by another famous Russian ethnologist and specialist in religious studies—Vladimir Bogoraz-Tan. He intended to make a comparative typological exposure of ritual objects of various peoples, from high Antiquity up to modern times. His goal was to present "religious phenomena as they actually were." Opened in 1930 in the halls of the State Hermitage Museum in Leningrad, this exhibition was called "The Antireligious Exhibition." (In 1930s Soviet Russia religion could only be considered critically.) The majority of museum items displayed in the Hermitage came from the *Kunstkamera*. The success of that exhibition made it possible to focus on the creation of a new museum dedicated to issues of religion.

The Museum of the History of Religion in Leningrad opened to the public on November 15, 1932, in the former Kazan Cathedral. The Museum was a complex phenomenon from the beginning. On the one hand, as a part of the Academy of Sciences of the USSR, the Museum was a center for Soviet religious studies. In his speech at the opening of the Museum, academician Alexander Orlov even remarked that the name "museum" didn't totally correspond with the Museum because in

his opinion it was also a research institution. On the other hand, the main activities of museum staff were holding exhibitions and carrying out educational work. At its fullest, this idea was formulated by Vladimir Bogoraz-Tan, the first director of the Museum, who said that the mission of the Museum was "to combine scientific approach with art design."

In 1954 the Museum received a new title: "The State Museum of the History of Religion and Atheism of the Academy of Sciences of the USSR." In 1961 it was taken over by the Ministry of Culture of the USSR. In the early 1980s it became the Academic and Methodological Center for the History of Religion and Religious Studies of the Ministry of Culture of the USSR. In 1990, its original title—the State Museum of the History of Religion—was returned to the Museum. Today the Museum collections number about 200,000 objects. Permanent and temporary exhibitions and special museum projects reflect the variety and unity of the spiritual life of humanity. The permanent displays include Archaic and Traditional Beliefs, The Religion of the Ancient World, The Origin of Christianity, The History of Russian Orthodoxy, Catholic Church History, Protestantism, Islam, and The Religions of the East: Buddhism, Hinduism, Taoism, Confucianism, Shinto, and The Pure Land of Amitabha Buddha. Annually the Museum carries out more than forty-five exhibition projects in Saint Petersburg, in Russia, and abroad. Thus, from the very beginning there have been a number of essential theoretical and practical points in our museum work, namely:

- a scientific approach: the study of religion in all its complexity,
- collecting and display,
- educational activities: exploring the history and cultural traditions of various peoples, while respecting their religious positions, but neither teaching the basics of religions nor imposing any preferences.

The Museum Today

Collecting, displaying, and research have always been tightly tangled. Our research at the museum doesn't aim to explore general theoretical problems of history, sociology, or the philosophy of religion, but to carry out practical studies of museum collections and to support exhibitions and scientific publications. To perform the task successfully it is crucial not only to coordinate collecting, publishing, display, and research work in the museum on a daily basis, but also to implement its long-term planning.

The collecting policy, which our museum has embraced recently, helps to bring together collections, displays, research, and planning. The collection of the Museum of the History of Religion includes tempera and oil paintings, original and printed graphics, portable figurines and pieces of monumental sculpture, and items of decorative and applied art. Historically, the museum has developed a system of religion-oriented collections, which now includes the following departments: Archaic and Traditional Beliefs, The Religion of the Ancient World and the Origin of Christianity, The Religions of the East, Islam, Orthodoxy: Fine Arts, Orthodoxy: Decorative and

Applied Arts, Orthodoxy: Graphics, The Religions of the West, The Religions of the West: Graphics. Although the collection is chiefly organized by religion, some collections require special storage conditions: precious metals, archival materials and manuscripts, rare books, philately, photographs, and textiles.

Acquisition reflects the Museum's exhibition policy. It aspires to satisfy the needs of different displays. Thus, the Museum collects not only religious artifacts and masterpieces of world art of high historical, cultural, and artistic value, but also models, copies, and mass-market items. Collecting aims to accumulate representative material and create a database of past and present religious life. The reason for acquiring an object is to expand already existing collections. Objects are selected on the following criteria: meeting the requirements of the museum's exhibition policies, scientific or historical value, uniqueness (exceptional character of an object or, on the contrary, mass circulation), being representative, attractiveness to visitors, authenticity, and documented legal history.

Special attention is paid to the connection of the object with particular historical figures or events. Information about the origin, history, functions, semantics, owners, or collectors is also taken into consideration. The object should clearly reflect ideas of religious life. The level of preservation and artistic value of the object are also important, however due to the specific educational mission of the Museum, which aims to record and display a variety of religious phenomena in full, our Museum also acquires mass-market, typical, or traditional objects, reflecting wider religious processes.

When we acquire or commission modern artworks and ritual objects, we take into account artistic value, meeting religious canons, presenting different tendencies of modern religious and secular art, and showing different styles and schools. In acquiring mass-produced objects, for instance, *eulogias* (secondary relics), our Museum prefers ones produced in the workshops of a religious center or monastery, handmade, and used for individual or cult practice. To re-create historical background and atmosphere our Museum also acquires objects of everyday life, historical and genre paintings, portraits of prominent people, city landscapes, depictions of ritual scenes, medals (religious ones as well), coins, stamps, documents, and so on.

Developing a new collection of *livres d'artiste* is an interesting example of our contemporary collecting activities. It was the preparation of the temporary exhibition, *The Divine Dante*, held in the summer of 2015, which gave a spurt to this activity. The exhibition was held during the Year of Literature in Russia, and was devoted to the 750th anniversary of Dante's birth. One section of the exhibition was devoted to the *Divine Comedy*, Dante's main work, in which he describes the poet's mystical travel through Hell, Purgatory, and Paradise. Natalia Suslova, the curator of the Collection of West European Graphics, who was the curator of the project, initiated the acquisition of the first example of this innovative art phenomenon of the twentieth century. This was a book made by French lithographer Édouard Goerg (Alighieri 1950). This acquisition was followed by a number of other artist-made books, which have made a compact but valuable collection welcoming further expansion.

Exhibition projects and educational programs that present the religions of China, Japan, India, Tibet, and Mongolia are always popular with visitors. This makes curators pay special attention to the acquisition of new objects for the Religions of the East department. From 2011 to 2016 the museum held a series of exhibitions devoted to the religious traditions of Japan: *The Many Faces of Kannon: Images of the Bodhisattva in Russia and Japan*; *Simplicity of Thought and Strength of Soul: Religion in the Life of Samurai*; and *Community and Home Rituals in Japan*. All these projects were brought to life thanks to the collecting activities of Sergey Shandiba, curator of the Japan collection. For instance, it was the exhibition devoted to the many faces of the goddess Kannon, which for the first time in Russia showed a collection of traditional Japanese paintings by the modern Japanese artist Wada Katsumi. After the exhibition this collection was donated by Wada Katsumi to the Museum. The central exhibit of the second exhibition was a piece of mid-nineteenth-century Samurai armor, bought in 2014 with the support of the Ministry of Culture. The display also showed the collection of recently purchased *tsuba*s, hand-guards on samurai swords, but in Japan also charms. Elaborately decorated with depictions of religious and mythic subjects, the *tsuba* is an interesting artifact that can be used for studying religious syncretism in Japan.

Today, developing the so-called Open Storage project gives us a new perspective on acquiring, studying, and displaying exhibits. The task is vital, because there is little hope of expanding our exhibition space, even in the far future. Our first experience of this came in 2014, when visitors were allowed access to the Freemasonry collection. Freemason items began to arrive in the museum's collection from 1934 but, though displayed occasionally at exhibitions in the museum and beyond, this was the first time in over eighty years that the museum could show visitors such a variety of objects—more than six hundred items. From 2016 to 2018 visitors are able to access Japanese collections, as well as West European painting and large-scale sculpture.

From a scientific point of view, acquiring new objects for the collections appears to be no more important and interesting than updating already formed collections, which means exploring new approaches to display and attracting new visitors. For example, one of the most valuable parts of our Museum collection is a remarkable collection of Chinese popular woodblock prints. It counts about one thousand items and dates from the early twentieth century. It was gathered and brought to Russia by the prominent Russian sinologist V. M. Alekseev, and just a few years ago for the first time became the subject of studies by a joint Russian-Taiwanese research team. The Museum acquired the greater part of the collection from Alekseev in 1938, in order to create a new permanent exhibition department devoted to Chinese religions, and to prepare several exhibitions introducing Chinese folk religions and art. Alekseev's travel diary, which he kept when in China, and explanatory notes made by his Chinese teachers stored in the Museum Research Archive add exceptional significance to the Museum's Chinese collection. Thanks to Alekseev's manuscripts, the Museum has

many possibilities not only for the display of Chinese popular prints and ritual objects, but for researching Chinese popular religion as well. The result of this work will be an online catalogue available in three languages: Russian, English, and Chinese.

Acquisition of objects for the Museum collection has happened in different ways. In the 1930s, for instance, Museum staff took part in expeditions working in various parts of the USSR, just as the active closure of monasteries and temples was taking place. Soviet Buddhists, who traditionally lived in Buryatia, Tuva, and Kalmykia, suffered much in the days of Stalin's religious persecution. During their expeditions to Buryatia, museum workers managed to examine roughly forty former Buddhist monasteries, and to fill the Buddhist collection of the museum with religious artifacts saved from destruction. In 2013, the head of the Buddhist community in Russia—the twenty-fourth Khambo Lama, Damba Ayusheev—paid a visit to the Museum and donated the twelfth Khambo Lama Etigelov's vestment, as a sign of respect and appreciation. Khambo Lama Etigelov was a prominent figure in the history of Russian Buddhism in the early twentieth century. This visit showed the great concern of the people of Buryatia for their cultural heritage, partly preserved thanks to the activities carried out by the Museum staff in the 1930s, and started a long-term and fruitful cooperation between the museum and the Buryat Republic.

The Future of the Museum: Virtual Branches

In September 2015 the first "virtual branch" of the Museum of the History of Religion, *Buddhism on the Banks of the Neva* (Figure 16.1), was installed on interactive screens at the National Museum of the Buryat Republic and at the largest Buddhist monastery in Russia, Ivolginsky Datsan in Buryatia, to celebrate its seventieth anniversary as the spiritual capital of the Buddhist Traditional Sangha of Russia and the residence of the Khambo Lama. Serious research work went into the opening of the virtual branch. This virtual exhibition displays a huge amount of newly published and hitherto unknown materials from the museum's Collection of Photographs and Research Archive. One important example is a 1912 seminary student's journal of his tour to Transbaikal, from the Aginsk Monastery. The original copy of the manuscript is deposited in the museum's Research Archive; now the electronic version is publicly available. The journal describes the everyday life and spiritual practices of Buddhist monks in the Aginsk monastery in the early twentieth century, as they were seen by a Russian Orthodox missionary. It is a unique record of the mission activity of the Russian Orthodox Church in the Transbaikal Region, and of the Orthodox mission experience of studying local religious traditions. The journal is a key source for Buryatia Buddhism in the early twentieth century.

The success of our virtual branch in the Buryat Republic convinces us that such an approach is effective and opens up broad horizons of future cooperation. In 2016 we intend to open new virtual branches of the Museum, *Islam on the Banks of the*

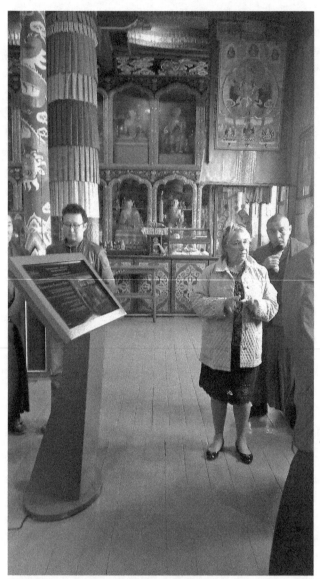

Figure 16.1 Opening of the virtual branch of the Museum of the History of Religion *Buddhism on the Banks of the Neva* at the Buddhist Ivolginsky Datsan in Buryatia. Photo by Anna Kogan.

Neva (Figure 16.2), in traditional Muslim regions of Russia. These openings initiate new steps in attributing and describing documentary materials from the Museum collection. Therefore, in terms of collecting and research, the Museum of History of Religion has a broad perspective. Cooperation with private collectors, artists, art workers, and religious organizations gives us a chance not only to purchase, but also

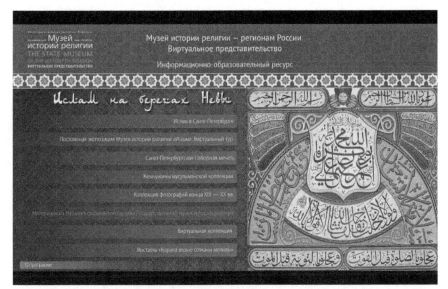

Figure 16.2 The virtual branch, *Islam on the Banks of Neva*, at the State Museum of the History of Religion. Photo by Anna Kogan.

to acquire as gifts a large number of new museum objects which become a part of our collections, are displayed, and are studied thoroughly. They also help us to give new life to old collections and to find new approaches to work with our visitors.

Reference

Alighieri, Dante. 1950. *L'Enfer: Eaux-fortes Originales d'Édouard Goerg*. Paris: Porson.

17 Studying, Teaching, and Exhibiting Religion: The Marburg Museum of Religions
(*Religionskundliche Sammlung*)

KONSTANZE RUNGE

Founded in 1927, the Marburg Museum of Religions (*Religionskundliche Sammlung*)[1] at the Philipps-Universität in Marburg, Germany, is the world's oldest university collection devoted to the comparative study of religions, and at the same time one of the first (and still few) institutions in which the variety of religions around the world is exhibited. Being at the interface of scholarly research on religion and the public, the Marburg collection with its more than 9,000 objects and images from more than twenty religious traditions holds a rich potential to be explored. The collection has been housed since 1981 in an attractive Renaissance building near the castle in Marburg, in ten exhibition rooms and a large vault. There museum visitors as well as students and scholars can discover objects from Hindu, Buddhist, Confucian, Daoist, or Shinto traditions;[2] objects of Jewish, Christian, and Islamic provenance; and pieces from the ancient Near East, ancient Egypt, from the Mayas, the Aztecs, and African and Oceanian religious traditions, as well as new religious movements (Figure 17.1).

This chapter will focus on the intersection of the study and teaching of religions and the communication of the findings of the scholarly study of religions to the public, this even today being the core mandate of the museum in Marburg.[3] Among those museums devoted specifically to religions, our museum in Marburg has perhaps the most complex, and in any case the longest, relationship with teaching and research. Neither teaching nor research can be treated without the other, considering the institution's history.

After shedding some light on the founding of the museum in Marburg and its entangled and ongoing history of exhibition, teaching, and research, I will discuss some insights into the changing understanding of studying and exhibiting religions in Marburg in the twenty-first century by examining some of the recent activities in the museum. This will be completed by a look ahead into the museum's future.

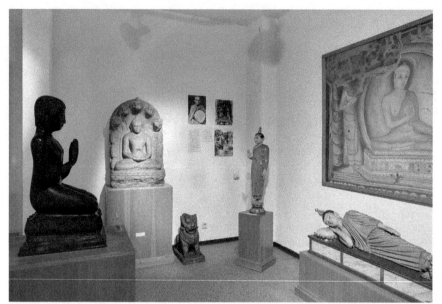

Figure 17.1 The Marburg Museum of Religions. "Buddhism in South and Southeast Asia." Photo by Georg Dörr.

Looking Back into the Museum's History

The museum's founder, Rudolf Otto, and his successors as museum directors, Heinrich Frick and Friedrich Heiler,[4] were all professors of Protestant theology and practicing Christians; and they strove to use the collection to visually present "other religions" as well as mission activities. But this did not prevent them from fighting for the museum's status as a central university institution independent of the Faculty of Theology. As a result, today the museum is associated with the Department of the Study of Religions (*Religionswissenschaft*) in the Faculty of Social Sciences and Philosophy. The benefits of this intermediate position, independent from any religious affiliation, will be pointed out in the following.

Five years before the publication of his very influential *Das Heilige*, the theologian and philosopher of religion Rudolf Otto had already formulated in 1912 his innovative idea of founding a collection of the "cultic and ritual means of expression of religions,"[5] as he put it, as an addition to his collection of written sources on religions. In building up the collection with the financial support of the Prussian state, Otto did not focus on the artistic or historical quality of the objects he acquired as much as on their, so to speak, educational value, on their capacity to instruct the museum's visitors about religious practices and concepts. During his extensive travels to India, China, Japan, and North Africa, he collected objects from popular religious cultures that made it possible to see and understand the very core of each religion. While it remains questionable whether these objects could really evoke and stimulate a feeling for the common "sense of the numinous" in the

various manifestations of religions and a sense for the proclaimed unity of religions in general, as described by Otto in *Das Heilige* (1917),[6] the first exhibition of the *Religionskundliche Sammlung* in the autumn of 1929 entitled *Fremde Heiligtümer* (Foreign sacred sites and objects) is said to have nonetheless attracted more than 6,000 visitors in only five weeks.

In the museum's founding period, Otto used the collections and displays as visual aids to explain them and the beliefs connected with them to his target audience of (theology) students and scholars, as well as to missionaries, merchants, diplomats, and physicians who were preparing to work overseas. With his focus on religious practices and on the capacity of the displayed objects to educate and inform visitors about the everyday religious culture of—above all non-European—believers, Otto purposely set this project apart from other museum models, such as museums of ethnology or art.[7]

This concept was shared and developed further by the missiologist and theologian Heinrich Frick, Otto's successor as museum director. "It is not simply an art collection or a museum for the study of ethnology. It is to be a collection illustrative of the whole of man's religious development, brought together for the purpose of stimulating and assisting in the study of religion," wrote Frick (1931, 7) and stressed the function of the collection as a research tool. Otto, Frick, and their successor Friedrich Heiler were all convinced of the crucial role the exhibited objects played in the competition of the so-called *Kulturreligionen* (cultivated religions), although they did not doubt that the winner of this great competition between religions would be their own.

Otto and Frick also had a vision that the collection should be the basis for an "International Institute for the Study of Religions",[8] which would integrate the collection as a visual and teaching aid, the large library, and space for academic conferences and international guests of various religious backgrounds. This institute was to be housed in the most spectacular venue Marburg could provide: the castle overlooking the small city. Although the plan could not be realized in its entirety, Heinrich Frick succeeded in reopening the Marburg Museum of Religions in the castle in 1950.

As already mentioned, Otto, Frick, and Heiler were using the exhibits to instruct visitors about "other religions" and to induce a sense of the unity of religions. As experts on religions, they were educating their visitors and students through guided tours and university lectures, demonstrating their affirmative approach toward religion, an irenic program aiming to promote interreligious tolerance, ecumenical endeavor, and mutual understanding. They played an active role in the theological and inter-religious debates of the time.

Today we practice a more open and differentiated understanding of the objects, integrating students, visitors, and colleagues into the process of exploring, researching, and exhibiting material religion. The objects themselves still play a core role in the teaching program of the Department of the Study of Religions; and since the launch of the BA and MA study programs in 2005, various study modules have been developed to enhance the integration of the collection into the teaching process. The collection attracts students of religions to Marburg, where they find a

unique environment in which the scholarly study of (intangible) religious concepts and beliefs is supported and stimulated by the use of tangible "real objects" of the studied traditions themselves. Rudolf Otto's vision of adding a new dimension to the scripture-based study of religions by using three-dimensional objects of the religious communities is cherished and developed, based on our growing understanding of the complexity of religions and their materiality (Houtman and Meyer 2012). Our students, as well as interns from other universities, can gain experience in museum work alongside their academic education.

Special Exhibitions on Various Aspects of Religions

It is not only since the material turn in cultural studies that exhibitions have been read as the presentation of research results. The whole process of planning and designing an exhibition on religion includes extensive research in the field of material religion and religion itself. Being invaluable sources of knowledge, religious objects teach and inform us about (popular) religious cultures and practices and about the people who made, used, and venerated them. The object's materiality forms a kind of data bank that can be used fruitfully for further scholarly investigation.

The 1960s and 1970s brought changes in how objects were dealt with in the collection and the purpose of "exhibiting" religions for teaching and research. When the indologist and historian of religion Martin Kraatz assumed the title of museum director in 1968, it was the first time that the collection was run by someone other than a theologian. The implications of this turn in the study of religions became apparent in the new permanent exhibit after the museum moved into the New Chancellery in 1981. In the course of his directorship, Martin Kraatz curated several special exhibitions, most of them devoted to religions with Asian origins.[9] Peter Bräunlein (2004), museum director from 2000 to 2005, combined a museological perspective with a special focus on popular religious culture and its visual representation.

A new dimension was brought into this tradition of special exhibitions on religion in Marburg when two of the ten exhibition rooms were rededicated to this purpose under the directorship of Edith Franke, professor of the Study of Religions and head of the museum since 2006 (Pye 2014). This expanded focus on special exhibitions provides not only the possibility of shedding light on various aspects of religions and focusing on their more contextualized (re)presentation, it also allows for more flexibility in responding to current social issues and challenges with regard to the dynamic roles of religions in society.[10]

In the past ten years, the whole process of communicating research findings to a broader public (i.e., the museum's visitors) via exhibitions has become the focal point of teaching and research in the Marburg museum. It has provided a forum for experimental teaching and learning approaches, where questions on the intersection of research on religions and the (re)presentation of knowledge about religions through the medium of an exhibition can be pursued. How can the complex realities of the sensitive field of relations and communications with the transcendent

be conveyed through the display of selected objects? Many ethical issues need to be considered. The exhibition *Tibet in Marburg* (2007–2009, curated by Adelheid Hermann-Pfandt) with its detailed catalogue is a striking example of the successful integration of students into the extensive scholarly research on the Tibetica of the Marburg collection (Hermann-Pfandt 2007). A focus on religious practices and their expression in religious artefacts was also evident in an exhibition on pilgrimage on the Japanese island of Shikoku (Katja Triplett 2009–11) and the exhibition *Ethiopia Celebrates: Fieldwork Photographs by Konstanze Runge*, which combined photos of the Ethiopian Orthodox *Meskel* feast and the *Irreechaa* feast of the Oromo people, with the museum's rich collection of Ethiopian Orthodox processional and hand crosses (2011–12).

A Special Exhibition on Religious Diversity in Islam

The special exhibition *Von Derwisch-Mütze bis Mekka-Cola. Vielfalt islamischer Glaubenspraxis*,[11] which opened in 2013 (Figure 17.2), was the museum's first special exhibition on Islam, showing the variety of Muslims' individual interpretations of their religion, and integrating the Sufi Islamica of the collection.[12] In times of growing Islamophobia, it provided insights into the all-too-often neglected diversity of Islamic religious practice and strove to shed some light on daily (religious) routines and lifestyles, instead of presenting Islam from the usual orientalist perspective of Islamic art, mostly from a "glorious" Islamic past, as is done in many museum exhibitions on Islam.

"How to make a good exhibition on diversity in Islam from a study-of-religions perspective" was more or less the subject of various consecutive courses I taught at the Department of Religious Studies at that time. While the objects presented in the past

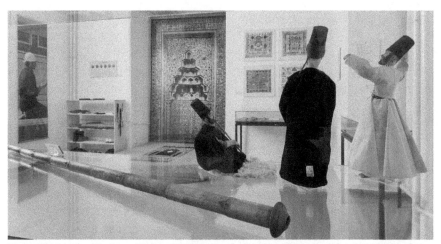

Figure 17.2 The Marburg Museum of Religions, Special Exhibition on Islam. Photo by Georg Dörr.

had remained quite remote and even exotic to visitors, today their contextualized presentation in a temporal as well as a local perspective is our main focus. Thus— despite the small size of our museum—some of the demands of the new postcolonial museologies could be applied (Kamel and Gerbich 2014).

In the course of the exhibition planning process, our attention shifted from object-related research on various Sufi items to more general considerations about the representation of diversity in Islam within the restricted means of a special exhibition on a small budget in a German university museum. How to communicate the diversity and heterogeneity of individual Muslims' relationships with their own religion was of special interest for us. Against this background we created an exhibition that comprised sections on Shi'i and Sunni prayer practice, pilgrimage practices, and the popular belief in charms and amulets against the evil eye, as well as Alevi concepts and Indonesian Islam. More than 80 percent of our visitors are schoolchildren. Thus, we also addressed the religious education of children, the roles of girls and boys, and the religious worlds of Muslim children. Here new pieces were purchased: toys and games with religious connotations, dolls such as *Fulla* or *Razanne*, puzzles, books, and other educational media representing the wide spectrum of Muslim religious education, ranging from very strict *Wahabbi* to very liberal interpretations. The relatively young target audience had also to be taken into account while designing the contents of a media station that provided an introduction to Islamic and mystical Sufi traditions and presented Islam and Muslims in Germany using music, pictures, and video material. It also served as a tool for visualizing the newest research results on Muslim youth cultures in Germany (Maske 2013) and on the diversity of Islam in Indonesia (Franke 2012). Last but not least, the inscriptions on a Persian dervish's ceremonial cap that inspired the title of our exhibition, as well as on a *kashkūl*, a beggar's bowl dating back to the seventeenth century, were deciphered for the first time with the help of colleagues from the Iranian Studies Department of Marburg University.

The tradition of students' and interns' active involvement in the whole process of creating exhibitions might be regarded as an encouraging basis for another special project in the department's and the museum's history: the special exhibition *SinnRäume. Einblicke in gelebte Religiosität in Deutschland*[13] is based on interviews on the materialization of religiosity in the homes of people of various religious affiliations. It is the result of a student initiative and integrates reflections about the museal (re)presentation of research results and the interactive participation of visitors.

Conclusion: Looking Ahead into the Museum's Future

Despite our limited means as curators of an academic collection, the staff of the Marburg Museum of Religions try to implement some of the demands of the new postcolonial museologies (critical museum studies), in terms, for example, of contextualized representation, deconstruction of essentialist statements about religions, and a multiperspectivity on religious phenomena. The symbiosis of the academic

study of religions and museum activities and the integration of the collection into the teaching program of the Department of the Study of Religions is an opportunity, since working with students in a museum provides for an ever new and current perspective on a collection founded nearly a century ago. It is also furthered by our interdisciplinary networks and cooperations (with, for instance, the Saint Petersburg Museum of the History of Religions).

"After the exhibition is before the exhibition": what could special exhibitions look like in the future? What distinctive roles could the collection's objects and their contextualized exhibition play? Needless to stress here the growing importance of well-balanced and finely nuanced information and knowledge about the variety and heterogeneity of religions and their dynamic roles in our multicultural and multireligious societies. One example from the museum's practice indicates the urgent need for even more differentiated information to promote respect and mutual understanding. It also highlights the crucial role religious objects can play in this very process. Currently, in the relatively small university town of Marburg (73,000 inhabitants including 26,500 students), refugee children have joined forty classes in various schools throughout the city. In the training that their teachers will receive, religious objects from our Islamic and other collections will serve as excellent instances to carefully reflect on the various sensitive issues of the meeting of various religious practices (Sunni, Shi'i, Alevi, Ahmadi, and more) that are to date unfamiliar to the teachers and might be sources of conflict between children of diverse ethnic, religious, or nonreligious backgrounds.

This training project illustrates the potential of the *Religionskundliche Sammlung* in opening up a "third space" as a communication center on non-confessional but empathetic ground, facilitating discussion about sensitive religion-based issues against the background of well-researched and differentiated knowledge about religions from a neutral perspective. The objects of our collections are excellent media for visualizing and communicating religious concepts and attitudes and at the same time stimulating further research and reflection.

Notes

1. https://www.uni-marburg.de/relsamm/.
2. More than half of the objects in the collection are of Asian origin.
3. I am very grateful to Andreas Hemming, Halle, for proofreading the English manuscript of this chapter.
4. Heinrich Frick directed the museum from 1932 to 1952 and was followed by Friedrich Heiler as director from 1953 to 1961.
5. *der kultlichen und rituellen Ausdrucksmittel der Religionen.*
6. To my mind the Museum of World Religions in Taipei, Taiwan, founded by Dharma Master Hsin Tao, represents in many regards a museum that best corresponds to Otto's vision.
7. It was also for the purpose of teaching that the early museum directors acquired models of larger sacred buildings and copies of unique, rare, or expensive originals.

8. The title of a brochure written by Heinrich Frick and published in Marburg in January 1931.
9. The 1975 exhibition *Yokigurashi* on the then relatively new Tenrikyō movement was not only the first museum representation of Tenrikyō in Europe but it also had a religious expert from the Japanese religious community, a *Yoboku*, present as an informant during the exhibition.
10. One example here is the decision of the Regional Court of Cologne on religious circumcision in 2013, which we discussed from various perspectives in one part of our special exhibition on Islam.
11. "From Dervish-Cap to Mekka-Cola. Religious Diversity in Islam." Cf. the accompanying catalogue (Franke and Runge 2013).
12. Rudolf Otto's personal and scholarly fascination with the religious worlds of East and Southeast Asia—an interest shared by most of its successors up to and including Edith Franke—may explain the relatively small number of objects of Islamic provenance in the collection and the fact that they had been handled in such a stepmotherly fashion. The existing roughly five hundred items (including two hundred pictures and photographs) mainly illustrated the mystical paths and practices of Sufis and dervishes.
13. "Sensual spaces: Insights into lived religion in Germany," opened in October 2015.

References

Bräunlein, Peter (ed.). 2004. *Religion und Museum: Zur visuellen Repräsentation von Religion/en im öffentlichen Raum*. Bielefeld: Transcript Verlag.

Franke, Edith. 2012. *Einheit in der Vielfalt. Strukturen, Bedingungen und Alltag religiöser Pluralität in Indonesien*. Wiesbaden: Harrassowitz.

Franke, Edith, and Konstanze Runge (eds.). 2013. *Von Derwisch-Mütze bis Mekka-Cola. Vielfalt islamischer Glaubenspraxis*. Marburg: diagonal-Verlag.

Frick, Heinrich. 1931. *International Institute for the Study of Religions*. Marburg.

Hermann-Pfandt, Adelheid (ed.). 2007. *Tibet in Marburg*. Marburg: diagonal-Verlag.

Houtman, Dick, and Birgit Meyer (eds.). 2012. *Things. Religion and the Question of Materiality*. New York: Fordham University Press.

Kamel, Susan, and Christine Gerbich (eds.). 2014. *Experimentierfeld Museum. Internationale Perspektiven auf Museum, Islam und Inklusion*. Bielefeld: transcript Verlag.

Maske, Verena. 2013. "Gottesfürchtig auf Erfolgskurs. Der Pop-Islam, eine muslimische Jugendkultur in Deutschland." In *Von Derwisch-Mütze bis Mekka-Cola. Vielfalt islamischer Glaubenspraxis*, edited by Edith Franke and Konstanze Runge, 87–107. Marburg: diagonal-Verlag.

Otto, Rudolf. 1917. *Das Heilige. Über das Irrationale in der Idee des Göttlichen und sein Verhältnis zum Rationalen*. Breslau. [English translation: *The Idea of the Holy* (London, 1923)]

Pye, Michael. 2014. "Exhibiting Religion." Unpublished paper on occasion of the Third Tenri University—Marburg University Joint Research Project, "Materiality in Religion and Culture", September 17–19, Marburg.

Section V Museum Interpretation of Religion and Religious Objects

18 Radical Hospitality: Approaching Religious Understanding in Art Museums

AMANDA MILLAY HUGHES

The story begins with children: visitors to the art museum who wanted to know "Why are there so many paintings of that lady in the blue dress?" "What did they use that for?" "Why are that man's ear lobes so long?" The museum is a natural environment for such questions, and although the answers move us into discussions of religious belief and practice, the conversation feels safe. Nobody is in danger of being converted to another faith, and some very significant learning can begin with the questions these objects evoke.

—**Ray Williams (Ewald 1999)**

My first encounters with art objects with religious significance happened before I could read. At the Detroit Institute of Arts (DIA, my childhood museum), to the right of the Great Hall, collections of European, medieval, and Renaissance art wrap the atrium below. The small circular staircase that leads down to the Kresge Court from the edge of these galleries (a favorite with children to this day) made trekking through these rooms an adventure. Early Orthodox icons were mysterious, strange pictures of "that lady in the blue dress," a miniature old man seated on her lap, and sometimes, golden circles around their heads. They were awesome with their glistening accents. They were also unknowable, literally out of reach for my four- and five-year-old self.

My father and I spent innumerable hours together in the DIA, and many were spent wondering how anyone could want to be anywhere else. His radio station, WQRS, was on the top floor of the Maccabees Building, diagonally across Woodward Avenue from the main entrance to the museum. My father was a broadcaster, a real talker, but in these galleries, he was uncharacteristically silent. I don't know what I thought of this at the time, but today I think it was a demonstration of healthy respect for his ignorance of the subject matter. The iconographic meaning, the traditions of a visual vocabulary that may have been meaningful to some, were relatively unknown to him and therefore to me. In every other gallery my father freely pontificated, his declarations gleaned from newspaper articles, collection guides, and exhibition catalogues. He was imaginative and playful in front of the suits of armor and didactic as we looked closely at the Diego Rivera mural. He taught me to look closely, to find Henry Ford in the lower corner and then discuss the birth of an international auto industry, the luxuries of living in a world-class city in Michigan. His approach still influences me. Look, I think, at the glint in the eye of Van Gogh's famous portrait of the *Postman Roulin*.

Consider what the Postman felt: is he happy? Is he tired? My father was my first curator and museum educator, and in this fond memory, we ambled, played, and learned together in and around this great collection. Nevertheless, in the galleries with religious art, my father was always remarkably silent. Taking my cue from him, so was I.

As a young man, religion was not his area of interest. This changed when he retired and joined the United Methodist Church in Durham, North Carolina. At his death, an archive of his weekly bible studies came to me, along with his other papers, and as I read through them, I was struck by the ahistorical nature of his understanding. I remembered my father in the galleries again: silent on the complex development of the Christian tradition, its heritage of controversy, and the role of art in developing and sustaining faith traditions across generations and cultures. His lectures included admonitions to trust God, to turn to Jesus in prayer, to study the words of faith, to join what he called "The Church of One at a Time"—but in all of those documents, several hundred carefully crafted nonscholarly lectures, there is not a single reference to a work of art and no mention of religious traditions beyond what he called "the Judeo-Christian world-view." This was a little surprising to me, if only because among the books of my childhood, I dearly loved the Book of Knowledge encyclopedia (purchased from a door-to-door salesman) and sets of Time-Life books with brightly colored images. He often spoke of the great big world but never of its religious diversity.

For my father, one true book (the Revised Standard Bible) and a natural propensity for words combined to form an intellectual assertion. His practice did not live in the body but in the mind. His experience was not phenomenological—it was simply logical. But for me, works of art challenged this approach, and museums have been a partner in my discovery, both as a museum professional and as a visitor. The religious beliefs depicted in paintings, sculpture, and ritual objects defy a singular logic. Over time, and with concerted effort, works of art recontextualized my understanding of religion. I moved from memorizing Bible passages, prayer book structures, the creeds, canons, and codes of conduct, to my own patient study of visual representations of faith in a broader context than American Protestantism. Today, I approach greater understanding by learning about the accompanying ritual practices of communities, families, and individual followers of the world's great religions. The complexity of religious objects led me to seek out poets and listen to musicians. Instead of approaching an object as distanced from meaning, focusing only on materiality and art history, I welcome the disagreements that complicate and contextualize the object itself.[1]

It is with this personal context and a penchant for "radical hospitality" toward visitors that I introduce the chapters in this section. The phrase "radical hospitality" is often credited to the Benedictine Rule and describes a practice of welcoming that, while demanding for the monastic, holds the potential to be transformational for the guest. The call to this level of inclusivity in the Rule is given to the Abbot first and foremost. I find this particularly interesting because it reflects Benedict's understanding of the maturity that this level of inclusion requires. Curators and educators must

likewise mandate open dialogues across opposing points of view, welcome visitors and their many questions and insights, yet at the same time hold the standard for excellence and truth that hallmarks their commitment to the objects themselves. The challenge to present objects with a generative balance of aesthetic values, historical accuracy, and relational understandings requires substantial effort. Whenever we openly acknowledge multiplicity, we cede territories of authority that have been long held by museum professionals alone. The demand of engaging audiences, a do or die mandate in most public museums, begs for a reconsideration of the role of the custodian curator and the singular voice of institutional authority.

"The role of the curator" is the unspoken subtext that runs through all the chapters in this section, with each author challenging notions of curator as *the* final and acknowledged expert in imagining every exhibition, engaged in a solitary activity, setting objects in relation to one another and to visitors. And yet, the question remains, why do museums resist full disclosure of the process of interpretation? I am reminded that every curator I have been privileged to know well spends much of their time in private conversation with scholarly texts, collectors, artists, and other curators. At the same time, educators and program coordinators engage in formal evaluation and informal conversations with audiences of all kinds. These negotiations with difference and with new sources of knowledge remain principally hidden from museum visitors, cloaked behind third-person object labels and introductory text panels. Why do we (as museum insiders) resist making these processes available to our audiences? Perhaps the processes themselves have merit not only for organizers of museum experience, but for museum visitors as well.

When museum directors and curators acknowledge their own radical hospitality in considering the ideas that led them to the selection of objects, their placement, and their interpretation, the results are transformative. I witnessed this shift in the work of the Ackland Art Museum's *Five Faiths Project*. Small and often incremental changes were recommended by a wide range of constituents. Among those adopted by the Ackland, we disclosed the authors of object labels, published the names of community focus group participants, provided full bibliographies for exhibitions, used historically accurate maps in the galleries to locate the origins of works of art and the migration of ideas, and engaged community practitioners (dubbed "community scholars") to provide tours and gallery talks in addition to the more traditional presentations by curators and academic scholars. Of course, as anyone working in museums might suspect, these recommendations stirred tensions between academic privacy and object preservation on the one hand, the realm of scholars and curators, and the values of transparency and access touted by educators and community members on the other.

Together, we were able to articulate the necessity of this tension. As Stephen Weil (2002, 3) notes: museums are not mysteries, nor are those most closely associated with them the keepers of mysteries. I assert that while they may not be mysteries, they are mysterious places to audiences. The effort needed to undertake an ongoing program of institutional self-disclosure, ongoing evaluation, and a certain dynamic

willingness to amend approaches to interpretation cannot be overstated, and it is the tie that binds these five chapters together. Each chapter suggests an approach to opening understanding not only of the objects on view, but of the very nature of museum engagement. Learning practices of hospitality requires both radical generosity and tenacious patience.

In John Reeve's examination of Islam and Museums, these very tensions set the tone. As he notes, "[D]espite many models of good practice, friction persists between educators, curators, designers and others inside the museum over challenging areas like Islam; and between museums and faith communities outside, even when they are consulted." A willingness to consider the needs of the unmediated, informal learner and to provide that visitor with the opportunity to "relax . . . and look at something beautiful" generates important questions about the role of knowledge in creating that relaxation. Do we provide our visitors the core knowledge they need to appreciate "something beautiful," or do we assume that they already have the "considerable knowledge" they will need to "reap maximum benefit?" Online resources create one avenue for dispensing knowledge, but, as Reeve suggests, "[w]hat is needed everywhere is a closer conversation, more open and self-critical, more consistent and sustained, between museums, communities, educators and curriculum."

In order to be successful, museum conversations must be multidirectional, developing expertise and experience in a true give-and-take improved by programs that "evaluate ruthlessly and keep responding so far as possible to how people react." We may agree with Reeve (and Stephen Weil whom Reeve credits with this cautionary note [Weil 2002]) that we must be realistic about what can actually be done inside the restrictions of the museum setting, but, at the same time, the challenge to welcome and inspire new generations of museumgoers mandates new approaches and justifies some risks.

In "Uneasy Companions," Tom Freudenheim explores his conviction that the exposition of "deeper religious meanings of art can enhance the aesthetic experience" without requiring participation in the religion from which the objects emerge. Of course, this assertion (with which I fundamentally agree) requires that museum educators and curators reimagine their role as "experts" to include the deeply hidden mysteries of their own practices. They might, for example, articulate the uncomfortable fact that "museum displays are organized by specialists who understand—and *frequently are still in the process of trying to decipher* [italics mine]—the meanings of the works on view." Presenting a more "open-source" approach to museum interpretation may hold promise. It may be that our audiences are better equipped to assimilate new knowledge through the lens of many possible answers to a single question than we have previously assumed. The 3.5 billion queries processed by Google every day may suggest that we are well practiced in searching for more than one way to approach our experience. These new sources of information, and thereby new attempts at meaning, may be a path to deepening visitor experience. As Facebook and other social media sites seem to suggest, perhaps, audiences "like"

windows on difference and through them find pathways to a richer engagement with their own understanding.

While an art museum cannot "be or do all things, satisfy all needs or options," curators can (and perhaps should) engage in practices that open not only icono-graphic specificity but their own process of discovery, revealing the opportunities they create for dialogues with difference through their selected comparisons and sugges-tions of original context. They might activate conversations of meaning by recalling "the private space for belief and spirituality—or their rejection" present within them-selves *and* visitor experiences. They might tantalize interest through deeper consid-eration of materiality. Human beings desire to touch and feel; we long to smell and taste. This is how we encounter and know the world around us, and we carry these longings into the museum setting. Is it too much to say that we long to embody the experience of knowledge?[2]

Perhaps that is the appeal of the "first-person interpreter" described in Gretchen Buggeln's chapter. Actor-interpreters suggest to adult audiences that it is possible to know the past—albeit a scripted knowing developed through historical research and reconstruction. The method is measurably engaging, requiring extensive research and experimentation, but when realized with the same level of excellence that hall-mark the best museum installations in the world, audiences connect through the power of a human voice to a narrative that is malleable enough to allow for their ques-tions. Buggeln suggests that we ask questions in order to hear our own stories, to find points of connection, to set ourselves into another time and place and ask "what would *my* experience have been?" While this strategy will not work for all visitors or for every museum installation, perhaps curators, directors, educators, and even security guards might benefit from some training in this approach as a way to invest in the curiosity of visitors and the possibility of enlivening labels, lectures, and other materials with the power of first-person narratives.

In Buggeln's example, the narratives are reconstructed from the diaries and letters of historical people. Christian G. Carron describes a different approach to developing these narratives in "Religion in Museums for Families with Children." For the *Sacred Journeys* exhibition at the Children's Museum of Indianapolis, educators constructed avatars (to extend the online metaphor), fictional characters to guide the visitor on a journey and describe the sights of imaginary religious pilgrimages. With these avatars presented as video recordings of teenage actors and accompanying first-person labels, the result was the presence of new and perhaps more comfortable authorities—young people speaking about the significance of objects, artifacts, and personal encounters within five religious traditions: Hinduism, Judaism, Buddhism, Christianity, and Islam.[3]

Among other preparations, "all museum personnel also underwent mandatory training about the messages and goals of the exhibition," in order to ensure the visi-tor concerns were appropriately addressed. This whole staff preparation is an excel-lent example, among many in the chapter, of the added layers of work involved in radical hospitality toward visitors. Advisors were engaged to define the focus of the

exhibition, identifying visitor "gateways" and encouraging the first-person narratives for labels. A nonlinear installation design entrusted navigation to the visitor—a subtle reflection on the actual practices of pilgrimage—while tangible objects allowed visitors, particularly young children, the chance to encounter both the privilege of seeing fine art and the chance to touch replicas, with prompts to consider what souvenirs one might collect on such a journey.

But, as in the work of the Five Faiths Project at the Ackland, it is the unexpected consequences of mutual respect and accommodation that make Carron's chapter so valuable to readers. Ceding authority to practitioners, curators installed a Muslim "prayer rug so that it faced Mecca" and covered a copy of a Guru Granth Sahib, a Sikh holy scripture, displaying the book "both covered and closed, next to a photograph showing the pages open" as a sign of respect to differing opinions on how the object should be displayed. The chapter reminds readers that it is not only possible, but also desirable to present exhibits about religion in which difference and disagreement are explicated rather than muted. Museum professionals can welcome others into planning processes at every level, and in so doing, demonstrate the shared enterprise that binds insiders and outsiders in productive engagement. Together, we understand. Together, we experience. Together, we acknowledge all the participants in the museum experience and their involvement in the processes of appreciation.

The ambiguities and complexities of religious belief systems and their accompanying narratives are part of what make these traditions meaningful and, perhaps, luminous. The light of this kind of knowing is broad-spectrum, capable of refraction and the generation of awe. In the account of his first exhibition at the Walters Art Museum in 1986, Gary Vikan outlines his sincere efforts to create "in our museum visitors a sense of being in the presence of the divine." He refused to dictate meaning without materiality, instead suggesting that a Byzantine icon "could not be realized for what it was without the numinous." He unapologetically challenged himself and his audience to directly encounter "Christ's enormous eyes." This kind of bravery, this willingness to articulate his feeling that "the divine was in the air for that show," compels us to reconsider our academic distance from feelings of religious devotion. When, we might ask with James Elkins, did we stop crying in front of pictures? Elkins (2001, 55) asserts:

> Sadly, most of us huddle under the middle part of the curve, where we feel about the same amount: not too much, not too little, and pretty much what everyone else feels. We're not quite sure how to behave, so we look around to see how other people see. Those other people are mostly silent. They whisper politely, they smile, they make decorous gestures.

The chapters in this section inspire me to continue to research and to experience the power of museums to teach us about ourselves *and* the world around us, as we are now, as we were, and as we may become in the unknown future. In my fondest memories of museums, I feel something more than intellectual engagement. I am in awe. I am filled with resonance and wonder (thank you, Stephen Greenblatt [1991],

for these accurate descriptors). I am awake to my ignorance and engaged in new learning. I am, I suppose, small in the world again, walking the galleries of the DIA.

Of course, I see the complexity and recognize that this kind of hospitality problematizes every assertion of meaning. One says one thing, and another asserts a different aspect. We are conditioned to understand (or to resist understanding) along our own preexisting frameworks. But as museums embrace a passionate resolve to include multiple voices from faith communities, songs and foods and clothing and prayer postures, the research of art historians and religious studies scholars, and reimagine spaces to engender feelings when encountering works of art, we no longer stand alone in the presence of the object; we are joined by others at every turn. My hope is that within the field, we might all become more radically hospitable to these others in the presentation of special exhibitions and collection installations.

Giving the scholar, the faith leader, the practitioner, the artist all equal ground may be too much to ask, but my little girl self, silent in those galleries, and her adult counterpart now writing from the perspective of a "museum worker" (Weil 2002) still cannot quite understand the apprehension. Just tell a million more stories to whet our interest. Show us the things that we might only discover in the rarified air of an art museum. Give us access to these outrageous and incredible examples of visual excellence and "the negotiations, exchanges, swerves, and exclusions" (Greenblatt 1991) from which they emerge and let everyone join the conversation.

The more practical-minded among us will certainly ask: How will we sustain these conversations? How do we archive the research in ways that are meaningful for those who come after us? How will we hand over our relationships as we move to new positions or retire from the very institutions that offer the finest examples of this sort of engagement? My desire for a more radical hospitality extends not only to the present, but into the future, requiring that we share our practices with audiences as well as with the next generation of museum professionals, who, I am persuaded, are watching for their moment to move into the privileged roles we currently hold.

Notes

1. I am deeply indebted to my colleagues at the Ackland Art Museum at the University of North Carolina at Chapel Hill for their willingness to engage these questions in the Five Faiths Project (funded in part by the Henry Luce Foundation). In particular, I must recognize Ray Williams, now head of education at the Blanton Museum of Art, for the original ideas for the project and for his relentless generosity in the presence of objects. Gerald Bolas and Carolyn Wood also deeply influenced my understanding in the years in which we worked together. Materials related to the Five Faiths Project may be found at ackland.org. Hughes and Wood (2009) present the broad findings of the Ackland's national conversations.
2. I confess that this is the methodology applied to the writing of this chapter. Rather than positioning the chapter as a statement of authority, I introduce a personal reflection on my own journey inside a museum as a child. It's difficult to distance myself from those

experiences. Over the past decade, I have conducted hundreds of tours at the Ackland. Among many learned insights, the wide range of visitor knowledge and experience continues to delight me and underscore my interest in acknowledging these diversities through a radical hospitality.

3. Historical listing preference is mine, oldest to newest.

References

Elkins, James. 2001. *Pictures & Tears*. New York: Routledge.

Ewald, Wendy (ed.). 1999. *Visions of Faith*. Chapel Hill, NC: Ackland Art Museum.

Greenblatt, Stephen. 1991. "Resonance and Wonder." In *Exhibiting Cultures: The Poetics and Politics of Museum Display*, edited by Ivan Karp and Steven D. Lavine, 42–56. Washington and London: Smithsonian Institution Press.

Hughes, Amanda Millay, and Carolyn H. Wood. 2009. *A Place for Meaning: Art, Faith, and Museum Culture*. Chapel Hill, NC: Ackland Art Museum.

Weil, Stephen E. 2002. *Making Museums Matter*. Washington, DC: Smithsonian Books.

19 Islam and Museums: Learning and Outreach

JOHN REEVE

Contexts: "Educate or Perish"?[1]

Especially since September 11 there has been growing interest in the presentation of Islamic collections in museums. Several major new galleries and exhibitions of Islamic art and culture, such as those at the Louvre and the Metropolitan Museum, have opened or are planned. However, these are mainly about historic "elite" art, and a product largely of soft diplomacy, art history, and the art market, and less about understanding religion or the Islamic world and Muslims today. What is actually happening in exhibitions of Islamic art and culture? More broadly, how much differ-ence can museums make as forums for learning and understanding in the face of widespread public prejudice and ignorance, in a context of concerns by some in the museum world about public trust and neutrality and the primacy of the aesthetic? How are learning programs and resources around Islamic collections being designed and used? Who are our best partners in this process? What is best practice?

Tensions and Disappointments

Many of the problems with presenting Islam are rooted in generic museum and wider educational tensions and inhibitions. UK educators are often wary of teaching about challenging subjects such as Islam, especially where there are large Muslim popula-tions. In museums, despite many models of good practice, friction persists between educators, curators, designers, and others inside the museum over challenging areas such as Islam; and between museums and faith communities outside, even when they are consulted. As a result, there may be disappointments in new "Islamic galleries" where collections rather than people or beliefs dominate, and this affects their educational potential and use. For the Victoria and Albert's (V&A) Jameel Gallery, for instance, these disappointments included finding that "[t]he average time spent in the gallery was 4 minutes" and that "visitors did not seem to understand the themes around which the gallery was organized" (Fakatseli and Sachs 2008). This is despite front-end evaluation, educator involvement, and focus groups. Not surprisingly, many visitors did mention religion and religious art in unprompted feedback, even though they were in an art and design museum. Certainly there are religious objects in the Jameel Gallery and quite helpful videos that present basic aspects of Islam for the

unmediated, "informal" learner, but there is nothing from our own time or from the United Kingdom, and the interpretation of religious belief and practice is slight. The V&A curator envisages this gallery as a "space in which people can relax about the Middle East and look at something beautiful" (Bayliss 2008).

Hence, as so often in museums, whether in London or New York, Paris or Doha, it may be the learning and outreach programs, events, and online resources that pick up the basic task of interpreting a living culture and its beliefs (see Reeve 2012 for a wider discussion).

Learning about Islam?

Modernist museum and gallery learning practices are knowledge-based, closed, and controlled; they involve *being told*. A modernist gallery like the British Museum's (BM) Islamic gallery is basically aesthetic, distancing, compressed, and assumes considerable knowledge to reap maximum benefit. Such galleries typically have very little overt religious content or context and are quite challenging for informal learners. At the BM, daily eye opener highlight tours by trained volunteers, regular events and changing displays, especially of "ethnographic" and contemporary material, and regular temporary exhibitions attempt to bridge the gap. Postmodern museum and gallery learning on the other hand is more open-ended, less boundaried, more challenging, participatory, interactive, hands on—as with the object handling tables in several BM galleries (see Hooper-Greenhill 2007).

Digital technology has provided an especially fruitful way for the BM to enhance both onsite and offsite learning around its Islamic collections. The informal learner with patience and a focused approach can now probably access nearly every Islamic object on show via the BM website, and "Digital Islam" is a popular session for teenage pupils. Websites like this, however, need more guidance for the informal learner (i.e., most of us) and better promotion, not least physically in the museum gallery space. Many educators and learners have no idea what is available to them through online museum programs beyond the top layer. About 8.7 million people accessed the main BM website in 2010/11, with 21 million visits overall to all the BM websites, including in Arabic. Generally, however, museum websites are underdeveloped and under-evaluated, not least for religions such as Islam. Notable exceptions include the Metropolitan Museum (Met) site (Ekhtiar and Moore 2012) and "Discover Islamic Art," an enterprising online collaboration between museums in Europe and the Islamic World as part of "The Museum with no Frontiers" project, with accompanying books.

Publishing for the serious student about Islam in museums has made enormous progress. Curator Mirjam Shatanawi (2014), for example, has produced a highly accessible introduction to the Amsterdam Tropenmuseum's Islamic collections, approached from many different perspectives, like the displays themselves. Other accessible publications for the informal learner accompany the BM, V&A, and David Collection, for example, and often put them in context more effectively than the displays do or perhaps can. My *BM Visitors Guide to World Religions* (Reeve 2006), while extremely directive, does attempt to provide context and to engage eye and

mind, while sifting the deluge of visual stimuli and various information in the galleries. I based it on my experience as a museum educator working with students, teachers, community groups, and the adult public including mature students studying world religions. It implicitly asks, "What are the strands of human experience and art that we have separated off as religious?"

In all of these contexts, it is difficult to know how much or how little to explain, especially for Islam, with all the misinformation that visitors may bring with them. What is needed everywhere is a closer conversation, more open and self-critical, more consistent and sustained, between museums, communities, educators, and curriculum, for religions as for everything else. This had begun to develop tentatively for museums and religious education in the United Kingdom as part of the "Learning outside the Classroom" campaign (Miller 2008), but there is still a gulf between faiths, curriculum, and museums.

There has been more progress in Scotland and Ireland (the Chester Beatty). In Glasgow's St. Mungo Museum of Religious Life and Art there are close links to strands of the Scottish national curriculum. Here, too, there is a strong sense of glocal mission: "This activity encourages learners to reflect on basic aspects of religious belief and on why regardless of whether 'we' believe personally, respect for other points of view is essential for life in contemporary Glasgow" (St. Mungo Museum, n.d.).

Reaching Out—Drawing In?

One successful museum learning approach to Islam, especially in non-Muslim countries with substantial Muslim minorities, is to see it as a living faith in the context of others, to consult varied people of faith and use their voices and insights overtly, through proactive curating and programming. This happened at the British Library in 2007 with the three Abrahamic faiths presented thematically in the *Sacred: Discover What We Share* exhibition (Reeve 2007; 2008). The Met also consulted widely among the three faiths, as did the Museum Aan de Stroom (MAS) Antwerp for the exhibition project *Religions of the Book*.

Successful projects work with Muslim communities from the outset and use their voices and identities. At the Tropenmuseum, Shatanawi has documented her work with local Muslim communities that make up a third of Amsterdam's population but only 1 percent of the museum's usual visitors. This went up to 11 percent for a special exhibition *Urban Islam* in 2003 in the aftermath of September 11. This exhibition was multivoiced and adopted a constructivist approach, encouraging diverse interpretations to break down a monolithic, historicized view of Islam and Islamic culture and life. Fourteen percent of the exhibition visitor sample thought it had changed their views (Shatanawi 2012). A good example of multivoicing by young people of faith comes from Brighton Museum. In the "World Stories" gallery, which explores global culture through the eyes of young people, *My Journey in Islam: From Brighton to Makka* was created with members of an organization for local young Muslims.

In UK cities with the largest Muslim populations, museums have innovatively attracted both Muslim and non-Muslim audiences. Birmingham Museums Trust had no permanent gallery of Islamic art and culture, so its curator Rebecca Bridgman worked offsite with an exhibition of Arabic calligraphy in the University Library that attracted 33,000 visitors over twelve weeks. Sixty percent identified as Muslim, many drawn by the display of a very early Qur'an. An extensive program included museum workshops for local groups in calligraphy; dance and film; a traineeship in curating; and links to new audiences through Islamic television and radio (Kilroy and Bridgman 2014). In Manchester, another city with a large Muslim population, Stephen Terence Welsh, curator of Living Cultures at Manchester Museum, runs the project "An Image of Islam: Islamic Art and Objects in Manchester" which seeks to redress misconceptions regarding Islam through an arts and culture festival, as well as through local partnerships and outreach work with schools and communities.

Muslim groups are also increasingly active in the United Kingdom in interpreting and sharing their own heritage with museums and outsiders. "Everyday Muslim" is a five-year project to create a central archive of Muslim lives, arts, education, and cultures from across the United Kingdom, including "places of worship, practise of faith, religious dress and the preparation and purchase of halal food." It organized an exhibition at Vestry House Museum in Walthamstow, east London, in 2015 based on the memories of Muslims who settled in Britain in the 1950s, and a very successful seminar bringing together leading people in the field such as curators and researchers (Everyday Muslim n.d.; see Heath 2015).

Hajj: A Model Exhibition?

The BM's 2012 *Hajj: Journey to the Heart of Islam* was the first major exhibition on the Hajj, reflecting personal stories and the many cultures brought together by it, including works by contemporary artists and aimed at specific target audiences (Porter 2012). Forty-seven percent of visitors to the Hajj exhibition were Muslim, significantly higher than the usual 3 percent, and in marked contrast to the normal pattern of limited museum visits and engagement by Muslims in the United Kingdom (see Heath 2007; McIntyre 2012, 5, 19). Feedback was positive from Muslim and non-Muslim visitors alike (8, 33, 73, 75). One non-Muslim responded, "It has made me start to see Islam in a very, very powerful light, in terms of it can really move and shape people and there must be something very beautiful in it if so many people are doing it. So now it has just sort of forced me to see it in a different way" (75). Despite a lack of basic introduction to Islam, "visitors left the exhibition highly motivated to explore topics further . . . Visitors also felt it was important to set the history of Hajj in a modern context, and the contemporary art in the exhibition helped to achieve this" (7).

As an example of global outreach, versions of the exhibition were well attended in Doha (Qatar) and Leiden and also the Institut du Monde Arabe in Paris, where it was seen by 66,000 people. Widespread outreach to the Muslim community, from other

museums as well as the BM, accompanied the exhibition in the United Kingdom. *Hajj* won the inaugural ISESCO-OCIS Prize for Educators for promoting dialogue and understanding between peoples and cultures.

Museums find it difficult to sustain community relationships and programs after exhibitions and festivals close, and this can cause a lot of ill feeling, especially when services are cut. New permanent offerings are needed to sustain and develop interest and understanding. At the BM, following the success of the Hajj exhibition, a radically new approach to interpreting Islamic culture is under way with great promise for better understanding and more varied informal as well as programmed learning. A new Albukhary Foundation Gallery of the Islamic World will replace the Addis gallery in 2018. It will encompass most of the Muslim world and reflect the present as well as the past. The vision of the Foundation is "to help forge a more equitable and tolerant world through health, welfare, education and cultural initiatives that bridge the divide between the haves and the have-nots and between Muslim and non-Muslim worlds." It will be interesting to see how its values are reflected in this new gallery and its educational mission (see Heath 2015; Suleman in Junod, Weber, and Wolf 2012).

And What Happens with Visitor Engagement in Museums of Islamic Culture in Islamic Countries?

In many Middle Eastern or South Asian contexts local museum audiences are limited, as are attractive programing, marketing or educational work. There are signs of change. The Albukhary Foundation supports the Islamic Arts Museum in Malaysia, Southeast Asia's largest museum of Islamic art. In Cairo, the Museum of Islamic Art was fairly static until its recent makeover (El-Rashidi in Junod, Weber, and Wolf 2012, 210). Schools have been slow to embrace museums in many Muslim countries, and governments are often unsupportive. It is different in the Gulf, where big investment in buildings, collections, and programs can build a strong sense of educational and political mission. For instance, the Museum of Islamic Art in Doha promotes Islam as peaceful and progressive. Museums in the Gulf may provide a corrective to deficiencies in mainstream public education as well as reinforcing official teaching about Islam and Islamic culture.

Conclusions

Museums have a key role to play in addressing outmoded and polemical public perceptions of Islam as monolithic, primitive and unchanging, or as innately threatening (Shatanawi 2014; Cannadine 2013). Given the lack of responsible, historically informed, or disciplined treatment of Islamic culture by most of the media and many politicians in the West, museums have an especial responsibility to do a good job with captive audiences like students, tourists, and informal learners. We need to focus our energy in these areas and move forward with confidence to build sustainably on successes such as I have described earlier. The principles are not obscure: present Islam

as living cultures; mix historic and modern art and ethnographic collections to do this around lives and experiences rather than focus exclusively on depersonalized and decontextualized art collections; multivoice as part of real community consultation and partnership; evaluate ruthlessly and keep responding so far as possible to how people react. Curators, educators, designers, programers, and marketing staff need to work hand in hand if these approaches are to work. European museums have found it difficult to cope with their own diverse cultures let alone the latest immigrants and their beliefs. Many museums and those who control them clearly do not see this as their role. We certainly have to be realistic, as the late Stephen Weil constantly reminded us, about what change we can achieve through museums, but "Business as Usual" in this field as every other is not an option. There is enough good practice to learn from, so what are we waiting for?

Note

1. Junod, in Junod, Weber and Woolf 2012, 292.

References

Bayliss, Sarah H. 2008. "A Positive Understanding of Islam." *Art News* (May) http://www.artnews.com/2008/05/01/a-positive-understanding-of-islam/ (accessed December 2015).

Cannadine, David. 2013. "Religion." in *The Undivided Past: Humanity beyond Our Differences*, 11–52. London: Penguin.

Discover Islamic Art. n.d. http://www.discoverislamicart.org/ (accessed December 2015).

Ekhtiar, Maryam D., and Claire Moore (eds.). 2012. "Art of the Islamic World: A Resource for Educators." New York: The Metropolitan Museum. http://www.metmuseum.org/learn/for-educators/publications-for-educators/~/media/Files/Learn/For%20Educators/Publications%20for%20Educators/Islamic%20Teacher%20Resource/Introduction.pdf (accessed December 2015).

Everyday Muslim. n.d. http://www.everydaymuslim.org/ (accessed December 2015).

Fakatseli, Olga, and Julia Sachs. 2008. "The Jameel Gallery of Islamic Middle East: Summative Evaluation Report." http://www.vam.ac.uk/__data/assets/pdf_file/0010/177886/47897_file.pdf (accessed December 2015).

Heath, Ian. 2007. "The Representation of Islam in British Museums." *British Archaeological Reports* (June).

Heath, Ian. 2015. "A Question of Access: Muslims, Museums and Heritage." https://www.youtube.com/watch?v=THpxJwE4sOc (accessed December 2015).

Hooper-Greenhill, Eilean. 2007. *Museums and Education: Purpose, Pedagogy, Performance*. London: Routledge.

Junod, B. Khalil, G, Weber, S and Wolf, G (eds.). 2012. *Islamic Art and the Museum*. London: Saqi.

Kilroy, Sarah and Rebecca Bridgman. 2014. Out of Context: Bringing a Manuscript Collection to a Broader Audience. http://www.nationalarchives.gov.uk/documents/conference-brief-dicovering-collections-2014.pdf (Accessed December 2015).

McIntyre, Morris Hargreaves. 2012. "Bridging Cultures, Sharing Experiences: An Evaluation of 'Hajj: Journey to the Heart of Islam' at the British Museum." https://www.britishmuseum.org/PDF/British_Museum_Hajj-exhibition_evaluation.pdf (accessed December 2015).

Miller, Joyce. 2008. "Learning in Sacred Space." *Journal of Education in Museums* 29: 37–44.

Porter, Venetia (ed.). 2012. *Hajj: Journey to the Heart of Islam*. London: British Museum Press.

Reeve, John. 2006. *The British Museum Visitor's Guide to World Religions*. London: British Museum Press.

Reeve, John (ed.). 2007. *Sacred: Books of the Three Faiths: Judaism, Christianity, Islam*. London: British Library.

Reeve, John. 2008. "Sacred—Discover What We Share: Exhibition at the British Library." *Material Religion* 4 (2): 255–258.

Reeve, John. 2012. "A Question of Faith." In *Museums, Equality and Social Justice*, edited by Richard Sandell and Eithne Nightingale, 125–141. London: Routledge.

Shatanawi, Mirjam. 2012. "Engaging Islam: Working with Muslim Communities in a Multicultural Society." *Curator: The Museum Journal* 55 (1).

Shatanawi, Mirjam. 2014. *Islam at the Tropenmuseum*. Arnhem: LM Publishers.

"Teacher's Resource—Pre-Workshop Information: All World Religions Workshops." St. Mungo Museum, n.d. http://www.glasgowlife.org.uk/museums/Documents/Learning%20and%20access/Religion%20Themed%20Sessions_Pre%20Visit%20info.pdf (accessed December 2015).

20 Museums and Religion: Uneasy Companions

TOM L. FREUDENHEIM

A plethora of bluster and public relations can't hide the reality that museums—especially art museums—are fairly benign institutions at their core. So perhaps it is fitting that claims are constantly being made for museums as the new churches, even cathedrals, of the middle and upper classes, whose increasing, and presumably worshipful, visits are responsible for record visitor numbers. Those soaring statistics then serve as arguments for the pairing of economic impact arguments with pleas for increased funding from public and private sources. The most egregious example of this can be seen at New York's Metropolitan Museum of Art, where the annual Costume Institute blockbuster exhibition draws an especially varied crowd of visitors who can be observed quite evidently venerating an array of clothing (a very free use of this term!) by celebrity fashion designers. The observable devotional intensity is concurrently persuasive and heartbreaking, often reflecting the combined suggestiveness in the artspeak and bizspeak of explanatory labels and panels. Yet this all too apparent reverential attitude seems to evaporate in front of art works with a religious, rather than monetary, core.

Why does the internal and professional discourse that promotes an understanding of the spirituality and implicit sanctity permeating so much of the art on display seem to avoid explicit connection between art and religion for museum visitors? Compared to the almost pious adulation expended on the work of Alexander McQueen, for example, there's an especially large elephant in the room when issues about contemporary (generally) Western religion arise in art museums: *embarrassment*. The cover of anthropology empowers natural history museums to explain religious ideas as an aspect of their scientific investigations. Art museums, on the other hand (in which I have had most of my experience), convey a sense of ongoing discomfort with anything more than the most superficial explanations about religious practices and rituals, especially those associated with Christianity. Presumably the assumption that in so-called Western societies a significant proportion of art museum visitors consists of Christians is accompanied by the presumption that those people will know the complex range of meanings inherent in Christian art. Yet despite the huge increase in visitor surveys, I am unaware of any that ask about comprehension in regard to what is being viewed. That lack of interest in whether anyone actually understands the meaning and symbolism of what he/she is seeing certainly extends beyond Christian religious art, and includes the vast range of Muslim, Buddhist, Hindu, Greek and Roman classical, and other references that pervade not only the art itself, but also its

various reiterations in later work. Nevertheless, the most glaring omissions of religious explication—and presumably embarrassment—relate to the Christian tradition.

Museum displays are organized by specialists who understand—and frequently are still in the process of trying to decipher—the meanings of the works on view. But sharing that often tentative exploratory process with viewers appears not to be a priority. This might be based on the arrogant assumption that museum viewers have a responsibility to educate themselves *before* they venture out on their visits. Or perhaps sharing interesting but inconclusive ideas turns out to be an unrewarding effort. My (entirely anecdotal) experience persuades me that entering into the deeper religious meanings of art can enhance the aesthetic experience. And that this does not require participating in the religion as an adherent. While a significant percentage of museum artifacts once had lives in religious environments, that information is only occasionally considered relevant to our understanding of the work. Getting at how reverence toward a sacred image might have functioned (or still functions) for a believer enlarges on our ability to appreciate or to doubt, or even try to evade, its power over us. That is especially important in conventional art museums, which tend to homogenize everything in generalizations such as Gothic, Dutch School, Northern Art, Italian Renaissance, Baroque, and so on. Simple categorization might be a useful organizational tool, but it encourages the dissipation of other classification options. Imagine, for example, groups of saints, or devotional sequences, or ecclesiastical images juxtaposed with domestic works, or literal versus interpretive Scriptural illustrations. By insisting on isolating the aesthetic and art historical positioning of works, we have essentially hijacked their devotional meanings and the potential power of religious and spiritual experiences. Expanding the options through which a museum discusses works of art provides the potential for enriching the museum experience.

This is especially important considering the difference in viewing works that have been displaced from their original environments, residing in museums, and visiting religious art in situ. Jacopo Tintoretto's *Crucifixion* painting at the Scuola Grande di San Rocco (Venice, Italy) gains some of its transformative power from the manner in which it outscales and overwhelms its relatively small chapel. Viewers are drawn into the mystical drama of Calvary, almost as participants; no ordinary museum could achieve that. (The Passover Haggadah urges Seder participants to feel as if they themselves had been liberated from Egyptian slavery; similarly, Christians are encouraged to reexperience the Christ's Passion.) Even at Venice's nearby Accademia, Paolo Veronese's gigantic *The Feast in the House of Levi* (1573) (a.k.a. *The Last Supper*) fits comfortably in its large museum gallery, inviting us into its space, but still feeling magnificently secular. Jan van Eyck's 1432 Ghent Altarpiece, *The Adoration of the Mystic Lamb* (in Belgium), still exudes its magic by remaining in St. Bavo Cathedral, although no longer in the specific chapel for which it was created. And while the Musée Unterlinden—a former convent—is not the original venue for Matthias Grünewald's *Isenheim Altarpiece*, 1512–16 (in Colmar, France), that complex work's almost gruesome realism might well be dissipated were it not displayed in a thirteenth-century chapel but in a museum gallery (Figure 20.1). Of course, galleries

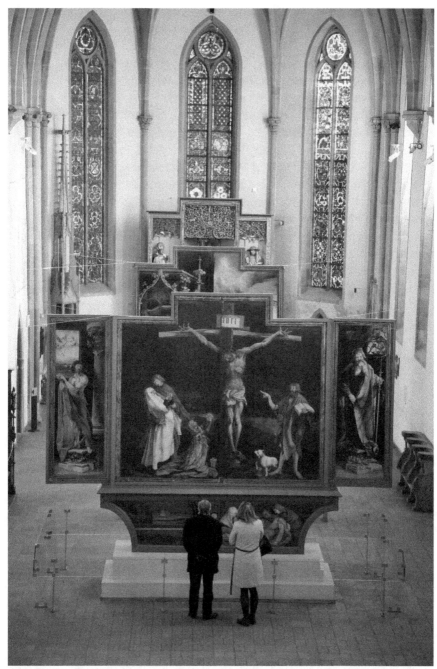

Figure 20.1 Mathias Grunewald, Isenheim Altarpiece, 1512–16. On display in historic chapel, now part of Unterlinden Museum. Photo by Vincent Desjardins. Copyrighted work available under Creative Commons Attribution only licence CC BY 4.0 http:// creativecommons.org/ licenses/by/4.0/.

enable us to compare and relate works that were not created to be displayed side-by-side; but the same kind of display can also somehow deracinate them. To some extent this is inevitable; an art museum cannot be or do all things, satisfy all needs or options. But it might do more to provide meaning and context to what's on view.

So it is interesting, or even encouraging, to take note of a few venues that bridge the gap between the assertedly aesthetic and the spiritual/devotional aspects of art. The Cloisters "branch" of the Metropolitan Museum of Art manages to succeed by its very essence: a faux mélange of bits and pieces of (mostly?) authentic medieval Christian religious buildings imbued with a special sanctity that cannot be achieved in an art gallery display of sacred paintings ripped from their context and primarily admired for their visual splendor. Even taking into account that it is essentially just another form of museum, it is worth observing the hushed and respectful visitor demeanor within the somehow spiritual spaces at The Cloisters, in contrast with conventional art museum viewing. This would be an ideal place for a study of whether there are message differences—both conveyed and received—dependent on the museum and gallery design aesthetics.

The Worcester Art Museum (Massachusetts) has experimented with yet another approach to bridging the gap between gallery gawking and devotional meaning in early Italian Renaissance painting. Instead of the conventional benches for tired museum feet, a small and dimly lit gallery includes a *prie-dieu* (not old; borrowed from a local church) that enables and subtly invites, but certainly does not force, visitors to kneel and attempt to experience the religious or spiritual content of several wonderful gold-ground paintings of the early Renaissance. The stunning simplicity of the approach is in itself inspiring.

The Tibetan Buddhist Shrine Room at New York's Rubin Museum of Art "provides an immersive experience inspired by a traditional shrine that would be used for offering, devotion, prayer, and contemplation. Art and ritual objects are presented as they would be in an elaborate private household shrine" (Rubin Museum, n.d.). Indeed, the museum here asks a question that seems out of bounds elsewhere: "What spaces are sacred to you?" The collection of Himalayan *thangka* (scroll paintings) and sculptures is sufficiently focused to provide a visual unity often missing in more diverse museums, so the invitation to engage with a meditation space feels wholly comfortable. And while much of the Rubin Museum's collection itself presents Buddhist art as "gallery wall" material, the mere presence of a shrine within the museum sequence enhances the experience of the rest of the art on display.

Another means of addressing religious content in art can be seen in the small Kauffman Museum, associated with Bethel College in North Newton, Kansas. As a Mennonite-affiliated school, Bethel presumably does not need to worry about "establishment" or "free exercise" of religion issues. It is the permanent venue for a traveling exhibition based on the engraved illustrations in the 1685 "Martyrs Mirror" book, revered by Mennonites, that depicts "the drama of people of authority, obedient to crown and church, torturing and killing Anabaptist Christians, who claimed a higher obedience" (Kauffmann Museum n.d.). But the real goal of this exhibition is

to pose serious questions which may not be strictly devotional and firmly suggest larger issues about art and religion—easily applicable to much of religious art, among them: "Why did good people torture and kill? Why did good people resist authority? Why do the powerful fear the weak? Why do modern governments continue to torture and kill? *What beliefs are worth dying for?*" (Kauffmann Museum, n.d.; my italics).

Museums have a history of uncomfortable relationships with issues that challenge their sponsors and funders. So in societies where religion plays an increasingly marginalized role, it is more common to focus on political issues, although their separation from religion is often not clear. In today's American politics the boundaries become increasingly permeable. Nevertheless, raising the specter of belief, spirituality, or faith as a means of understanding and respecting museum artifacts ought not to feel threatening, even to the nonbeliever. It was in this context that I experienced an especially interesting series of events. Sometime during the late 1980s, while I served as the Smithsonian Institution's assistant secretary for museums, I was sitting at a senior staff meeting listening to opposing arguments about something wholly unfamiliar to me. Native American staff members were insisting that human remains (of which the Smithsonian had massive numbers) should be returned to their respective nations/tribes for appropriate disposal or burial. On the opposing side were the Smithsonian's anthropologists, describing the significant scientific information that was available through the study of those same human remains. Indeed, with the development of increasingly sophisticated diagnostic tools and DNA evidence, this was considered an expanding area in the field of physical anthropology (and human biology) (see Chapter 11 in this volume).

I was unprepared to form my own opinion on this debate. I vaguely remembered reading about the sanctity of cemetery sites that were occasionally threatened by road or other construction plans. I know (because I had lived there briefly in the late 1960s) that in Bratislava, the grave of a venerated rabbi Chatam Sofer (1762–1839) had been saved from demolition during a road/tunnel construction project in 1943, even under Slovakia's then-Fascist government. And this led me to remembering the ongoing efforts to recover remains of missing-in-action servicemen from wars in Europe, Japan, Korea, and Vietnam. I had seen photographs of the apparently vast US Military Cemetery at Colleville-sur-Mer in Normandy. I knew that even the probably obliterated remains of airplane disaster victims are the objects of recovery searches. More recent concerns in this field involve the still-ongoing attempts to identify victims lost in the 9/11 World Trade Towers catastrophe.

How could this discussion of "deceased human beings" versus "specimens" be resolved, especially in a museum that, as noted earlier, is its own kind of sacred space to many? Museums presumably assist us in expanding our own sense of humanity, enlarging our understanding of the world—and ourselves. But they also lay legitimate claim to being scientific research institutions. At the time of these ongoing Smithsonian internal (and occasionally newsworthy) debates, NAGPRA (the Native American Graves Protection and Repatriation Act) was in the process of development, and its enactment, in November 1990, presumably made some of the internal

Smithsonian arguments moot. NAGPRA requires that federally funded institutions return "cultural items" to lineal descendants and culturally affiliated Indian tribes and Native Hawaiian organizations. Those items may include human remains, funerary and sacred artifacts, as well as objects of cultural patrimony (which, for some, would include "art"). Case closed! Except that the mechanics of carrying out these legal requirements can (and often do) involve lengthy negotiations and foot-dragging, the latter presumably not one of the humanistic values museums espouse.

While the human remains and "cultural artifacts" discourse remained primarily an internal policy matter (albeit Congressionally resolved and of ongoing concern to Native peoples), the confused message of the American national museums regarding religion reflects the enormous gap between "enlightened" intellectual mainstream thought and the political power of specific national or ethnic groups. Thus, for example, various tribal displays at the National Museum of the American Indian proudly include a range of "creation stories" (I don't believe they are referred to as "myths") to reflect the cultural specificity (and spiritual beliefs) of various tribes/nations. No one objects to that. In fact, various groups—so-called Native voices—have been empowered to tell their own story (see Buggeln, chapter 3).

However, at the National Museum of Natural History, where the development of humans as both physical and cultural beings is explored, it would be unthinkable to invite the many groups whose cultural artifacts are on view to provide their own narratives and/or interpretations, even if they are presumably consulted. While increased sensitivity to "the other" has smoothed the brittle edges of artifact descriptions that formerly reveled in concepts of exoticism, there are still lines one cannot cross, among them the inclusion of so-called creationism. This despite the fact that a 2014 Gallup poll found that 42 percent of Americans believe "that God created humans in their present form 10,000 years ago." Which raises question about the complicated roles a museum needs to play as both a scientific and cultural institution.

My recollection of the Smithsonian managing to keep such a dispute at arm's length during my time working there (1980s and 1990s) is combined with amusement at a personal incident regarding a religious artifact. In the early 1980s, my son received a *Hanukkiah* (lamp used in celebration of the Jewish festival of Hanukkah) as a gift for his Bar Mitzvah. It was a collections-based artifact (replica) sold by the Smithsonian shops. A few years later, when I wanted to purchase the lamp as a gift, it turned out that "religious" objects were no longer being sold by the Smithsonian Shops. This presents a vignette of the ever-confusing disagreements about the meaning of the First Amendment to the US Constitution, which states (among other things) that "Congress shall make no law respecting an establishment of religion, or prohibiting the free exercise thereof." Generally considered as paired, if distinct, concepts—the "establishment clause" and the "free exercise clause"—these form the textual basis for how frequently the courts (and also nonlegal discourse) argue, manage (and even mismanage) issues of religion in public institutions, museums among them. Fear of (increasingly costly) litigation can often motivate institutional action or inaction.

But it is likely not the fear of litigation so much as the embarrassment factor that pervades our museums' inability to deal with religion more thoughtfully. By now a wide range of ethnic and religious groups have developed their own museums; among the pioneers in this field were the Jewish museums, of which there are now many across the world. In a seminal and comprehensive article about these museums, critic Edward Rothstein (2016) laments that he has not "seen anything quite so strange as the ways in which various Jewish communities in the United States, in Europe, and in Israel have come to depict themselves in museums." Having initiated my museum work in this field over fifty years ago, I now understand retrospectively how complicated the issues of ethnicity continue to be. The conflicts between pride and victimhood permeate many museums, while being explicated in interchangeable and generic narratives. Indeed, it is at the Museum of the American Indian, because of the proximity of the various tribe-generated narratives, that one confronts this most directly: every group cares about the eternal values of family, learning, and tradition, always making certain to express a unity with spirituality and nature at its core. All groups are now championing the *ur*-belief in "green" everything to validate themselves with the fashionable concerns of the moment. Despite a century of their ongoing development, Jewish museums still have a difficult time relating the various identifiers of whatever "Jewish" is and relating that to questions of belief and spirituality (or lack thereof). So artifacts (material culture) associated with Jewish rituals (individual, family, and communal) are as dissociated from belief, spirituality, and ritual validation in a Jewish museum as are the Christian objects in most art museums, buried in their cleansed generic narratives.

The occasional attempt to move across cultures, as in the especially beautiful *Sacred Silver* installation at London's V&A Museum—juxtaposing objects from different religious traditions—still carefully refrains from assisting visitors in understanding how *visual* similarities don't necessarily confirm *belief* similarities. Even New York's now-defunct Museum of Biblical Art (MOBIA), which explored a range of art inspired by the (Hebrew and Christian) Bible, tended to work around questions of belief and spirituality. MOBIA was, assertively, *not* a museum of religious art per se. The ability to explicate the *belief* connections and disconnects of what's on view ought to be included in the brief of the scholars (and curators) who decide on and explain what is on view in a museum. Their depth of knowledge includes the religious dimensions, even if that is seldom conveyed to visitors. The private space for belief and spirituality—or their rejection—that each of us rightfully demands is not necessarily invaded by complexity of information. Given the increasingly sophisticated technological devices that invade and control our lives, we have ever greater means to purvey religious ideas, beliefs, and rituals that give greater specificity and meaning to what we see in our museums. It is time to shed the (enlightened?) embarrassment that has led museums to omit or erase a cornucopia of ideas and information underlying most of the faith-related works on view.

References

Kauffmann Museum. n.d. "The Mirror of the Martyrs." Available online: https://kauffman.
 bethelks.edu/martyrs/.
Rothstein, Edward. 2016. "The Problem with Jewish Museums." *Mosaic* (1 February).
 Available online: http://mosaicmagazine.com/essay/2016/02/the-problem-with-jewish-
 museums/.
Rubin Museum. n.d. "Sacred Spaces with the Tibetan Buddhist Shrine Room." Available
 online: http://rubinmuseum.org/events/exhibitions/sacred-spaces.

21 Conversing with the Past: First-Person Religion Programming at Colonial Williamsburg

GRETCHEN BUGGELN

Tourists walking down Duke of Gloucester Street in the open air museum of Colonial Williamsburg (Virginia, USA) see neat brick and wood-frame houses, taverns, and government buildings. Costumed interpreters take them through the Governor's Palace or the Capitol Building, and historic tradesmen patiently explain what they are doing as they forge iron implements or hammer out a silver teapot in their craft shops. Most of these interpreters, although dressed as colonials, address visitors as fellow twenty-first-century citizens. Occasionally, however, a tourist may find herself face-to-face with Thomas Jefferson.

This type of "first-person" interpretation, a professional technique also called "roleplaying" or "museum theater," has its roots in the 1970s United States.[1] At Plimoth Plantation, a reconstructed English Colonial Village of 1627 on the coast of Massachusetts, staff pioneered first-person, portraying documented characters that chatted with visitors in authentic dialects while they went about their seventeenth-century business (Roth 1998, 30–37).[2] Like all museum interpretation, first-person has both strengths and weaknesses. Success depends on a positive exchange between talented and thoroughly educated interpreters who can represent a broad historical worldview and engage visitors. At its best, it invites an empathetic, sensory connection to the past (cf. Chapter 6 in this volume), opens curiosity, and fosters a type of "time travel" that is not only playful but memorable and significant.

This chapter considers how first-person interpretation can work as a means for opening conversations about religion. Colonial Williamsburg, long a leader in first-person (actor-interpreter, or AI) interpretation, will be the focus. At Williamsburg, some first-person religion programs are scheduled and scripted, such as a debate between patriots Thomas Jefferson and Patrick Henry over the separation of church and state. Many of these interactions are performed in an auditorium for a seated audience; other dramas take place in the streets. Actor-interpreters also wander among the visitors, engaging them in improvised, freewheeling conversations.

The Rev. Gowan Pamphlet

One character who appears frequently in the historic area is the Reverend Gowan Pamphlet, an enslaved, African American, Baptist preacher portrayed in 2016 by

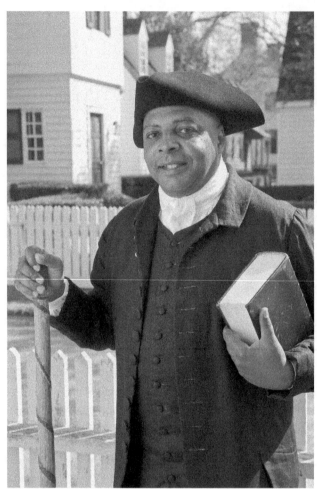

Figure 21.1　Actor-interpreter James Ingram portraying Reverend Gowan Pamphlet.
Photo courtesy of the Colonial Williamsburg Foundation.

interpreter James Ingram (Figure 21.1). The strength of Ingram's portrayal of Rev. Pamphlet is indicative of both the rigorous development of first-person programming at Williamsburg and a substantial, two-decades' old effort to enhance the interpretation of religion (and also African American life) at the museum. First-person interpreters, because they so often have to go off script yet remain in character, require a depth of understanding and knowledge that goes beyond what is typically required for museum interpreters. A close look at Ingram's portrayal of Rev. Pamphlet and the research behind it displays the potential of using actor interpreters to teach religious history to museum visitors.

When Ingram arrived at Williamsburg in 1995 there was little discussion of religion beyond colonial debates over the separation of church and state (Buggeln 2009). Almost no attention was paid to individual practice or piety. Although Anglicanism

was the official religion of the colony, a visitor would not see a Book of Common Prayer or a Bible in any of the historic houses. At that time, however, Williamsburg was poised to enhance religion programming, supported by several major grants. In 1998, the theme "Freeing Religion" marked program development and interpretation across the institution, resulting in a tremendous boost to research and the production of interpretive materials still in use two decades later.

Linda Rowe, a historian in Williamsburg's Department of Historical Research, is an expert on Rev. Pamphlet and African American religion and life in the colonial South. She has worked closely with Ingram developing his interpretation (Rowe 2012). Pamphlet appears in the historical record in 1779 as a slave working for widowed tavern keeper Jane Vobe. Apparently literate and mobile, he labored with a small group of enslaved and free blacks to build a Baptist congregation. Dissenting churches promoted a theology of equality that was threatening for its tendency to regard blacks worthy of not just salvation but education and freedom. For many years the congregation had to meet in secret outside of the city center, and Pamphlet's preacher mentor, known only as Moses, was on several occasions brutally whipped for his religious activities.

Ingram was intrigued by Pamphlet because, like Ingram himself, he was ordained by the Dover Baptist Ministers' Association (2015). Pamphlet made his application to this organization in 1791, no doubt, Ingram believes, because of the focus on emancipation in the association's mission statement. In 1793, Pamphlet and his First Baptist Church were accepted into the Dover Association. That same year, 1793, Pamphlet gained his freedom from Jane Vobe's son and heir. After 1800, the congregation of about 500 moved into a building in Williamsburg proper. This was the first Baptist church in the United States organized by and for African Americans, and it is still an active congregation. Although demolished, the location of this early building is marked with a historical plaque, and in a reconstructed carriage house nearby an exhibition interprets African American life. Pamphlet died around 1807, a well-known religious figure among the whites and blacks of Williamsburg.

James Ingram's knowledge of religion in the colonial South is extensive. He can talk about the first dissenters in the area, Quakers who came in 1687. He speaks knowledgeably about the waves of Presbyterians, Baptists, and Methodists who arrived from the West in the mid-eighteenth century, challenging the status quo of Virginia's established Anglicans. When Ingram (2015) began working at Williamsburg, he noticed "a whole lot of guests were religious in nature but there basically weren't any programs for them to attend," something that struck him as especially odd considering "the importance of religion in the eighteenth-century world." Ingram began experimenting with expanded programming, and he often attracted a large crowd of people who stopped to hear his Rev. Pamphlet preach in the streets. Williamsburg's administrators took note.

As a trained minister himself, Ingram is comfortable acting the preaching role, and through his historical sermons he has found a powerful way to tap the historical consciousness of his museum's visitors. His favorite Rev. Pamphlet program, one he

has offered for over a decade, is an hour-long scripted presentation in the auditorium, a sermon titled "God Is My Rock," based on the biblical story of Daniel in the Lion's Den. This text would have resonated with an enslaved audience, people who were also torn from their homes, given new names, and forced to abandon their traditions. Ingram preaches from the stage in a forceful and animated manner that invites the sensory historical immersion that is one of the advantages of character interpretation; the interpreter literally embodies history and communicates in a direct and personal way. Ingram says his audience expresses amazement that the hour passes so quickly. After his sermon, Ingram takes questions. He will answer some in character, but allows that it is sometimes necessary to break from the roleplaying and offer historical context. "There are some guests that probably won't get it . . . and you need to help them to understand this topic from the twenty-first century standpoint" (2015).

Religion is a challenging topic, Ingram notes, because most visitors, whatever their own religious background, come "with baggage." Because Ingram is an African American interpreter playing a slave, that particular visitor baggage relates to understandings about the slave experience as well. "Somehow, in forty-five minutes or twenty minutes or whatever time I have," he says, "I have to help them unpack some of that [baggage] and repack it with things they can use." "It is really second nature now," he feels, "to the point where I don't know if I'm actually aiming to a particular result . . . all I want to do is to really let them understand the history of this country." When asked if he gets theological questions from the audience, Ingram (2015) replied, "All the time." He attempts to answer these questions as Pamphlet would (this requires extensive knowledge of eighteenth-century Baptists) or he moves the question toward something he does know.

Visitors who engage the AIs often are seeking to find their place in this colonial religious context—if I had lived here, they wonder, what would *my* experience have been? They generally expect Ingram to know about the history of other denominations in this place and time, and they ask questions in order to hear their own story. It is a surprise to many to hear Rev. Pamphlet talk about the variety of religions represented in Virginia several centuries ago, for instance, the South Asian Muslims down the road in Jamestown, brought by the business of the East India Company. On the other hand, when a self-professed atheist in his audience once asked, "What about me? What would happen to me in the eighteenth century?" Ingram (2015) replied, "If you were born in any of these colonies you were going to be an Anglican, whether you believed in God or not." What this example highlights is just what Ingram values so much in his work as an actor interpreter: "You can see the wheels turning," "Being able to take them into that eighteenth century world. Being able to create it for them" (Ingram 2015). He believes this interaction leads to more useful, memorable, and deeper learning.

Gowan Pamphlet's mentor Moses has been played by Stephen Seals, who in 2015 became senior manager of both African American and Religion Programs at Williamsburg and thus knows these programs inside and out. Seals illustrates the benefits of first-person presentation of religious content by citing the annual

Williamsburg appearance of English Methodist the Reverend George Whitefield. After a contextual introduction by an educator, "the Reverend Whitefield" climbs into the pulpit of Bruton Parish Church and reads an excerpt from an actual sermon he preached there in December 1739, in which he is "very unapologetic about his feelings about those who have not come to Christ." "We could not do his sermon unedited if it were not first person," Seals (2015) explains, "partly because there are three separate instances where he talks about how horrible the Jews are." Being able to show the "ugly parts of the past" in this fashion means that "people can't point at you and say "what are you trying to agendize?" Visitors know they are getting these words straight from the past, and while they may be shocked by some of the content, they do not feel they are being manipulated.

According to Seals and his staff, very few visitors have offered negative feedback. Most are grateful to encounter an honest discussion of religion. Seals says the most common reaction now is: "We can't *get* this anyplace anymore! Thank you for talking about it, and talking about it honestly and without any sort of agenda." Seals notes a certain awkwardness in discussing religion in America, despite widespread spirituality; many who are "personally interested in religion are ashamed to talk about it," and pleased to find the subject openly addressed at Williamsburg. Interpreters know they must proceed carefully, in order to minimize bias and provoke the visitors to ask questions and draw their own connections and conclusions. "We give the context," Seals (2015) states, "but it's their job to connect."

In addition to Pamphlet and Whitefield, popular first-person portrayals in the realm of religion include Church of England ministers, Baptist dissenters, and political figures engaged in church-state debates. Two programs feature women: "The Pious Man's Daughter, the Rebel's Wife," the story of Elizabeth Nicholas Randolph developed by an AI who wanted to interpret religious duty and Christian education from a woman's perspective; and "Lessons with Ann Wager," in which a teacher at Williamsburg's Bray charity school for slaves takes young museum guests and teaches them the catechism. Seals (2015) would like to create additional programs that focus on "where we came from," highlighting African religious traditions. Knowing that there were both Muslims and Jews in Williamsburg in the eighteenth century, as well as closet Catholics, Seals believes first-person interpretation would be a successful way to make that diversity come to life for visitors. It is evident from the breadth of these programs that first-person interpretation is also an ideal way to integrate different themes: religion and slavery, religion and the role of women, religion and politics. This helps visitors understand religion as something woven into the fabric of everyday life in all its complexity.

Conclusion

First-person interpretation is only as good as the interpreter, and to some extent only as good as the visitor who asks questions. Particularly for improvised interaction, the interpreter must have command of knowledge that far exceeds the content of

each conversation. Rowe, Seals, and Ingram all noted that it is increasingly common that Americans know very little about religion and its place in American history. Many Americans do not understand how limited and restricted religious freedom actually was in the North American colonies and how little tolerance one could expect. Seals and Ingram believe that conveying such difficult, or surprising, truths via first-person interpretation works well because visitors are curious and open without being suspicious.

This is not a technique that works equally well for all visitors. Some prefer to read label copy, or hear a lecture, or talk to a museum employee about historical realities. That said, first-person interpretation is a fruitful, and so far highly successful, means of introducing visitors to religious themes and problems. For visitors who see Mr. Gowan Pamphlet walk down the street, preach a sermon, or perform a marriage between slaves, the encounter prompts questions and opens important conversations in a uniquely engaging way. Although the range of such interpretation will be limited by the nature and resources of individual museums, the technique and its successes have much to teach museum professionals about the value of open questions, direct visitor engagement, and integrated interpretation. They also point to what many of the authors in this volume have noted: the public is usually grateful for the opportunity to learn more about religion in the context of a museum visit.

Notes

1. First-person interpretation today is most common in North American and British museums. In addition to museum staff interpreters, freelance companies, like Past Pleasures in the United Kingdom, provide character interpretation (see www.pastpleasures.co.uk). See also the International Museum Theatre Alliance, www.imtal-europe.net. This technique is a natural fit for open-air museums with costumed interpreters and a ready-made historical setting. More comprehensive history museums, such as the Indiana History Museum, have experimented with staged settings for focused actor-interpreter (AI) portrayals. What distinguishes this interpretation from more traditional historical theater, or historic re-enactments, is that it is first of all for public education, and unscripted (although often structured to a degree.)
2. Other North American museums soon followed, including Upper Canada Village, Connor Prairie, Mystic Seaport Museum, and Old Sturbridge Village.

References

Buggeln, Gretchen. 2009. "Remarks on the Recent Interpretation of Religion at American History Museums." In *Museums and Faith*, *edited by* Marie-Paule Jungblut and Rosemarie Beier-De Haan. Luxembourg: Musee d'Histoire de la Ville de Luxembourg and Internation Council of Museums (ICOM).

Personal interview with Stephen Seals, Colonial Williamsburg, September 25, 2015.

Personal interview with James Ingram, Colonial Williamsburg, September 24, 2015.

Roth, Stacy. 1998. *Past into Present: Effective Techniques for First-Person Historical Interpretation*. Chapel Hill: University of North Carolina Press.

Rowe, Linda. 2012. "Gowan Pamphlet: Baptist Preacher in Slavery and Freedom." *Virginia Magazine of History & Biography* 120 (1), 3–31. EBSCOhost

22 Religion in Museums for Families with Children

CHRISTIAN G. CARRON, SUSAN FOUTZ, AND MELISSA PEDERSON

Religion is such a challenging topic to address in public forums that many museums in the United States refrain from tackling it altogether. Likewise, public schools find it difficult to teach children about religion, even though curricular guidelines exist for teachers. These are precisely the reasons why The Children's Museum of Indianapolis (TCMI) organized *National Geographic Sacred Journeys*, a temporary exhibition about world religions for the museum's primary audience, children and their families.

With 1.2 million annual visitors, The Children's Museum of Indianapolis is the largest museum dedicated to children and families in the world. It develops and presents exhibits on a wide variety of topics ranging from dinosaurs to toys. Unlike most children's museums it also utilizes artifacts and specimens in all of its experiences as well as actor interpreter performances to assist in bringing stories to life.

Tackling Topics of Substance

While its experiences are kid-friendly and educational, TCMI has a history of tackling tough topics of substance. In *The Power of Children: Making a Difference*, audiences explore Anne Frank's message of hope amidst the terrors of the 1940s Holocaust, see the bravery of Ruby Bridges, one of the first black students to integrate a 1960s white school in the American South, and learn about how teenager Ryan White fought fear and misinformation about HIV/AIDs in the 1980s. The museum's *Take Me There* exhibit series investigates how people in other countries live their daily lives, in order to promote awareness and respect for other cultures. Successful outcomes of these exhibitions emboldened TCMI to address other difficult but important issues for families and children, particularly religion.

A recent survey by the Pew Research Center showed that the United States is one of the most religious of all developed nations. Nearly 60 percent of Americans say religion is very important in their lives, and 40 percent attend worship services weekly (Religious Landscape Study 2014). But another Pew survey revealed that large numbers of Americans are uninformed about the beliefs, practices, and history of major faith traditions including their own (US Religious Knowledge Survey 2010). This is further complicated by confusion between court rulings that religious devotional practices and indoctrination are unconstitutional in public schools, and curriculum guidelines which encourage instruction in comparative religion and the

history of religions. As a result, public schools often do not properly include religion in the curriculum (Haynes 2004, 2). Recognizing that knowledge about religion is important, but that most children and adults have insufficient exposure to the topic outside of their own religious practice, TCMI staff engaged in a dialogue with the Lilly Endowment to fund an exhibition drawing on aspects of multicultural and global education (Cole 1984, 151–154). One "Big Idea" was developed as the foundation upon which all aspects of the exhibit would be based: Sacred Journeys have the power to transform us—our values, our perspectives, and our feelings. Understanding the sacred journeys of people around the world fosters awareness of cultural diversity and respect for religious traditions.

The museum created the exhibit for a primary audience of children of at least eight years of age accompanied by an adult caregiver, but designed it to appeal to audiences that represent a diversity of ages, religions, and life experiences. Approximately 76 percent of Americans subscribe to a religion, about 70 percent of which are Christian (US Religious Landscape Survey 2014). Based on this the exhibit team assumed a majority of audience members would identify as religious, most likely Christian. However, it was decided that information would be presented in a simple, clear, and precise manner, assuming that visitors may have had no previous knowledge of religions. Supported by the work of developmental psychologists, designers targeted the exhibit at children eight years and older (Ginsburg and Opper 1988, 109–112). Experiences would be designed to encourage adult caregivers to discuss content with young family members and help bridge the gap between concrete examples and abstract concepts.

To further explore the target audience's perceptions, the research and evaluation department conducted front-end evaluation interviews focused on perceptions of and expectations for an exhibit on world religions, topics that respondents felt were important to convey about their own beliefs, and questions about other faiths that could be explored. The study results were confirmatory in some respects and surprising in others. The exhibit concept was understandable and appealing to the identified target audience. Surprising to the team was the positive reaction to the topic and visitor willingness to share their thoughts about religion. This was taken as an encouraging sign that family audiences would not shy away from the exhibit.

Developing Content Messages with Advisors

A group of academic experts on world religions and education about religion for children was enlisted to advise the exhibit team. Advisors decided that "personal spirituality" was too broad as a topic, and recommended that the exhibit should concentrate on the journeys of people within the context of organized religions. They also advised that the exhibit should focus on "living" religious traditions in the modern-day context. One of the biggest challenges advisors addressed was the question of which religions to include. In the end, they recommended five world religions: Judaism, Christianity, Islam, Hinduism, and Buddhism. These choices were based on the

numbers of practitioners worldwide, their impact on world history, the number of adherents who might be neighbors to museum audiences, and the traditions most associated with misconceptions in need of correction or further exploration.

The advisors also made other recommendations for the exhibition. They felt strongly that the exhibit should focus on the practices of everyday people and should not be distracted by rituals that might be interpreted as extreme or bizarre. They explained that some religions place a greater emphasis on belief while others focus on action so both aspects should be addressed. Finally, they warned that even though it is possible to use common lenses to examine different religions, it should not be suggested that all religions are the same. Rather, it is by recognizing the differences that understanding can occur.

Even though TCMI had presented controversial subject matter before, and front-end evaluation suggested that audiences seemed willing to learn about world religions, valid concerns were raised based on high-profile news stories about religious fear and intolerance. Would some visitors be bothered by the inclusion of certain religions, or upset that their own tradition did not get enough attention? Would extreme groups protest? Would some people attempt to proselytize or become combative with gallery staff? Staff worked with advisors to prepare responses and statements for different scenarios, none of which, thankfully, were ever needed. All museum personnel also underwent mandatory training about the messages and goals of the exhibition, so staff would be prepared to address visitor concerns.

Advisors also confirmed that it was impossible to teach everything about world religions in one gallery. They identified several "gateways" for engaging families in exploration of world religions, including annual seasons and life cycles/rites of passage; religious culture or beauty and creativity; sacred texts and documents; and "sacred journeys"—travel and pilgrimages to sacred sites. Inspired by a 2011 National Geographic photographic publication titled *Sacred Journeys*, TCMI chose to make this the primary storytelling portal and enlisted National Geographic Society as a collaborator in the development of the exhibit. National Geographic Society curated images of sacred sites that were used in video presentations and wall-sized murals to create immersive spaces representing religious destinations.

Exhibit Design and Encounters with the "Real"

To support the "Big Idea" several design principles were employed. The exhibit team developed the stories of five fictional but plausible people who are traveling to religious sites highlighted in the exhibit. These pilgrims, dubbed exhibit "guides," were depicted in the gallery using life-sized photographs and short videos (Figure 22.1). Visitors were encouraged to follow the guides on their journeys. TCMI chose to cast teenagers as the guides to make the exhibit more accessible for child and teenage visitors. It was also hoped that looking into the guides' faces would have an important humanizing effect on visitors, helping them to be more open to learning about the experience of an individual than an abstract group. Through labels and dialogue

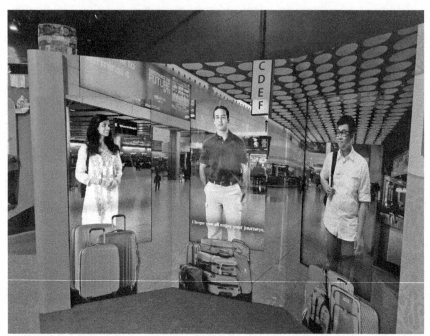

Figure 22.1 Visitors come face-to-face with videos of teenagers embarking on sacred journeys. Photo courtesy of The Children's Museum of Indianapolis.

written from a first-person perspective, the guides also conveyed plausible emotional and personal reactions drawn from pilgrimage experiences of actual teens. This provided a warmer tone than the more traditional third-person didactic labels about artifacts and historical sites. Finally, visitors could experience religious rituals vicariously through the guides' journeys, without actually taking part in unfamiliar religious practices themselves.

The traffic flow throughout was intentionally nonlinear, allowing visitors to construct their own journeys and follow different paths. The exhibit began with a video exploring why people take sacred journeys, and another introducing the guides about to board their flights at the airport. Audiences then encountered five immersive environments representing actual sacred places coinciding with the five major religions chosen for the exhibit: Bodh Gaya in India, Our Lady of Guadalupe Basilica in Mexico City, sites sacred to several religions in Jerusalem, the Great Mosque in Mecca, and the Ganges River in India. Additional displays were dispersed throughout, which increased the variety of religions and artifacts using intriguing personal stories of real individuals. The exhibit concluded with a video of the guides' reflections on the ways their journeys affected them and encouraged audiences to reflect on their own experiences.

Objects provided tangible encounters with the sacred places discussed in the exhibit. It is unusual for a children's museum to produce object-centered exhibits, but in *Sacred Journeys*, artifacts were critical for creating connections between visitors and the stories featured. Utilizing the museum's collection and artifacts from more than

twenty lenders, *Sacred Journeys* presented journey stories through objects of faith and religious practice. Some sites are tied to the sacred artifacts found there, such as fragments of the Dead Sea Scrolls and the caves of Qumran where they were hidden. Some served as evidence of an event, like the trunk that Brigham Young used on the Mormon Trail. Some displayed the physical beauty of a sacred place, such as a tile from the Dome of the Rock in Jerusalem. Some represented festivals, like a colorful statue of Ganesh from Mumbai. Still others were souvenirs from a journey, including a *lota* vessel used for bathing by Hindus in the waters of the Ganges River. Many were deeply personal, like the Hebrew prayer book taken by astronaut David Wolf to the International Space Station. A few sacred objects were represented by reproductions, such as a clearly identified, full-sized replica of the Shroud of Turin, which was displayed so that it could be examined up close and at eye height for children.

Sometimes nothing can substitute for intimate contact with the "real thing," as was demonstrated by visitors who left offerings in front of the Dalai Lama's throne, or gently placed their hands on a touchable block of the Western Wall in Jerusalem (Figure 22.2). Hands-on experiences can be important for all audiences, but especially for families with children. While many loans could not be touched, interpretation staff in the gallery led programs with musical instruments from different faiths allowing for tactile and auditory learning with objects. Dome of the Rock mosque tiles were replicated in a hands-on puzzle to show how art was used to illustrate the concept of infinity.

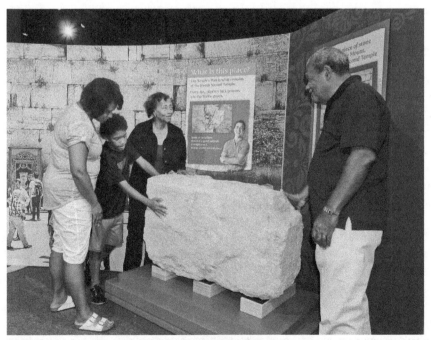

Figure 22.2 A multigenerational family examines a block from Jerusalem's Western Wall. Photo courtesy of The Children's Museum of Indianapolis.

Community Dialogue

An important part of the development process involved the building of trust through inclusion and dialogue. TCMI listened and learned from local faith representatives and lenders about the rituals and artifacts in the exhibit. How could it provide a safe place for dialogue and promote respect if the exhibit team did not engage in substantive conversations and treat religious practitioners as partners? In turn, local religious leaders became advocates for the exhibit where their stories were treated with respect.

These faith representatives also played an important role informing curators of special considerations for exhibiting certain artifacts. Dialogue with a Muslim advisor led to the hanging of a prayer rug so that it faced Mecca. A sand mandala created by Tibetan Buddhist monks followed a design recommended by the Dalai Lama as acceptable for public display. According to Buddhist custom the mandala was ceremonially destroyed by the monks when the exhibit closed to symbolize the impermanence of life, and the sand was dispersed into flowing water to release its energies back into the world.

The lender of a Guru Granth Sahib, a Sikh holy scripture, instructed curators to display the book on a raised platform, higher than other objects in the case, and with a whisk or fan. Curators were originally informed that the book could be displayed open but partially covered by a scarf. But a difference of opinion among Sikh leaders resulted in a request that it be displayed both covered and closed, next to a photograph showing the pages open. As a sign of respect TCMI complied with the request.

Impact

Exhibitions about religion have a potential for creating transformative experiences in families and children, but how do you measure transformation? TCMI measured outcomes in a number of ways. Quantitatively, approximately 165,000 people visited the exhibition during its six-month run in Indianapolis. Observational studies revealed that objects which attracted the most attention ranged across several different religious traditions, including the Shroud of Turin replica, fragments of the Dead Sea Scrolls, the Ganesh statue, the block from the Western Wall, and the Dalai Lama's throne.

Interviews measured the receptivity of the audience to the exhibit's messages. When asked if they agreed, disagreed, or were neutral with regards to the statement "[s]ome people might say that a family-oriented museum *should not* present an exhibit about religion or faith," visitors overwhelmingly supported the presentation of the topic. Visitors' reasons for support included their view of the museum as an educational venue, and the benefits to society that a greater understanding of different religions can create. Some respondents specifically valued the presentation of multiple viewpoints, and appreciated that the exhibit did not promote any one religion or endorse any one faith as "right" (Foutz et al., 2016).

The case study of *Sacred Journeys* demonstrates that it is not only desirable but possible to present exhibits about religion for families with children. By focusing on the journeys people make to visit sacred places, the museum created a concrete, accessible, and personal gateway to the treatment of a complex subject. Even during a period of divisive rhetoric about religions, faith leaders were eager to share their artifacts and stories, and families with children were receptive to learning about them. In recognition of the difficulty of interpreting the subject of religion, *Sacred Journeys* was selected as a winner in the 28th Annual American Alliance of Museums (AAM) Excellence in Exhibition Competition for Special Achievement for (tackling) a Risky Subject. For the project team, this recognition demonstrated that the intentional approach used to develop the project was well worth the effort (AAM 2012).

However, it may be that the real value of this exhibit was in the conversations it encouraged. TCMI's approach to experience development promotes conversations within the family group, not between groups of visitors who do not know each other. This positioned *Sacred Journeys* not as part of the public dialogue about the role of religion in American society, but as an opportunity for parents and their children to learn together and reflect as a group about the topic. The evaluation study confirmed that the museum's goals were realized: 40 percent of families reported that they had a conversation in the gallery that they typically do not have as a family. The vast majority of families surveyed (87 percent) reported talking about faiths that were not their own while in the exhibition, which is higher than the percent who talked about their own religion (66 percent). Perhaps the strongest indicator of potential for transformation was the response by 75 percent of the visitors that they continued to talk after they left the museum, primarily about the diversity of religions represented and their positive experience in the gallery (Foutz et al., 2016).

The interpretive strategies that most supported family conversations were engaging collections and visuals to spark curiosity; labels that were brief, free of jargon, and fact-based; a nonlinear floor plan to allow for visitor choice in moving through the space; and a presentation of religion that was positive and inspiring while not shying away from diversity. By placing families in an inviting space that exposed them to practices, objects, and beliefs outside of their daily experience, *National Graphic Sacred Journeys* demonstrated that with intentional planning, family-oriented museums can engage visitors with this "risky" subject.

References

American Alliance of Museums. 2012. *Standards for Museum Exhibitions and Indicators of Excellence*. Available for download at http://name-aam.org/about/who-we-are/standards.

Cole, Donna J. 1984. "Multicultural Education and Global Education: A Possible Merger." *Multicultural Education* 23 (2): 151–154.

Foutz, Susan, Trish Gibson, Rachael Mathews, and Amelia Whitehead. 2016. "National Geographic Sacred Journey Summative Evaluation." Internal Technical Report, The Children's Museum of Indianapolis, Indianapolis.

Ginsburg, Herbert, and Sylvia Opper. 1988. *Piaget's Theory of Intellectual Development*. Englewood Cliffs, NJ: Prentice-Hall.

Haynes, Charles C. 2004. *A Teacher's Guide to Religion in the Public Schools*. Nashville, TN: First Amendment Center.

"Religious Landscape Study." 2014. Pew Research Center, Washington DC. http://www.pewforum.org/religious-landscape-study/.

"US Religious Knowledge Survey." 2010. Pew Forum on Religion and Public Life, Pew Research Center, Washington DC. http://www.pewforum.org/2010/09/28/u-s-religious-knowledge-survey/.

23 Bringing the Sacred into Art Museums

GARY VIKAN

In 1985 I began working at the Walters Art Museum in Baltimore as assistant direc-
tor for curatorial affairs and curator of Medieval Art, a position I held until I became
the museum's director in the spring of 1994.[1] For me, being a curator meant schol-
arly exhibitions with hefty catalogues. I guess I had inherited that academic bias
from my Princeton graduate school training and my German-born thesis advisor,
Kurt Weitzmann. But my year at the National Gallery of Art in Washington, DC, as
a Kress Fellow, in 1973–74, had introduced me to the exhibition showmanship of
Carter Brown and his brilliant installation designer, Gil Ravenel. Each day for the last
three months of my fellowship I walked through *African Art and Motion* on my way
to my cubicle above the Widener Room. I marveled at the way Ravenel brought indi-
vidual works in the show to life with piped-in tribal music and with videos showing
dance rituals in which works like those on display were used. The powerful sense of
place and intense visitor engagement he had created amazed me. The galleries were
packed. And yes, the catalogue was hefty.

That is what I wanted for my exhibitions, but it was impossible at Dumbarton
Oaks, Harvard's research center for Byzantine studies in Washington, DC, where
I held various curatorial positions from 1975 through 1984. This was not only for lack
of money and a Dumbarton Oaks version of Gil Ravenel with whom to work, but
also because my "gallery" consisted of three small wall cases in a hallway bathed in
daylight. Videos, piped-in music, evocative wall colors, dramatic lighting, and stage
sets were out of the question. The result was that my first exhibitions at Dumbarton
Oaks were comically dense and insanely didactic. I tried to tell very complex stories —
for example, of Byzantine pilgrimage art — in those three small wall cases with tiny
objects that were mostly inherently ugly and all but impossible for nonscholars to
figure out.

In my first exhibition at the Walters, *Silver Treasure from Early Byzantium*, in the
spring of 1986, I borrowed from Gil Ravenel by building a miniature church in the
gallery, with an altar, columns, and arches. I also created a video, shot on-site in
Hagia Sophia in Istanbul, to introduce our visitors to Byzantium and its liturgical silver.
The video's background music, Byzantine chant, spilled over into the galleries and
created a wonderful effect. My little stage set was intended to evoke the church for
which the silver treasure that was the subject of the show would have been made
in the sixth century. People seemed to like it. This was a kind of intellectual exercise,
though, and I had no great hope that our plywood and Styrofoam church would

achieve the magical aura of the sacred that Chartres Cathedral had for me when I stepped into it for the first time. Much less, the intensity of audience engagement of *African Art and Motion*.

I did, however, have some hope for the power potential of the star of the show, the famous Antioch Chalice from the Metropolitan Museum of Art, which our scholarly consultant had concluded was neither from Antioch nor was it a chalice—rather, it was very likely a lamp. Accepting that conclusion as true, I was also aware that for decades, beginning in the 1920s, the Antioch Chalice has been believed by millions to be the outer casing for the Holy Grail, the onyx cup out of which Christ drank on the night of the Last Supper. So, I assumed there was a predisposition on the part of at least a segment of our potential audience to cling to this fantastic theory, and in doing so to inform a sixth-century lamp from northern Syria with the spiritual potency of Jerusalem and Jesus. Our label made clear what we thought the object really was and when and where we believed it to have been made. But it also told the tale of the Holy Grail. In addition, we placed this one work all by itself in the first large gallery, with sepia photo murals on the walls evoking the exotic feel of the Holy Land and ancient times—and the spillover Byzantine chant from the nearby video theater. We put the Antioch Chalice in a case that was taller than all the others in the show, which meant our visitors had to look up to it. By doing all of this, we allowed for an ambiguity that let a sense of the divine creep in and, for some, flourish. I know it worked, because I recall the staff in silent awe when we installed the piece—and how reluctant our art handlers were to touch it.

But my ultimate goal was to present the icon, Byzantium's "theology in color." This, I knew, would be my medium for working the numinous—for creating in our museum visitors a sense of being in the presence of the divine.[2] My opportunity came with a call from Carter Brown of the National Gallery of Art in September 1986. Melina Mercouri, who was then Greek minister of culture, was eager to send exhibitions abroad celebrating Hellenic culture. She had offered two to Carter: one devoted to Byzantine icons and frescoes and the other to the human form in classical Greece. Carter chose the latter, and he was kind enough to think of me for the former.

I partnered with a Washington DC exhibition-circulating agency called The Trust for Museum Exhibitions, applied for and won a major National Endowment for the Humanities grant, and with the Trust organized a national tour, from Miami to San Francisco. With *Holy Image, Holy Space: Frescoes and Icons from Greece*, I was going to introduce the Byzantine icon to the non-Orthodox American public. Of course, this meant a deep dive into the theology and history of the icon, with special emphasis on its role in the Byzantine church. My tools were primary sources of the Byzantine period and a seventeen-minute video called *The Icon*, which transported museum visitors back in time, into the Byzantine churches at Daphni and Hosios Loukas. But beyond this didactic aim, and pretty much independent of it, I was going to load the show up with the numinous. I had come to the conclusion that a Byzantine icon, unlike a Byzantine chalice or lamp, could not be realized for what it was *without* the numinous. To put it back in its church by reconstructing an icon

screen comparable to the *Silver Treasure* reconstructed church altar was fine—and I did that—but the real story of the Byzantine icon is not how and where it is situated in a Byzantine church, but rather how it is understood as a vehicle for gaining access to the holy by the supplicants for which it was created. It was, and is, an agent for engaging the divine—a door or window to heaven.

The critical ingredients for creating a sense of the divine in the galleries for *Holy Image, Holy Space* were wall color (a deep blue), ambient darkness, dramatic lighting, medieval chant (which spilled over into the galleries from the video theater), and the positioning of the best of the individual icons in such a way that they would dominate and control the visitors' field of vision and thus command their emotions. What set the tone for the whole exhibition was my choice for and placement of the very first work the visitors would encounter—an enormous, five-feet-tall icon of *Christ the Wisdom of God* of the later fourteenth century. It is a big, powerful, and commanding icon, showing a bust-length image of Christ, a book in one hand and the other hand raised in blessing. I wanted this icon to bring to life, to make real, for each visitor a compelling text of around 1200 that describes how a single icon of Christ, much like this one, could inspire very powerful, but different emotions, depending on the psychological state of the viewer:

> His eyes are joyful and welcoming to those who are not reproached by their conscience . . . but to those who are condemned by their own judgment, they are wrathful and hostile.[3]

To make certain that this icon would do its numinous work, I put it all alone at the end of the long, dark entrance hall to the show—right in the middle of the hall, in such a way that it seemed that there was no way to get around it and into the exhibition proper. Each visitor was forced to come straight at this great icon and stare back into Christ's enormous eyes. Only once arriving directly in front of it could they skirt it, at the last moment, and enter the first gallery. My aim was to make clear that in this space, in this exhibition, Christ is in charge. And he knows what you're thinking. Michael Brenson, who characterized *Holy Image, Holy Space* as "a good and perhaps a great show," in his *Times* review, got it. His first four paragraphs, which flanked a large reproduction of the *Christ the Wisdom of God* icon, were devoted to how that icon worked in the show. He assumed that the congregation of the church for which it was created, around 1400, "must have had absolute faith that this image in the front of the apse was a door or window to Christ." And he went on to complete the thought with precisely the affective, emotive outcome I was after: "Six hundred years later, on another continent, in a museum, the icon still seems like a medium, a passageway to another realm." Just what I had hoped for. But what the reviewer criticized—what made this a good but not a great show in his view—was the tension between my academic labels and my theatrical installation. I felt (and feel) that the art history of a work must be told, and told accurately. So for Michel Brenson, and I am certain for many visitors to *Holy Image, Holy Space*, there was a constant back and

forth between a sense of transcendental rapture and lessons in the iconography and history of icons. I never resolved that.

I presented three icon exhibitions between 1988 and 1993, from Greece, Russia, and Ethiopia. Each was the first of its kind in America and they toured to eighteen cities from coast to coast and were seen by about half a million people. In each, my aim was to create a sense of the divine for our visitors. The great *Glory of Byzantium* exhibition at the Metropolitan Museum of Art in 1998, five years after the last of my three icon shows opened in Baltimore, was far bigger than my three combined and was seen by about half a million people in its single venue. It was a magnificent exhibition. But I like to think that our efforts were complementary, and that I somehow paved the way. In the end, over a ten-year period, the United States became well acquainted with the icon.

This was long overdue, for reasons that I think have something to do with the affective power of icons and America's discomfort, in academic circles and in daily life, with embracing an art form over which it (we) simply cannot maintain critical disinterest. Despite its stylistic austerity, the icon is a hot medium and, to get it, you have to get hot with it, as it brings you face to face with the divine. You simply have to take the icon on its own terms. So, bravo for us; we brought the icon into art museums on its own, numinous terms, and it was embraced by our audiences. And embraced as well by the academic community, for which the icon became a topic of critical research and scholarly conversation as never before. When Byzantine icons are presented in traditional museum settings they lack that spiritual potency, at least for most people. I say that from having watched visitors to *Heaven and Earth: Art of Byzantium from Greek Collections* at the National Gallery of Art in the spring and summer of 2014. The great icon of *Christ the Wisdom of God* and the magnificent two-side icon with the dead Christ from Kastoria (Figure 23.1), the two stars of *Holy Image, Holy Space*, paid a return visit to the United States after a quarter century. But this National Gallery installation was completely different from that at the Walters in 1988. Dry and lifeless, it was essentially a match for the installation of the Ashcan School American paintings in the gallery opposite the exhibition's entrance. No drama, no numinous, no spiritual rapture—and so, no kisses on the Plexiglas (see later).

Celebratory reviews in *The New York Times* and lots of visitors are good signs. And all three of my icon shows got both—as did the Met's great Byzantine shows that followed. But Jeff Koons, with his balloon dogs, and David Hockney, with his watercolors of Cornwall, get that. And neither is in the business of working the numinous. How can you tell if you've captured the holy—the sense of profound affect that the object, the icon, can impart, but only when the viewer completes it? I recall a scrawny guy whom I took to be maybe thirty-five, who had the thickest glasses I had ever seen. Truly, the bottoms of Coke bottles. Pretty soon, I am seeing this person in *Holy Image, Holy Space* every Wednesday, which was our free day. He had one of those collapsible chairs with three legs and a canvas seat—very small, and he brought it in each Wednesday with him. He behaved like a monk, but he was dressed in street clothes. I never spoke to him, but he parked himself in front of the same icon

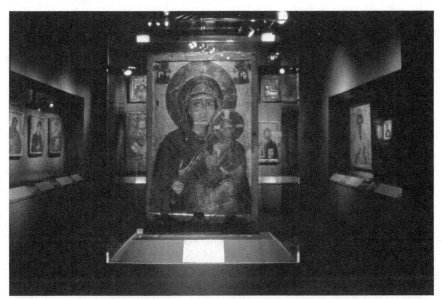

Figure 23.1 Processional icon of the Virgin Hodegetria (front) and the Man of Sorrows (back), late twelfth century. Byzantine Museum, Kastoria. Shown as installed at Walters Art Museum, Baltimore. Photo by Gary Vikan.

each time: a two-sided icon with an anxious-looking Virgin Mary with Christ Child on one side, and the dead Christ, chest up, on the other. For me, and I guess for him, it is the greatest icon ever created. Powerful, beautiful, puzzling in its meaning, and anonymous. It is from Kastoria, in northern Greece, and dates around 1200. See this icon and you shall never forget it. Anyhow, that is where Mr. Bottle-Glasses in Folding Chair parked himself every week for eight weeks. And then the show went to Miami, which seemed like an odd place for icons. And I went to give the opening lecture, in an anonymous darkened hall downtown. And as my eyes adjusted to the low light, I saw someone I sort of knew at the far right of the first row: Mr. Bottle-Glasses. I realized then that there is such a thing as an icon groupie.

And then there is Frederica Mathewes-Green, whom I only learned about and met later. Nowadays, she leads an Orthodox parish just south of Baltimore with her husband. Frederica started her life as a Catholic and later, through marriage, became an Episcopalian. She went to *Holy Image, Holy Space*. I still occasionally see her, and she tells the same story each time I do, the story of the impact on her of that very same Kastoria two-sided icon that Mr. Bottle-Glasses parked himself in front of each week. She, too, was profoundly moved. But in her case it took the form of precipitating her conversion to Orthodoxy, which she wrote about in a book called *Facing East: A Pilgrim's Journey into the Mysteries of Orthodoxy*. These two anecdotes evidence that the divine was in the air for that show.

Holy Image, Holy Space opened on Sunday, August 21, 1988, and I knew immediately that I had found the magic. How? First, there were the many kisses on the

Plexiglas of the cases that had to be cleaned off constantly. But what really showed the power of this show on day one was the report I got from the security staff by mid-afternoon—that visitors were kissing the hand of Saint Francis. Now, to be clear, we ended the show with a few panels reputed to have been painted by Domenikos Theotokopoulos, El Greco, while he was a young icon painter on the Island of Crete. Not great works, and not securely by him, but very interesting and provocative. Anyhow, Henry Walters bought a magnificent El Greco of his own, a canvas showing *The Stigmata of Saint Francis*. I decided to include it in the show to remind our visitors what this Cretan icon painter turned out to be in later life. It was the only work in the exhibition not covered by Plexiglas. To my knowledge, in the half century that the Walters had been open to the public before *Holy Image, Holy Space*, no one had ever kissed this painting. But that day, it seems, lots of people were kissing this painting. This made no sense, given that Saint Francis is among the most nearly Catholic of Catholic saints, and has no relationship whatsoever to Byzantium or Orthodoxy. But such is the power of the numinous. And I had nailed it. So we put a stanchion in front of Saint Francis.

Notes

1. This chapter is adapted from a chapter in my book, *Sacred and Stolen*: *Confessions of a Museum Director* (New York: SelectBooks, 2016).
2. "Numinous," a word made popular in the early twentieth century by the great German theologian Rudolf Otto, comes from Latin *numen*, "a nod of the head"—as if a deity were nodding to make his will known.
3. Nikolaos Mesarites, ca 1220, describing the now-lost dome mosaic of Christ in the Church of the Holy Apostles. G. Downey, *Transactions of the American Philosophical Society*, n.s. 47 (1947), 855–924.

Bibliography

Brenson, Michael. 1988. "Windows into a World of Unshakable Faith." *New York Times*, September 4.
Ethiopian Art: The Walters Art Museum. 2001. Baltimore: Walters Art Museum.
Grierson, Roderick. 1994. *Gates of Mystery: The Art of Holy Russia*. Cambridge: Lutterworth Press.
Heldman, Marilyn, and Stuart C. Munro-Hay. 1996. *African Zion: The Sacred Art of Ethiopia*. New Haven: Yale University Press.
Otto, Rudolf. 1958. *The Idea of the Holy*. Oxford: Oxford University Press.

Section VI Presenting Religion in a Variety of Museums

24 Rich and Varied: Religion in Museums

CRISPIN PAINE

Museums come in almost every imaginable size and shape, from huge institutions with hundreds of staff to a single showcase; they cover topics from paleontology to can-labels, and include in their collections both airliners and microbes. Equally varied are the techniques they use to explain their collections and tell their stories, from the traditional label and guided tour to the latest virtual reality. Their visitors, too, may include scientists looking for data-sets, art-lovers looking for joy and inspiration, or families looking for entertainment plus education. What's more, the same person may, on different days and in different moods, be looking for all of these.

In all these situations religion can appear, and though classification is not useful in itself, to examine how the pattern of that appearance reflects different kinds of museum and different museum programs can be illuminating. Note that we are concerned here only with the *stories* that different types of museum tell, not with any possible "religious" role that museums may fulfill in modern society. We have long learned from Carol Duncan (1995) that art museums are venues for a modern ritual carried out by visitors. Mary Bouquet and Nuno Porto (2005) have shown that this role is not limited to art museums, but is one fulfilled by museum-type institutions of all sorts.

Religious Museums

For many people the term "religious museum" refers to a museum dedicated to objects used in the religious practice of a particular faith. Often these are collections of liturgical objects that once took their place in the sacristy or the treasury of a great church or temple. One of the best-known and most visited is the treasury of St Mark's, Venice. Occasionally—as most famously in the Sree Padmanabhaswamy Temple at Trivandrum, South India—these can be treasures of quite staggering richness; if the recommendation that a temple museum be created there is ever actually implemented, on the level of wealth at least it will outshine every other such museum. There are very many rather more modest collections of liturgical objects, often still part of their church or temple, in many parts of the world (Capurro 2013; Gahtan 2012; Minucciani 2013a, 2013b). Sometimes these are developed as "interpretation centers," and sometimes they can double up as shrines (Paine 2013, 68).

Another kind of religious museum is that created, not by an actual place of worship, but by a religious organization of one type or another. These have been called "denominational museums." Sometimes they are merely collections of miscellaneous

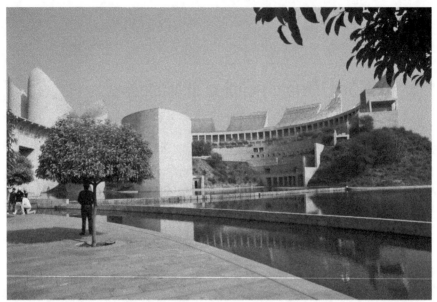

Figure 24.1 *Virasat-e-Khalsa* (The Khalsa Museum), Anandpur Sahib, India. The museum, designed by Israeli architect Moshe Safdie (see Chapter 1 in this volume), attracts over 6,000 visitors a day—the vast majority Sikhs. It tells the story of Sikhism though the story of the Sikh Gurus, presented in high-quality and sophisticated displays. Photo by Crispin Paine.

objects that illustrate the organization's history; sometimes they are founded as an important part of the organization's core mission. That is, the story they tell is about their particular faith, and their intended audience is very often members of that faith— or at least outsiders who might be interested (Figure 24.1). Such museums, of which there must be many hundreds worldwide, can achieve very high standards. Ena Heller describes (Chapter 25 in this volume) her own work with the American Bible Society to create the Museum of Biblical Art in New York, successfully overcoming suspicions about its motives to "take the religion behind the art seriously, yet present it through a secular lens and in a scholarly manner."

The outstanding example of this type of museum is surely the Vatican Museums, which attract nearly six million visitors a year (on a par with the British Museum) and generate a surplus for the Vatican of fifty million euros (over fifty-six million dollars). But much more typical is the Museum of Methodism in London. This is sited in the crypt of Wesley's Chapel, founded in 1778 by John Wesley, the founder of Methodism. Also on the site is Wesley's House, restored as it was when he lived there. Thus the complex—Chapel, Museum, and House—form a powerful attraction for visiting Methodists as well as for people interested in history. Many of these visitors are Methodists from abroad (particularly from Korea), while others may know little about Methodism, or even perhaps about Christianity. So the recent

redisplay of the museum faced a real challenge in striking the balance between simplicity and detail.

The Creation Museum in Kentucky is a very different kind of place; it attracts some quarter of a million visitors a year, and it presents a very different understanding of Christianity. But it also addresses believers and unbelievers alike, and uses a wide range of modern techniques to do so. Its founder, Tim Ham of "Answers in Genesis," claims that "[w]e're not out to convert people to believing in Intelligent Design. We're not out to convert people to *not* believe in evolution. And we're not out to just convert people to being Creationists. We're Christians" ("Creation Museum"; see also Emling and Rakov 2014). In fact within Christianity it does seem to be Protestants who most use the museum as a tool of mission: other examples, from no doubt hundreds, include Geneva's Musée Internationale de la Réforme (Leahy 2008, 252), the many Huguenot museums in France (Lautman 1987), and the John Knox House Museum in Edinburgh.

A particular subset of faith museums are the Christian Missionary Society museums described in this volume by Chris Wingfield. What distinguishes these today is the enormously important history that their collections encapsulate, while the ideology that originally created them is often no longer acceptable.

Scholarly Museums

There are a very few museums in the world that are specifically about "religion" as a human phenomenon; even fewer approach the topic from a disinterested, scholarly, standpoint. Surely one of the first was the "Musée Religieuse" opened in 1879 at Lyon in France by the industrialist and scholar Émile Guimet. The following year he founded the scholarly journal *Revue de l'Histoire des Religions*, which still flourishes 126 years later, and launched an ambitious program of publications under the title *Annales du Musée Guimet*. In 1889, though, the museum moved with state support to Paris as the Musée Guimet, where (especially after the founder's death in 1918) it slowly changed into a museum of oriental archaeology.

The leading scholarly museums of religion today are Marburg's Museum of Religions, and St Petersburg's Museum of the History of Religion. The Marburg Museum, part of the University of Marburg, was founded in 1927 by theologian and philosopher of religions Rudolf Otto, one of the most influential figures in the modern study of religion, thanks to his 1917 book *The Idea of the Holy* (see Chapter 17 in this volume). Similarly the Museum of the History of Religion in St Petersburg (see Chapter 16 in this volume) was formerly the Museum of the History of Religion and Atheism, and it is often wrongly imagined that in those days it was merely a vehicle for atheist propaganda (Paine 2010; see also Lüpken 2010). Certainly atheism was its underlying ideology, and for many years it presented displays overtly attacking religion, sometimes quite crudely. But the museum has always *also* been a serious scholarly institution, and it is certainly so today.

Rescue Museums

The motive behind many of the antireligion museums of the USSR was—often covertly—the rescue and preservation of church treasures (Kaulen 2001). A similar motive lies behind other religious museums. One of the best known is the Musée des Religions du Monde at Nicolet in Quebec, Canada. Often seen as a solidly Catholic Province, where indeed 74 percent of people still identify as Catholics, the practice of religion has gone into dramatic decline since the 1960s. From well over 50 percent, attendance at mass has fallen to well below 10 percent; vocations to the priesthood and the religious and monastic life have similarly collapsed. The earlier years of this decline coincided with the refurbishing of churches in the reforms following the Second Vatican Council, so the Province had a large number of redundant churches, monasteries, and church furnishings. It was to rescue at least some of Quebec's Catholic heritage that the museum was set up (Royal 2007, 153).

This rescue mission raises the question of "heritage" value as against "religious" (and other meaningful) value, a debate currently much in vogue (Byrne 2014; and Chapter 8 in this volume). The introduction to a splendid book on the museum response to the collapse of Catholicism in Quebec suggests:

> For the faithful, as well as for those who do not practice, Church treasures have become heritage, things from their past they want to conserve, transmit, highlight, and promote, as a means of national pride. They are more than cult objects, they are objects of culture, objects that speak and that are the history of a whole people. (Turgeon 2005, 17; trans. author[1])

To consider objects of culture as "more than" objects of cult is striking.

But the Nicolet museum, though it has led campaigns to rescue Quebec's religious heritage, is much more than a refuge store. Its director describes it as "essentially ethnographic" (Danneau 2005). Although 90 percent of its permanent collection is Catholic, it aims to present Buddhism, Hinduism, Islam, Judaism, and Christianity, which it does principally through its highly varied and imaginative temporary exhibitions, and its much-praised learning program.

"Many-Routes" Museums

More "religious museums" come from faith traditions that see their own faith as just one of many routes to God, Salvation, or Enlightenment. At the Sai Baba Ashram at Puttaparthi in southern India is the Sanathana Samskruti Museum, or the Eternal Heritage Museum, opened in 1990, whose displays (as the Sai Baba website puts it) "highlight the main teachings of the major religions of the world and also the lives and teachings of great saints and spiritual masters whose mission has been the spiritual uplift of all humanity." The museum is substantial: 20,000 square feet on three levels, designed in the "Shikhara" style of temples of North India. Moreover,

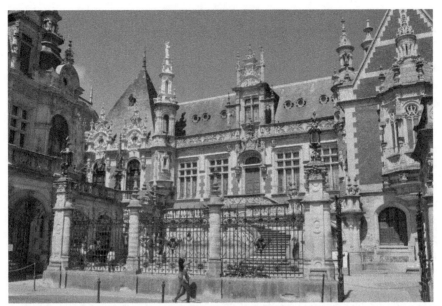

Figure 24.2 Religion, museum, and commerce: the Palais Bénédictine at Fécamp, Normandy. Opened in 1888, this museum comprises the medieval art collection of a Fécamp wine dealer, Alexandre le Grand. His "religious museum" gave his new drink—*Benedictine*—a respectable status, associated it firmly with the Benedictine Order, and gave his distillery an extraordinary "front of house." Photo by Crispin Paine.

the museum is supported by another museum in this pilgrimage town: the Chaitanya Jyothi Museum was opened in 2000 to commemorate Sai Baba's seventy-fifth birthday; it uses a range of multimedia techniques to present his life and teachings (Maclean 2005, 300).

On the sixth and seventh floor of a department store building in Taipei, Taiwan, is the Museum of World Religions. This museum relies heavily on multimedia to convey its message of interfaith dialogue; it has rather few objects, concentrated in the "Display of World Religions" gallery, which covers Buddhism, Daoism, Christianity, Islam, Hinduism, Sikhism, Judaism, Shinto, and currently Ancient Egyptian and Mayan religions—plus a section on popular religion in Taiwan. (It is interesting to see the choices museums make when they address "world religions" [Wilke and Guggenmos 2008; Orzech 2015; see also Lin 2005]).

Ed Gyllenhaal introduces below another faith tradition that has given rise to a "many routes" museum. Swedenborgians believe "that the kingdom of God is spread throughout the entire world, and includes people from all religions and cultures." So did an eccentric High-Church Anglican priest between the wars. Father Ward was a visionary who—rejected by the official Church—founded his own community and in 1934 opened outside London a museum of extraordinary quality. This was the Abbey Folk Park, a cross between a decorative arts museum and an open-air folk museum, all dedicated to encouraging visitors to think about spiritual matters in preparation for

the imminent end of the world, and also dedicated to preserving (as monasteries in the Dark Ages had done) "a reservoir of knowledge and information which may be retained when modern civilization collapses"—as it shortly would. Though the original Folk Park only survived a few years, its successor flourishes still in Caboolture, Queensland, Australia, famous nowadays for the quality of its collections and for its annual Medieval Festival, but scarcely a "museum of religion" any more (Ginn 2012; Paine 2012).

Community Harmony Museums

Motives for setting up a museum of religion may be various: a single museum can seek to attract tourists, promote scholarship, and offer an educational service to local schools. St Mungo's Museum of Religious Art and Life in Glasgow, Scotland, does all of these, but predominantly it is (in the words of its founder) "an intervention in society, a contribution toward creating greater tolerance and mutual respect among those of different faiths and of none" (O'Neill 1995, 50).

The big first-floor "religious art" gallery of St Mungo's presents splendid objects from various faiths, in a beautifully and conventionally art-gallery way, with Scottish stained glass, a big *Siva Nataraj*, and Ahmed Moustafa's painting *Attributes of Divine Perfection*, which combines the calligraphic and geometric traditions of Islamic art, looking across at an imposing Buddha figure. The Gallery of Religious Life focuses on the role of religious activity in different aspects of the life cycle, whether birth, initiation, marriage, healing, or death. Exhibits include a Nigerian carved figure intended to represent the spirit of smallpox to assist in healing, an Egyptian mummy, a Hindu bridal suit, and a Scottish Christening gown. The third main gallery is devoted to religion in Western Scotland and concentrates on promoting mutual understanding between the faiths of this multifaith city; it has, though, been criticized for downplaying the sometimes problematic historic role of Presbyterianism and Catholicism.

More important, perhaps, than the public displays themselves is the museum's focus on involvement in the community. Susan Kamel (2004) recognized that the museum

> realizes a constructivist model of communication through aiming to intervene in society. It provides access to religious phenomenon on various levels, employing the visitors as active meaning makers through consulting with various religious communities, even during the process of designing the exhibition. What is more this interaction with public is ongoing. (Kamel n.d.)

She contrasts this approach with the normal religious museum/gallery approach— especially that of Islamic art museums—whose "formal aesthetic mode of presentation construct a phenomenological definition of religion," in other words treat it as other and fail to engage with it.

Science Museums

Science museums seem most often to meet religion in the vexed area of evolution. (Especially is it vexed in the United States, where four in ten Americans continue to believe that God created humans in their present form 10,000 years ago [Newport 2014].) The design of the Hall of Human Origins at the Smithsonian's National Museum of Natural History in Washington was based on the question "What does it mean to be human?" and set out to engage visitors in dialogue, with a variety of interactives and the use of volunteers ("docents"). In 2011 the curator reported that

> visitors representing diverse worldviews generally seem to enjoy the exhibit without incident. Docents routinely have mutually respectful conversations with visitors from conservative Christian schools where human evolution is not being taught. Potts points out that many such visitors "can be excited about the discoveries of science." Enthusiasm for science then sets the stage for increasing visitors' level of comfort with science and the nature of scientific evidence. (Leshner 2011)

This, though, is a rather negative response to religion. Science museums could, and perhaps should, engage much more actively with religion. One area they might well tackle is the contribution neuroscience is making to the understanding of religion. Melbourne Museum in Australia has very lively displays on neuroscience, including one on changing consciousness. This, though, largely concentrates on the role of drugs, and the opportunity to examine the extraordinary history of consciousness-changing in religion is missed (see also Chapter 4 in this volume).

A specific type of science museum that certainly does engage with religion, though, is the health museum. Most displays on human health recognize that for millennia before the rise of "scientific" medicine, illness was seen through a religious lens; the British Museum has a large central gallery devoted entirely to that distinction, while two other London galleries funded by the Wellcome Trust, the Science Museum's Wellcome Galleries (currently under redisplay), and the Wellcome Collection itself give the religious alternatives to origins of modern medicine a great deal of space. The Science Museum's website on the history of medicine similarly has a significant section on "Belief and Medicine."

Art Museums

Art museums dominate the scene. An extraordinarily high proportion of the art displayed in museums and galleries worldwide has a religious theme, comes from a religious context, or was indeed created to serve a ritual, liturgical, purpose. Raphael's *Sistine Madonna* was commissioned in 1512 by Pope Julius II for the abbey church of San Sisto in Piacenza, to mark its accession to the Papal States. It was intended as the focus of devotion for the priest saying mass at the high altar, and served that purpose until 1754,

when it was bought by the Saxon elector Augustus II for his collection in Dresden. There it took on a new role as a work of art—something beautiful and uplifting.

Art galleries have long been criticized for allowing aesthetic considerations to over-whelm all others—social historians complain quite as much as students of religion that art galleries give far too little attention to the content or history of their works of art. However, the criticism can be overdone. Already in the 1850s the Sistine Madonna was displayed in an altar-like setting, and the occasional art museum and exhibition makes a real effort to help visitors understand the religious background of their works of art. A magnificent example was the 2009 *Sacred Made Real* exhibition at London's National Gallery. The art-historical purpose was to demonstrate the close relationship between the paintings of seventeenth-century Spain and its little-known but astonish-ing hyperrealist polychrome sculpture. But the exhibition also presented them as the aids to devotion they once were. The audio-guide even had a Jesuit priest explaining how meditation on the Passion and Crucifixion of Christ makes real and valuable peo-ple's own experience of suffering. Public reaction was overwhelming.

This is exactly the type of presentation we must hope art galleries will increasingly adopt in the future: presentation that is true to the aesthetic tradition of the gallery world, but that *also* helps visitors to understand and empathize with their works' religious story and meaning.

In another way art museums are already moving. A recent seminar at the Wallace Collection in London asked, "Does Religion Belong in Museums?" The answer of course was yes, but not because visitors need to be helped to understand religion, rather because art and religion are doing the same job in "elevating the soul." Art can be sacramental—transformative, even transfigurative. "Beauty will save the world," as Dostoevsky put it.

Museums of the Human Story

Archaeology and anthropology museums have always been less open to the criticism that they ignore religion. On the contrary, archaeologists and anthropologists have always been very aware of the role played by religion in the cultures they studied and have presented that awareness in their displays and programs (see Chapter 5 in this volume). Just one, particularly striking, example was the exhibition *Paradise* at the Museum of Mankind in London in 1993, which examined the material culture as it was then of the *Wahgi* people of Papua New Guinea. This caught a community in the middle of dramatic change, with the impact of globalization spearheaded by the impact of Protestant Christianity. A reconstructed *bolyim* cult house from the Pig Festival was surrounded by a ring of beer bottles, with a large white cross beside it (O'Hanlon 1993). At the time of writing the British Museum has a small exhibition on the Pacific god A'a, entitled *Containing the Divine*. Made to house the skull and long bones of a revered ancestor, the sacred wooden figure of A'a was handed to mis-sionaries after the people of Rurutu in the South Pacific had decided to convert to Christianity. It came to London in 1823.

The great majority of museums throughout the world, though, are local history museums. True, that may be differently understood in Ireland to how it is understood in Thailand, for example, but generally the commonest museums are those that present the social history of a comparatively small area. This is my own background, so I feel free to draw attention to the failure of local museums generally to address religion. Of course, there are exceptions (by pure coincidence, my local museum is one), but these tend only to be museums which happen to have religious items—usually beautiful ones—in their collections (Claussen 2009). What is missing is the sort of local fieldwork that will reveal how local people *do* religion today, and the sort of displays that will tell the local community about itself and help local people to recognize themselves.

One thing such local research probably would reveal, at least in those countries where organized religion is fast declining, is that people do many more "religious" things than is commonly imagined. Such local fieldwork may, too, reveal that people's religious behavior is far less orthodox than ministers, priests, imams, rabbis, and other "authorities" might wish. Too often at present, when a museum *does* want to include something on religion in an exhibition, the curators turn to the leaders of the local churches, synagogues, mosques, temples, or gurudwaras for advice. This is not to deplore such consultation: on the contrary, the still-quite-new practice of consulting the originating community before putting an object on display is to be welcomed very warmly. Modern museums are rightly wary of trying to foist a particular understanding of their objects on the public—an understanding that can sometimes be alienating, even offensive, to people who feel a close relationship with those objects. Local research, though, will very probably reveal that what these leaders hope their flock believes and practices, may not be quite what they actually believe and practice—may indeed be really very different. I am calling, in other words, for sociological fieldwork, and for museum displays to present what actually happens religiously locally, rather than what is supposed to happen.

Such research is a guarantee that the rich diversity of our museums will remain, indeed grow richer yet. If in the future an art museum is planning an exhibition that involves "religious" objects, it should surely employ a religious studies specialist to ensure that that side of the story is told well, alongside the art history and wider social history story. A local museum planning an exhibition on social history needs to ensure that at least one person on the planning team understands the area's religious history and can tell that side of the story to people with little or no familiarity with it. Of course, it is easier to ignore difficult subjects, to leave them to the specialist museums, but all museums have a responsibility to tell the story as accurately and as clearly as we can.

Note

1. Pour les fidèles comme pour les non-pratiquants, les biens de l'Église sont devenus un patrimoine, c'est-à-dire les biens de leur passé qu'ils veulent conserver, transmettre, metre en valeur et promouvoir comme un moyen d'une fierté nationale. Ce sont plus

que des objets de culte, ce sont des objets de culture, des objets qui disent et qui font l'histoire de tout un peuple.

References

Bouquet, Mary, and Nino Porto. 2005. "Introduction." In *Science, Magic and Religion: the Ritual Processes of Museum Magic*, edited by Mary Bouquet and Nino Porto. New York and Oxford: Berghahn Books.

Byrne, Denis. 2014. *Counterheritage: Critical Perspectives on Heritage Conservation in Asia*. Routledge Studies in Heritage. New York: Routledge.

Capurro, Rita. 2013. *Musei e Oggetti Religiosi: Arte, Sacro e Cultura Religiosa nel Museo*. Milan: Vite e Pensiero.

Claussen, Susanne. 2009. *Anschauungssache Religion: zur Musealen Repräsentation Religiöser Artefakte*. Bielefeld: transcript.

"Creation Museum." n.d. *Wikipedia*, https://en.wikipedia.org/wiki/Creation_Museum (accessed February 2016).

Danneau, Marcel. 2005. "Le Musée des Religions de Nicolet: Mission et Vision." In *Le Patrimoine Religieux du Québec: Entre le Cultuel et le Culturel*, edited by Laurier Turgeon, 217–221. Quebec: Les Presses de l'Université Laval.

Duncan, Carol. 1995. *Civilizing Rituals: Inside Public Art Museums*. London: Routledge.

Emling, Sebastian, and Katja Rakov. 2014. *Moderne Religiöse Erlebniswelten in den USA: "Have Fun and Prepare to Believe."* Berlin: Reimer.

Gahtan, Maia Wellington. 2012. *Churches, Temples, Mosques: Places of Worship or Museums?* Florence: Edifir.

Ginn, Geoffrey. 2012. *Archangels & Archaeology: J. S. M. Ward's Kingdom of the Wise*. Eastbourne: Sussex Academic Press.

Kamel, Susan. 2004. *Wege zur Vermittlung von Religionen in Berliner Museen: Black Kaaba meets White Cube*. Berliner Schriften zur Museumskunde. Wiesbaden: VS Verlag für Sozialwissenschaften.

Kamel, Susan. n.d. "Freie Universität Berlin: Dr. Susan Kamel." http://www.geschkult.fu-berlin.de/e/relwiss/forschung/vw-stiftung/kamel (accessed February 2016).

Kaulen, M. E. 2001. *Muzei-khramy i muzei-monastyri v pervoe desiatiletie Sovetskoĭ vlasti*. [Cathedral and Monastery Museums in the First Decade of Soviet Power]. Moscow: Luch.

Lautman, Françoise. 1987. "Objets de Religion; Objets de Musée." In *Muséologie et Ethnologie*. Paris: Réunion des Musées Nationaux.

Leahy, Helen Rees. 2008. "Musée Internationale de la Réforme." *Material Religion: The Journal of Objects, Art and Belief* 4 (2): 252.

Leshner, Alan. 2011. "How Science Museums Are Promoting Civil Religion-Science Dialogue." *Huffpost Religion*, May 25. www.huffingtonpost.com/alan-i-leshner/science-centers-museums-a_b_746864.html (accessed February 2016).

Lin, Thelma. 2005. A Place for Love, Respect and Tolerance: the Museum of World Religions at Taipei. *Material Religion: The Journal of Objects, Art and Belief* 1 (2): 297–300.

Lüpken, Anja. 2010. *Religion(en) im Museum: Eine vergleichende Analyse der Religionsmuseen in St. Petersburg, Glasgow und Taipeh*. Berlin: LIT Verlag.

Maclean, Mark. 2005. "Chaitanya Jyoti, the Sai Baba Museum." *Material Religion: The Journal of Objects, Art and Belief* 1 (2): 300.

Minucciani, Valeria. 2013a. *Religion and Museums: Immaterial and Material Heritage*. Turin: Allemandi.

Minucciani, Valeria. 2013b. "Towards a Museography of Religion." Online presentation. https://docs.google.com/viewerng/viewer?url=http://www.frh-europe.org/wp-content/uploads/2013/11/Valeria-Minucciani.pdf&hl=en (accessed February 2016).

Newport, Frank. 2014. "In US, 42% Believe Creationist View of Human Origins." *Gallup*, June 2. http://www.gallup.com/poll/170822/believe-creationist-view-human-origins.aspx (accessed February 2016).

O'Hanlon, Michael. 1993. *Paradise: Portraying the New Guinea Highlands*. London: British Museum.

O'Neill, Mark. 1995. "Exploring the Meaning of Life: the St Mungo Museum of Religious Life and Art." *Museum International* 185 (UNESCO, Paris).

Orzech, Charles. 2015. "World Religions Museums: Dialogue, Domestication, and the Sacred Gaze." In *Sacred Objects in Secular Spaces: Exhibiting Asian Religions in Museums*, edited by Bruce M. Sullivan, 133–144. London: Bloomsbury.

Paine, Crispin. 2010. "Militant Atheist Objects: Anti-religion Museums in the Soviet Union." *Present Pasts* 1 (accessed February 2016). doi http://doi.org/10.5334/pp.13.

Paine, Crispin. 2012. Review of *Archangels & Archaeology: J. S. M. Ward's Kingdom of the Wise*, by Geoffrey Ginn, *Material Religion: The Journal of Objects, Art and Belief* 8 (4): 533–537.

Paine, Crispin. 2013. *Religious Objects in Museums: Private Lives and Public Duties*. London: Bloomsbury.

Royal, Jean-Francois. 2007. "Protecting and Interpreting Quebec's Religious Heritage: The Museum of Religions at Nicolet." *Material Religion: The Journal of Objects, Art and Belief* 3 (1): 153.

Turgeon, Laurier, 2005. "Introduction." In *Le Patrimoine Religieux du Québec: Entre le Cultuel et le Culturel*, edited by Laurier Turgeon, 17–39. Quebec: Les Presses de l'Université Laval.

Wilke, Annette, and Esther-Maria Guggenmos. 2008. *Im Netz des Indra: das Museum of World Religions, sein Buddhistisches Dialogkonzept und dir Neue Disziplin Religionsästhethik*. Vienna: LIT.

25 The Museum of Biblical Art: A Worthwhile Experiment

ENA GIURESCU HELLER

The Museum of Biblical Art (MOBIA) opened in May 2005 with the exhibition *Coming Home! Self-Taught Artists, the Bible and the American South*, an expansive survey of paintings, drawings, sculpture, and multimedia works which explored the role that American Protestantism played in the art of seventy-eight self-taught artists working in the Bible Belt in the second half of the twentieth century. Ten years later almost to the month, the museum closed in June 2015 with the exhibition *Sculpture in the Age of Donatello: Renaissance Masterpieces from Florence Cathedral*. MOBIA was the only venue for this unprecedented—and highly unlikely to be repeated—trip across the Atlantic by some of the most iconic sculptures of Early Renaissance Florence (Crown 2004; Verdon and Zolli 2015). The two exhibitions could not have been more different in the material they explored, the approach they took, even in the exhibition design. What they had in common was sound scholarship and an intentional focus on the relationship between art and the biblical traditions. Together, they bookended a remarkable ten-year experiment named MOBIA (Figure 25.1).

Looking back on those ten years—during the first seven of which I was the museum's executive director—the most remarkable thing about MOBIA is this: the model it pioneered was a success.[1] That paradox is what I propose to explore in this essay, largely through an analysis of the reception the museum enjoyed from visitors, museum professionals, the academic community, and the press. In hindsight, the pertinent question in the context of this volume is not why MOBIA closed, but rather if it has left a footprint in the way museums present religious art in our country.

The press materials that accompanied the opening of MOBIA in 2005 hailed it as a "small museum with a large mandate: to better understand how the narratives and symbols of the Bible have influenced the history of art and today's visual culture. MOBIA considers the religious as well as the aesthetic and historic significance of objects created in the Jewish and Christian traditions."[2] Its mission was what made MOBIA unique in the United States: while many museums have significant religious art collections, and occasionally organize exhibitions centered on them, for MOBIA biblical art was the museum's single focus. Moreover, while religious art is commonly exhibited as bearer of style, and sometimes of iconography, MOBIA set out to show it as bearer of belief. The goal was to take the religion behind the art seriously, yet present it through a secular lens and in a scholarly manner. The vision was undoubtedly

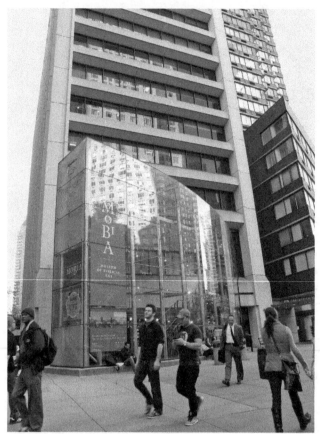

Figure 25.1 The Museum of Biblical Art, street view. Photo by Gina Fuentes Walker.

ambitious and the challenges daunting but, with the exuberance of youth and unre-stricted by the parameters of a permanent collection, MOBIA started exploring the immensely varied field of art that derives from, is inspired by, and often augments the biblical traditions.

The roster of exhibitions purposefully showcased this diverse field, aptly encom-passed by the museum's tagline, "One book, a world of art." Some covered expected material, such as medieval art, Ethiopian icons, or Albrecht Dürer's biblical prints. Others explored lesser-known connections of modern and contemporary artists with Jewish and Christian traditions, and even the religious angle of street art in New York City. Still others ventured into the world of material culture (through biblical movie posters) and public art (through Art Deco mosaics). In parallel, the art of the Book was illustrated not only through the extraordinary collection of Rare Scriptures of the American Bible Society, on long-term loan to the museum, but also through contem-porary examples.

The most successful exhibitions presented new scholarship that reevaluated the interconnection of artistic practice and religious history. I will mention only three

here, each of which can serve as a case study for MOBIA's mandate—and its legacy. *Scripture for the Eyes: Bible Illustration in Netherlandish Prints of the Sixteenth Century* (June 5 to September 27, 2009), curated by James Clifton and Walter S. Melion, explored the central role played by printed illustrations of Old and New Testament subjects in one of the most dramatic artistic and religious transformations in European history. Challenging common assumptions that prints follow artistic developments in the more prestigious medium of painting, and more generally that the visual arts only mirror societal change, this exhibition showed that biblical prints were a dynamic force in both the transformation of Northern European art between Albrecht Dürer and Rembrandt van Rijn and in the intensified attention to Scripture in the religious turmoil of the Reformation and Counter-Reformation (Clifton and Melion 2009). *Louis C. Tiffany and the Art of Devotion* (October 12, 2012 to January 20, 2013), curated by a team led by Patricia C. Pongracz, filled a scholarly gap in a seemingly crowded field by being the first exhibition to focus exclusively on Tiffany's commissions for America's churches and synagogues and examine them in a contextual manner, against the backdrop of the religious building boom that started in the 1880s (Pongracz 2012) (Figure 25.2).[3] *Uneasy Communion: Jews, Christians, and the Altarpieces of Medieval Spain* (February 19 to May 30, 2010), curated by Vivian B. Mann, highlighted the presence of Jewish artists working alongside Christians in ateliers producing both *retablos* (large multipaneled altarpieces) and Latin and

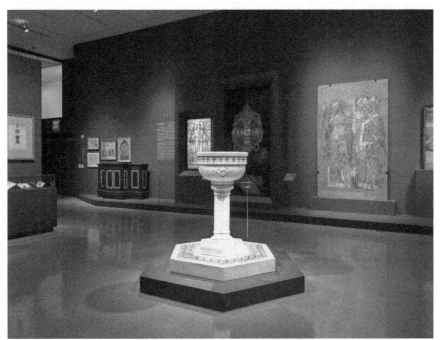

Figure 25.2 Installation view of *Louis C. Tiffany and the Art of Devotion* at MOBIA, fall 2012. Photo by Gina Fuentes Walker.

Hebrew manuscripts in the fourteenth and fifteenth centuries. Research into this artistic practice revealed a unique *convivencia* (coexistence) in the province of Aragon alongside signs of the ongoing conflicts which would culminate in the Expulsion of 1492 (Mann 2010). All these exhibitions embody MOBIA's mandate at its best and illustrate the need the museum filled at the time. *Uneasy Communion* was one of several exhibitions that had been proposed to other—sometimes multiple—museums before coming to MOBIA.

MOBIA's reception in different quarters illustrated the peculiar place the museum held in the artistic landscape of New York City. Early on, a visitor wrote in the comments book for the exhibition *The Word on the Street: The Photographs of Larry Racioppo* (summer 2006): "It is encouraging to see a legitimate museum dedicated to understanding faith and art in contemporary society." Time and time again MOBIA had to prove its "legitimacy" as a serious museum. The press was immediately skeptical, as one would expect when dealing with a museum dedicated to biblical art, let alone one funded by the American Bible Society. The *New York Times* warned that "it will be not easy to convince scholars, curators and art lovers that this is intended to be a serious museum, not a glorified Sunday school or covert outpost of the religious right" (Kennedy 2005). And yet it was precisely scholars and curators who embraced MOBIA early on.[4] Helen Evans, the Mary and Michael Jaharis Curator for Byzantine Art at the Metropolitan Museum of Art, noted: "MOBIA is catching a wave that's going to grow. Art history in general is reconsidering the canon. We're all shifting and seeking to diversify our audiences."[5] In 2009, Aaron Rosen (2009, 3), then junior research fellow at the Oxford Centre for Hebrew and Jewish Studies, wrote: "Surprisingly, visitors need not worry about any 'hidden agenda.' MOBIA has a much more challenging aim than convincing anyone of some single truth: to unpack the Bible in its ever multiplying messages." Eventually, even the press followed suit: The *New York Times* characterized *Uneasy Communion* as "a momentous turn in scholarly thought about Spanish art"; while the *Wall Street Journal* gave *Sculpture in the Age of Donatello* a glowing review, noting that New Yorkers "have abundant reason to be grateful for it" (Johnson 2010; Scherer 2015).

Visitors' comments mirrored the back and forth between appreciation and skepticism. Many embraced the mission, remarking that "MOBIA increased my understanding of the message conveyed through the art," "greatly educated me," and even "offered a wonderful, spiritual experience." Others shed some of their initial resistance as time went by, as one visitor wrote in 2010: "Oddly, what kept me from visiting in years past was a vague sense that the museum was a 'storefront' (apologies!) for Protestant fundamentalism, a view shared by one or two friends when I mentioned I was visiting. I mention this only so that the museum might have an awareness of how it may be read in certain quarters."[6]

For every frequent visitor there were many who never set foot in the museum. Attendance numbers were low by New York standards—and yet, what differentiated MOBIA from the traditional approach to art and the Bible was consistently noticed. One of my favorite exhibitions, in this context, was *The Wanderer: Foreign*

Landscapes of Enrique Martinez Celaya (October 1 to December 23, 2010; Siedell and Gaskell 2010). Any connections that Martinez Celaya's paintings and sculptures have with the world of the Bible are indirect and oblique. Yet, as a discerning reviewer noted, although not straightforwardly religious, they "were gravid with mystery and doubt . . . presided over by shelves of antique Bibles, as if to remind the viewer that the Scriptures themselves pose similar questions" (Milliner 2011). That juxtaposition encapsulates the legacy of the Museum of Biblical Art.

In 2011, I wrote in the journal of MOBIA's first Visionary Award Gala: "My hope for the MOBIA of the future is that it will fully embody Marcel Proust's words 'the voyage of discovery is not in seeing new lands but in having new eyes' and will help museum-goers in New York and elsewhere see familiar things in new ways, see them differently." Looking back, I believe that MOBIA tapped into a quiet need for scholars and did play a small yet important part in the process of teaching museum professionals and visitors alike to look at the relationship between art and the biblical religions with new eyes.

Notes

1. I differentiate here between the actual museum housed in the headquarters of the American Bible Society in New York City and the museological model it offered. The closing of the museum, in my opinion, was largely caused by the fact that its funding infrastructure lagged behind the growth of the operation, and relied too heavily on too few major donors, in particular the organization which helped birth the museum and became its landlord, the American Bible Society.
2. Many of the quotations in this chapter are from the museum files I had access to while working there; since the closing of the museum its archives are preserved at the New York Historical Society.
3. The curatorial team was composed by Elizabeth De Rosa, Lindsy R. Parrott, Patricia C. Pongracz, and Diane C. Wright. See Pongracz (2012).
4. MOBIA's opening was preceded by a three-year research project, *New Directions in the Study of Art and Religion*; see Heller (2004).
5. See note 2.
6. See note 2.

References

Clifton, James, and Walter S. Melion. 2009. *Scripture for the Eyes: Bible Illustration in Netherlandish Prints of the Sixteenth Century*. New York and London: Museum of Biblical Art in association with D. Giles.

Crown, Carol (ed.). 2004. *Coming Home! Self-Taught Artists, the Bible and the American South*. Jackson, MI: Art Museum of the University of Memphis in association with the University Press of Mississippi.

Heller, Ena Giurescu (ed.). 2004. *Reluctant Partners: Art and Religion in Dialogue*. New York: The Gallery at the American Bible Society.

Johnson, Ken. 2010. "Medieval Remnants of the Jews in Spain." *The New York Times*, April 29. http://www.nytimes.com/2010/04/30/arts/design/30biblical.html (accessed January 2016).

Kennedy, Randy. 2005. "A Museum about the Bible Aims to be Taken Seriously." *The New York Times*, May 11. http://www.nytimes.com/2005/05/11/arts/design/a-museum-about-the-bible-aims-to-be-taken-seriously.html?_r=0 (accessed January 2016).

Mann, Vivian B. (ed.). 2010. *Uneasy Communion: Jews, Christians, and the Altarpieces of Medieval Spain*. New York and London: Museum of Biblical Art in association with D. Giles.

Milliner, Matthew. 2011. "The Return of the Religious in Contemporary Art." *The Huffington Post*, January 8. http://www.huffingtonpost.com/matthew-milliner/champagne-and-butterflies_b_805398.html (accessed January 2016).

Pongracz, Patricia C. (ed.). 2012. *Louis C. Tiffany and the Art of Devotion*. New York and London: Museum of Biblical Art in association with D Giles Limited.

Rosen, Aaron. 2009. "Unpacking the Bible." *Art and Christianity Journal* 59 (Autumn).

Scherer, Barrymore Laurence. 2015. "Faith and Its Trials, Chiseled in Stone." *Wall Street Journal*, March 11. http://www.wsj.com/articles/faith-and-its-trials-chiseled-in-stone-review-of-sculpture-in-the-age-of-donatello-renaissance-masterpieces-from-florence-cathedral-at-the-museum-of-biblical-art-1426111888 (accessed January 2016).

Siedell, Daniel A., and Ivan Gaskell. 2010. *The Wanderer: Foreign Landscapes of Enrique Martínez Celaya*. New York: Museum of Biblical Art.

Verdon, Timothy, and Daniel M. Zolli (eds.). 2015. *Sculpture in the Age of Donatello: Renaissance Masterpieces from Florence Cathedral*. New York and London: Museum of Biblical Art in association with D. Giles Limited.

26 Missionary Museums

CHRIS WINGFIELD

Connections between Christian missionaries and museum history might be traced back to the collecting activities of the seventeenth-century Jesuit Athasius Kircher (Findlen 2004). Nevertheless, the missionary museum as an institution in its own right appears to have been born out of the Protestant missionary expansion of the late eighteenth and early nineteenth centuries. By the early twentieth century, missionary museums displaying material sent by overseas missionaries for the benefit of supporters at "home" had been established at many locations in Europe and North America. Other missionary museums were established in the "field," often alongside educational establishments, with the intention that potential converts visit them. In addition, museums at former mission stations, now regarded as heritage sites in their own right, represent a third category. While these three categories are "ideal types," masking a degree of internal variation as well as overlap, they nevertheless demonstrate some of the ways in which museums and missionaries have interacted in significant and sometimes surprising ways. What follows will consider examples of these main types of missionary museum in order to explore their history, as well as the challenges many face today.

The "Home Missionary Museum"

One of the earliest examples, established in 1814, was the museum of the London Missionary Society (LMS), originally known simply as "The Missionary Museum." Its establishment was largely driven by the accumulation of "curiosities" brought to Europe for display, including specimens of natural history, items of local dress, and examples of local religious and superstitious practices, sometimes given up as a result of conversion (Wingfield 2016). During the mid-nineteenth century the display of "idols" became a regular focus for missionary meetings in Britain, and their potency in raising funds quickly became apparent.

In 1832, the Rev. William Ellis, foreign secretary of the London Missionary Society, sent "a few curiosities" from the LMS museum to the Mission College in Barmen, Germany, recently established by the Rhenish Missionary Society. These included idols from the Pacific, a Buddha from Rangoon, a brass Hanuman figure from India, a Chinese figure, as well as various artefacts from Africa, accompanied by printed

missionary texts in local languages, and wrapped up together in a piece of Tahitian cloth. It was suggested that they

> might be useful in conveying a more lively impression of the actual degradation of the heathen and the polluting character of idol-worship; and also of showing what Missionaries had been able to effect in promoting the knowledge of the True God and the Only Saviour.[1]

As well as being institutions that were visited in their own right, missionary museums regularly loaned material for use in missionary meetings and exhibitions. The LMS museum was ultimately overshadowed in the early twentieth century by exhibitions arranged by the Society, but in other instances museums were established following exhibitions. For Protestant missionary societies, the creation of a pavilion of Protestant Evangelical Missions at the Universal Exhibition in Paris in 1867 seems to have been a particular spur to collecting (Jensz 2011, 67). For Catholics, a focus was provided by the Pontifical Missionary Exhibition at the Vatican in 1925, coordinated by Fr. Wilhelm Schmidt of the Society of the Divine Word (SVD)—an order associated with the establishment of several missionary museums (Kahn 2011). It is unclear exactly how many missionary museums were established across Europe and North America during the nineteenth and twentieth centuries, but recent work has identified at least thirty-three missionary museums in German-speaking locations alone.[2]

It was common for missionary museums to be associated with missionary training colleges, their collections supplemented by gifts from former students. The *Misjonsmuseet* established at Stavanger in 1864 as part of the training school of the Norwegian Missionary Society remains on the campus on the School of Mission and Theology. Its future is uncertain, however, since many staff feel the museum no longer accords with their political and theological views. Many similar museums in Europe have closed, their collections transferred to secular museums—most recently the museum of the Finnish Evangelical Lutheran Mission, whose collections transferred to the Helsinki Museum of Cultures in early 2015.[3] In the Netherlands, the Afrika Museum at Berg-en-Dal has its roots as a missionary museum established by the Catholic Congregation of the Holy Spirit in 1954, but has recently been integrated into a state-funded institutional structure alongside the Tropenmuseum in Amsterdam and the Museum Volkenkunde in Leiden (Welling 2002). The costs of sustaining sometimes large historic collections as public museums generally exceeds what many religious organizations in Europe, faced by dwindling church memberships, are able to justify.

Many European missionary organizations have restructured themselves since the 1960s to account for the fact that the activity of churches in Europe is increasingly eclipsed by those in other parts of the world. Within this context, "home missionary museums" present a potentially embarrassing legacy, sometimes representing outdated ethnocentric assumptions. Nevertheless, while these museums may be challenging reminders of a past that many Europeans would rather forget, the collections

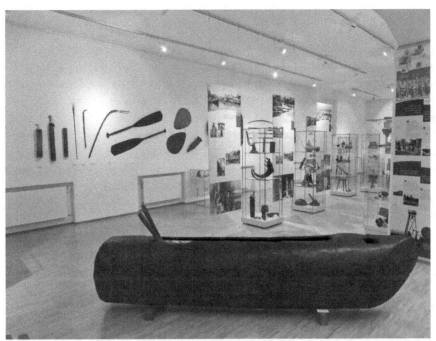

Figure 26.1 Museum auf der Hardt in Wuppertal, Germany. Copyright the author/Museum auf der Hardt, 2015.

held by these museums often document extremely significant events in the histories of other parts of the world over the past two centuries (Jacobs, Knowles, and Wingfield 2015).

While many home missionary museums in Europe have closed, those that remain open have responded to these challenges in different ways. The Missionary Museum at Steyl in the Netherlands effectively presents itself as a historical curiosity, a missionary display unchanged since the 1930s, thereby sidestepping a great deal of contemporary critique. The Vatican Ethnological Museum, which reopened in 2010 having dropped the word "mission" from its name, has adopted a celebratory mode—presenting objects in its collection as "cultural ambassadors" (Mapelli 2012, 17). More ambitiously, the collections of the former Rhenish Missionary Society (now UEM—United Evangelical Mission) have been comprehensively redisplayed and reinterpreted between 2008 and 2014 at the *Museum auf der Hardt* in Wuppertal, Germany (Figure 26.1).[4] The new presentation attempts to engage with complex and contested aspects of missionary history, partly through including the perspectives of historic actors, such as missionaries and converts, as well as local opponents of mission. Providing a critically aware and balanced view of missionary histories, however, has necessitated a major financial investment of the kind not available to many surviving European missionary organizations.

The "Mission Field Museum"

In November 1818, when representatives of the Calcutta Committee of the Church Missionary Society signed a deed of transfer for a building in Benares, intended primarily to be "a school for instruction in all kinds of science," they noted that alongside the schoolroom was a large room intended for a library and museum, and another for a printing press.[5] The association between educational establishments, museums, and printing presses was also found at the Anglo-Chinese College, established by the LMS at Malacca, also in November 1818. By 1823 the college had a museum including "specimens of Natural History" as well as a range of artefacts that were "illustrative of Chinese Customs."[6] The college also had what it called "Philosophical Instruments" for experiments including "Globes, Electrical Machine and Battery, Chemical Apparatus, Air Pump, Barometer and Thermometer, &c."

The museum at Malacca might be regarded as a forerunner of a number of similar museums, established by missionary societies on the Chinese mainland in the late nineteenth and early twentieth centuries (Smalley 2012). Some concentrated on displaying Western science, while others focused on documenting local practices. Nevertheless they all seem to have anticipated a local audience, including potential converts. Museums of this kind in a way became missionaries in their own right, contributing through their displays to the promotion of "Christianity and Civilization."

A curious example is the museum at the LMS's Anglo-Chinese College at Tsientsin (Tianjin). The college and museum were established in 1904 by Samuel Lavington Hart, a former fellow at St. John's College Cambridge, and its building was an architectural tribute to his alma mater. It featured photographs showing views of Cambridge, landmark buildings from across the British Isles, as well as a smattering of global landmarks such as the Egyptian pyramids. In the same room it also contained scientific equipment, including a "Dynamo Electric Machine," "Cinematograph," and "Gramophone." The museum's guidebook began by explaining that "[m]useums have been built in many of the large towns in Western lands so that people by visiting them may be able to learn about important matters" but a surviving photograph of the interior shows an archway, over which large letters exhorted visitors to "Consider the Wonderful Works of God."[7]

The Tianjin museum also displayed a number of objects collected by the LMS missionary James Chalmers in New Guinea, arranged around his portrait, perhaps something of a shrine to the latest martyr missionary of the LMS (Chalmers was killed in 1901). The guidebook, however, hints at a more complicated rhetorical intention. Alongside these items, images were displayed of Vatorata College in New Guinea, the lecture hall of the LMS training institution in Rarotonga, as well as Rarotongan evangelists working in New Guinea. This museum, established as part of an institution intended to educate the children of wealthier Chinese, seems to have been intent on demonstrating the promise offered by a community of global Christian fellowship. As such, the "Hall of New Learning," as the museum was

described in Chinese, created a different perspective to that of contemporary home missionary museums in Europe, but one similarly connected to global missionary networks.

While some "field missionary museums" established during the nineteenth and twentieth centuries have become the basis for museums that continue to operate in transformed educational institutions, field missionary museums are still being founded, though their aims can be rather different (Smalley 2012). The Kivu Museum, opened in 2013 at the Bukavu mission of Italian Xaverian Fathers in the Democratic Republic of Congo, displays a collection amassed since the end of the Second Congo War in 2003, featuring masks and idols to preserve local traditional practices.[8] While histories of missionary collecting in Congo have frequently been linked with iconoclastic destruction, this museum attempts to collect and preserve items placed at risk by ongoing conflicts in the region.

A similar institution, displaying the traditional practices of local people, is the Chamare Museum, opened in 2002 alongside an active wood-carving project at the Kungoni Centre of Culture and Art in Central Malawi.[9] Situated on the Mua Mission, founded by the White Fathers in 1902, the museum also represents something of the mission's own history, linking it to the third category of missionary museums.

The "Missionary Heritage Museum"

Museums of this type are generally associated with successful evangelical efforts, and form part of a wider array of practices through which missionary histories are commemorated today. The earliest missions in particular regions are frequently regarded as especially significant, including the location of the earliest Christian mission to Britain, today a UNESCO World Heritage site.[10] The Hawaiian Mission Houses Historic Site, formerly known as Mission Houses Museum and designated as a US National Historic Landmark in 1965, sets out to connect the story of American Protestant missionaries to the history and culture of Hawai'i through the display of historic artefacts and restored early-nineteenth-century buildings.[11] The site of Genadendal in South Africa, established by the Moravian Missionary Society in 1737, has a similar status, and incorporates a museum, established in 1963, whose collection was declared a National Cultural Treasure in 1991 (Figure 26.2).

A more curious example is the David Livingstone Centre, established in 1929, not at a former mission, but rather at the site of the famous nineteenth-century missionary's birthplace in Blantyre, Scotland. Nevertheless, like missionary heritage museums in Africa and the Pacific, the site became a location at which a great deal of historic material associated with missionary history was gathered, sometimes attaining a status close to that of the religious relic (Wingfield 2012). David Livingstone and his father-in-law Robert Moffat are similarly commemorated at the site of the former mission at Kuruman in South Africa, established in 1821, where a collection of nineteenth-century artefacts have been gathered to complement the historic buildings.

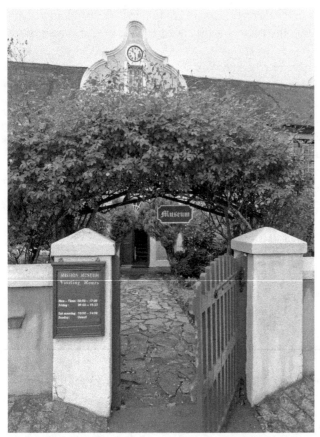

Figure 26.2 The Missionary Museum at Genadendal, South Africa. Copyright the author, 2015.

As with home missionary museums, the costs of managing, maintaining, and interpreting missionary heritage sites, and the collections associated with them, can be considerable. Sometimes they can make a successful claim for national significance, and thus access state financial support, but this depends on the local political contexts and how missionary history is regarded by the national élite. Where former mission sites remain owned and managed by church organizations, it can be a challenge to prioritize the fund-raising needed to sustain such heritage sites against other calls on resources.

Conclusion

Competition between the resources needed to run a museum and those involved in other forms of evangelism is a recurring motif in the history of missionary museums. In many cases their survival depends on gaining recognition from local heritage regimes, and in at least one case, international heritage regimes such as UNESCO.

The ability of missionary museums to achieve this recognition depends on attitudes to the missionary past, which can range from celebration in parts of the Pacific and Africa, to ambivalence and embarrassment in Europe.

Nevertheless, what missionary museums of all three types have in common is their attempt to materialize the somewhat immaterial process of conversion. How conversion is made visible at different times and in different places is extremely revealing of underlying conceptions of religion and religious practice. The forms this takes vary depending on who is responsible for the displays, but also according to their anticipated audience. While nineteenth-century European Protestants regarded the abandonment and destruction of religious idols as indications of dramatic conversion, the conversions offered by missionary museums in Asia involved scientific knowledge and machinery. At missionary heritage museums historic conversion processes are made visible through the arrival of new forms of architecture and other new technologies such as printing, writing, and medicine. Despite the challenges many missionary museums face, they remain an important, if often overlooked, cultural phenomenon that have shaped and been shaped by significant histories of encounter and exchange over recent centuries.

Notes

1. Document RMG 207—Ellis 1832: provided by Christoph Schwab, Kurator, Museum auf der Hardt der Archiv und Museumsstiftung der VEM.
2. Pers. comm. Rebecca Loder-Neuhold, October 5, 2015.
3. http://www.kansallismuseo.fi/fi/kansallismuseo/kokoelmat/kuukauden-esine-2015/lahetysseuran-kokoelma/mission-collection.
4. http://www.vemission.org/en/museumarchives/ethnological-museum.html.
5. University of Birmingham, Cadbury Research Library: CMS/B/OMS/C I1 E2/32 Copy of deed of transfer of house near Jungrum Baree.
6. *Missionary Register*: December 1823 (11): 542–544.
7. SOAS: CWM Library Q231. Pamphlet: "Guide to the Tientsin Anglo-Chinese Museum," p. i.
8. http://www.dailymail.co.uk/wires/afp/article-3006145/Hidden-DR-Congo-museum-safeguards-endangered-tradition.html.
9. http://www.kungoni.org/page1.html.
10. http://whc.unesco.org/en/list/496.
11. http://www.missionhouses.org.

References

Findlen, Paula (ed.). 2004. *Athanasius Kircher: The Last Man Who Knew Everything*. London: Routledge.

Jacobs, Karen, Chantal Knowles, and Chris Wingfield (eds.). 2015. *Trophies, Relics and Curios? Missionary Heritage from Africa and the Pacific*. Leiden: Sidestone Press.

Jensz, F. 2011. "Collecting Cultures: Institutional Motivations for Nineteenth-Century Ethnographical Collections Formed by Moravian Missionaries." *Journal of the History of Collections* 24 (1): 63–76.

Kahn, Alison-Louise. 2011. "The Politics and Ideologies behind the Pontifical Missionary Exhibition in the Vatican in 1925." Unpublished paper.

Mapelli, Nicola (ed.). 2012. *Ethnos: Vatican Museums Ethnological Collection.* Vatican: Edizioni Musei Vaticani.

Smalley, Martha Lund. 2012. "Missionary Museums in China." *Material Religion* 8 (1): 105–107.

Welling, Wouter. 2002. "The Spiritans and the Afrika Museum: Changing Perspectives on Africa." In *Forms of Wonderment*, 37–58. Berg en Dal: Afrika Museum.

Wingfield, Chris. 2012. "Remembering David Livingstone 1873–1935: From Celebrity to Saintliness." In *David Livingstone: The Man, the Myth and the Legacy*, edited by Sarah Worden, 115–129. Edinburgh: National Museums Scotland Press.

Wingfield, Chris. 2016. "'Scarcely More Than a Christian Trophy Case'? The Global Collections of the London Missionary Society Museum (1814–1910)." *Journal of the History of Collections*. Doi: 10.1093/jhc/fhw002.

27 Religion at Glencairn Museum: Past, Present, and Future

ED GYLLENHAAL

Glencairn, the castle-like former home of Raymond and Mildred Pitcairn, was built in Bryn Athyn, Pennsylvania, in a style based on medieval Romanesque architecture (Figure 27.1). Raymond (1885–1966) was the son of John Pitcairn, an industrialist and philanthropist who made his fortune in Pennsylvania coal, gas, and oil production, and as a cofounder of the Pittsburgh Plate Glass Company. Trained as a lawyer, and with no formal background in architecture, Raymond supervised the design and construction of both Bryn Athyn Cathedral, dedicated in 1919, and Glencairn, completed in 1939. He also became renowned as a collector of medieval Christian stained glass and sculpture, which he acquired in order to inspire his artists and craftsmen with some of the finest examples from the period. He went on to collect important works of art from ancient Egypt, the ancient Near East, ancient Greece and Rome, and a few objects from Asian and Islamic cultures.

Raymond Pitcairn died in 1966. After the death of Mildred in 1979, Glencairn and the Pitcairn art collections were gifted to the Academy of the New Church, a Swedenborgian Christian educational institution. At that time the Pitcairn collections were merged with the holdings of the Academy's museum, which had been founded in 1878 "for the purposes of mythological study" (Benade to Pitcairn, Rome, November 2, 1878). Glencairn, as the new location of the Academy's museum, opened to the public in 1982.

History and Mission

Glencairn serves as a museum of religious art and history, continuing the intellectual legacy of the museum of the Academy of the New Church. The Academy's museum was founded by John Pitcairn and the Reverend William Henry Benade (1816–1905), a Swedenborgian pastor and later bishop (Gyllenhaal 2006, 2010). In 1877, the two men left on an extended trip to Europe, Egypt, and the Holy Land, returning with a collection of more than a thousand artifacts from ancient Egypt, as well as a number of ancient Greek, Italic, and Roman vases and lamps. Benade initially set up a portion of the museum in a three-story house in Philadelphia, a building that also served as classroom space for the Academy's college and theological school. The museum changed locations several times, but in 1912 the collection was moved to the nearby

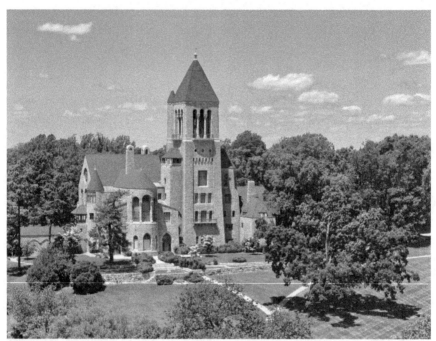

Figure 27.1 Glencairn Museum, Bryn Athyn, Pennsylvania. Glencairn, the former home of Raymond and Mildred Pitcairn, was built between 1928 and 1939 in a style based on medieval Romanesque architecture. It is now a museum of religious art and history. Photo by Ed Gyllenhaal.

suburb of Bryn Athyn, where it was installed in a new building financed by John Pitcairn to house the Academy's museum and library.

Benade's interest in the history of religion was inspired by his fascination with the writings of Emanuel Swedenborg (1688–1772), a Swedish scientist, philosopher, and theologian. Most eighteenth-century Christian writers focused on the differences between ancient religions and Christianity, with Christianity being considered the only true religion. Swedenborg, however, wrote that the spiritual history of the world was a succession of five *ecclesiae* ("churches"), each one of which had a genuine connection to God and its own form of divine revelation (Gyllenhaal 2010, 179). Swedenborg also maintained that the kingdom of God is spread throughout the entire world and includes people from all religions and cultures.

Today Glencairn Museum seeks to encourage reflection and a sense of wonder about religious traditions around the world, past and present, through an exploration of the cultural expressions of faith. We hope to engage visitors in the ongoing dialogue about the contemporary relevance of spiritual belief and practice, leading to understanding, empathy, and, ultimately, compassion and tolerance for one another in our common human endeavor to find meaning and purpose in our lives.

Galleries located throughout the building are devoted to Ancient Egypt, the Ancient Near East, Ancient Greece, Ancient Rome, Asia, and Native America.

Several galleries feature medieval Christian stained glass, sculpture, and treasury items. A space on the first floor is used for revolving temporary exhibitions (generally three or four per year). Past exhibitions have included *Buddhism in Pennsylvania*; *Hinduism in Pennsylvania*; *Art & Soul: Picturing the Spirit Within*; *In the Service of God: The Sacred Arts in the Middle Ages*; *From Gutenberg to Kindle: The Art of Bible Making*; *Sacred Stories: Scripture, Myth and Ritual*; *Marc Chagall and the Bible*, and *Christmas Traditions in Many Lands*. *World Nativities*, an annual exhibition of three-dimensional Nativity scenes, occupies the entire first floor of Glencairn. This popular holiday exhibition is intended to demonstrate the universal appeal of the Nativity story, and how individuals around the world seek to give the story relevance by relating it to their own spiritual, intellectual, cultural, and regional environments.

Glencairn Museum News, a monthly electronic publication distributed via website, social media, and email, includes essays by scholars from a variety of fields about religious objects and themes in Glencairn's collections. Glencairn has an active education department with both full-time and part-time museum educators and is a popular destination for local schools. We also offer programs for the general public, including guided tours, workshops, and festivals, focusing on religious belief and practice. The annual Sacred Arts Festival features live demonstrations, including stained-glass painting, manuscript illumination, icon writing, and a working Gutenberg-style printing press. The highlight of the festival is the creation and ritual dismantling of a Tibetan Buddhist sand mandala in Glencairn's great hall.

Interpretive Vision and Audience Impact

The National Association for Interpretation defines "interpretation" as "a mission-based communication process that forges emotional and intellectual connections between the interests of the audience and meanings inherent in the resource." Relatively little, however, has been written about techniques for the interpretation of religious objects in museums. Recently the entire Glencairn Museum staff read and discussed *Religious Objects in Museums: Private Lives and Public Duties* (Paine 2013), which examines how religious objects are cared for and interpreted by museum curators, and the impact these objects have on museum visitors. According to Paine, "museums should make explicit the religious meaning of the objects in their care, both out of concern for the feelings of people to whom such objects are significant, and in order to help visitors understand them more fully" (2013, 78). Glencairn has worked steadily over the past several decades to "make explicit the religious meaning" of the religious objects in our collection—using a variety of interpretive methods, with varying levels of success.

In recent years we have felt the need to strengthen Glencairn's interpretive program by placing it on a sound theoretical foundation. In our search for theoretical models suited to our museum's mission of promoting interfaith understanding, we have recently been reconsidering our interpretive efforts from the perspective of the phenomenology of religion.[1] A group of historians and philosophers of religion of the so-called

Dutch school, including W. Brede Kristensen, Gerardus van der Leeuw, and C. Jouco Bleeker, developed this approach by expanding on the philosophical phenomenology of the German philosopher Edmund Husserl (1859–1938). Phenomenologists of religion attempt to set aside judgments of religious truth and value in order to understand religion "from the inside," giving priority to the perspectives of believers themselves. In other words, a religion cannot be fully understood unless the scholar confronts the experiences of believers from a position of empathetic openness, temporarily "bracketing out" the scholar's own academic theories or personal religious convictions. Two "empathetic" approaches that originated within the phenomenology of religion seem especially relevant to the interpretive efforts of a museum with an expressed goal of building understanding between people of all beliefs.

The first approach emerges from the nine-step phenomenological method for the study of religion articulated by James Cox in his book *An Introduction to the Phenomenology of Religion* (2010). One step in particular is relevant to the interpretation of religious objects for the public—what Cox refers to as "empathetic interpolation":

> Empathy, in this context, refers to a process of cultivating a feeling for the practices and beliefs of a religion other than one's own or at least of a religion which does not originate in the scholar's own culture or historical period. To interpolate means to insert what is apprehended from another religion or culture, which to the outsider often appears strange or unusual, into one's own experience by translating it into terms one can understand. (52)

Empathetic interpolation, in addition to being part of a phenomenological method for scholars of religion, can be effective as an interpretive technique in museums. For example, ancient Egyptian beliefs and practices relating to the afterlife often appear mysterious and bizarre to museum visitors. An educator in a museum's Egyptian gallery may therefore, intentionally or unintentionally, find himself or herself emphasizing the "otherness" of Egyptian funerary religion while interpreting tomb reliefs and objects from burial chambers. However, in doing so the educator will have missed an opportunity to provide a space for the cultivation of empathetic feelings within the group toward the "other" religion. What if, instead, the educator were to ask the group if they would be willing to share what they know and value about funerary prayers, rituals, and monuments from their own religious traditions? While in many instances these will differ greatly from ancient Egyptian beliefs and practices, there will also likely be similarities. Many funerary customs—past and present—meet the same human needs to grieve and to pay tribute to loved ones who have passed on. By creating opportunities for empathetic interpolation, the museum interpreter can increase the probability that visitors will go home with a deeper understanding of religions different from their own. Interpretation planners at museums with religious objects would do well to keep in mind the dictum of Terence, the Roman playwright: "I am a human, and nothing of that which is human is alien to me" (*Heauton Timorumenos*: Act One, Scene One).

The second feature of the phenomenology of religion that may prove useful in museum interpretation is its historic emphasis on describing religious traditions in a way that is acceptable to the adherents themselves. W. Brede Kristensen (1960, 14) insisted that "believers were completely right" about the meaning of their own faith and practice, while W. Cantwell Smith (1959, 42) maintained that "no statement about a religion is valid unless it can be acknowledged by that religion's believers." In other words, if a scholar produces a description of a religious tradition that its adherents cannot affirm as a fair representation of their beliefs and practices, then the scholar has failed. Smith further developed this principle into an explicit set of criteria for the work produced by phenomenologists of religion. He proposed that descriptions of religious traditions should be simultaneously comprehensible to the adherents of the religious tradition described, to members of the scholarly community, and to lay people of a different faith (52–53). In the context of interpretive planning for museums, this approach may be reimagined as a threefold test for developing exhibitions, tours, and programs that encourage understanding and empathy. In a museum, any description of a religious tradition for the general public should be comprehensible (1) to the adherents of the religion in question, (2) to the professional community of scholars, and (3) to the visiting public, which includes people of all faiths and none. In the case of living religious traditions, the implications of this approach for community engagement are clear. When possible, the "believers" should be consulted about each new interpretive undertaking, and the result should be presented in a way that scholars can affirm and the visiting public can readily understand and, ideally, empathize with.

Providing opportunities for museum visitors to meet with representatives from source communities may be one of the best ways to generate interfaith understanding. For the past several years, the Venerable Lama Losang Samten has created a Tibetan Buddhist sand mandala in Glencairn's great hall during the annual Sacred Arts Festival (Figure 27.2). Before his move from India to the United States in the 1980s, Samten was a master of ritual dance and sand mandalas and the personal attendant to His Holiness the XIV Dalai Lama. In 1988 the Dalai Lama asked Samten to demonstrate the creation of a sand mandala for a Western audience, an unprecedented event that took place at the American Museum of Natural History in New York City. Since then he has made many sand mandalas in museums, universities, and other venues throughout the United States. At Glencairn the staff work with Samten to build a large altar near the mandala, combining his own ritual objects with objects from the museum's collection. According to Samten (2014),

> At the altar, each morning, I offer either water or a small cup of coffee or a small cup of tea. At the end of the day the offering is removed, and the bowls are cleaned and refilled the next day. For every bowl that I am putting water in, I am meditating or thinking about what each water bowl represents. They do not just represent water, and each one represents something different . . . It creates good karma.

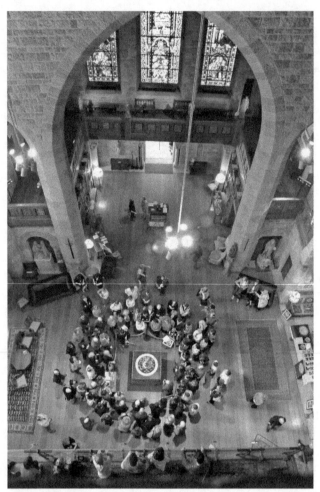

Figure 27.2 At the conclusion of the annual Sacred Arts Festival at Glencairn Museum, visitors are invited to participate in the ritual dismantling of a Tibetan sand mandala. Photo by Ed Gyllenhaal.

Samten works steadily on the sand painting for several days, while also interacting with school groups and the visiting public. A dismantling ceremony is held at the conclusion of the festival, and visitors (often children) are invited to help brush the sand into the center of the mandala—an affirmation of the impermanence of all things. After Samten chants prayers (the significance of which he carefully explains), the audience joins him in a procession to a wooded area behind Glencairn, where the sand is ritually poured into a pond as a blessing:

> The ceremony starts with me, and then I like people to participate in pushing the sand into the middle of the table to mix all of the colors together. The sand is then dispersed in water. Plus, if people want, they can take a little bit of sand from that day and disperse it around their home, or in their garden. It is very beneficial.

At the close of the twentieth century museum professionals began to recognize the need to make their museums more accessible to the general public by becoming less object-centered and more visitor-centered. In the twenty-first century many museums are taking this approach a step further by exploring ways they can use their collections, facilities, and intellectual resources to actually effect social change. (In 2015 the conference theme of the annual meeting of the American Alliance of Museums was "The Social Value of Museums: Inspiring Change," while the theme for 2016 was "Power, Influence, and Responsibility.") It has been pointed out, however, that a museum may have relatively little control over its own impact, since visitors come to museums for a wide variety of reasons and create their own meanings that do not necessarily align with the expressed goals of the institution (Falk 2009, 241–249). Empathy as a desired impact is sometimes difficult to achieve, and even more difficult to measure. Randi Korn's (2013, 31–43) planning model for museums, which she calls "intentional practice," is a framework for articulating and evaluating a museum's social impact. Certainly an intentional planning process in which the entire museum staff continually focuses, not just on *what* the museum does, but on the intended *result* of what the museum does, will be necessary if we wish to create exhibitions, tours, and programs that result in understanding and empathy on the part of visitors.

At Glencairn Museum our search for useful theoretical models will continue. We are especially interested in hearing about models and interpretive methods being used at other museums with collections of religious objects. The future will likely see innovations and progress that we can barely imagine today, as researchers and museum practitioners work to bring source communities and visitors together in order to transform museums into agents of social change.

Note

1. See James Cox (2006) for a history of the development of the phenomenology of religion in the twentieth century. Those familiar with the field of religious studies will be aware that the influence of the phenomenological method, which dominated the field during much of the twentieth century, has waned with the rise of a variety of alternative approaches to the study of religion, including the emerging cognitive science of religion. Cox (2010, 166), for one, does not regard phenomenological and cognitive approaches as mutually exclusive, believing that "the cognitive science of religion may merge with the phenomenology of religion to produce the next advances in the academic study of religion." I would like to thank David Gyllenhaal, Princeton University, and James Cox, University of Edinburgh, for their valuable advice about the portion of my article that involves the phenomenology of religion.

References

Cox, James. 2006. *A Guide to the Phenomenology of Religion: Key Figures, Formative Influences and Subsequent Debates*. London: Continuum.

Cox, James. 2010. *An Introduction to the Phenomenology of Religion*. London: Continuum.

Falk, John. 2009. *Identity and the Museum Visitor Experience*. Walnut Creek, CA: Left Coast Press.

Gyllenhaal, Ed. 2006. "Glencairn Museum, Bryn Athyn, Pennsylvania." *Material Religion: The Journal of Objects, Art and Belief* 2 (1): 132–136.

Gyllenhaal, Ed. 2010. "From Parlor to Castle: The Egyptian Collection at Glencairn Museum." In *Millions of Jubilees: Studies in Honor of David P. Silverman* 1, edited by Z. Hawass and J. Houser Wegner, 175–203. Cairo: Publications du Conseil Suprême des Antiquités de l'Egypte.

Korn, Randi. 2013. "Creating Public Value through Intentional Practice." In *Museums and Public Value: Creating Sustainable Futures*, edited by C. Scott, 31–43. Farnham: Ashgate.

Kristensen, W. Brede. 1960. *The Meaning of Religion: Lectures in the Phenomenology of Religion*, translated by J. Carman. The Hague: Martinus Nijhoff.

Paine, Crispin. 2013. *Religious Objects in Museums: Private Lives and Public Duties*. London: Bloomsbury.

Samten, Losang. 2014. "Tibetan Sand Mandala at Glencairn Museum: an Interview with the Venerable Lama Losang Samten." *Glencairn Museum News*, April.

Smith, Wilfred Cantwell. 1959. "Comparative Religion: Whither—and Why?" In *The History of Religions: Essays in Methodology*, edited by M. Eliade and J. Kitagawa, 31–58. Chicago: University of Chicago Press.

Afterword: Looking to the Future of Religion in Museums

GRETCHEN BUGGELN, CRISPIN PAINE, AND S. BRENT PLATE

What of the future? Contributors to this volume have pointed to a variety of trends that can be expected to grow, presenting further challenges for museums as they collect, interpret, and take care of religious artifacts, and interact with diverse communities. Museums will need to determine which issues they can and should take up and to select approaches and techniques that will help to both frame and address questions and topics in useful and appropriate ways.

Museums over the past generation have undergone a major shift, increasingly seeing themselves as "in the service of society," with a responsibility not only to offer education, entertainment, and "improvement" to the individual, but actually to help effect societal change; in the process they have become increasingly political. More recently, too, museums have begun to work much more with emotion—Holocaust museums and other memorials of tragedy are one approach, the recent fashion for "empathy" in museums another (Alba 2015; Williams 2008; Gokcigdem 2016); Gruber 2012). Often, the emotional dimensions are tied to new displays that engage viewers' senses beyond vision alone. In the name of interactivity and accessibility, the feel, smell, and sound of objects are becoming more prominent. With a shift to multiple senses, emotions, memory, and empathy, religion finds itself more and more at home in museums.

Communities increasingly expect their museums to help promote interreligious understanding and harmony. We must certainly expect this trend to continue. But we should be wary, too, of the opposite. Admittedly, some partisanship will always inflect the work of museums, whether or not professionals are aware of their biases. Yet as museums are recognized as more and more popular and effective opinion-formers, we may fear attempts by particular groups to control them. For example, *The Sacred Made Real* exhibition at London's National Gallery—praised by a number of contributors here—was largely paid for by a far-right American millionaire supporter of antigay and pro-Creationism campaigns, who has called for the imposition of Old Testament law in the United States (Doward 2005). How much does this sort of thing matter? This question of sponsorship is a particular quagmire for museums, and we must show courage by resisting the pull of money when it conflicts with the greater needs of our communities. All this will require open conversation and negotiation. When we

talk about a "radical hospitality" that invites diverse perspectives, which perspectives will be out of bounds, and who will decide?

Much of the progress made by religion in museums in recent years has been the achievement of learning staff. In the chapters in this volume, Chris Carron, Susan Foutz, Melissa Pederson, and John Reeve fly the flag for learning/education staff, whose skill and expertise is required if museums are to help visitors of all ages understand religion and religions. Arranging a public event or children's activity that addresses religion is often easier and potentially less controversial than interpreting religion in a new gallery or even a temporary exhibition. One major challenge for museums—especially perhaps for secular museums—will be to bring the skills, flexibility, and approach of learning staff into the museum mainstream of public exhibitions and—above all—permanent galleries. We can expect, too, that the sort of outreach initiative described by Ekaterina Teryukova at the St. Petersburg Museum of the History of Religion will become much more common. The use of the web, and of digital technology generally, to promote understanding of religion will surely become very common. Topics of complexity can be successfully presented in interactive and self-paced digital media.

We need to know much more about our visitors. Not just who they are and what prompted their visit—most museums collect this kind of marketing information—but what they are looking for. What understandings, assumptions, prejudices, and hopes are they bringing with them? How do they learn in a museum environment (an oddly little researched subject)? We also need to know much more about the results of their encounters with religion in museums. How are they affected by museum spaces? By different kinds of interpretation? Which types of display and visitor engagement are the most effective, or, to use an increasingly common term, the most "transformative"? Concern for visitor comfort and enjoyment must be balanced with the museum's mandate to use its unique abilities to bring "foreign" or "other" objects and cultures into view. Such educational concerns need to remain central.

One of the huge challenges museums face is to help people who have never had any contact with religion understand what it is that motivates religious people: what "devout" feels like inside. Here digital technology is not enough. We can perhaps expect to see much greater use made of volunteers—believers willing and able to engage and interact with visitors, perhaps more first-person narratives of the kind Gretchen Buggeln noted in Colonial Williamsburg. Tact will be at a premium! It will be needed, too, in developing ways of involving visitors actively in religion exhibits. So will imagination; the offerings, touchings, prayers, and selfies that a number of contributors here have described happening in museum galleries will not suit all visitors. Unbelievers, in particular, will need other approaches, new types of "interactives."

Future progress will come from both museum workers and scholars. Since most museum professional training takes place in universities, there's a particular opportunity for religious studies departments and museum studies departments to cooperate. Museum studies specialists can discover modern understandings of religion, while religious studies specialists can learn from their museum colleagues both how

religion can be presented in museums and also how a museum and material approach to religion can enhance their scholarly work and inspire their students. To involve other university departments would add greatly to such conversations: archaeology, history, architecture, music, psychology, area studies, cultural studies, and so on. Moving these conversations outside the halls of the university, as when Ed Gyllenhaal and the staff at Glencairn Museum read religious studies texts on the phenomenology of religion to better serve the public, is vital, but above all we need to find new ways of involving this wider public in those very conversations.

Together museum workers, scholars, and audiences from many backgrounds and many parts of the world can tackle some of the big questions about religion in museums raised by contributors to this book. These questions, as we have seen, are about authenticity, ethics, approaches to display and interpretation, religious forms, and the relation of museums and their buildings to places of worship and sacred places. Above all, our task is to understand an increasingly wide array of curious museum visitors and to present—with intelligence, openness, sensitivity, and creativity—religious objects and stories to their communities.

References

Alba, Avril. 2015. *Holocaust Memorial Museums: Sacred Secular Space*. London: Palgrave Macmillan.

Doward, Jamie. 2005. "Anti-Gay Millionaire Bankrolls Caravaggio Spectacular." *The Guardian*, March 6. http://www.theguardian.com/uk/2005/mar/06/arts.artsnews (accessed June 5, 2016).

Gokcigdem, Elif. 2016. *Fostering Empathy through Museums*. Lanham, MD: Rowman & Littlefield.

Gruber, Christianne. 2012. "The Martyrs' Museum in Tehran: Visualizing Memory in Post-Revolutionary Iran." *Visual Anthropology* 25(1–2): 68-97.

Williams, Paul. 2008. *Memorial Museums: The Global Rush to Commemorate Atrocities*. London: Bloomsbury Academic.

Index

Locators of figures in bold